PATTERNS IN **NATURE**

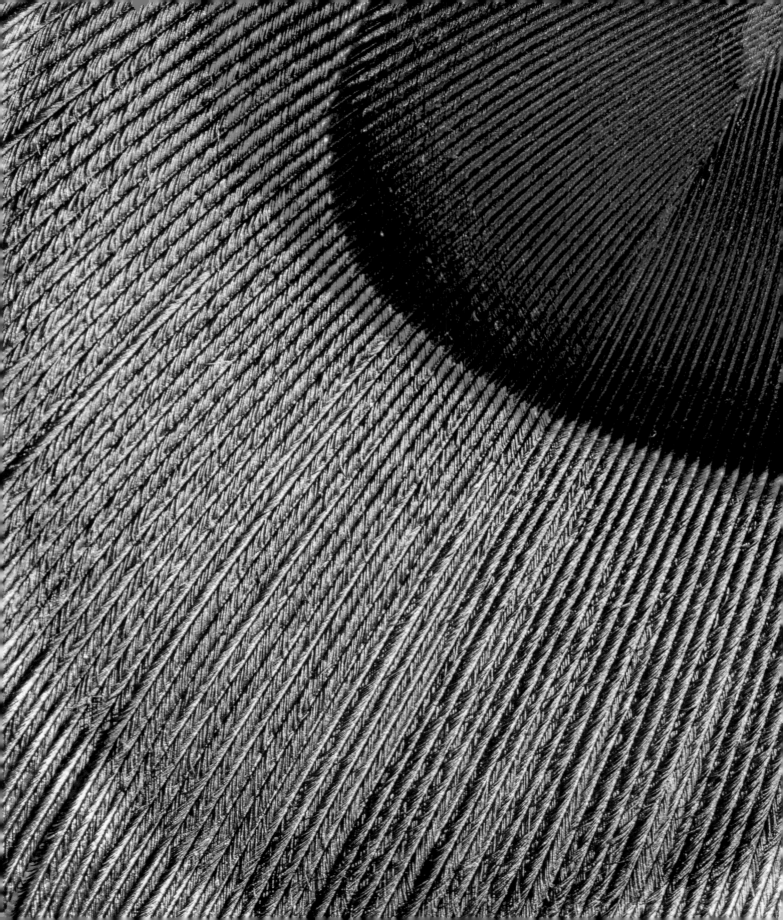

PATTERNS IN
NATURE

WHY THE NATURAL WORLD LOOKS THE WAY IT DOES

Philip Ball

The University of Chicago Press
Chicago and London

The University of Chicago Press, Chicago 60637
The University of Chicago Press, Ltd., London
© 2016 by Marshall Editions
All rights reserved. Published 2016.
Printed in the United States of America

25 24 23 22 21 20 19 18 17 16 1 2 3 4 5

ISBN-13: 978-0-226-33242-0 (cloth)
ISBN-13: 978-0-226-33256-7 (e-book)

DOI: 10.7208/chicago/9780226332567.001.0001

Library of Congress Cataloging-in-Publication Data

Ball, Philip, 1962– author.
Patterns in nature : why the natural world looks
the way it does / Philip Ball.
pages cm
Includes bibliographical references.
ISBN 978-0-226-33242-0 (cloth : alk. paper)
-- ISBN 978-0-226-33256-7 (e-book) 1. Pattern
formation (Physical sciences) 2. Pattern formation
(Biology) 3. Geometry in nature. 4. Nature. I.
Title.
Q172.5.C45B357 2016
500.201'185—dc23
2015034568

Conceived, edited, and designed by
Marshall Editions
The Old Brewery
6 Blundell Street
London N7 9BH
www.marshalleditions.com
QUAR. M PTN

Senior Editor: Chelsea Edwards
Senior Art Editor: Emma Clayton
Designer: Plum Partnership
Art Assistant: Martina Calvio
Copyeditor: Sarah Hoggett
Proofreader: Claire Waite Brown
Picture Researcher: Sarah Bell
Art Director: Caroline Guest
Creative Director: Moira Clinch
Publisher: Paul Carslake

Color separation in Hong Kong by
Cypress Colours (HK) Ltd
Printed in China by
Hung Hing Off-set Printing Co. Ltd

CONTENTS

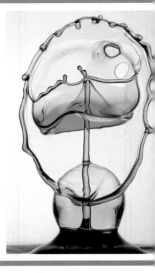

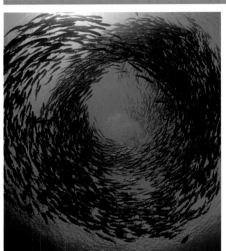

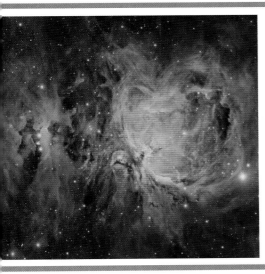
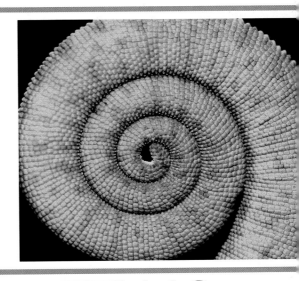
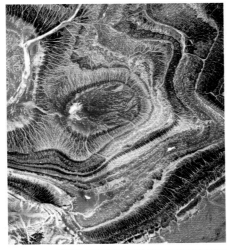
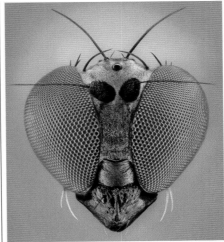
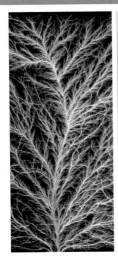
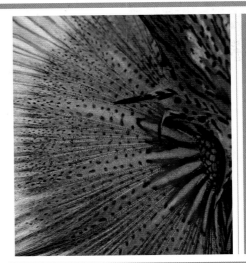

Introduction

The world is a confusing and turbulent place, but we make sense of it by finding order. We notice the regular cycles of day and night, the waxing and waning of the moon and tides, and the recurrence of the seasons. We look for similarity, predictability, regularity: those have always been the guiding principles behind the emergence of science. We try to break down the complex profusion of nature into simple rules, to find order among what might at first look like chaos. This makes us all pattern seekers.

It's a habit hardwired into our brains. From a baby's first inklings of repeated sounds and experiences, recognizing pattern and regularity helps us to survive and make our way in the world. Patterns are the daily bread of scientists, but anyone can appreciate them, and respond to them with delight and wonder as well as with aesthetic and intellectual satisfaction. Just about every culture on earth, from the ancient Egyptians to Native Americans and Australian Aborigines, has decorated its artifacts with regular patterns. It seems that we find these structures not only pleasing but also reassuring, as if they help us believe that, no matter what fate brings, there is a logic and order behind it all.

But when we make our own patterns, it is through careful planning and construction, with each individual element cut to shape and laid in place, or woven one at a time into the fabric. The message seems to be that making a pattern requires a patterner. That's why, when people in former times recognized patterns in nature—the bee's honeycomb, animal markings, the spiraling of seeds in a sunflower head, the six-pointed star of a snowflake—they imagined it to be the fingerprint of intelligent design, a sign left by some omnipotent creator in his handiwork.

Today, we don't need that hypothesis. It's clear that pattern, regularity, and form can arise from the basic forces and principles of physics and chemistry, perhaps selected and refined by the exigencies of biological evolution. But that only deepens the mystery. How does the intricate tapestry of nature contrive to organize itself, producing a pattern without any blueprint or foresight? How do these patterns form spontaneously?

There are clues in how they look. Perhaps the most curious thing about natural patterns is that they come from a relatively limited palette, recurring at very different size scales and in systems that might seem to have nothing at all in common with one another. We see spirals, say, and hexagons, intricate branching forms of cracks and lightning, spots and stripes. It seems that there are types of pattern-forming process that don't depend on the detailed specifics of a system but can crop up across the board, even bridging effortlessly the living and the non-living worlds. In this sense, pattern formation is universal: it doesn't respect any of the normal boundaries that we tend to draw between different sciences or different types of phenomena.

Growth and form?

Do these patterns have anything in common, or is the similarity in their appearance just coincidence?

The first person to truly grapple with that question was the Scottish zoologist D'Arcy Wentworth Thompson. In 1917 Thompson published his masterpiece, *On Growth and Form*, which collected together all that was then known about pattern and form in nature in a

MATHEMATICAL ORDER
Regular geometric designs of great sophistication are common in traditional Islamic architectural decoration, expressing a sense of an orderly cosmos. Some of these Islamic artists seemed particularly drawn to pattern elements that cannot in themselves be packed into identically repeating arrays—such as pentagons and octagons.

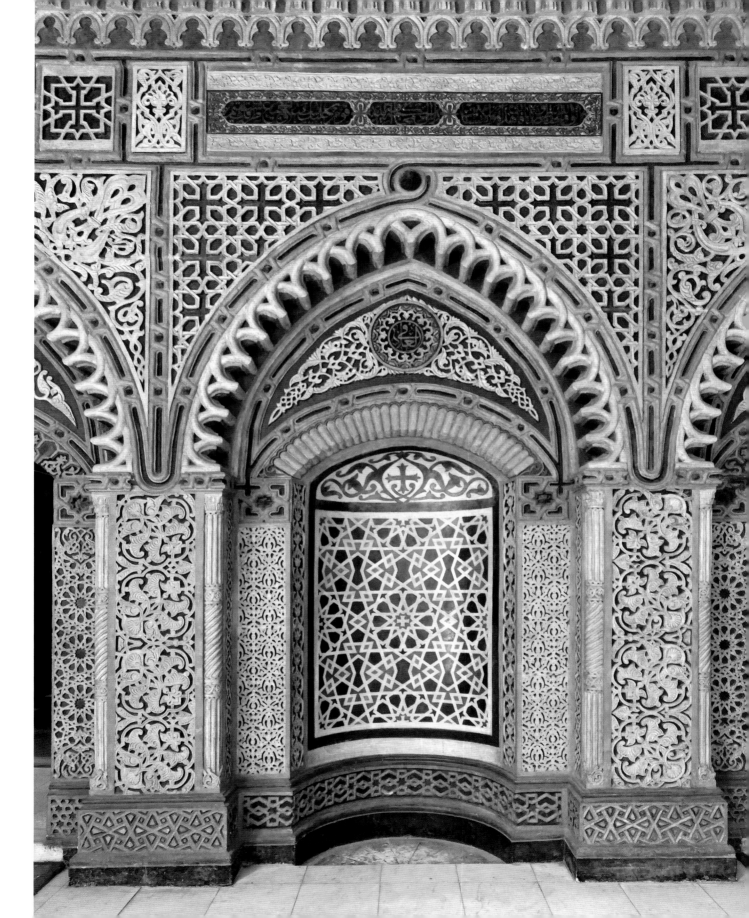

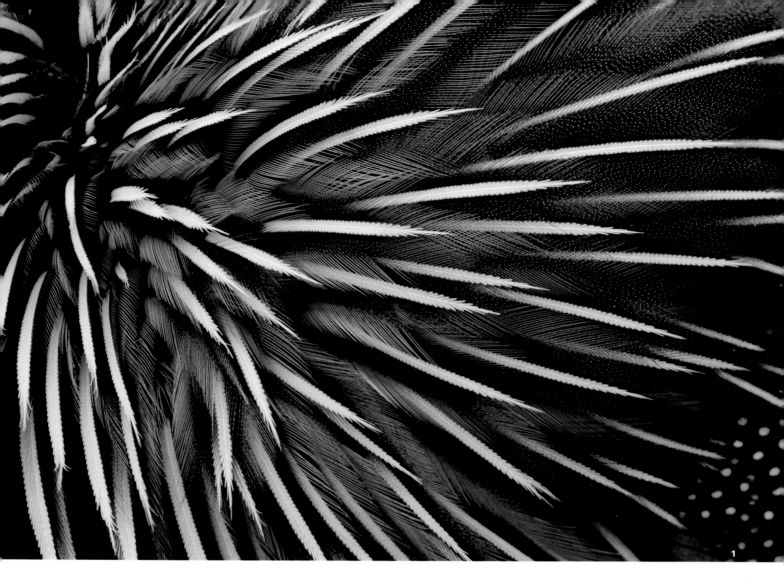

stunning synthesis of biology, natural history, mathematics, physics, and engineering. As the title indicates, Thompson pointed out that, in biology at least, and often in the non-living world, pattern formation is not a static thing but arises from growth. "Everything is what it is," he said, "because it got that way." The answer to the riddle of pattern lies in how it got to be that way—how the pattern grew. That's less obvious than it sounds: a bridge or a paddy field or a microchip is "explained" by how it looks, not by how it was made.

Part of Thompson's agenda was to put a brake on the runaway enthusiasm that had developed at that time for explaining all form and order in the living world by invoking Charles Darwin's theory of natural selection—to say that the pattern was there because it served some adaptive purpose in

helping the organism to survive. Not necessarily, Thompson cautioned. Perhaps nature simply had no choice: the shape is decided by the dictates of physical forces, not by the convenience for biology. Even living creatures have to be soundly engineered to withstand the whims of fate. It was a timely reminder of the constraints on Darwin's theory, but it doesn't actually conflict with it. In the living world, pattern formation seems both to restrict the options for adaptive change and to offer new adaptive opportunities—to operate, in other words, in parallel and sometimes in sympathy with Darwinian evolution. It supplies, for example, the color markings that animals put to striking use for camouflage, or as warning signs to predators, or so that members of a species can recognize each other. These patterns might not be arbitrary, but they can be useful.

1 NATURAL EXUBERANCE
The glorious plumage of the vulturine guinea fowl, native to northeastern Africa.

2 PATTERN EVERYWHERE
Regularity and order pervade the natural world, both living and non-living. Sometimes it takes a microscope (or a telescope) to see it, as in the case of these pollen grains.

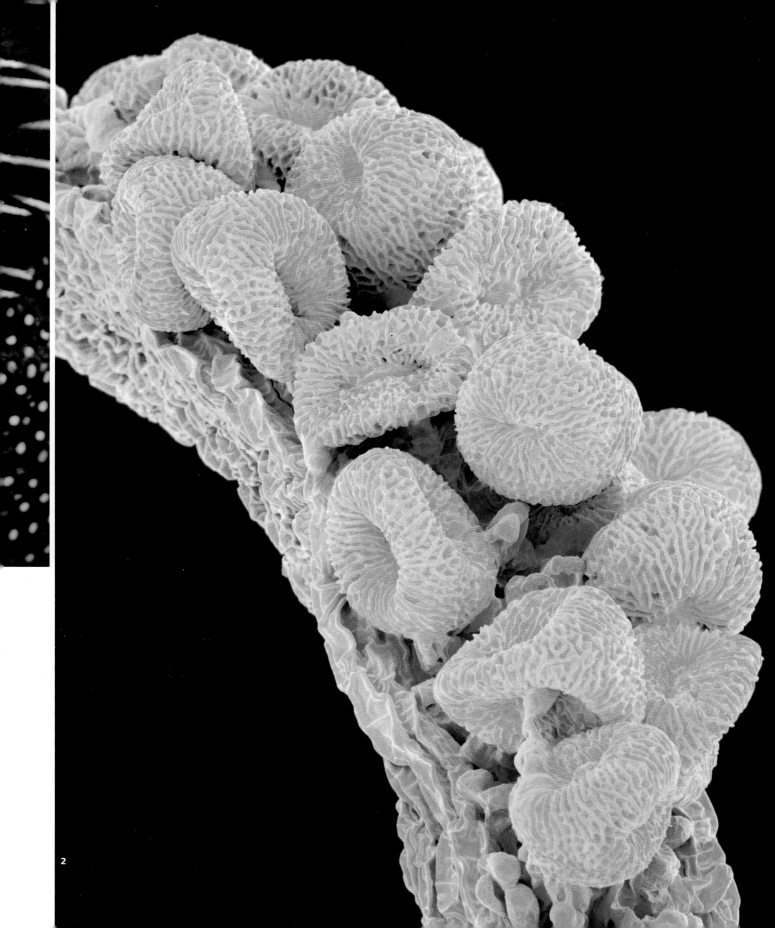

At the same time, however, Thompson's book helped to show why it was not simply coincidence that the same patterns and forms ranged across the sciences—why, say, the arrangements made by soap bubbles might resemble those of clusters of living cells or the meshlike skeletons of small sea creatures, why snail shells and ram's horns curl into mathematical spirals, why animal backbones are shaped like cantilever bridges.

In the midst of wonders

He didn't get everything right, by any means, but Thompson was on the right track. In the century that has elapsed since *On Growth and Form* was published, many new natural patterns have been identified and explained, and today there are scientists who specialize in studying these things, aided by conceptual, experimental, and computational tools that Thompson lacked. The questions are fascinating and challenging, but it's hard not to suspect that a big part of the allure is aesthetic: these forms and arrangements are also beautiful.

These patterns affirm, too, what the American physicist Richard Feynman said about the workings of the universe: "Nature uses only the longest threads to weave her patterns, so each small piece of her fabric reveals the organization of the entire tapestry." The principles that operate in the world are general ones, and you can sometimes read them as clearly in a small corner as in a big vista: in a saucepan on the stove, you might see an intimation of the convection patterns that arrange the clouds across the sky, for example, while the network of veins in your body echoes (for good reason) the great river networks that cross continents and shape mountain ranges.

This doesn't mean to say that one grand theory explains all these things, although some scientists have dreamed, and still dream, of such a thing. But it does make many patterns variations on a theme, and reflects the fact that they often arise from broadly similar processes—ones in which some driving force, be it gravity or heat or evolution, prevents the system from ever settling into a steady, unchanging state; in which various influences interact with each other, sometimes reinforcing and sometimes competing; in which patterns and forms might switch abruptly to a new shape and appearance when the driving force exceeds some threshold value; in which small events can have big consequences and what goes on here can influence what transpires at a distant point there; and in which accidents may get frozen into place and determine what unfolds thereafter. There is no Law of Pattern Formation, but there is perhaps a recipe book.

This book will certainly not explain all or even most of those prescriptions. That's been done elsewhere (see Further Reading, page 283, for examples). The aim here is to offer a flavor of the recipes, but most importantly, to display the results in all their glory. This, perhaps more than any other field of scientific study, is a topic driven by wonder. I confess that some of the images in these pages are ones that science can't yet fully explain; perhaps the general principles are clear, but not the details and nuances. There are also some images that are included not because they illustrate a clear or single scientific process but because of their sheer splendor. We need that too. We need to marvel and admire as well as to analyze and calculate. Natural patterns offer raw delights, but they also point to something deep, as Feynman intimated. They show that, sometimes, to understand the world we need not only to dissect it into its component parts but also to build it back up again. Forms and effects emerge from the rich interplay of components in a way that you would—indeed could—never guess by looking at them individually. It is not mere mysticism or anthropomorphism to suggest that this emergence of new form reveals a kind of spontaneous creativity in nature. The world uses simple principles to bring forth variety and riches, Darwin's "endless forms most beautiful." Some of that beauty is captured here.

THE PATTERN PALETTE
Certain forms, shapes, and patterns recur again and again in the natural world, in systems that seem to have nothing to do with one another. Waves of growth are one of them, as can be seen in this piece of agate.

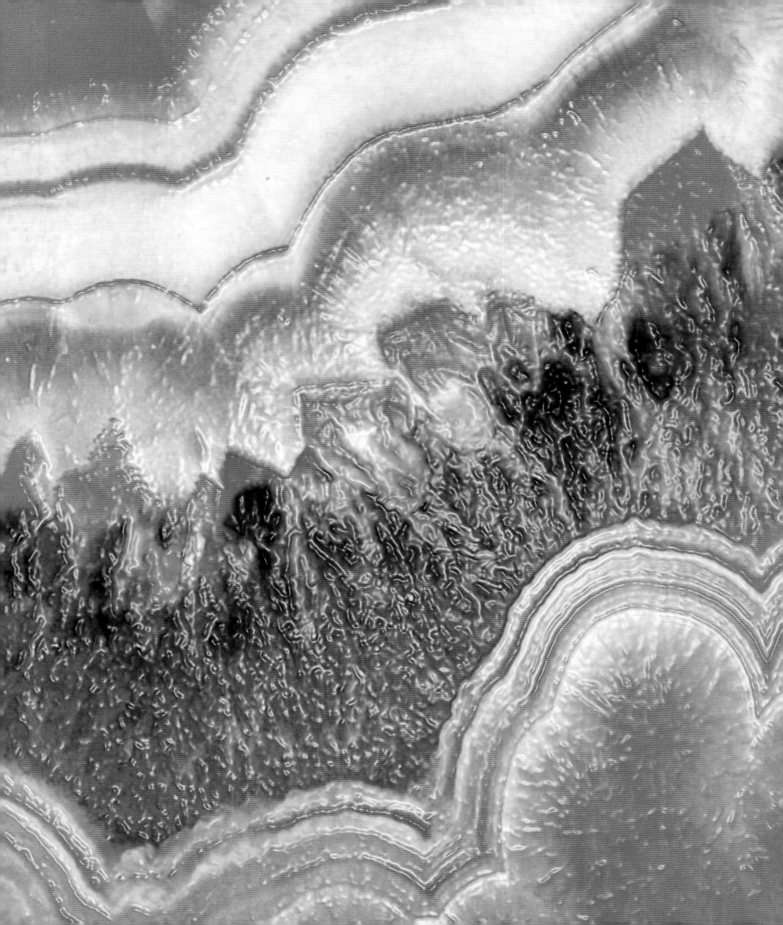

1 SYMMETRY

Why your left is like your right
(and why it's different)

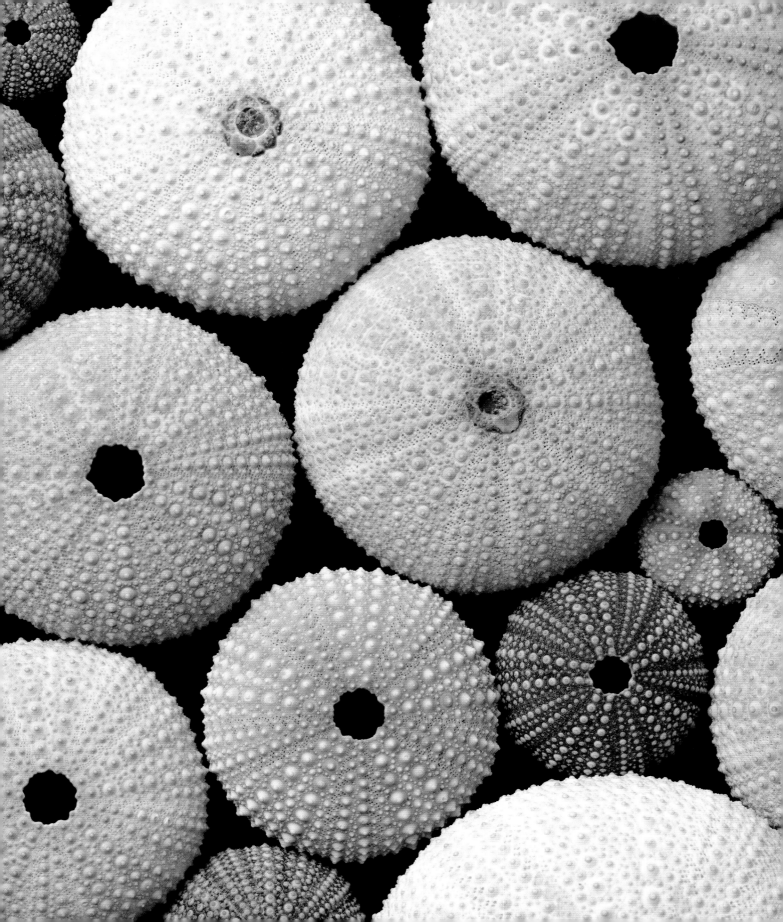

What is a pattern, anyway? We usually think of it as something that repeats again and again. The math of symmetry can describe what this repetition may look like, as well as why some shapes seem more orderly and organized than others. That's why symmetry is the fundamental scientific "language" of pattern and form. Symmetry describes how things may look unchanged when they are reflected in a mirror, or rotated, or moved. But our intuitions about symmetry can be deceptive. In general, shape and form in nature arise not from the "building up" of symmetry, but from the breaking of perfect symmetry—that is, from the disintegration of complete, boring uniformity, where everything looks the same, everywhere. The key question is therefore: why isn't everything uniform? How and why does symmetry break?

People dreamed of an ordered universe even in ancient times—perhaps especially then, when they were more vulnerable to the random whims of nature. "God, wishing that all things should be good, and so far as possible nothing be imperfect," wrote the Greek philosopher Plato in the fourth century BCE, "reduced the visible universe from disorder to order, as he judged that order was in every way better." Plato imagined a universe created using geometric principles, based on ideas about harmony, proportion, and symmetry. It is a vision that has resonated strongly ever since. Symmetry is one of the key concepts that modern physicists use to understand the world, and they believe its deepest laws will show this feature.

What exactly are these properties of symmetry and pattern that we find in nature, and where do they come from? The best way to understand symmetry is as a property of an object or structure that allows us to change it in some way while leaving it looking just the same as it was before. Think of a sphere: you can rotate it any way you like, and you'd never know: it appears unchanged. Or think of the grid of lines on a piece of graph paper. If you move the paper exactly one grid square's width in a direction parallel to the lines, the grid is superimposed on how it looked at the outset.

These are both symmetries, but of different kinds. The sphere has so-called rotational symmetry, meaning that its appearance is unchanged by rotation. The graph paper has (ignoring the edges) translational symmetry: a "translation" here means a movement in a particular direction. The sphere in fact has perfect rotational symmetry, meaning that it is symmetrical for any angle of rotation. Imagine instead a soccer ball made from hexagonal and pentagonal patches sewn together: only certain rotation angles will superimpose the hexagons and pentagons exactly on their initial positions.

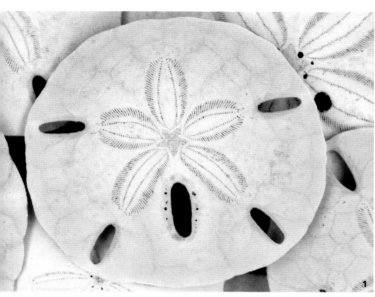

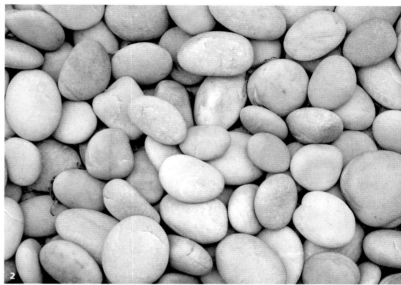

1 SUBTLE SYMMETRY
The sand dollar, a kind of sea urchin, seems to pretend that it has fivefold symmetry, like a pentagon—but the oval slots undermine it.

2 ARE ALL PEBBLES ALIKE?
Even pebbles have, on average, a characteristic shape that can be written in mathematical terms, which describes the range of different amounts of curvature they have over their surfaces.

Another kind of symmetry is reflection, which is really just what it sounds like. If you put a mirror upright on the graph paper, the reflection in the mirror looks just like the piece of the sheet that lies behind it. This is exactly true only if the plane of the mirror is placed in just the right position: it has to run either along one of the grid lines or exactly at the halfway point of a square, so that the half-squares you can see and the other halves in the mirror reflection look like a full square. There's another place you can put the mirror, too: exactly along the diagonals of the squares, at an angle of 45°, to the grid lines. So this is another of the pattern's "planes of symmetry." If the angle is any different from 45°, the reflection doesn't superimpose exactly on the original grid that it hides: that isn't a true plane of symmetry.

Mathematicians call these rotations, reflections, and translations "symmetry operations"—movements that don't alter the appearance of the object. A plus sign and a square have the same symmetry: they have an identical set of operations that leaves them looking unchanged. A square grid, meanwhile, has a different set of operations from a hexagonal grid such as a bee's honeycomb or chicken wire.

Bodies

One of the most common kinds of symmetry that we see in the natural world is called bilateral symmetry. An object with this symmetry looks unchanged if a mirror passes cleanly through its middle. To put it another way, the object has a left side and a right side that are mirror images of each other. This, of course, is a characteristic of the human body, although little random quirks and accidents of our life history make the symmetry imperfect. There's some evidence that people whose faces are more symmetrical are deemed more attractive on average, and it has also been claimed that other animals with

"Symmetry is one of the main concepts that modern physicists use to understand the world."

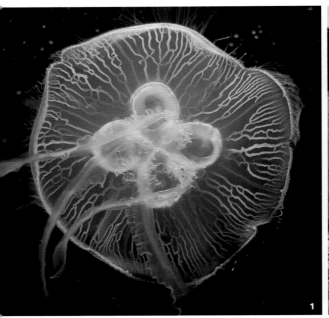

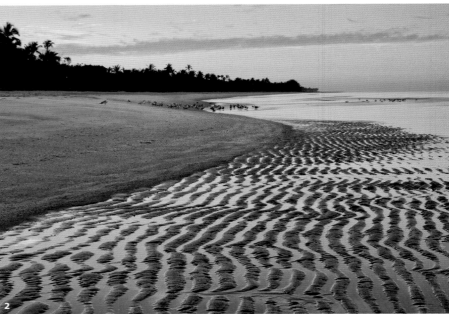
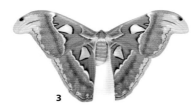

1 JELLYFISH
"Endless forms most beautiful": this is how Charles Darwin described the shapes made by evolution.

2 LOW TIDE
Patterns in sand appear spontaneously, engraved by nature's forces.

3 BILATERALISM
A tale of two halves: the atlas moth.

bilaterally symmetrical bodies have more mates the more symmetrical they are.

Bilateral symmetry seems almost to be the default shape for animals. Fish, mammals, insects, and birds all share this attribute. Why is that? One possibility is that bilateral symmetry makes it easier to move in a specific direction: think of the streamlined gliding of a fish, compared with the awkward wriggling of a starfish. Or perhaps a bilateral body meant that such creatures could develop a spine and central nervous system, which has advantages in terms of organizing nerves into a brain. Even starfish have evolved from bilateral ancestors, and in fact their larvae are still bilateral: starfish only develop their fivefold symmetrical bodies as they mature into adults. This kind of shape, which can be superimposed on itself by rotating through a particular angle around one axis, is said to be "radially symmetrical."

Animals first acquired bilaterally symmetrical body designs at least half a billion years ago, and branches of the animal kingdom that don't share this form show that the alternatives tend to have more permissive symmetries, or none at all. There are, for example, the sponges and corals, which, with their tubular, branched, or crinkly funguslike shapes, might easily be mistaken for sea plants. There are tentacled anemones, which often have an approximate radial symmetry: they have an obvious top and bottom, but from the side they look the same from any angle.

Symmetry-breaking and patterning

All kinds of systems and processes, involving both living and non-living objects, can spontaneously find their way into more or less orderly and patterned states: they can self-organize. There is no longer any reason to appeal to some

"Bilateral symmetry seems almost to be the default for animals. Fish, mammals, insects, and birds all share this attribute."

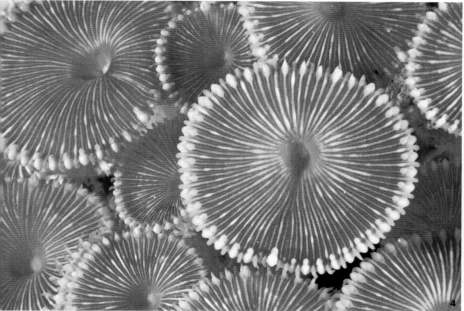
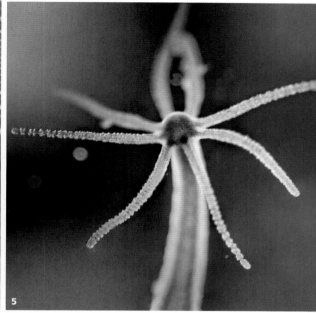

divine plan to explain this, and there is nothing mysterious about it—but that need not diminish our sense of wonder and appreciation when we see it happen. Without any blueprint or guidance, molecules, particles, grains, rocks, fluids, and living tissues can arrange themselves into regular, sometimes geometrical patterns. The laws of nature seem capable of delivering "order for free." Patterns appear in systems even though we can't find any prescription for them in the fundamental rules that govern how their individual components behave. In this case, the patterns and ordering are said to be emergent: they are a property of the whole system, not deducible by looking reductively at the separate parts.

Symmetry is at the root of understanding how such patterns appear. Because in everyday terms we associate patterns with symmetry—think of the designs on wallpaper or Persian rugs, for

example—we might be inclined to imagine that the spontaneous appearance of a pattern in nature involves the spontaneous generation of symmetry. In fact, the opposite is true. Pattern comes from the (partial) destruction of symmetry.

The most symmetrical thing you can imagine is something that you can rotate, reflect, or translate any which way and yet it still looks the same. That's true if the thing is perfectly uniform. So to get pattern from something that is initially unpatterned and uniform involves reducing the symmetry: it is what scientists call a process of symmetry-breaking, which is nature's way of turning things that are initially the same into things that are different. The more symmetry that gets broken, the more subtle and elaborate the pattern.

Randomness might seem the opposite of uniformity, but the two can be equivalent: a

4 A GOOD TURN
A coral with radial symmetry: rotate it, and every few degrees it looks identical.

5 SEEING THE POINT
The starlike radial symmetry of a freshwater hydra.

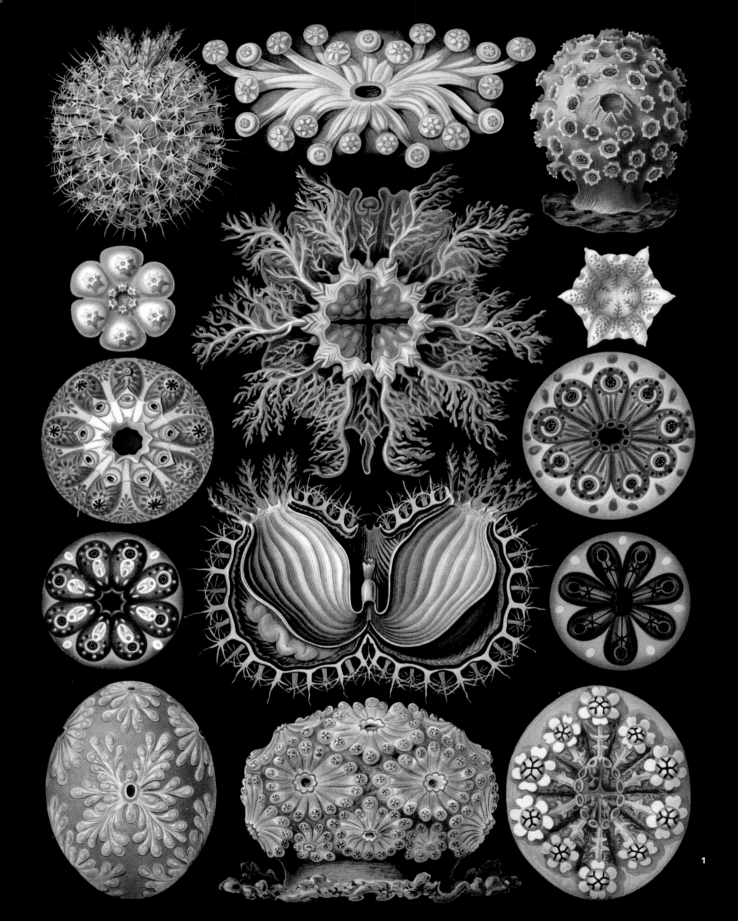

1

random structure is perfectly symmetrical and uniform on average, which means that it too recognizes no "special" directions in space. In the natural world, perfect uniformity or randomness are surprisingly hard to find, at least at the everyday scale. Put yourself on a seashore. The sky is scattered with clouds, perhaps patterned into rows or feathery cirrus. The sea's surface is wrinkled into waves that arrive on the shore with a distinctive pulse. There are plants around the shore, each with its own characteristic shape of flower and leaf. The sand at the water's edge is grooved with ripples, and strewn with the delicate whorls of shells. All around there is shape and form: diverse, yes, but far from random, far from uniform. Symmetry is being broken, again and again.

Cause and effect

In the natural world, when symmetry breaks we often have no cause to have anticipated it. Here's what I mean. If we turn a random pile of bricks into the regular pattern of a wall, it's because we have laid each brick in place. The uniform symmetry of a sheet of paper is broken in making a paper airplane because we folded it that way. In other words, the symmetry gets broken by some force—our moving hand—that compels it to break that way. It's obvious where the symmetry-breaking came from: we put it there.

Compare this to a droplet falling onto the still surface of water. At the start it is perfectly circularly symmetrical: it looks the same in any direction parallel to the surface. But then the splash develops a rim that breaks up into a series of little points, a crown that spits out little droplets from its tips. The rim no longer has its circular symmetry, but has acquired a lower grade of radial symmetry, like a starfish, in which some directions are distinct from others. The process of splashing spontaneously lowered the droplet's own symmetry.

In this book we will see many more examples of such symmetry-breaking. A smooth layer of

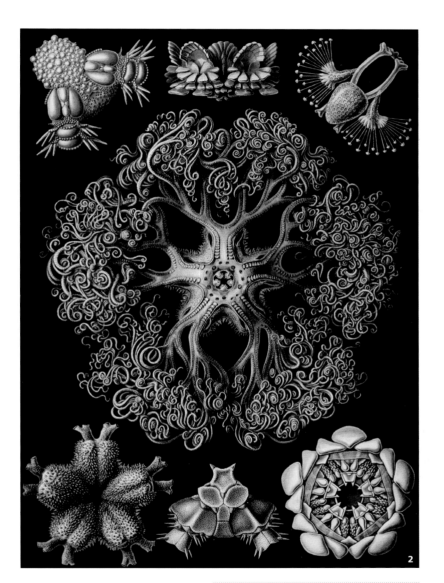

ART FORMS IN NATURE
The ornate symmetries and striking colors of marine invertebrate animals such as tunicates (1) and echinoderms (2) were depicted, sometimes with a little over-elaboration, by the German biologist Ernst Haeckel at the start of the twentieth century.

water breaks up into cells of top-to-bottom circulation when it is uniformly heated from below. A block of material that is shrinking in all directions splits into a network of cracks. Spiraling patterns form in a perfectly mixed solution of chemicals. This is how so many natural patterns form: as if by magic out of a featureless landscape.

We can see it happen, too, on a spider's web. The web itself is a gorgeous natural pattern, but it's not a spontaneous one: the spider makes it the hard way, as we would, by stringing each thread in its place. However, catch the web while the early morning dew is still out and you'll find it beautifully decorated with tiny beads of water hung out like rows of pearls. Did the spider put them there? Not at all—they have been self-organized as dew condensed to coat the silk threads. A thin column of water like this is unstable: it will develop a waviness that pinches it off into little beads, each one regularly spaced where the peaks of the wave were.

Symmetry offers a useful way of thinking about pattern and shape, but even apparently irregular, totally unsymmetrical objects can have a hidden order that mathematics can reveal. Take

a pebble. How would you describe its shape? It is sort of round, like a sphere but not quite. A perfect sphere is easy to define mathematically: it has the same amount of curvature everywhere on its surface. But for a pebble, the curvature differs slightly from place to place, and from pebble to pebble. There is a range of curvatures, and the general "pebble shape" can be described by a graph showing the relative amounts of different degrees of curvature in a selection of many pebbles.

Unlike a sphere, pebbles often have some parts that are concave rather than convex: dimples, not bulges. (Potatoes have similar shapes, and the concave parts are the bits that are hard to peel.) Mathematically, these parts are said to have negative curvature. So the graph showing the distribution of curvature of a pebble reaches into negative as well as positive values. But for any collection of pebbles, the overall graphs of curvature have the same shape! Each individual shape differs, but on average there is a single "pebble shape" described by the curvature distribution. Math reveals the common forms underlying the apparent diversity.

NATURAL CURVES
The proboscis of the geometer moth curls into an elegant spiral, decorated with a regular array of tiny hairs.

"Even apparently irregular, totally unsymmetrical objects can have a hidden order that mathematics can reveal."

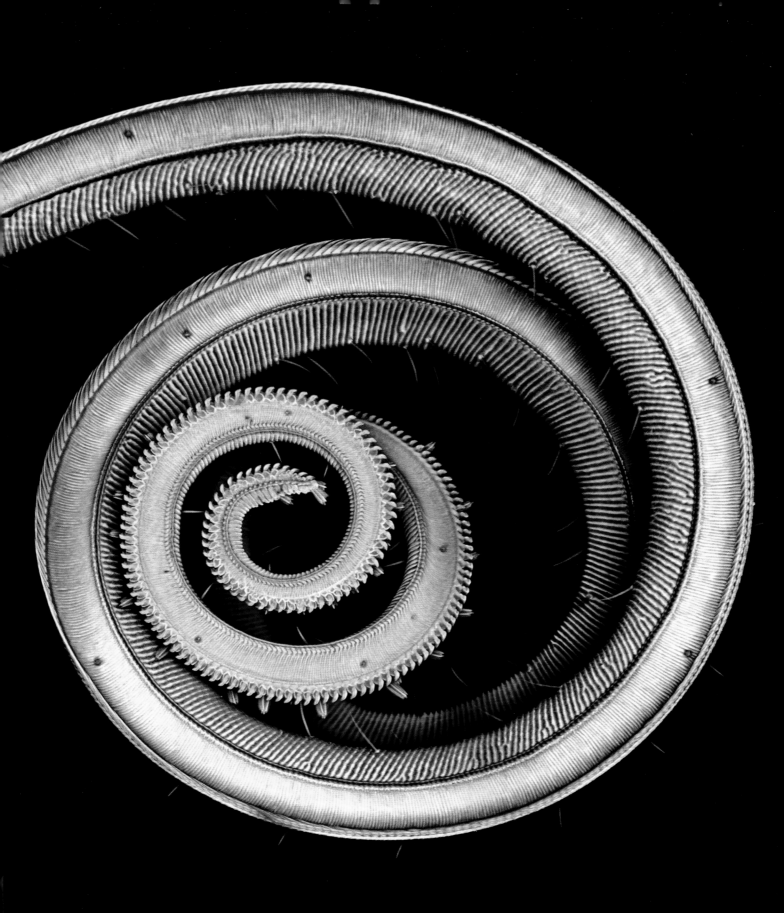

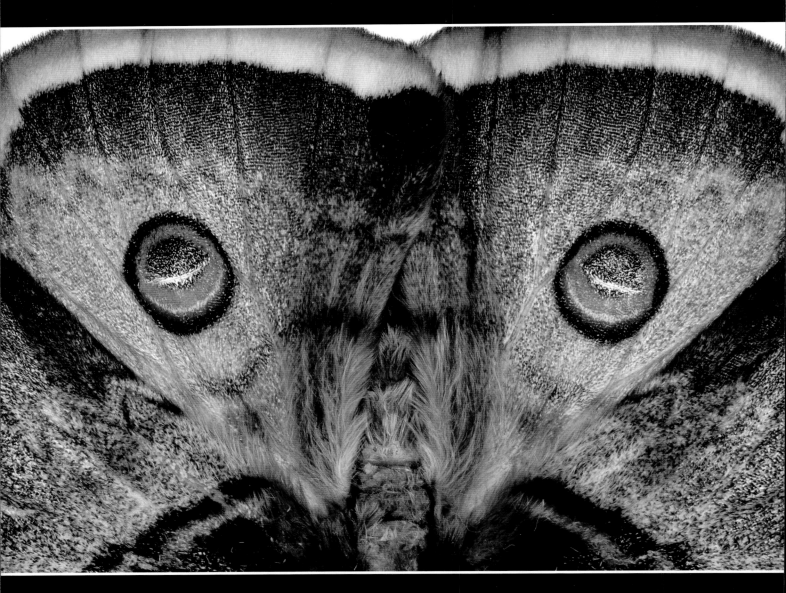

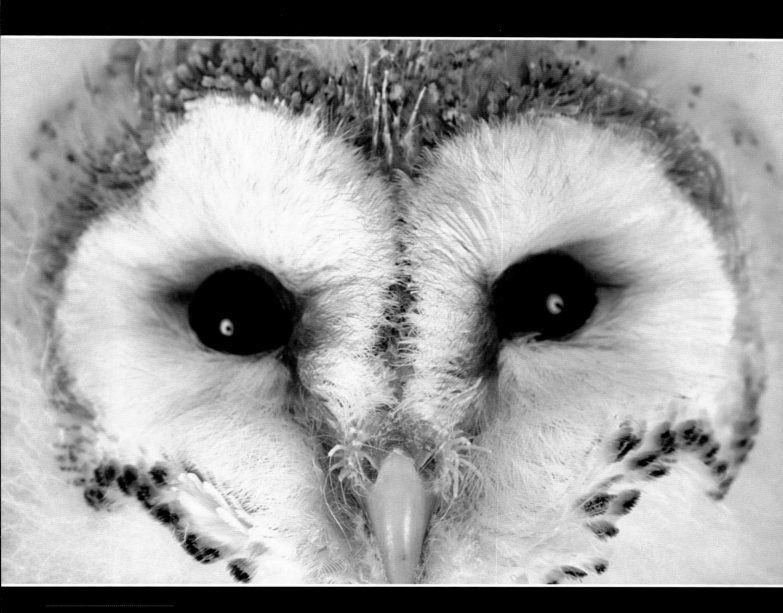

ACCIDENTAL MIMICRY
*The emperor moth
and the barn owl.*

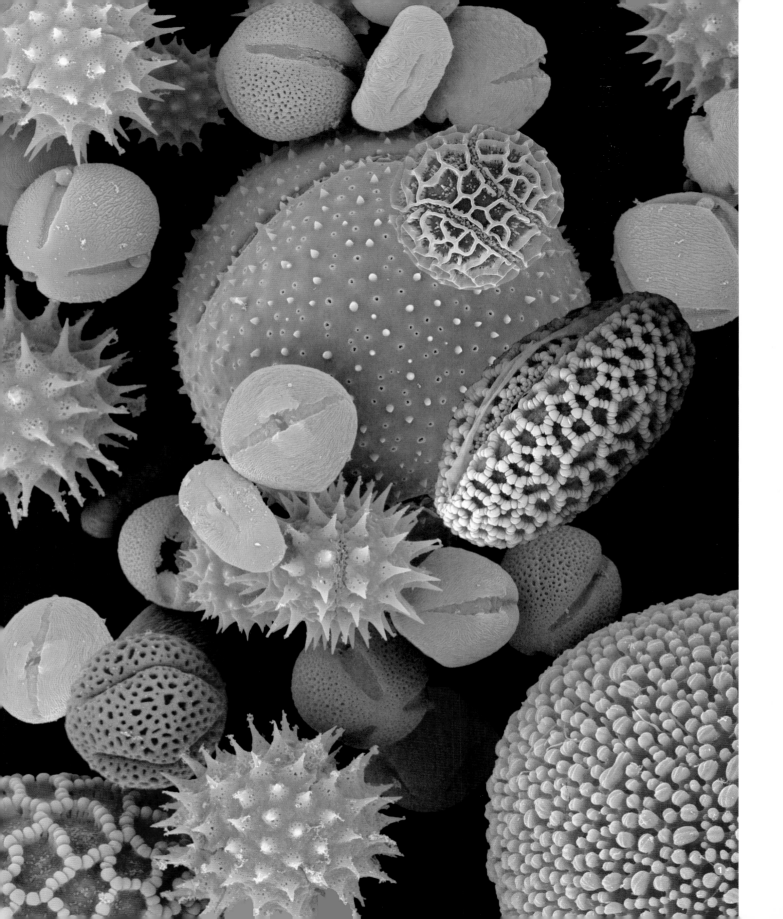

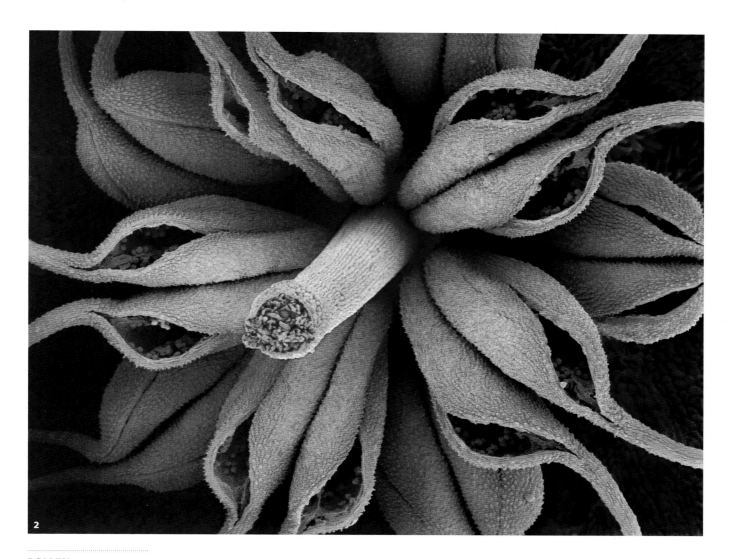

2

POLLEN
We can intuit order in patterns, such as pollen grains (1) or flowers such as this Enkianthus (2), even if they lack formal mathematical symmetry.

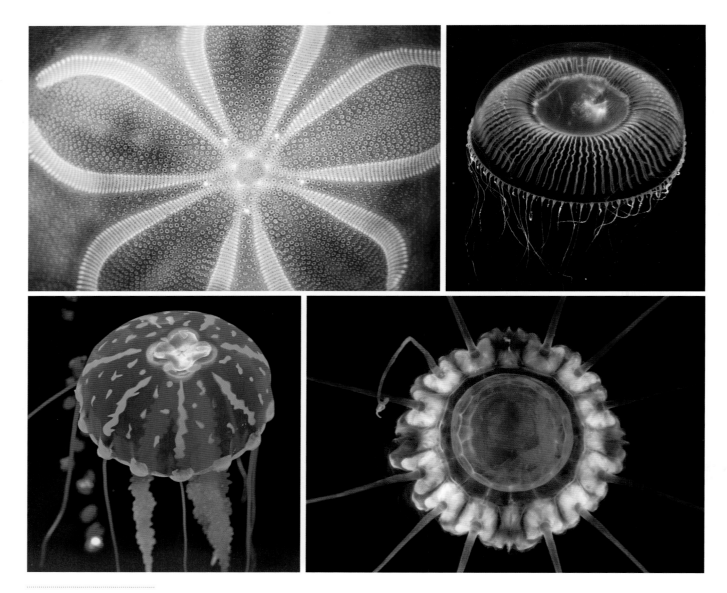

**ELEGANT VARIATION
ON THE RADIAL THEME**
*Five jellyfish display the
inventiveness of nature.*

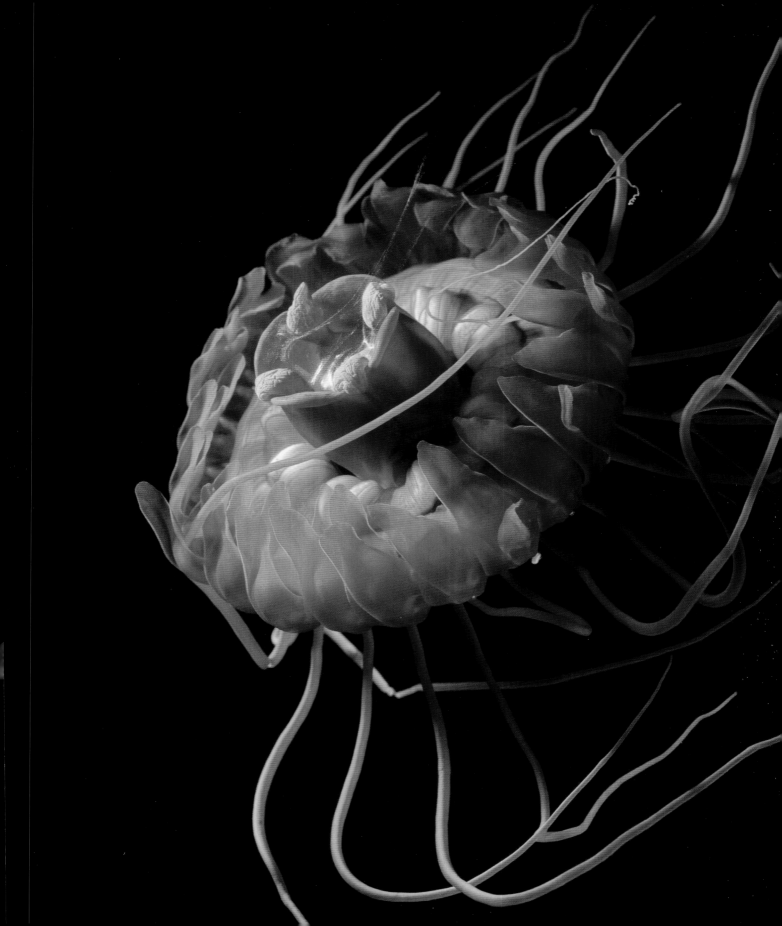

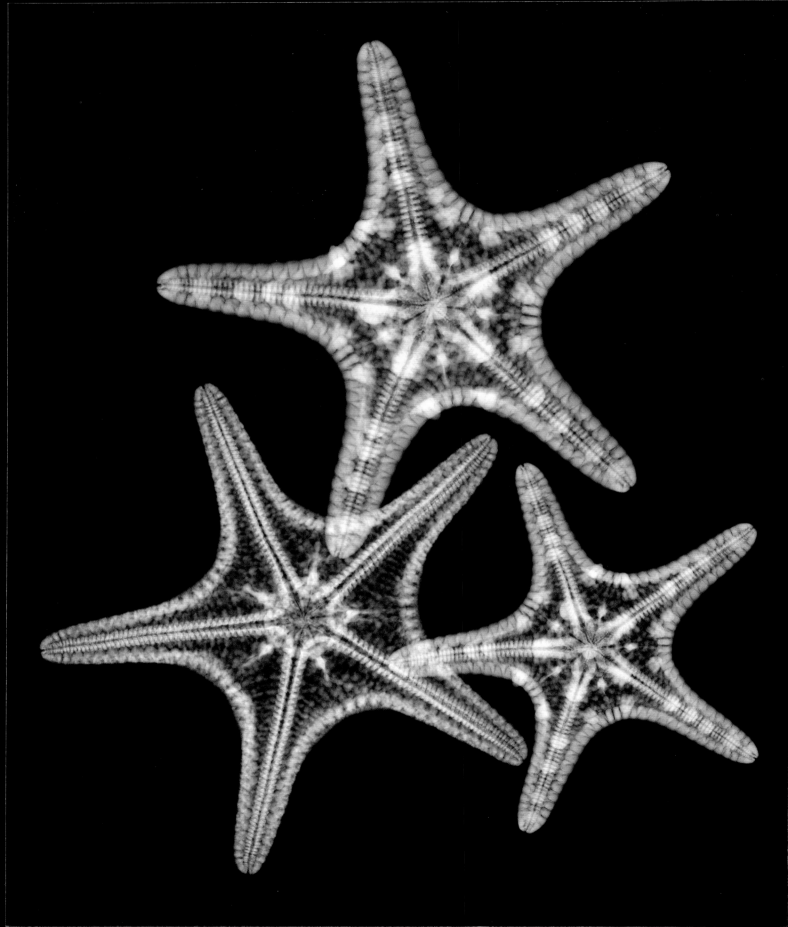

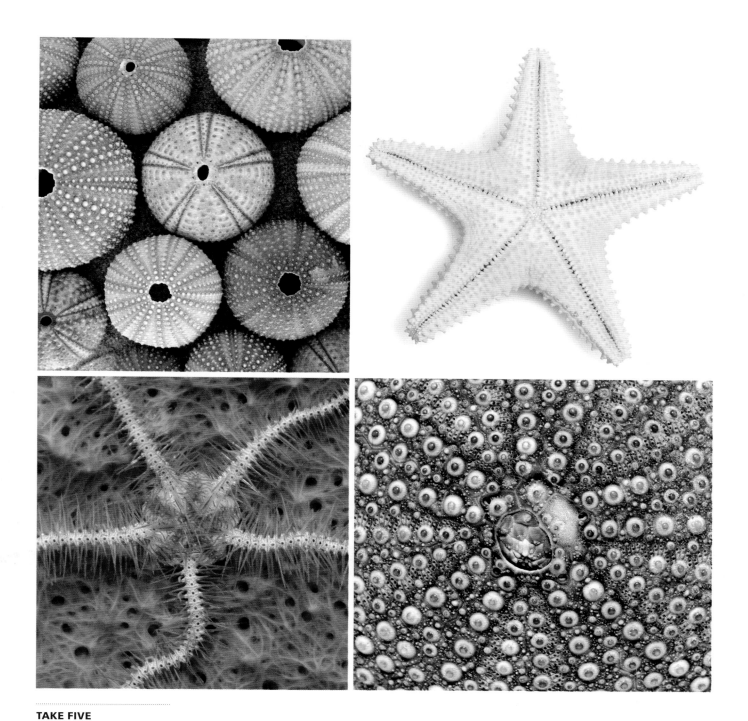

TAKE FIVE
Fivefold symmetry is often favored by echinoderms such as starfish and sea urchins. Oddly, these evolved from creatures with only bilateral (twofold) symmetry.

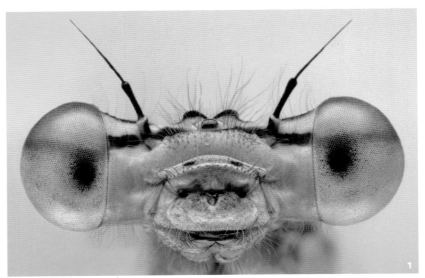

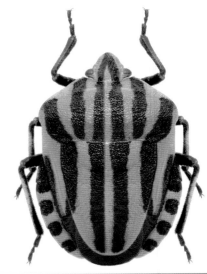

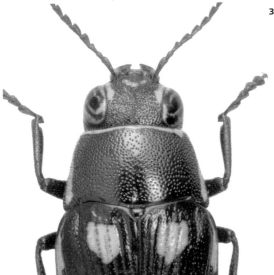

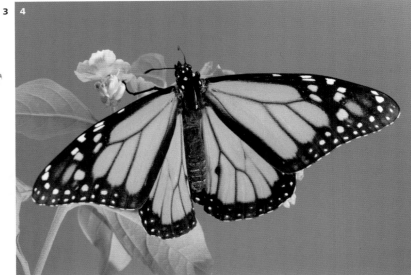

BILATERAL INSECTS
It may look like an alien, but the damselfly's bilateral head (1) still gives it a weirdly humanoid feel. The markings of the striped shield bug (2), the metallic wood borer beetle (3), and the monarch butterfly (4) scrupulously observe their mirror symmetry. Even the emergence of a body plan in the midge pupa (5) is a progressive elaboration of its bilateral symmetry.

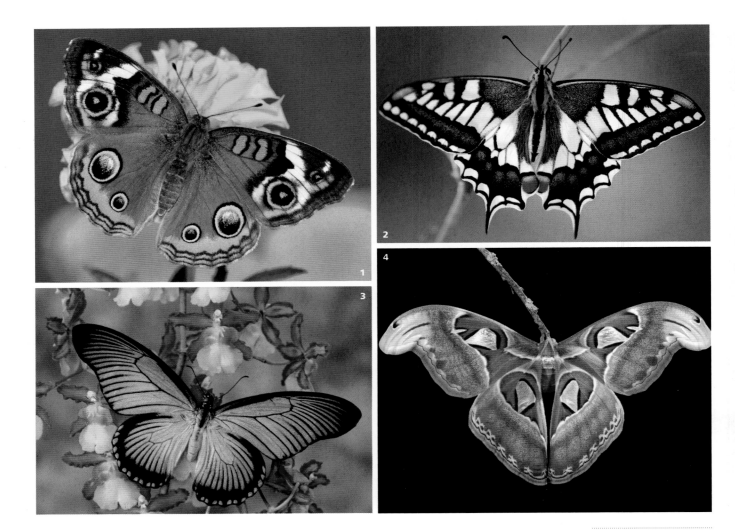

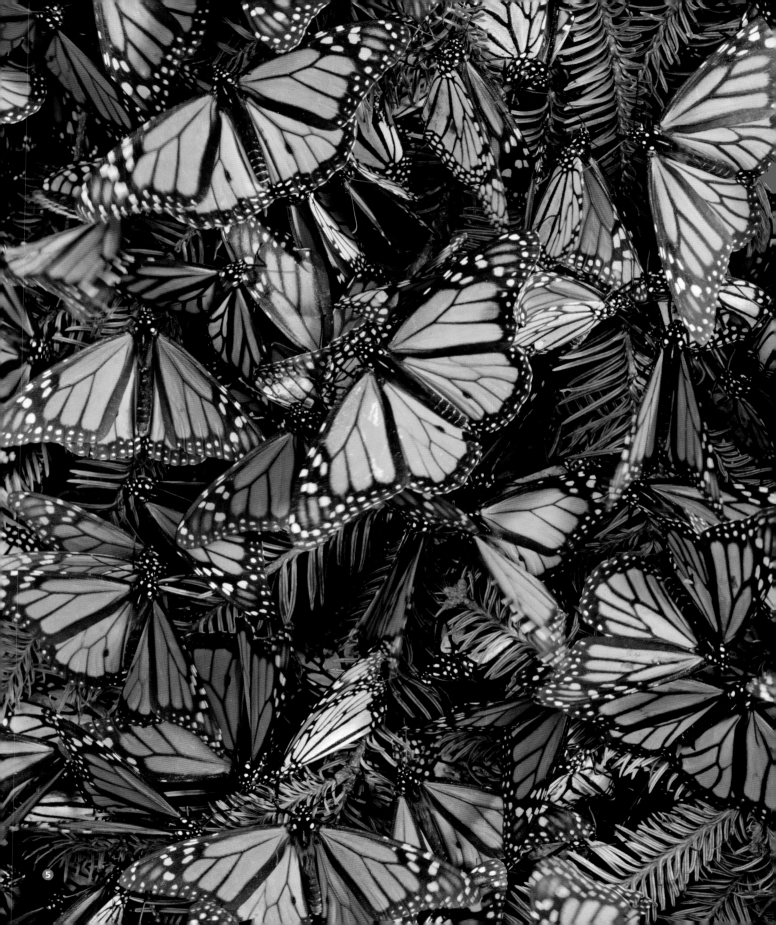

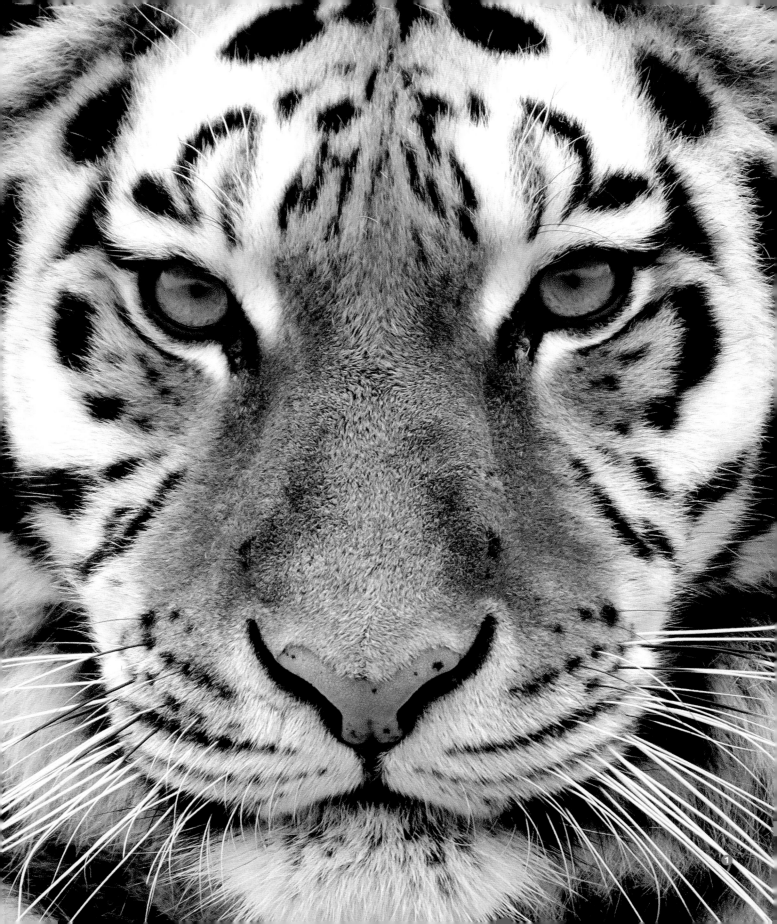

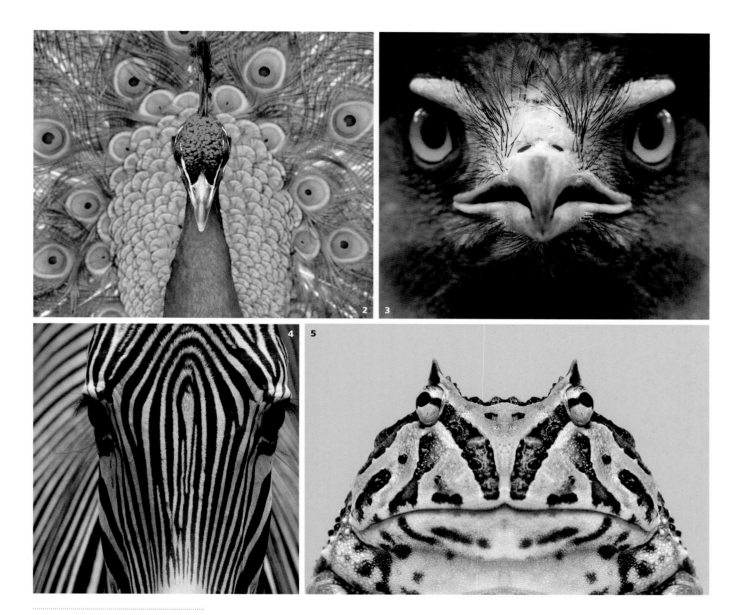

BILATERAL SYMMETRY ACROSS THE ANIMAL KINGDOM
Tiger (1), peacock (2), serpent eagle (3), Grevy's zebra (4), and Argentine horned frog (5).

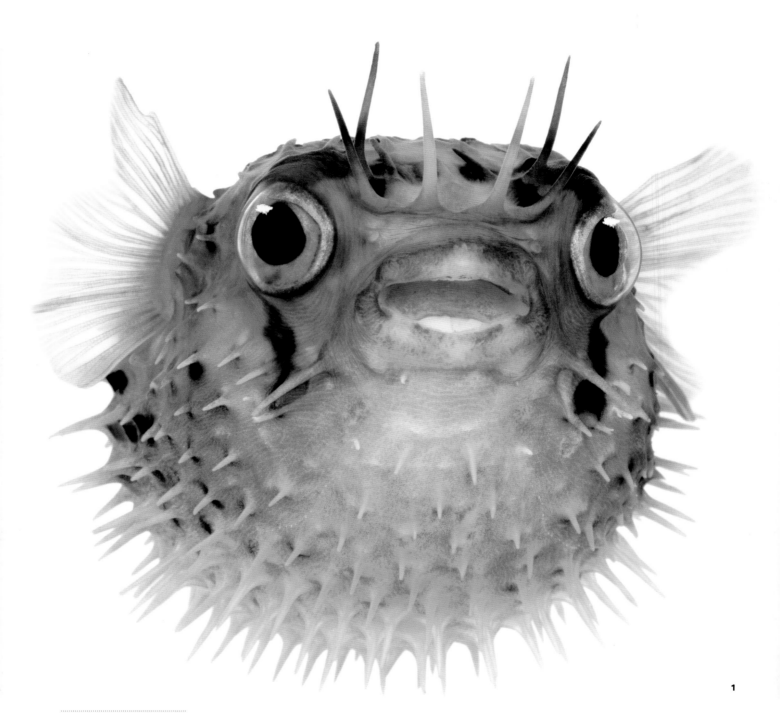

1

**BILATERAL SYMMETRY
IN FISH** *Balloonfish (1) and
sand diver (2).*

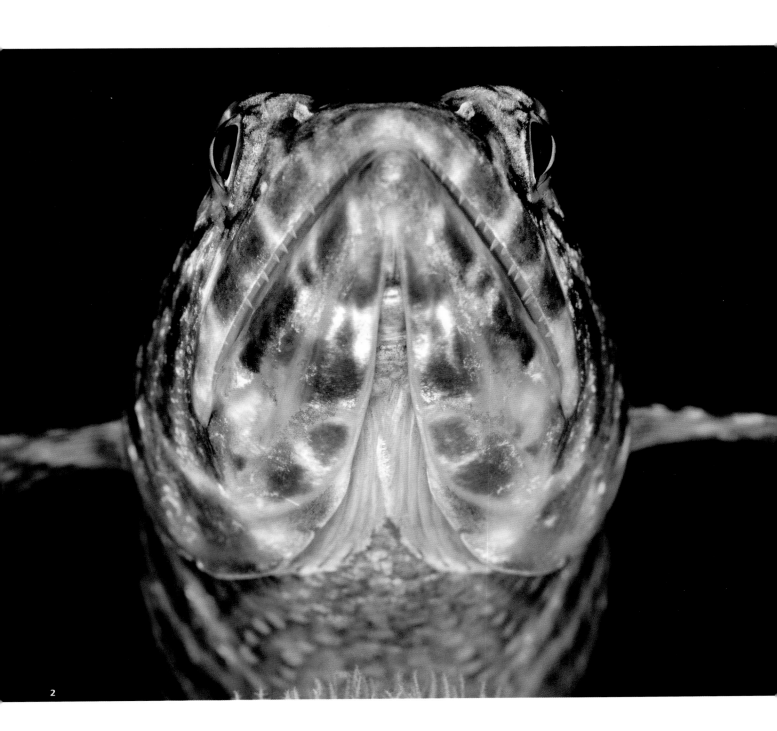

2

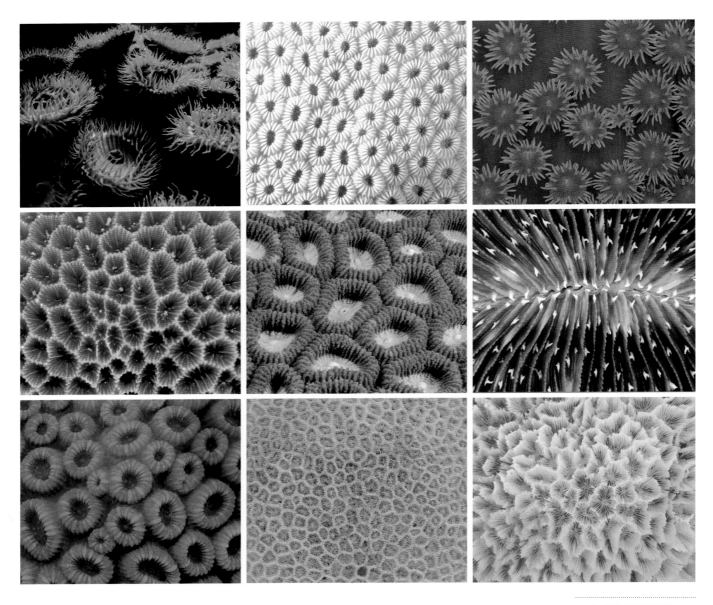

MARINE DESIGNS
*Anemones and corals
show a wide range of
textures and patterns, in
none of which is there
an exact symmetry in a
mathematical sense.*

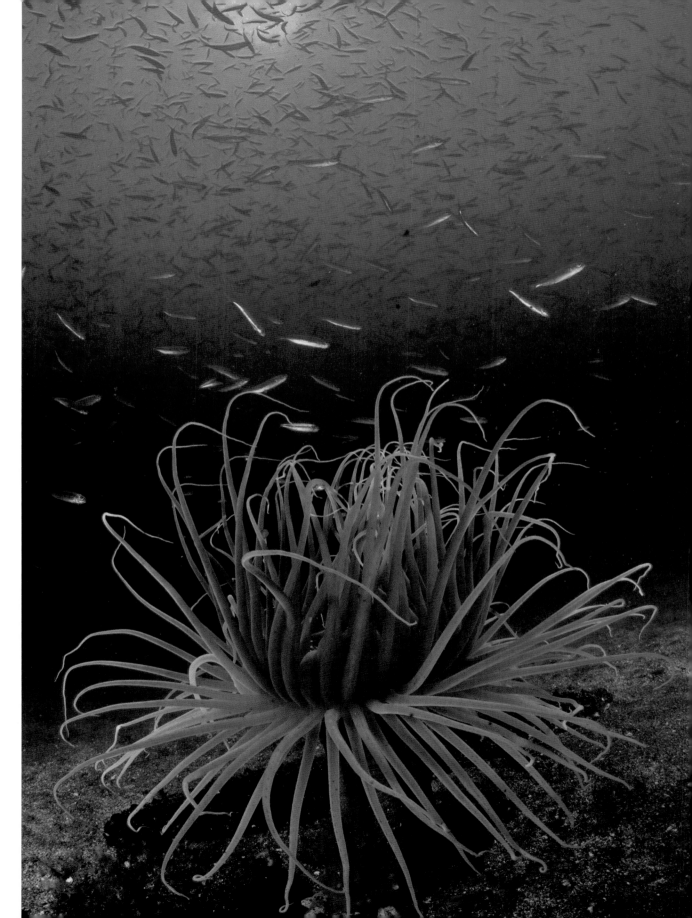

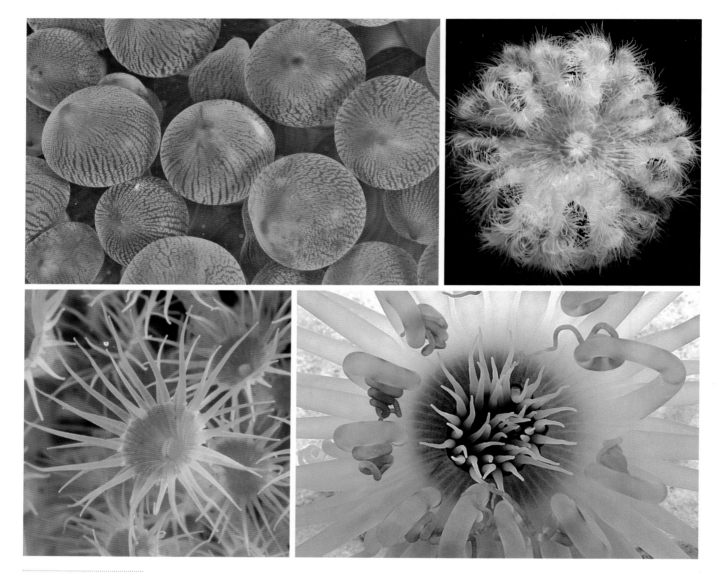

THE EDGE OF ORDER
Intricately patterned sea anemones.

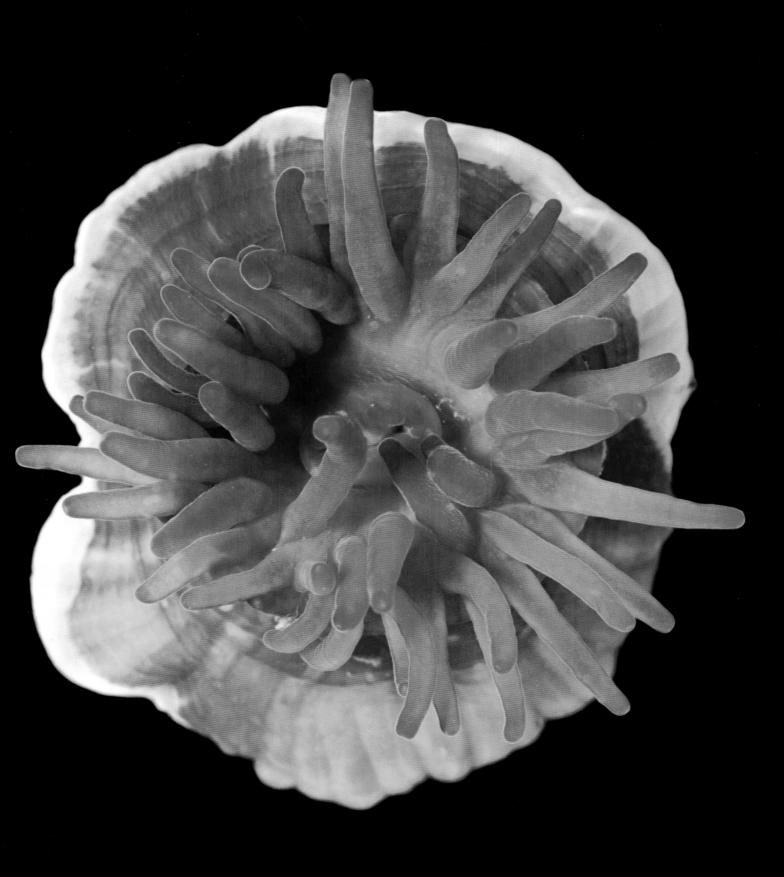

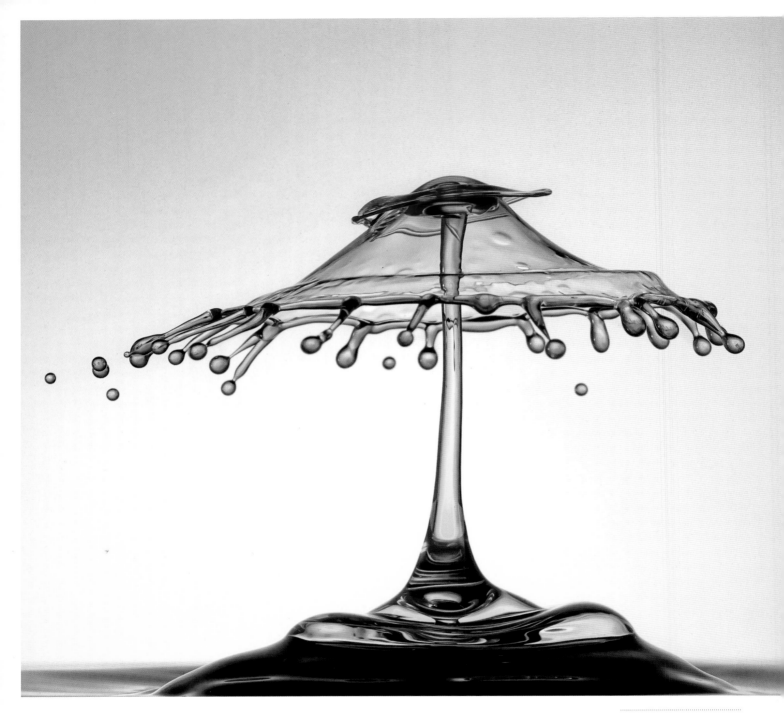

SPLASHES
The circular symmetry of the corona of ejected water gets broken in ornate ways as the rim breaks up into droplets.

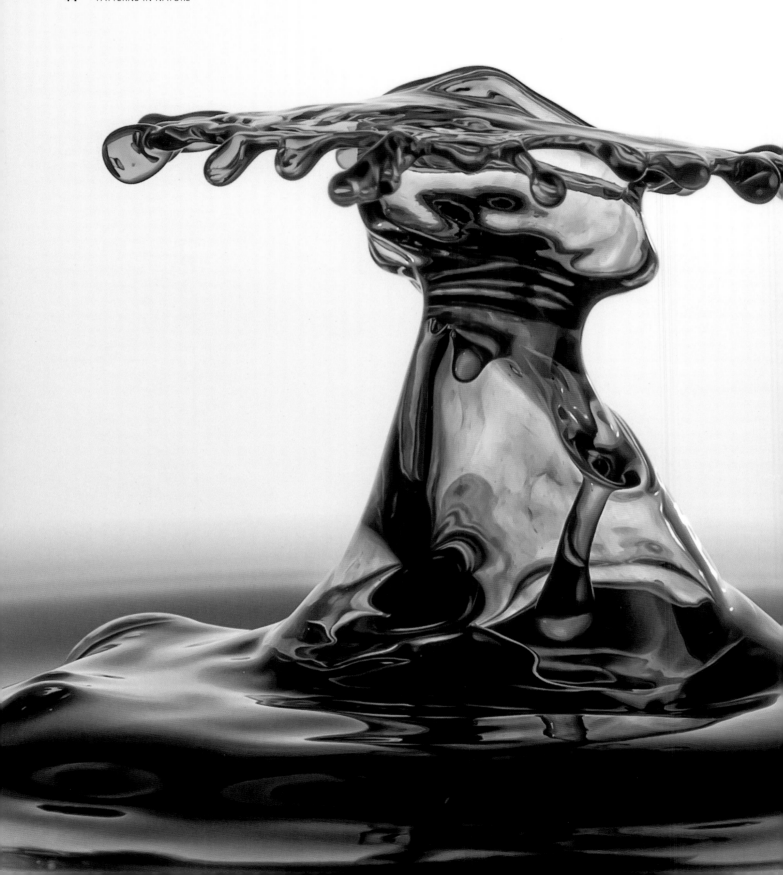

2 | FRACTALS

Why mountains look like molehills

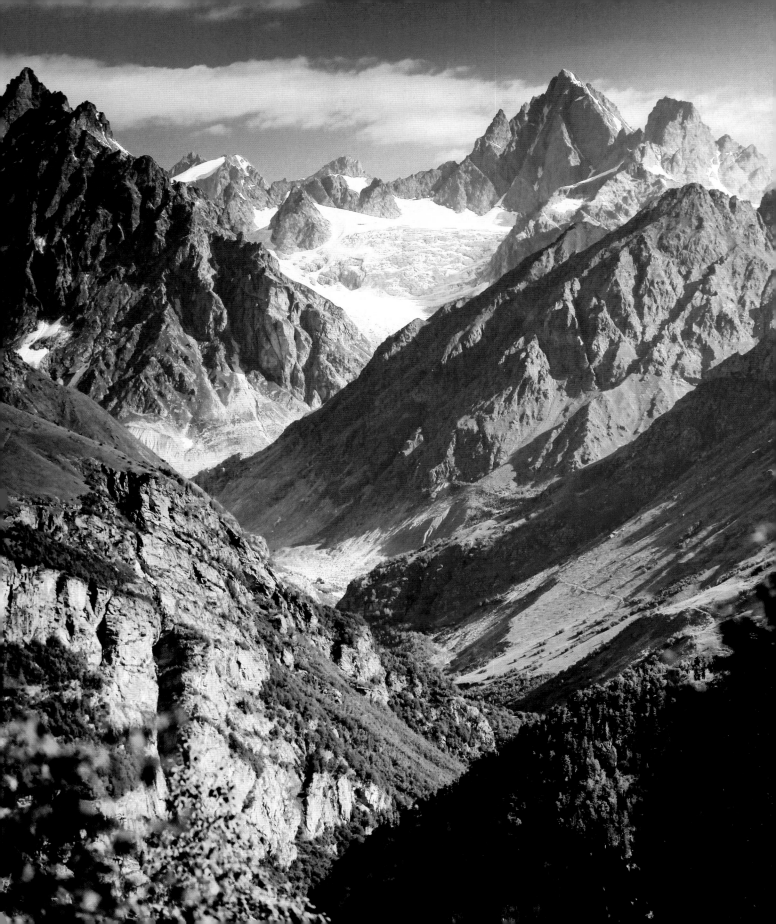

If we look at an aerial photograph of a jagged coastline, without a scale bar we can't be sure if we're seeing a stretch that is a mile long, or ten miles, or even a hundred. This indistinguishable appearance at different scales of magnification is a property called fractal. It is a remarkably common feature of nature: think of the fluffy edge of a cloud, or the way a twig from a branch tip mimics the shape of the whole tree, or the repeated branching of the lung's passageways. In fact, fractals have even been called the geometry of nature. Many natural fractals look disorderly when you first see them: there's no exact symmetry in a tree or a mountain profile. But the fractal property discloses a kind of "hidden logic" to the pattern: there's a hierarchical repetition of the same general form at decreasing scales. What are the processes that create this logic? And why is it useful for living organisms?

Natural patterns with a symmetrical form, like the bee's honeycomb, surprise and delight us precisely because they are rather rare. Nature doesn't often display such strict order and regularity. Whether it is the spindly filigree of a naked tree's silhouette in winter or the rugged jumble of a mountainous skyline, what we find in the wild seems more often to have a lot of unpredictability and disorder to it.

Yet these structures have a hidden kind of pattern, too. The logic of the shape or form only becomes fully evident when we try to describe it mathematically, but we already intuit a sort of organization, even without this specialized knowledge. There is surely something pleasing and entrancing about the branching shape of a tree that we wouldn't discover in a totally random arrangement of parts. It's not hard to see where this magic ingredient lies. The shape of a tree is complicated, and we can't easily describe it in the same way as we might describe a square or a hexagon. But we can give a very concise description if we focus instead on the process that produces the shape. A tree shape might be said to be "a trunk that keeps branching."

This description is what scientists would call an algorithm—an instruction for making a structure or, more generally, a process that has to be carried out to get what you're after. The reason why a tree's shape "feels" pleasing rather than incomprehensibly complicated is, I would argue, that we sense the simplicity of the algorithm needed to make it.

Even minor changes to the algorithm will produce a wide range of different treelike shapes. If the branching angle is small and the branches stay straight, we'll end up with a poplarlike network. If the branching angle is wider and the branches can bend and twist, the result is more like an oak.

Looked at this way, an object that seems at first to be geometrically very complex, compared to a cone or a cube, is revealed to have an underlying simplicity. How can we describe this geometry mathematically? A tree has no real symmetry at all in the sense explained in the previous chapter: you can't rotate or reflect it in any way to produce a shape that looks identical. We might be tempted to conclude that geometry has, in fact, nothing to say about this pattern.

But it does. We just need a *different kind* of geometry. It is called fractal geometry, and it has been said to be "the geometry of nature."

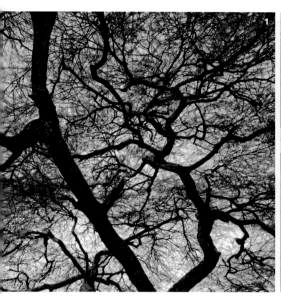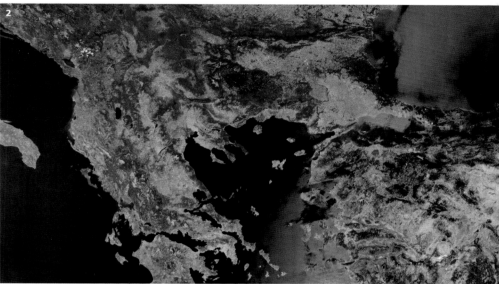

1 BRANCHING FRACTALS
Tree branches in Lake Manyara National Park, Tanzania.

2 FRACTAL COASTLINE
The complex boundaries of the Aegean sea.

The key to fractal geometry lies with the algorithmic approach to the forms it produces. What the "tree algorithm" is really saying is: keep making the same kind of structure (in this case, a branching junction) again and again at ever-smaller scales. Because of this repetition at different scales, a small part of a tree can resemble the whole thing. Break off the end of a branch and you have something that looks rather like a miniature tree. If you imagine continuing the branching steps without end, then you'd not really be able to tell, simply by looking at a fragment of the shape, how big it was: whether you were seeing the whole tree, or a yard-long branch segment, or a tip no longer than your thumb.

This kind of structure that repeats again and again at smaller scales is said to be "self-similar." Fractals are always self-similar. Their structure is "hierarchical," which means that it is patterned over a succession of different size scales: the trunk of a tree represents one level of the hierarchy,

the main branches constitute the next level, and so on.

In some natural fractals, the self-similarity of the structure extends over a wide range of scales. A coastline may be rugged and irregular over distances ranging from a yard or so (a fractured cliff edge, say) to perhaps hundreds of miles. Without any points of reference to give us clues about the scale—such as a coastal cottage on the cliff edge—we might be quite unable to tell from an aerial photograph whether we're looking at a bay a hundred yards across or the entire coastline of a country. It's the same for a cloud, the wispy edge of which might also have a fractal shape: if you're shown just a bit of it, you can't tell how much of the whole it represents.

Nature can make fractals that are more orderly than the random crenellations of a coastline. Some plants branch in an almost regimented progression, so that each level of the hierarchy offers a rather precise echo of the last, reduced in

"Looked at this way, an object that seems at first to be geometrically very complex is revealed to have an underlying simplicity."

1 LAND'S END
Erosion carves coastlines into forms with details at many scales.

2 DIMINISHING FRACTAL
Ferns show an orderly mirroring of form at several successively smaller levels.

3 WHORLS WITHIN WHORLS
The florets of Romanesco cauliflower are conical structures reproduced and elaborated on several scales.

4 FRACTAL NETWORKS
The vein systems of leaves achieve efficient distribution of fluids through networks of progressively smaller elements.

scale. In ferns, each Christmas-tree-shaped stem sprouts a train of sub-stems, their size diminishing steadily toward the tip even as they remain almost perfect replicas of the whole stem itself. Still more captivating is the fractal head of a Romanesco cauliflower, its conical profile embellished with smaller versions of itself over three or so hierarchical levels. Equally impressive in its way is the dragon's blood tree of the Socotra archipelago in the Indian Ocean, with branches that repeatedly divide neatly in two.

There is a limit to the fractal branching of a tree, because real objects are made of a tangible substance that can't become indefinitely fine in its details. If nothing else, the wiggles and crinkles can't get smaller than the atoms from which the thing is made. There's also an upper limit: you don't get trees as big as mountains. So all natural objects that have a self-similar fractal structure do so only over a particular range of scales.

But some mathematical fractals sustain their self-similarity no matter how finely you look, because numbers can keep getting more minutely distinct forever. In the 1970s the mathematician Benoit Mandelbrot, who gave fractals their name, discovered an equation that can generate a fractal boundary in "number space," now

known as the Mandelbrot set. The edges of this blobby "snowman" shape are covered in smaller blobs that, when looked at closely, resemble tiny versions of the same basic shape, sometimes with fine, jagged filaments extending outward. No matter how much you magnify the shape, the same weird snowman keeps showing up. It was a shock for mathematicians, used to the calm decorum of geometric shapes, to discover that pure numbers can spawn something this elaborate, poised at the border of regularity and chaos.

Growing fractals

Natural fractals such as coastlines and mountain ranges are generated by a process of gradual erosion and removal of material. The opposite phenomenon of steady accumulation can also result in these capricious, unpredictable shapes. Take the dark, branching veins called mineral dendrites that can be found lacing through rocks, with forms so irregular and seemingly organic that they were once mistaken for the fossils of primitive plants. These are a kind of creeping crystal, formed when mineral-rich fluids percolate through the rock and deposit their bounty of dissolved substances as tiny grains of insoluble salts. The

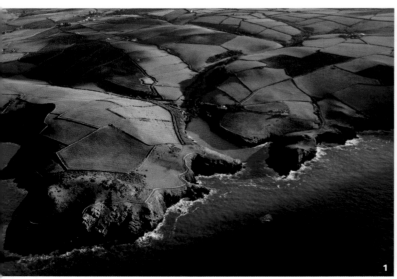
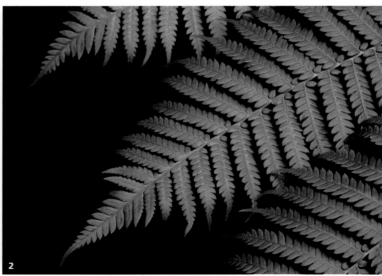

grains stick together in tenuous branches, their tips advancing and splitting as they go. Or take the fluffy particles of soot formed when tiny blobs of carbonized material float through the air and stick to one another—three-dimensional fractal clusters that, under the electron microscope, resemble solid yet wispy clouds.

These are processes of aggregation: objects sticking together. What seems surprising is that this doesn't just create dense clumps of material, but that instead the clusters sport delicate branches with lots of empty space in between.

Imagine a cloud of particles drifting along random, erratic paths through air or water, which will stick together the instant they touch. That process of aggregation will create a rather irregular cluster. Once a bump appears by chance, it will grow faster than the rest, because, purely by virtue of poking out from the surface, it is more likely to encounter another particle. The further out it protrudes, the more it grows. This is called a growth instability: there is feedback process that makes bumps self-amplifying. The randomness of the particle motions means that new bumps will appear on existing ones: they grow into arms that then branch into more arms. The branches are forever becoming elaborated into sub-branches.

And as these tendrils extend outward, the chances of an erratically moving particle finding its way between them to fill in the gaps become ever smaller: such a meandering particle is bound to touch a branch and stick there before it can penetrate far down the fjords in between. So the gaps never get filled, and the aggregation process produces fluffy, airy clusters.

As this example shows, fractals don't totally fill up the space that they occupy. They extend through it while leaving lots of empty space: they are not "space-filling." A tree extends through all directions in space, but it isn't exactly three-dimensional: that would correspond instead to a solid block of wood. Similarly, mineral dendrites sprawl across the surface of a rock (they often

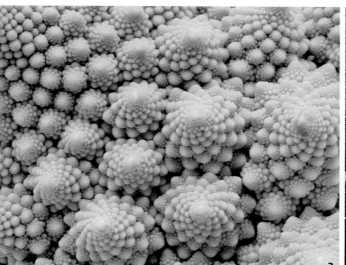

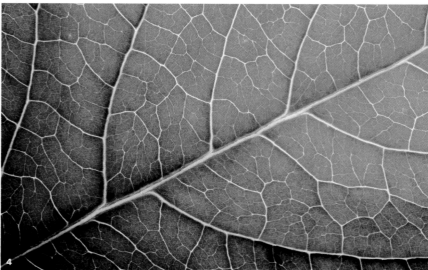

FRACTAL BREAK-UP
*To begin with, there's a
particular size scale to
the ink drops falling into
water. But as they mix
with the water, the flow
becomes turbulent and
the ink takes on a fractal
appearance, structured
on a wide range of scales.*

grow over fracture surfaces where the rock has
split and fluids can seep through), but don't
totally cover that surface like a spreading ink
blot. This means that fractals can be considered
to be objects with a dimensionality that is not
an integer: they are not three-dimensional (like
a cube) or two-dimensional (like a square), but
two-and-a-bit-dimensional, or one-and-a-bit.
They exist between dimensions. The larger the
fractal dimension, the more of the available space
it occupies; the more densely branched it is. It is
from this "fractional" dimensionality that fractals
get their name.

Fractal branches are so common in biology
that you have to suppose they have a useful role.
Think, for example, of the bifurcating passages
of the lung, or the network of arteries, veins,
and capillaries in the vascular system—both of
them fractals with the same kind of hierarchy of
branches that we see in trees. It's fair to imagine
that these branching networks convey some kind
of adaptive benefit.

Such a network exists to distribute vital fluids,
whether that is air, blood, or the sugary sap
of a plant. It's not hard to see that the treelike
structure is a good way to get fluids to all parts
of the body or tissue, but that can't be the whole
answer. One big advantage of a self-similar,
fractal network is that, since a part of the system
mirrors the whole, the network is easy to scale
up: the same principles will work for the vascular
system of a pigmy shrew or an elephant, or
for the branches of a japonica and a redwood.
And fractal networks are especially good at
reaching throughout the body's volume without
filling it up entirely, precisely because they are
"between dimensions." It also turns out that these
branching networks are the most efficient in terms
of energy: their structure means that the amount
of energy needed to transport the fluids to all
those points is as small as it can be. That energy
saving is a huge benefit to the organism.

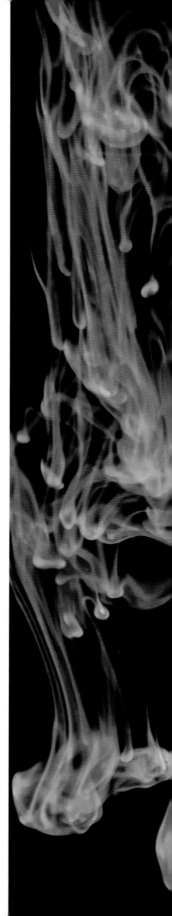

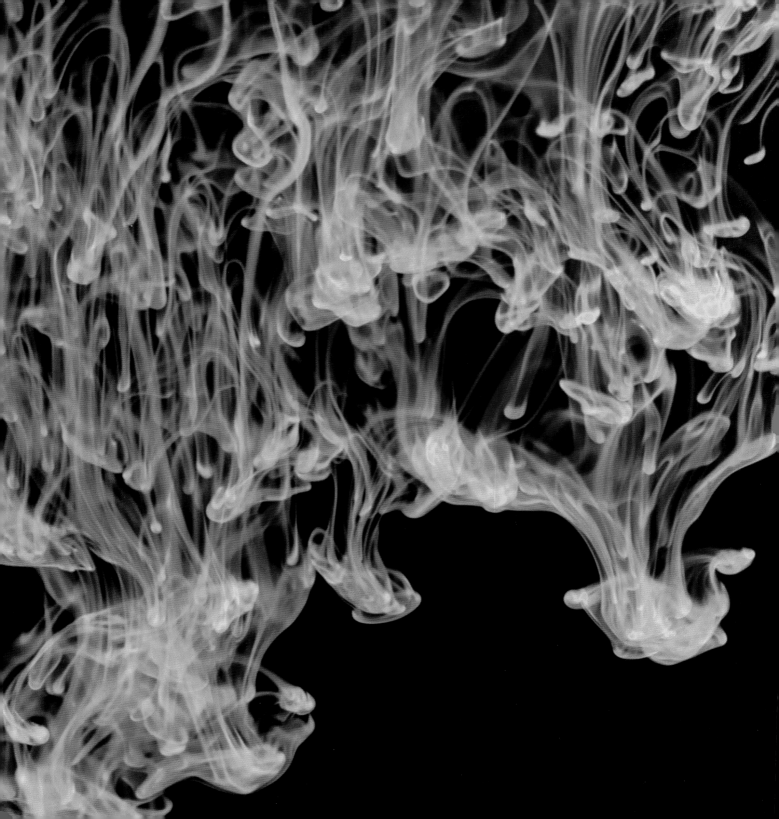

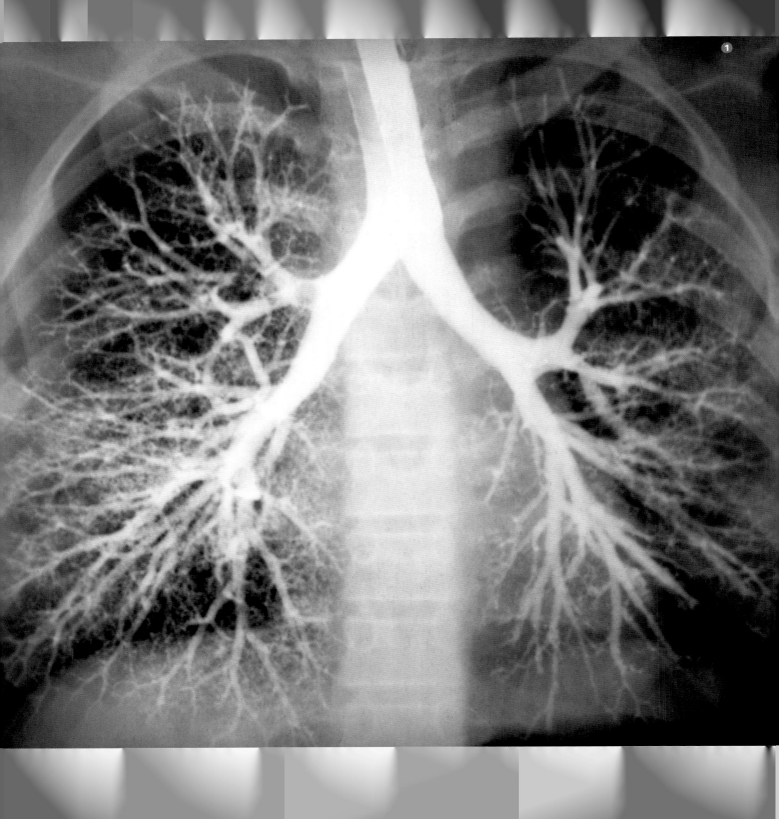

BRANCHING CRYSTALS
*Mineral dendrites, often mistaken
for the fossils of ancient plants,
can be very beautiful.*

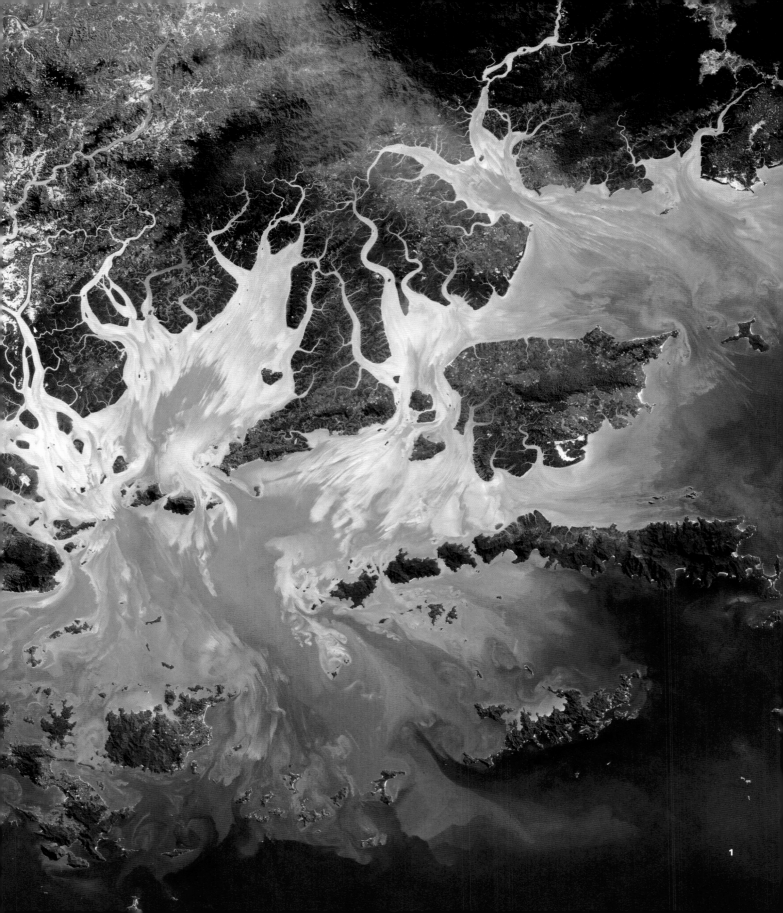

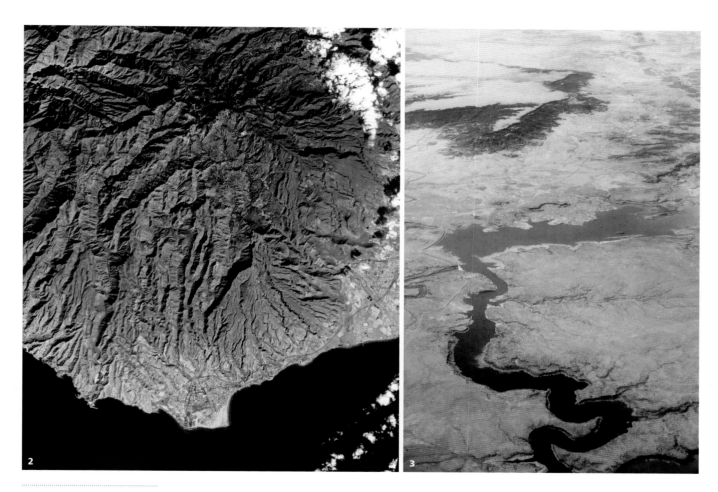

GEOLOGICAL FRACTALS
*The forces of erosion elaborate
the forms of coastlines and
sculpt mountains and river
valleys into fractal profiles:
Mergui Archipelago, southern
Myanmar (1), Canary Islands (2),
and New Mexico (3).*

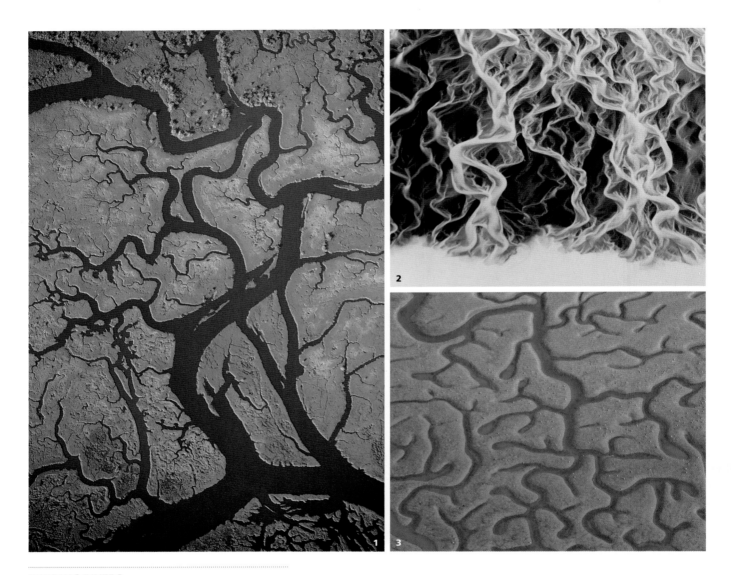

WINDING RIVERS

River networks are formed in a complex process of erosion and sedimentation, and their forms are diverse. But in general they are "optimal" networks, which dissipate the energy of the flowing water at the fastest rate possible. It turns out that this often gives them a branching, fractal form. Columbia river, USA (1), Iceland (2), saltmarshes, Spain (3), and Siberia, Russia (4).

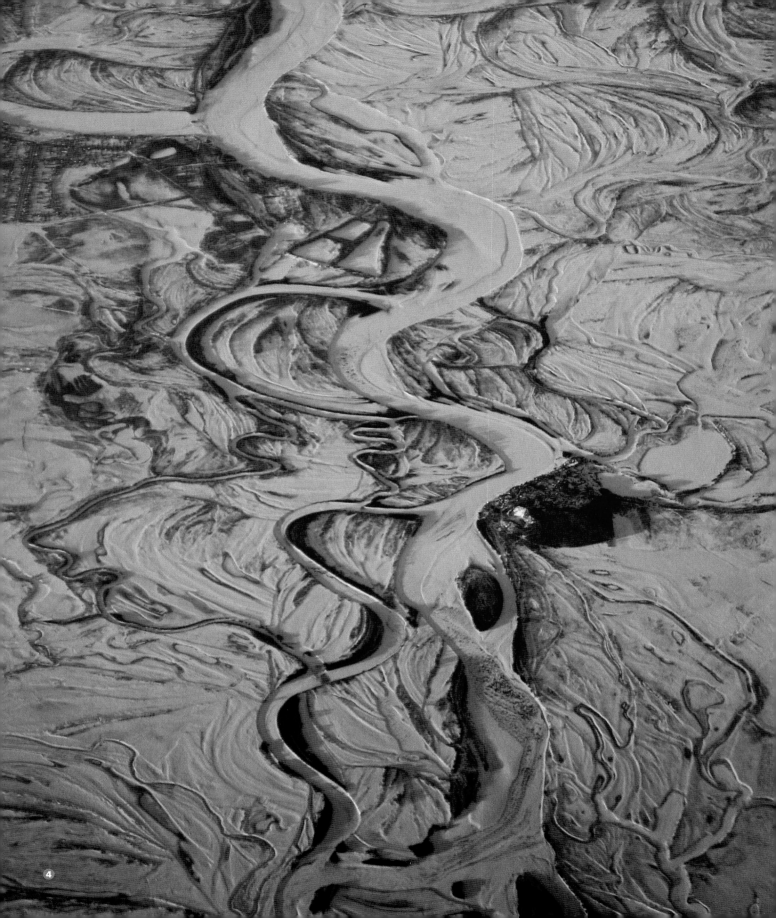

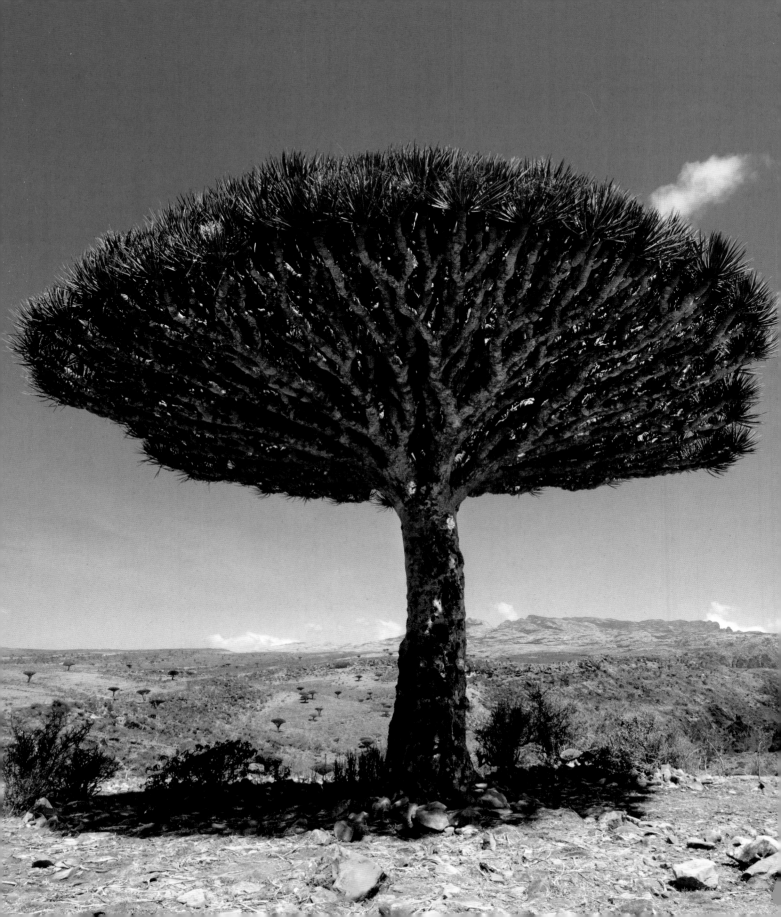

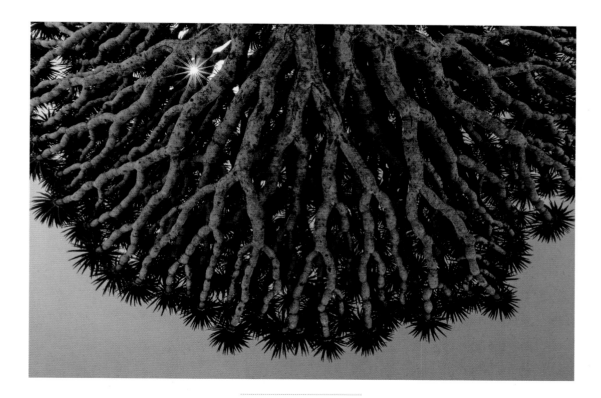

DIVIDE BY TWO
*Few living systems exhibit
as orderly and systematic
a fractal branching
scheme as that of the
dragon's blood trees of
Socotra Island in Yemen.*

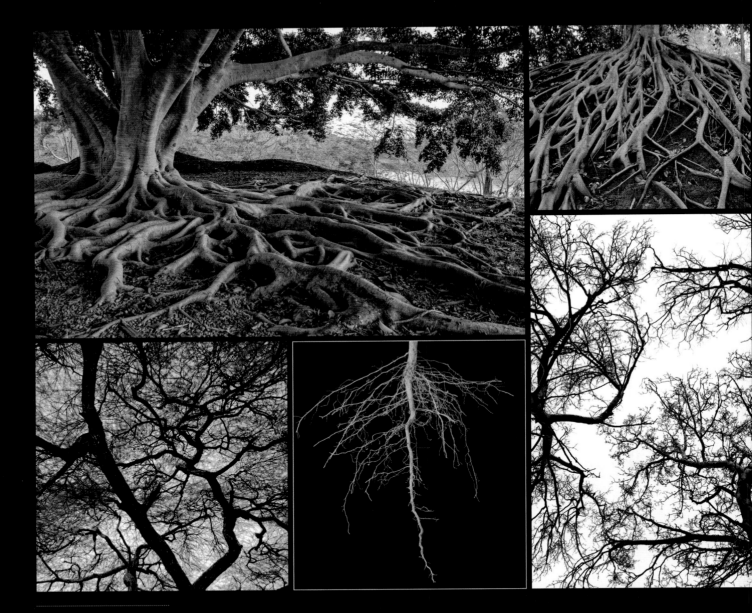

ROOTS AND BRANCHES
*The fluid distribution
networks of trees have
the same form top and
bottom, because both are
particularly efficient at
transporting the vital fluids
throughout the space the
tree occupies.*

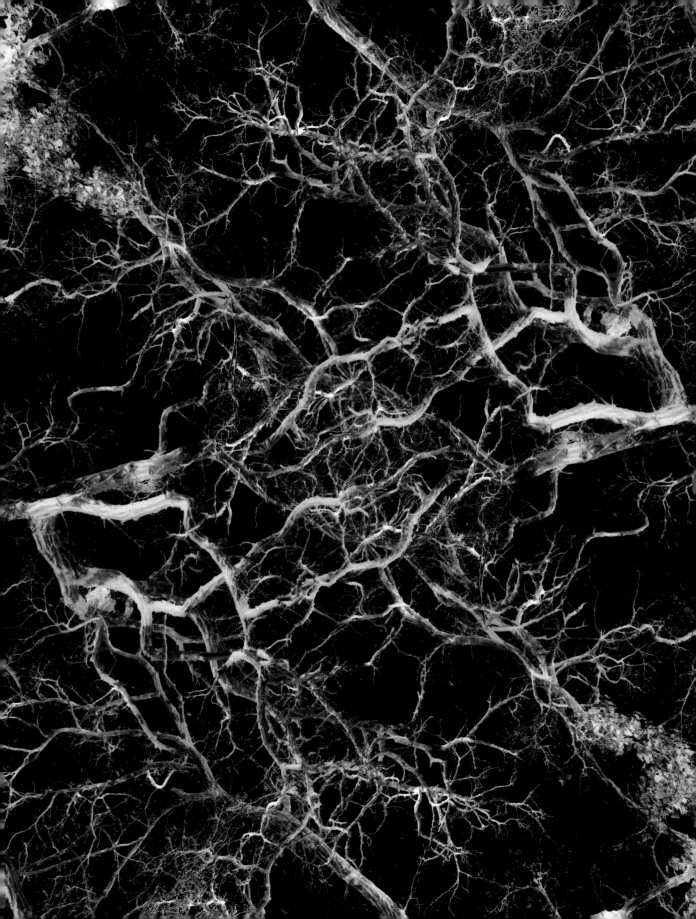

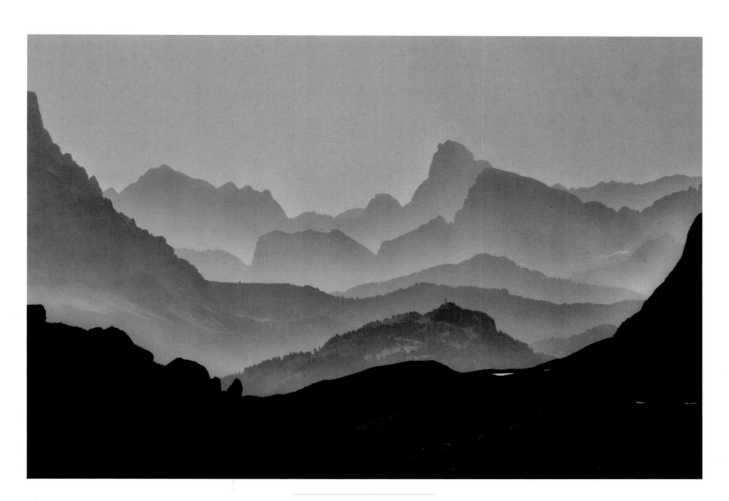

MOUNTAINS OF FRACTALS
The fractal profiles of mountains can take many forms—some taller, some flatter, but all with the same repetition of shape at different scales.

STEAMY SKIES
Whether they are wispy and ragged or bulbous and rounded, the shapes of clouds typically give us no clues about the scale of the region we are looking at: they display the fractal property of "scale invariance."

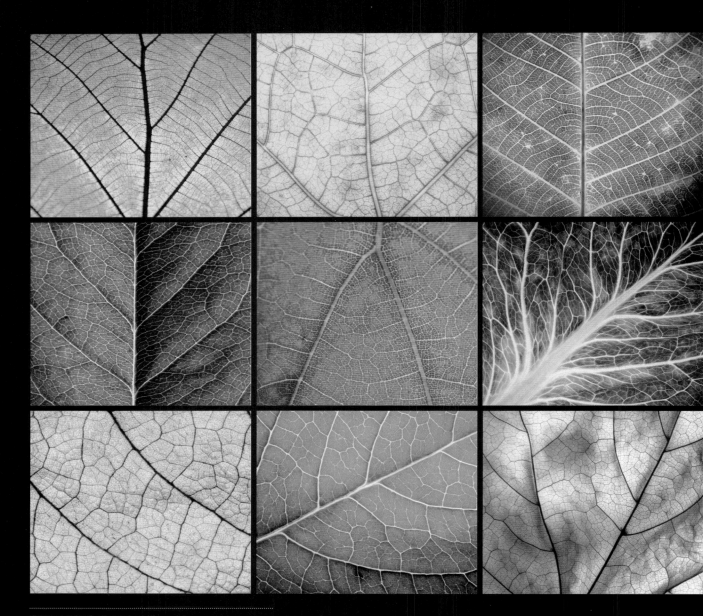

SPREADING IT AROUND
*Fluids carrying nutrients are spread across the
surfaces of leaves by branching vein networks with
a hierarchy of different scales. Unlike the branches
of trees and their roots, the tips of these branches
can intersect and join up, forming loops that provide
alternative pathways if parts of the leaf are damaged.*

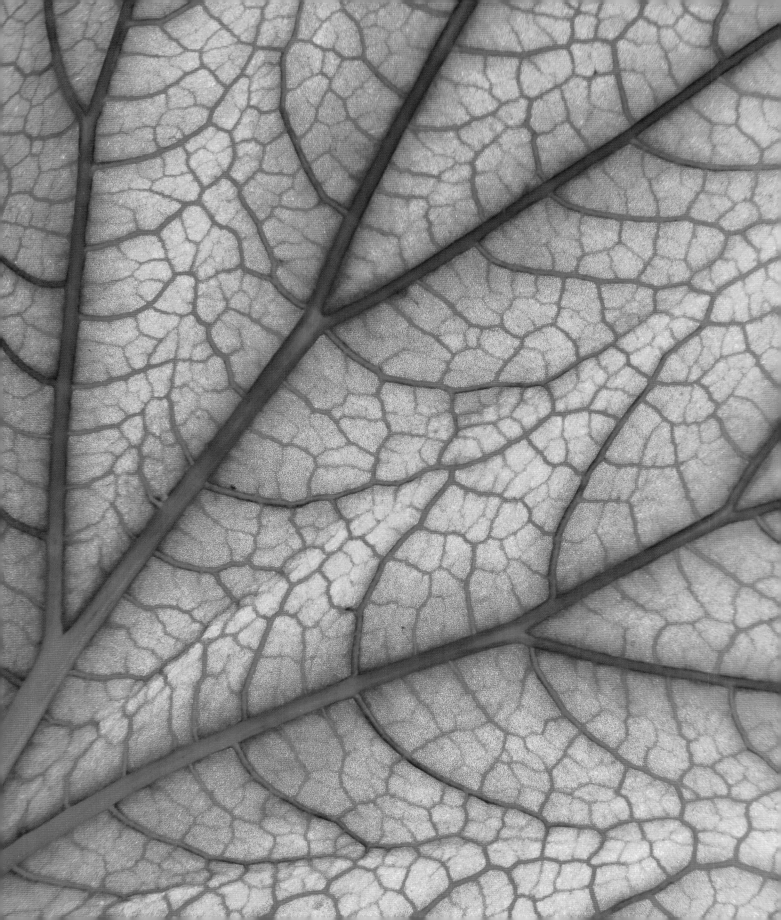

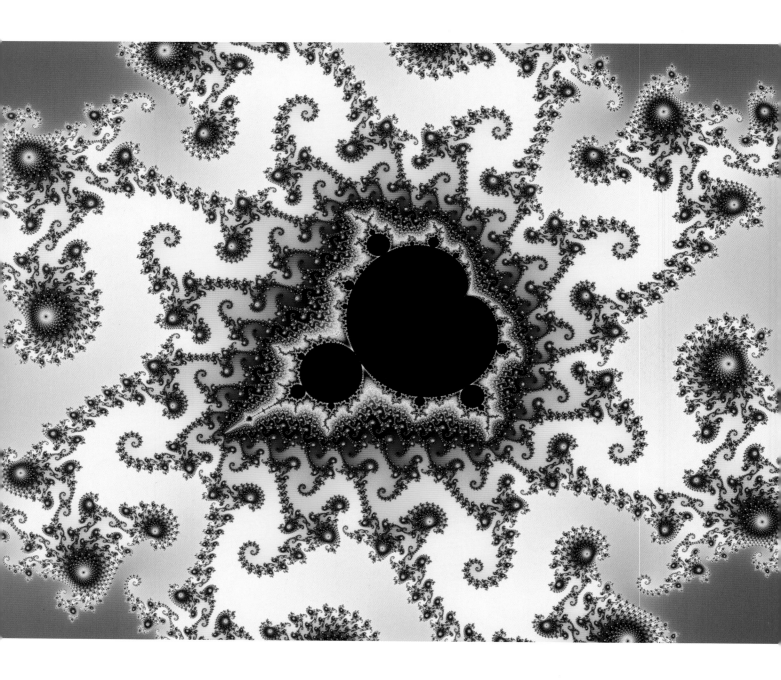

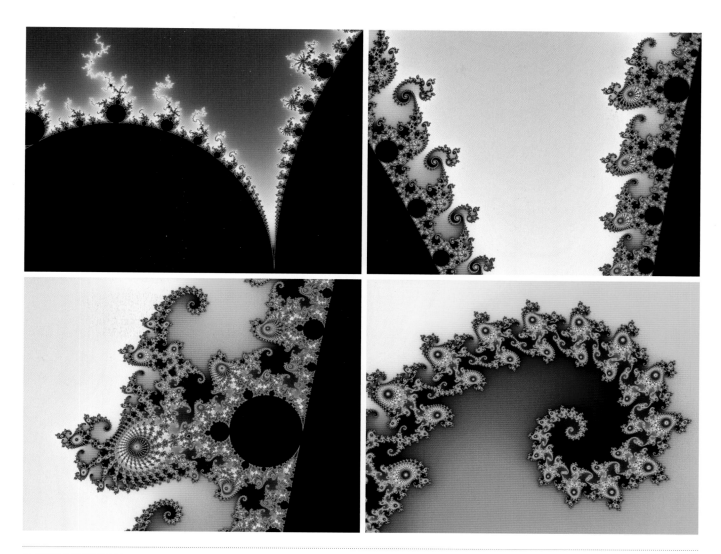

MANDELBROT SET

Purely mathematical fractals can be generated by equations that pick out numbers in the two-dimensional plane: ordinary (real) numbers supply one axis (east–west), and "imaginary numbers" containing the square root of -1 are arrayed along the other (north–south). Numbers containing both real and imaginary parts occupy the plane beyond these two axes.

Shown here are fragments of the so-called Mandelbrot set at different scales of magnification. It is traced out by an equation that takes one number and transforms it into another, which is then "fed back" into the equation in an iterative process. Repeating this process again and again produces numbers that either stay finite or grow to become infinite. The Mandelbrot set, shown in black, is the space occupied by numbers that do not grow to infinity when subjected to this iteration. This space has an intricate structure that repeats at different scales. Coloring the rest of the space according to the rate at which the respective numbers grow to infinity reveals yet more fractal structure, producing these baroque spirals.

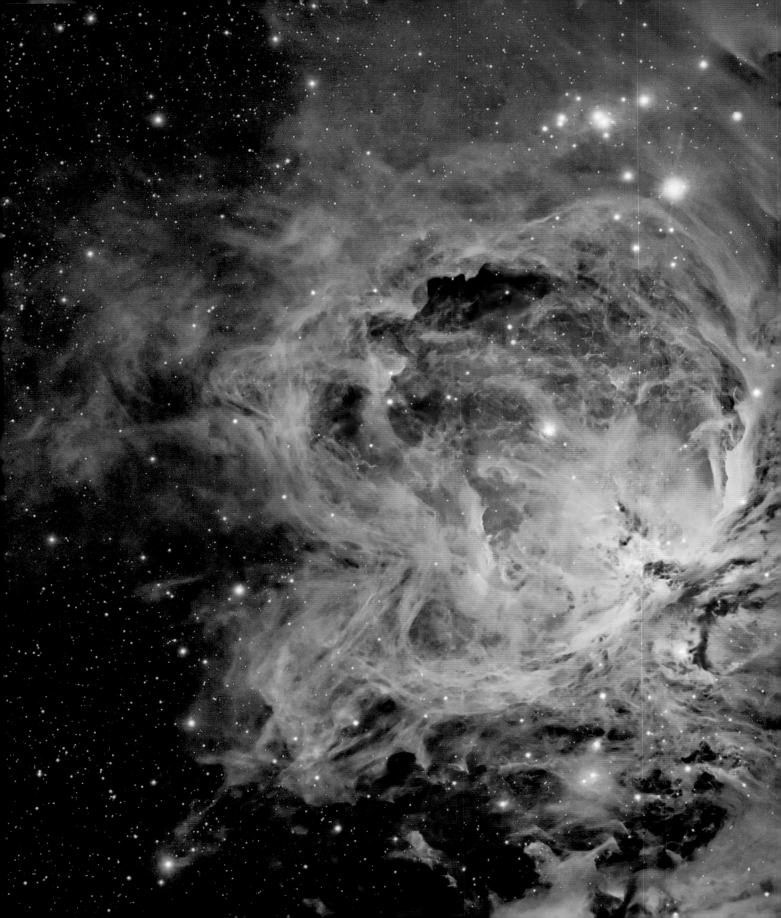

COSMIC FRACTALS
Turbulent flow is a fractal form in which energy is channeled down to ever finer scales, generating increasingly small structures in the process. The resulting forms can be chaotic—it's impossible to predict exactly what they will look like or how they will evolve over time—but nonetheless they have a mathematical fractal structure that represents a kind of "hidden order." The richness of shape and form that results is apparent in these views of the turbulent clouds of gas and dust in the Orion nebula (left) and the Tarantula nebula (see pages 76–77).

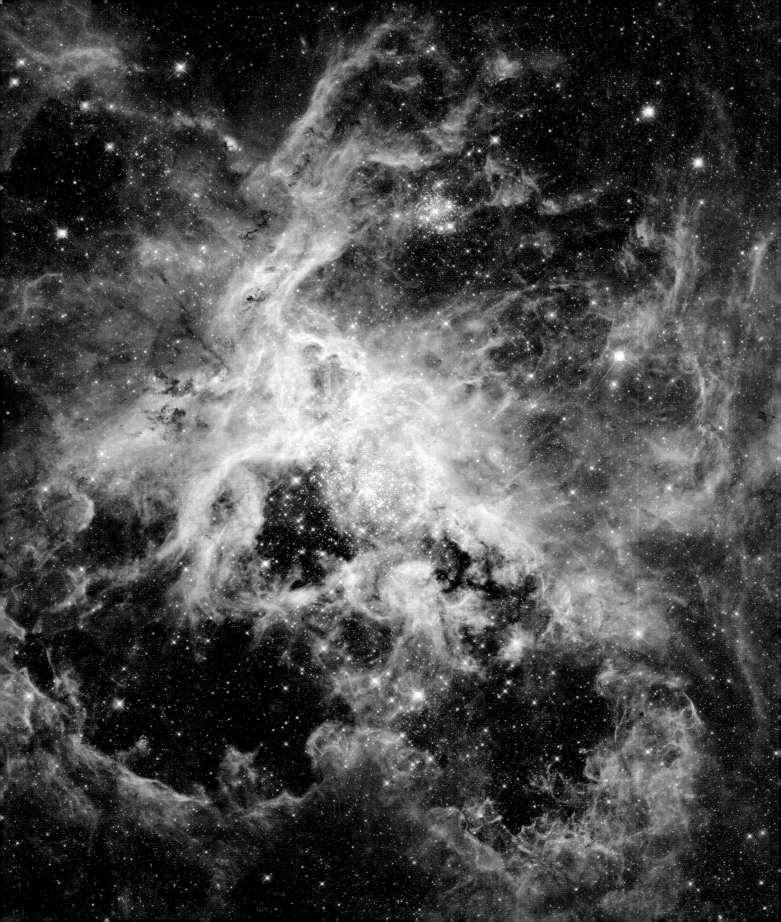

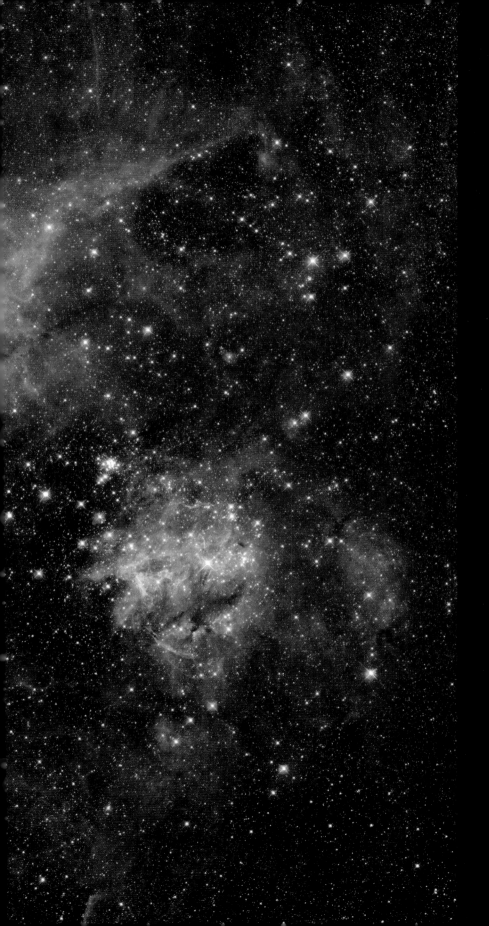

3 | SPIRALS

The math in snails and sunflowers

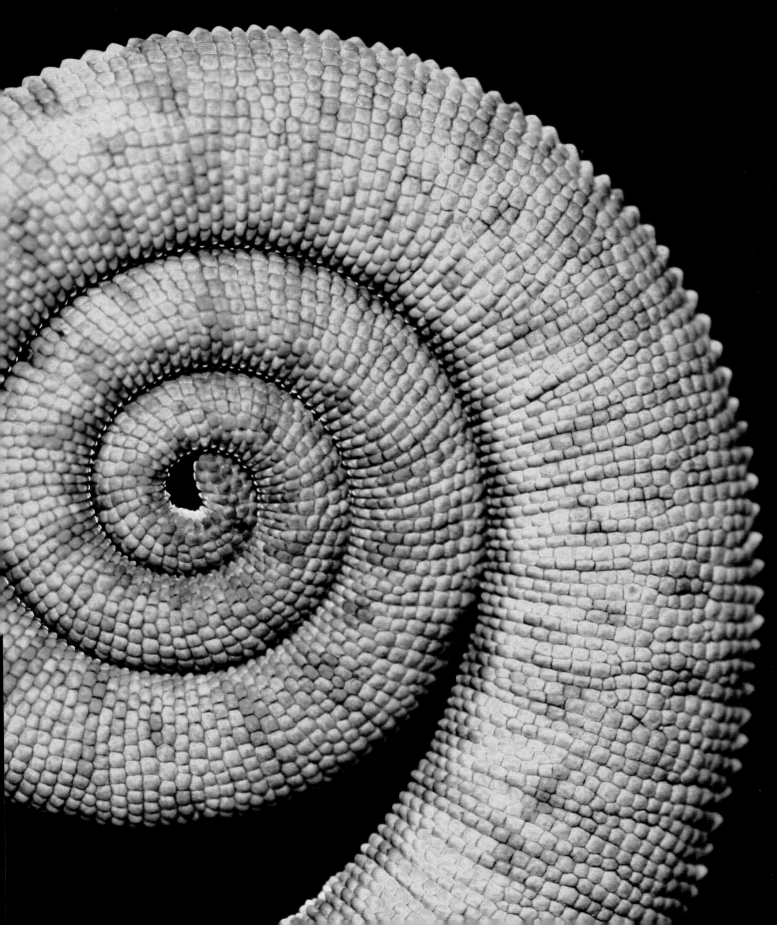

We see spirals everywhere in nature, from the sea snail's shell to the swirling gas and stars of a spiral galaxy. But do they share anything in common? On the whole, they do. Most natural spirals have a shape called logarithmic, which means that, like fractals, a small part looks just like a bigger part. A snail shell grown in such a form can stay the same shape as it gets ever bigger. Such spirals may also appear in less obvious places; the circular arrangement of florets in the head of a sunflower is made up of two sets of logarithmic spirals rotating in opposite directions. And spiral vortices form in flowing fluids, from bath water disappearing down the plughole to cyclonic storms on Earth and Jupiter. This is one of nature's universal designs.

What makes spirals so special that they recur at scales from tiny to cosmic? Do these forms really share commonalities, or are their parallels just coincidental?

Many natural spirals, like that of a snail shell, are not just any old scrolling shape. They begin with graceful, almost languid curves, but become increasingly tightly coiled as we move in toward the center. This is different from the kind of spiral made by rolling up a garden hose. In that case, the width of the coils remains the same on every turn. This is a vital distinction.

The coiled-hose spiral is called an Archimedean spiral, because Archimedes described it in the third century BCE in his book *On Spirals*. When it appears in the physical world, that's generally because it does indeed come from rolling up some long or flat object with a constant width: a rope, a sheet of paper or a carpet, a worm.

The snail shell, meanwhile, has a form called the logarithmic spiral, because one way of writing the mathematical equation that describes it involves logarithms. This spiral has a very special property: its shape remains the same no matter how small or big it is. It is another example of a self-similar pattern.

What does self-similarity mean here? Isn't a spiral always a spiral shape anyway? Yes, it is—but there are distinctions. For one thing, an Archimedean spiral can only get so small and no smaller. When the radius of the coil is the same as its width, you're at the limit: you can't coil a rope more tightly than this. But as the logarithmic spiral rotates into its center, the coils go right on

getting narrower and narrower, so the curvature can get tighter and tighter. You could say that the decreasing width keeps perfect pace with the greater curvature, so that the spiraling knows no limit.

Another way of saying this is that the spiral looks the same no matter what scale you see it on. Zoom into the center of a snail shell and the curve looks just the same as it did before. In principle, a logarithmic spiral can go on curling inward or outward forever and its form would never change.

This self-similarity is just what a gastropod mollusk like a snail needs. As the organism grows, it needs a bigger shell. But the shell is made of hard stuff—calcium carbonate, the same mineral as chalk and marble. It can't expand, and it would be terribly tough on the snail to be forever taking the shell apart to build a new one. So mollusks simply adds an extension, growing a larger house out from the rim of the previous one. The early part of the shell, now too narrow, is simply abandoned.

Such gradual widening of the rim could produce a cone, and that's certainly one option for the creature. But to avoid carrying an ever lengthening burden, the cone is curled up compactly into a spiral, and this is more or less what a logarithmic spiral shell is: a sort of rolled-up cone.

So the logarithmic spiral is a great design for a gastropod. It doesn't "know" this, however. All it needs to heed is a growth rule that says "keep the shape of the rim the same, but increase its circumference at a steady rate." To make the cone

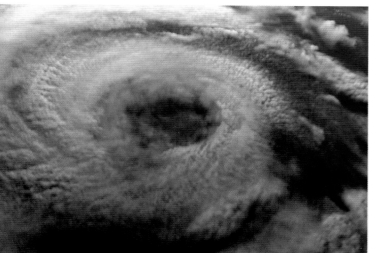

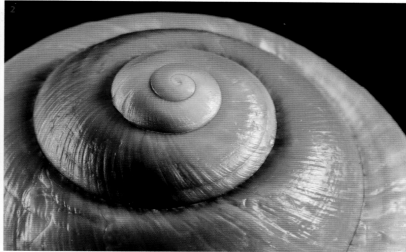

curl neatly into a logarithmic spiral, just add the condition that the rate of growth is faster on one side of the rim than the other: the cone will then spiral automatically. This simple principle is sufficient to construct a vast range of different shell shapes, like those seen in different species of marine gastropods, just by varying the perimeter of the mouth of the shell.

This prescription for growing logarithmic spirals isn't just followed by mollusks. These pleasing forms are also found in the convolutions of animal horns, talons, and claws, although there the spirals sometimes might not even complete a single full revolution.

Spiral galaxies such as the Milky Way often (but not always) have a logarithmic shape, at least roughly. So do cyclones, tornadoes, whirlpools, and plughole vortices. Not all vortices in fluids fit this shape, but it is a common outcome of the way fluids circulate, especially if there is a "sink" at the center, like a plughole that is removing the fluid.

Why do fluids seem so readily to coordinate their movements into this tightly organized path? The organization comes from the drag that one part of a moving fluid exerts on the other parts nearby—the same force that creates eddies and wakes as a coffee spoon stirs in the cream. These mutual influences of one flow driving another give rise to feedback that can marshal small, random disturbances into coherent large-scale movements. The gigantic vortices of cyclones rotate counter-clockwise in the Northern Hemisphere and clockwise in the Southern Hemisphere. The preference is caused by the rotation of the Earth,

a phenomenon called the Coriolis effect. Some scientists have asserted that, if you take care to let all the initial randomness in a tank of water settle down, the very small influence of the Coriolis effect creates a detectable bias in a bathtub vortex, too. But it's not clear if this is true—the experiment is very hard to do.

The secret life of plants

Of all the patterns and forms of nature, the spiral has probably held the greatest appeal for mystics and dreamers. It is revered by adherents of "sacred geometry," who consider the patterns and forms of nature to embody spiritual truths of the cosmos. Spirals are found in ancient and indigenous art ranging from the carvings on the Bronze Age stones of Newgrange in Ireland to the paintings of Australian Aborigines.

Nothing better exemplifies the apparent mystery and profundity of the logarithmic spiral than its manifestation on the heads of flowers such as sunflowers and daisies. The seeds of a sunflower head are arrayed in rows that trace out not just a single logarithmic spiral but two entire sets of them, rotating in opposite directions. The pattern that results has profound mathematical beauty: crystalline precision combined with organic dynamism, creating shapes that seem almost to shift as you stare at them. The same

1 INTO THE VORTEX
A hurricane on Earth seen from space.

2 MOLLUSK MATH
A sea snail shell.

"What makes spirals so special that they recur at scales from the tiny to the cosmic?"

double-spiral form can be seen in other plants: in the leaflets of a pine cone (most easily seen by looking down at the base), the leaves twisting along the branches of a monkey-puzzle tree, the segments on the skin of a pineapple, and the florets of a Romanesco cauliflower head. All these arrangements are examples of so-called phyllotaxis, which literally means "leaf motion."

If you count the numbers of spirals in each set, you find that they only take certain values. For pine cones, these special pairings are generally 3/5, 5/8, or 8/13. For smaller sunflowers there might be 21 spirals in one direction, 34 in the other. For very large heads, there might be as many as 144 and 233. But only these pairs of numbers—never, say, 22 and 35. Why are some of these numbers favored over others?

Each of these pairs corresponds to two adjacent numbers in a sequence in which each number is the sum of the previous two. If we start the sequence from the smallest pairing possible (0 and 1), then it runs like this:
0, 1, 1, 2, 3, 5, 8, 13, 21, 34, 55, 89, 144, 233, ...

Because this sequence was first written down in 1202 by the Italian mathematician Leonardo of Pisa, known as Fibonacci, it is called the Fibonacci

series. The ratio of two successive terms in the series gets ever closer to a constant value as the numbers get larger: a number called the Golden Mean, roughly 1.618.

No one is yet sure why the sunflower seeds adopt this arithmetical arrangement. One long-standing idea is that it enables the florets or seeds or leaves to pack most efficiently as they bud from the tip of the growing stem. In other words, a new bud appears only when it can find enough space to do so. This is simply a geometric problem: if you want to arrange objects in an array spiraling out from a central source, what should be the angle between one object and the next? It turns out that the most efficient packing, which gives the double-spiral Fibonacci pattern of phyllotaxis, is one for which this angle is about 137.5°—known as the Golden Angle.

That's not the whole explanation, however. For one thing, how do plants "measure" where the next bud should go? The Fibonacci sequence and the packing idea describe how sunflower heads are arranged, but don't explain how they achieve this arrangement. One possible explanation is that biochemical processes involving the growth hormone that triggers bud formation create what

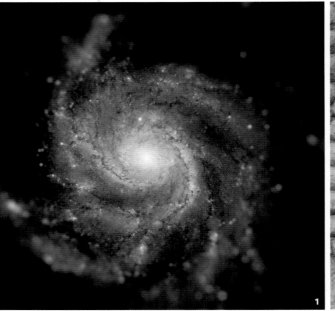
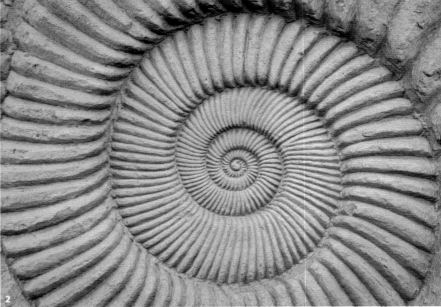

is in effect a kind of repulsive force between one bud and the next, so that the angle between them and the spiral center can't be less than the Golden Angle.

An alternative theory is that the "force" that keeps buds a certain distance apart, marshaling them into the spiraling arrangements, is not chemical (caused by hormones) but mechanical: it comes from wrinkling and buckling of the soft tissue at the tip of the stem. At the very top of the stem, the "skin" is soft and flexible, but it gets tougher and stiffer further down the stem. The way the stem grows will compress the stiffer fabric near the tip and make it buckle. Perhaps new buds will then sprout from the crests of these wrinkles. Calculations of what this buckling looks like show that the patterns may resemble either Fibonacci spirals—little whorls of peaks around the stem's center—or concentric, symmetrical folds on each side of the plant in alternating directions, first north–south, then east–west, and so on. That, too, is a pattern found in phyllotaxis.

The buckling model looks particularly appealing for explaining some of the bud arrangements in cacti, where the stubby, spiraling protrusions look more like wrinkles in hard skin.

This concertinalike folding makes it easy for the soft tissues inside to swell quickly when there is water to absorb. Regular pleats and grooves are quite common on the tough outer skins of pulpy fruits such as pumpkins and gourds. These, too, may be patterns self-organized by the stresses that develop in the skin as the fruits grow and swell.

Wrinkle patterns at the tips of our fingers can develop into spirallike concentric whorls. Because the wrinkles of fingerprints all have more or less the same width, the whorls aren't logarithmic spirals, but more like the coil-of-rope Archimedean spiral. The buckling here seems to be caused by different layers of skin growing at different rates during early fetal development. Fingerprint whorls tend to be centered on the pads of your fingertips, where the curvature of the surface is greatest. But the details of the folds are determined rather randomly, and so your exact fingerprint pattern is unique. That's so often how it is with natural patterns: they are endless variations on a theme.

FLORAL TWIST
Spirals, often following strict mathematical relationships, are a common feature of phyllotaxis, the arrangement of plant structures such as leaves and petals. Here they can be seen in a Romanesco cauliflower (3) and a rose (4).

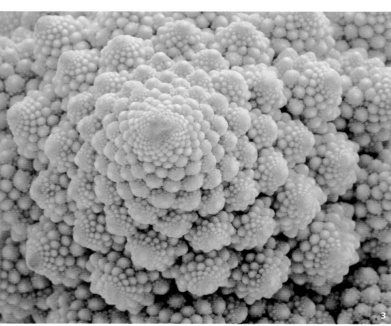

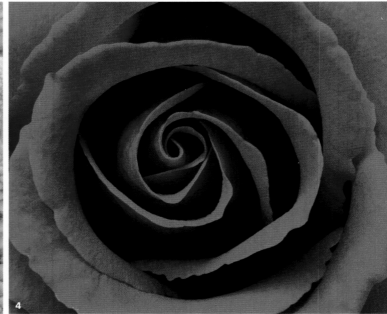

3 4

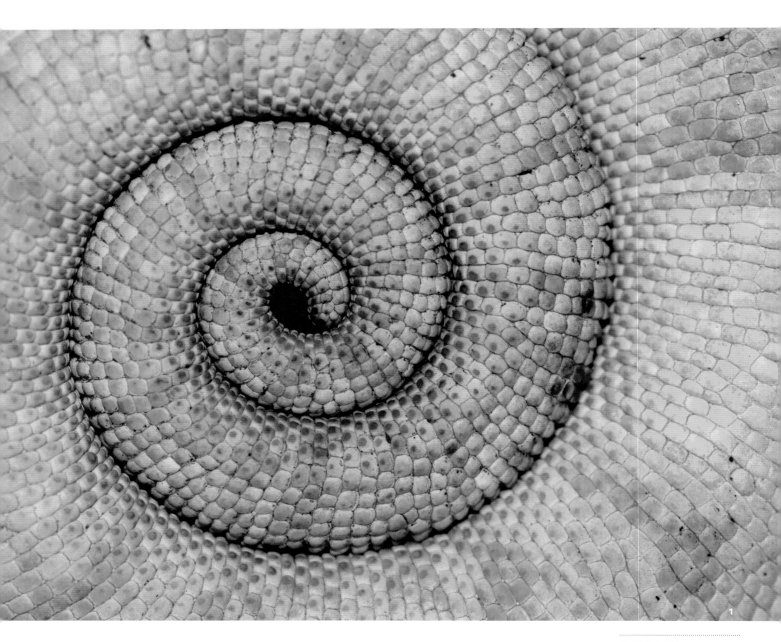

COILED UP
*Logarithmic spirals such
as this chameleon tail
(1) and millipede body
(2) may be formed from
the rolling up of a gently
tapering cone.*

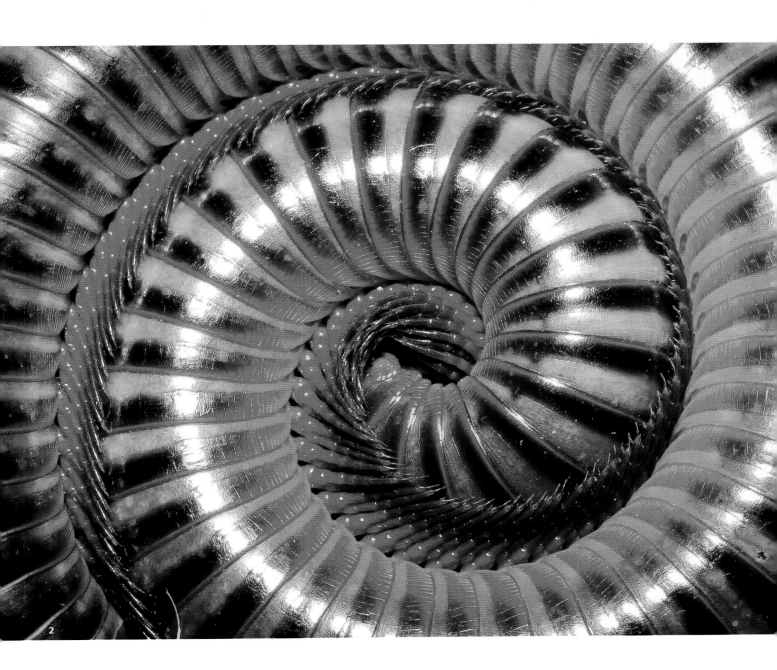

2

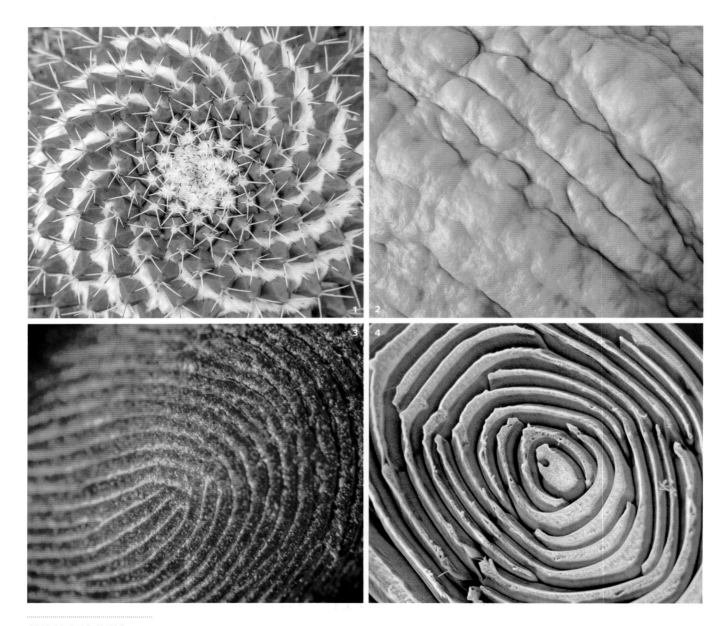

SPIRAL BUCKLING
*Wrinkling can generate
more or less orderly
patterns, including spiral
ones: cactus flower (1),
pumpkin (2), fingerprint (3),
cactus (4), and aloe (5).*

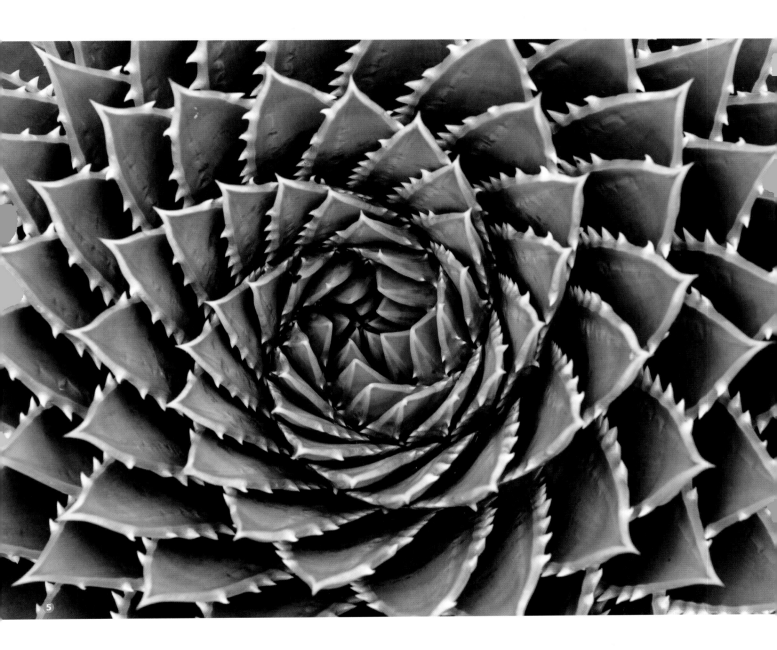

5

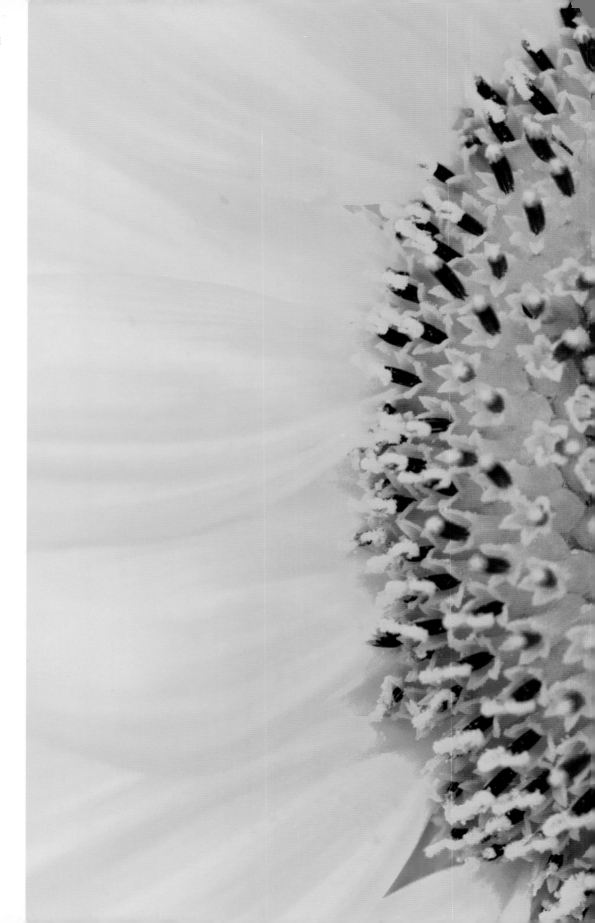

CURVES OF LIFE
The spiral arrangement of floret heads and seeds in a sunflower follows the Fibonacci sequence.

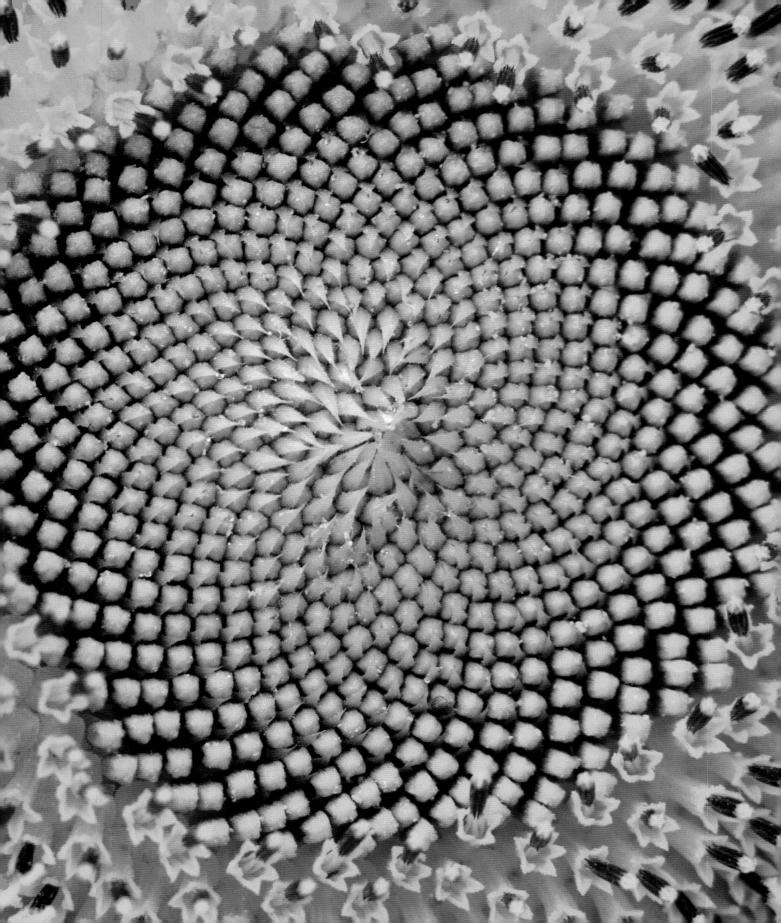

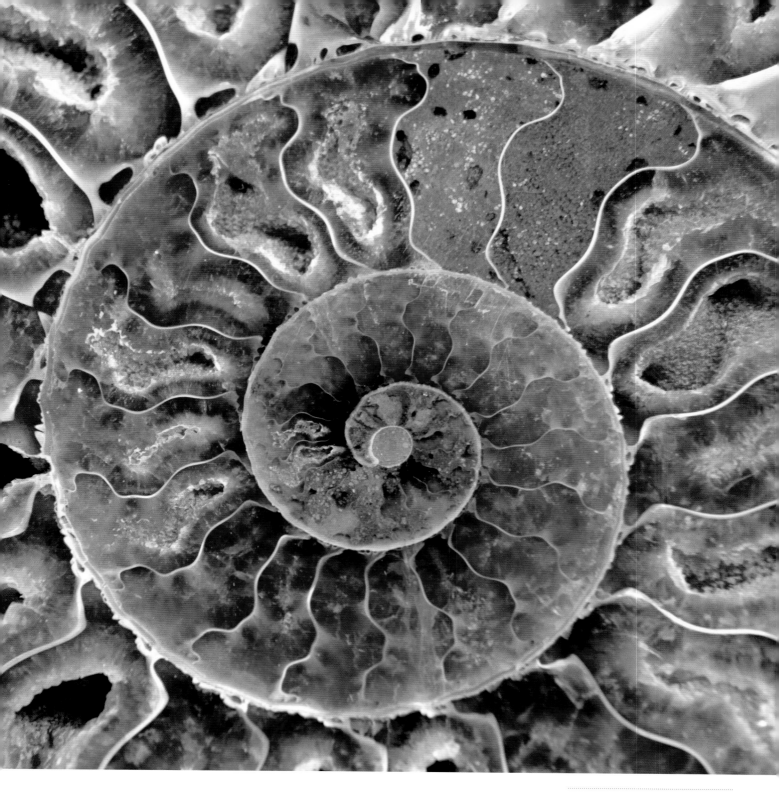

INSIDE THE SPIRAL
Spiral mollusk shells are logarithmic spirals, which enables them to retain the same shape as each successively larger chamber is added.

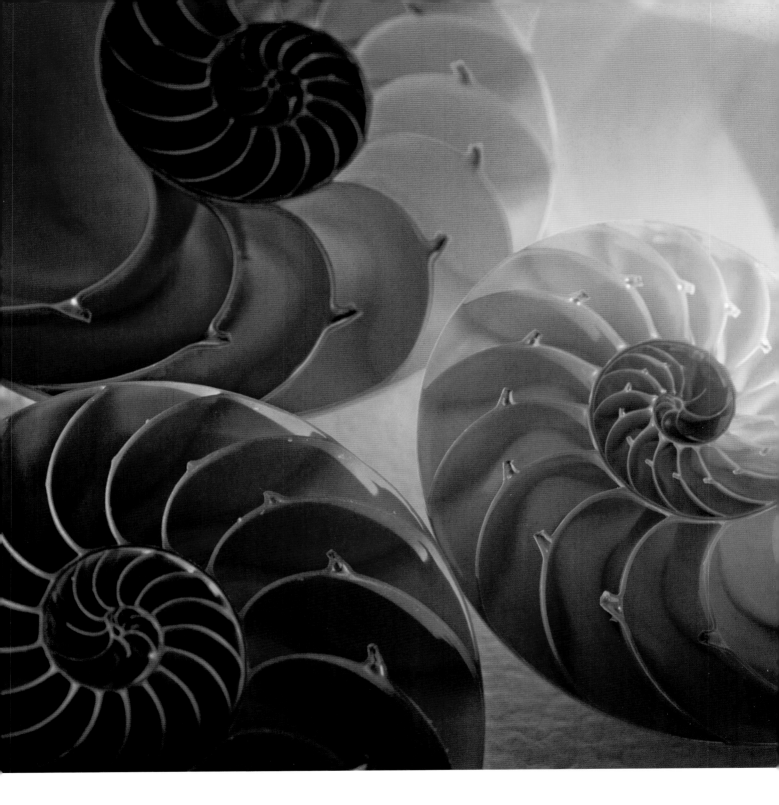

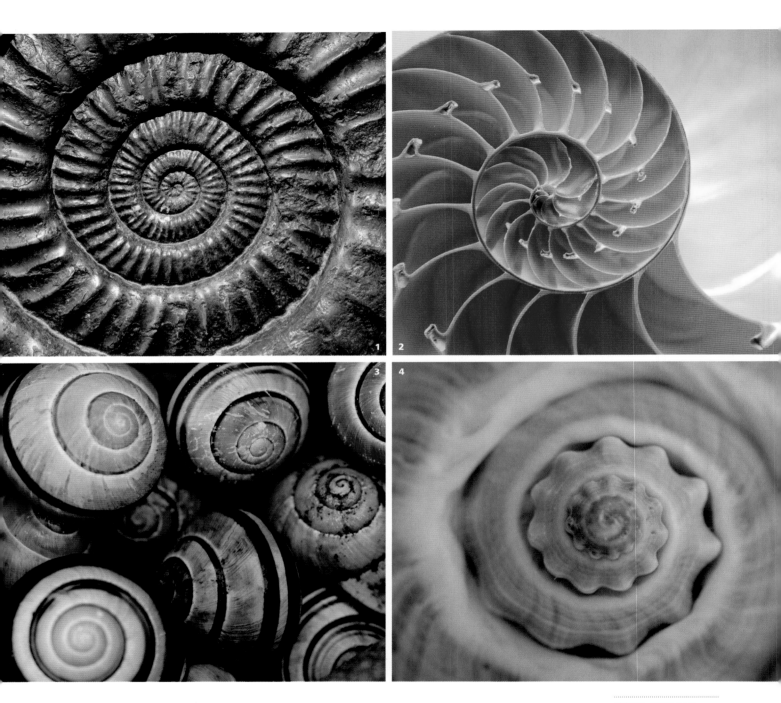

SHELL SPIRALS
Ammonite (1), nautilus (2), snail (3), conch (4), and polished nautilus (5).

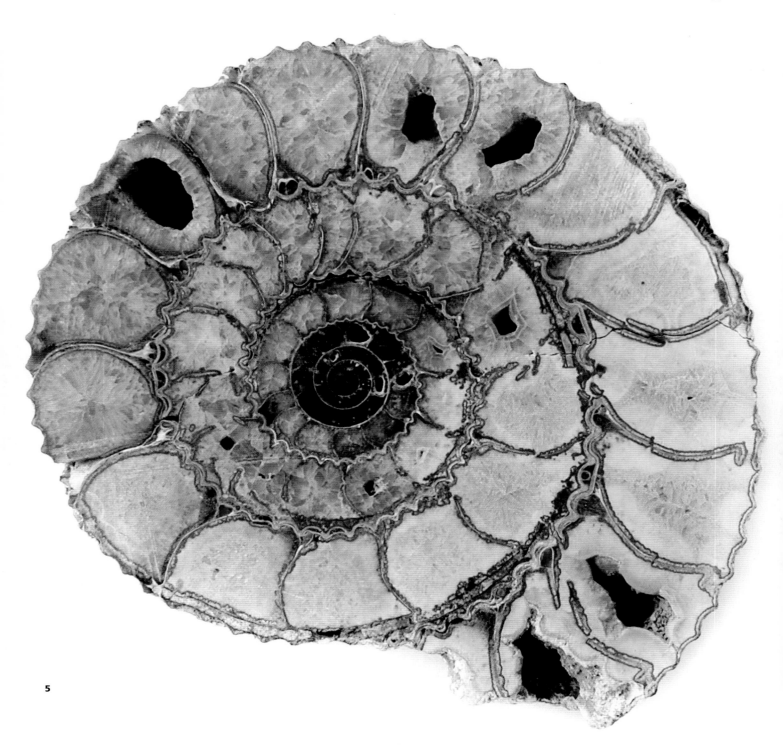

5

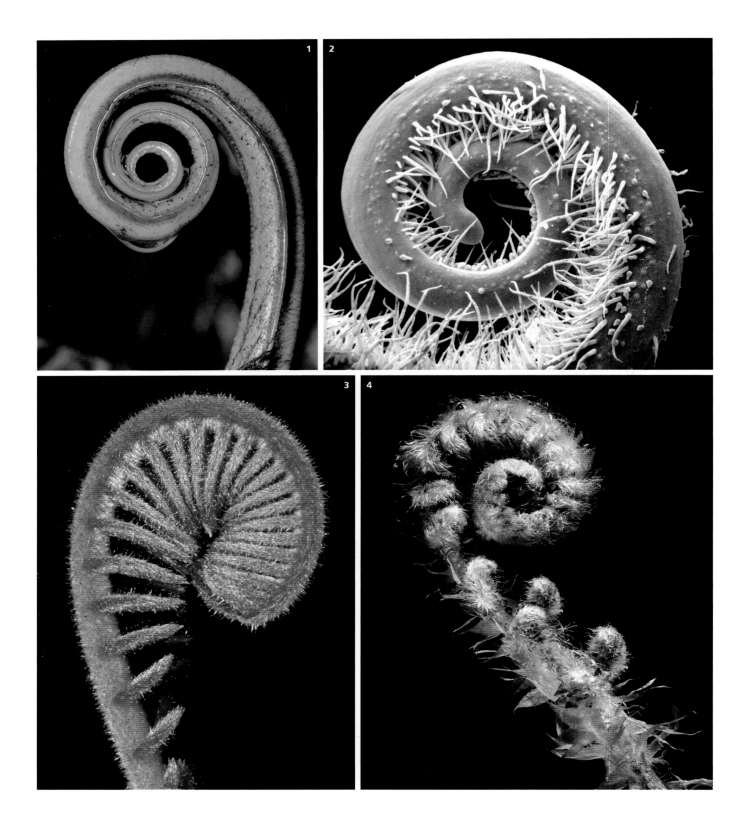

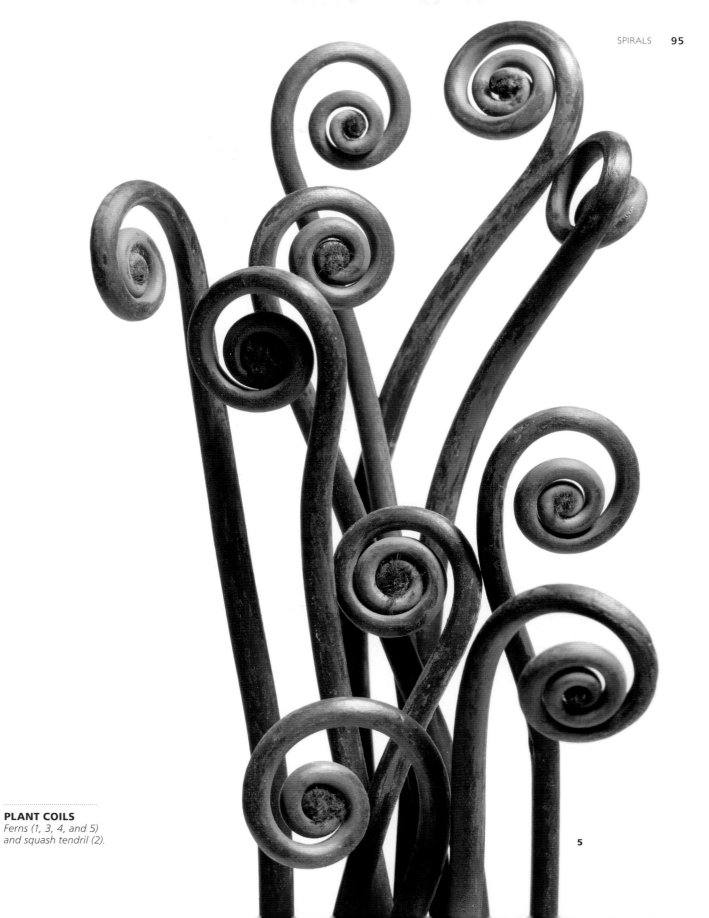

PLANT COILS
*Ferns (1, 3, 4, and 5)
and squash tendril (2).*

5

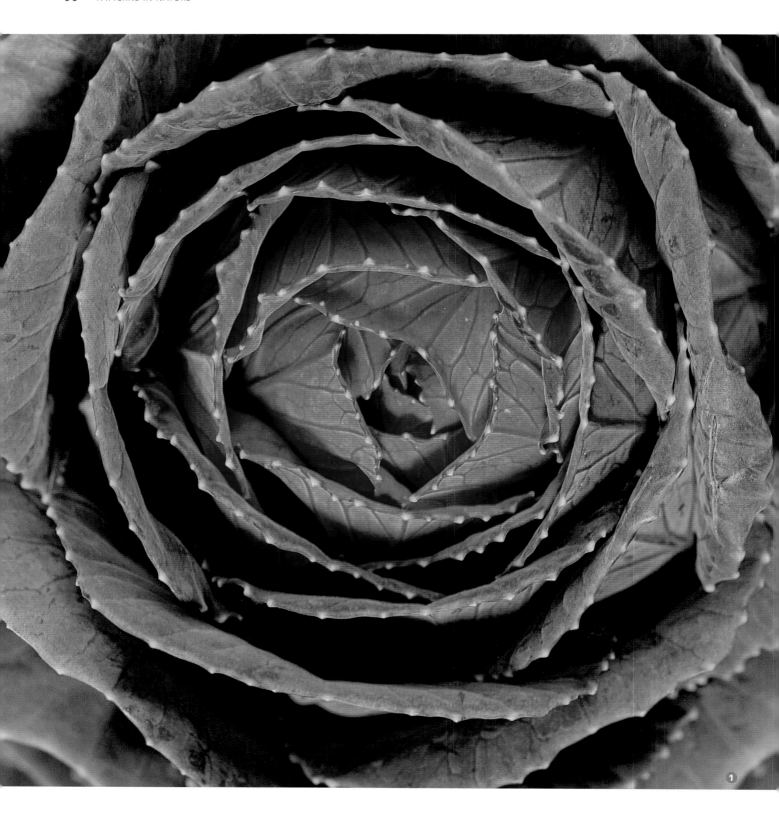

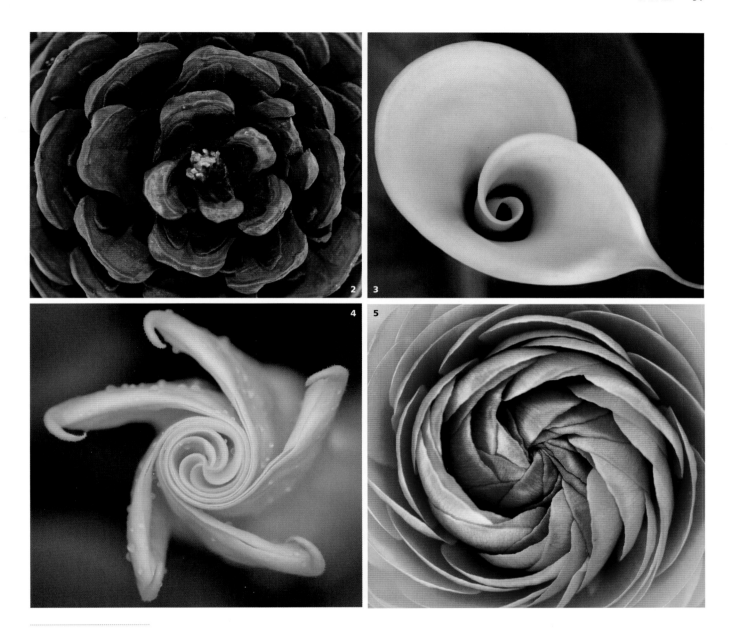

BOTANICAL SPIRAL
*Flowering kale (1), cedar
pine cone (2), calla lily (3),
floral bud (4), and rose (5).*

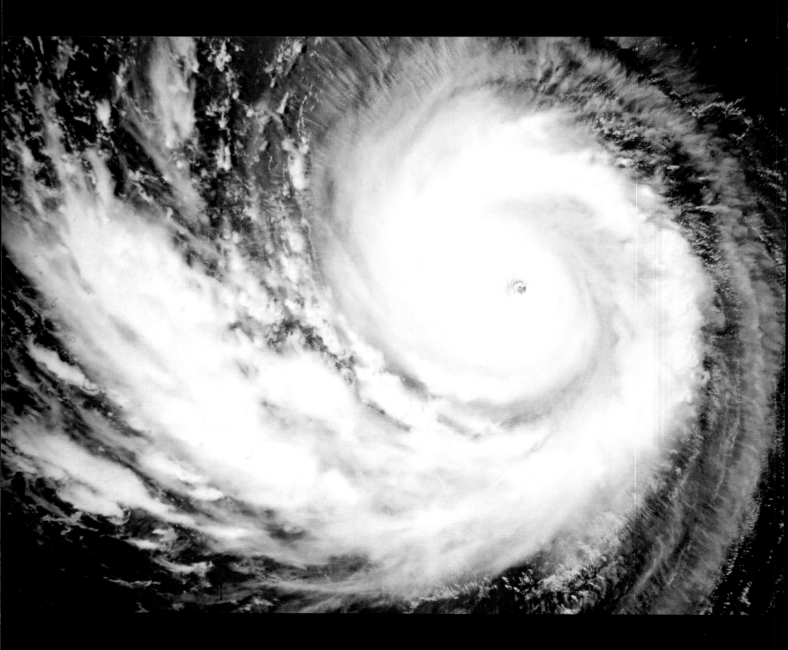

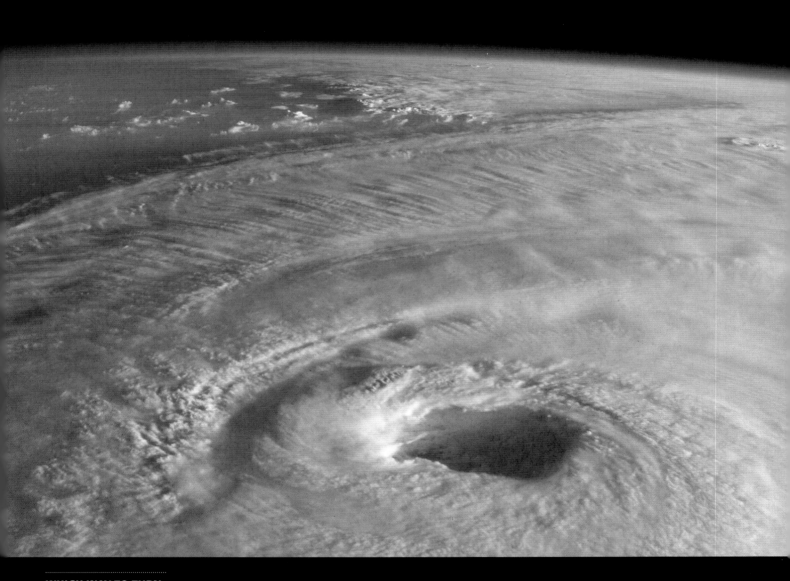

WHICH WAY TO TURN
*Hurricanes or tropical
cyclones spiral in opposite
directions within the
Northern and Southern
Hemispheres, owing to
the planet's own rotation.*

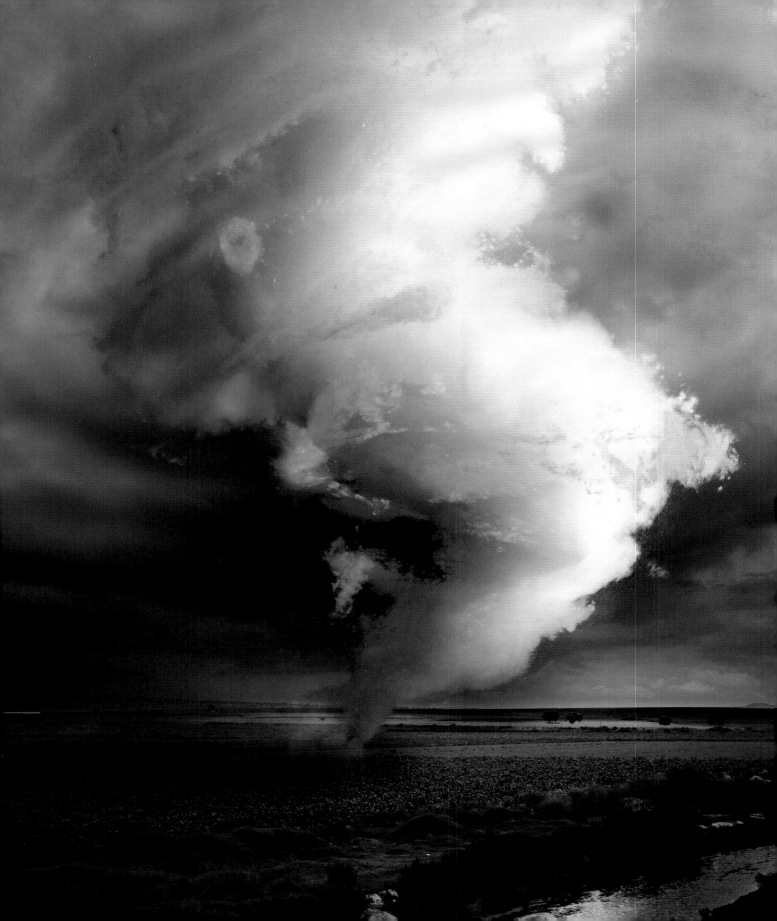

TORNADO
*Flowing fluids often
organize themselves into
spiral vortices—sometimes
to devastating effect.*

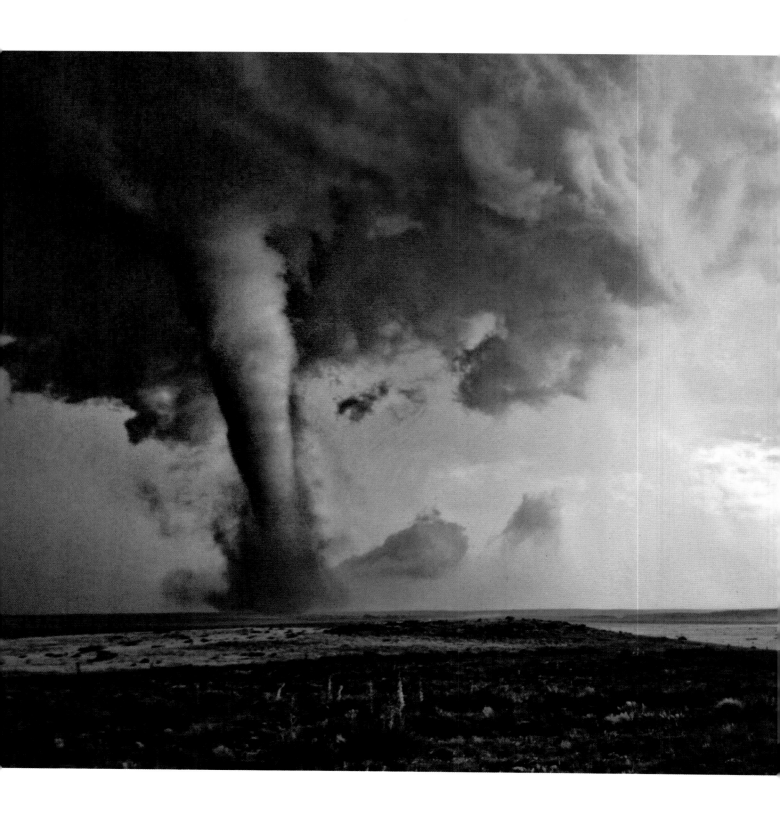

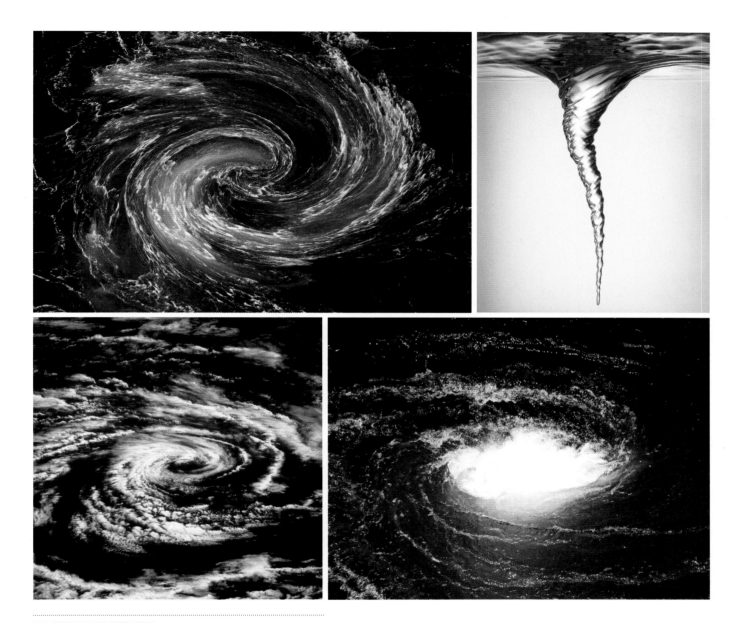

DOWN THE PLUGHOLE
Vortex flows range in scale from the mundane spiraling of bath water as it drains to the terrifying gyrations of tornadoes and hurricanes. As a fluid flows inward toward a central core, the slightest deviation from perfect circular symmetry (which could happen at random) may be amplified because of the friction that makes one part of the flow influence another. Gradually, rotation becomes organized into a single coherent vortex. This is an example of spontaneous symmetry-breaking: the rotation transforms circular symmetry into an asymmetric twist, either clockwise or counterclockwise.

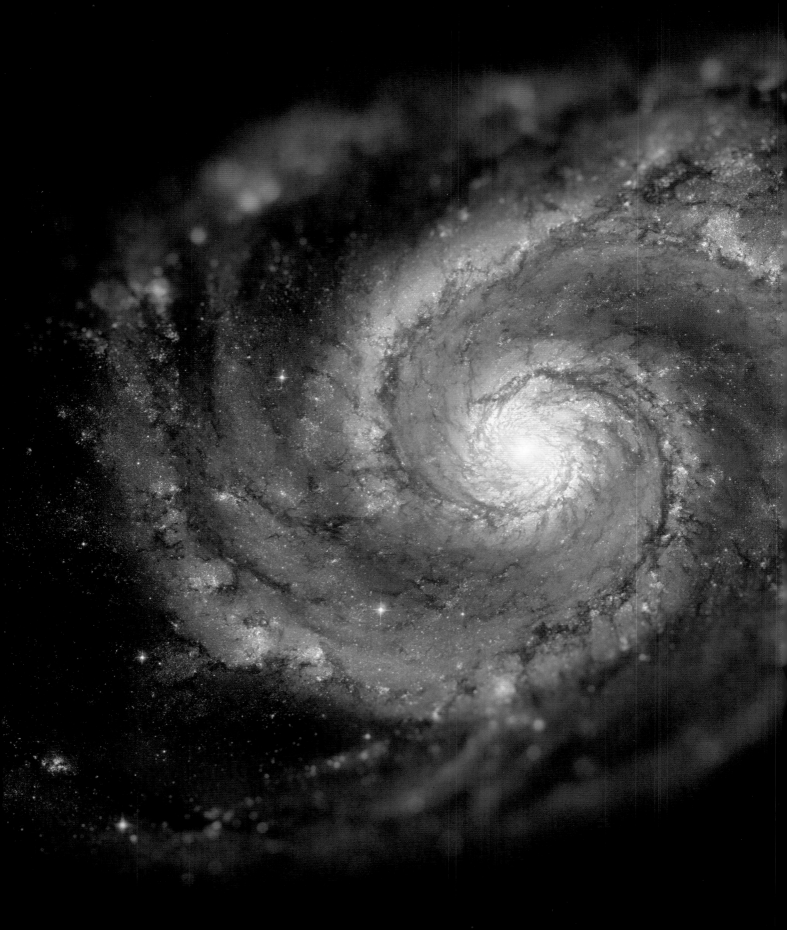

STIRRING UP THE STARS
*Spiral galaxies, such as the
Whirlpool Galaxy here, are
not flow vortices but self-
organized density waves in
a disk of stars.*

FLOW & CHAOS

Finding the hidden order

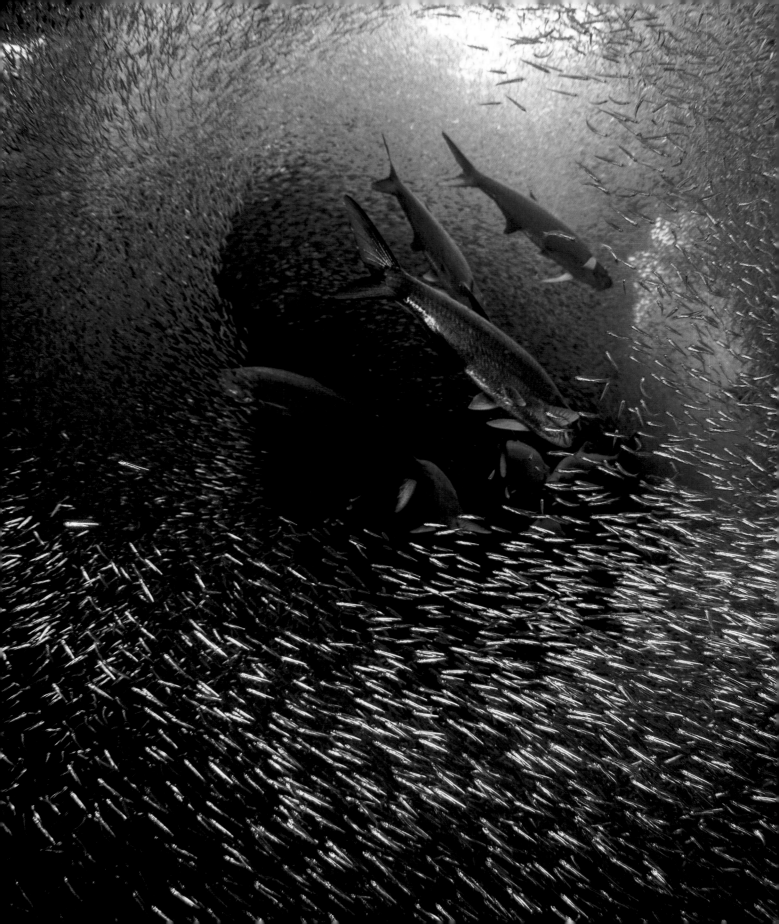

The universe is dynamic—always on the move. From clouds of gas and dust, stars coalesce. Water circulates around the ocean in great loops and gyres, driven by differences in temperature and saltiness; convection currents stir the air and summon up clouds and jet streams. Rivers flow down from the mountains in branching formations like those through which our blood courses. Many of these flows are turbulent—too fast to maintain any constant form or to be fully predictable—and yet that doesn't strip them of all order. The fundamental forms of fluid flow, such as the whirlpool vortex, are as familiar in coffee and cream as they are in a tropical cyclone; a storm in a cup, indeed. In these and other ways, patterns of flow surround us with mystery and majesty.

Rivers have always attracted artists. In China, poets of the Tang Dynasty sat contemplating them for days, while painters tried to capture the characteristic flow forms of the water in fluid brush strokes, alive with the vital energy they called *qi*. They were doubtless tantalized by the same thing that captivated Leonardo da Vinci when he sketched many images of flowing water in fifteenth-century Italy—the perception that amid the turbulent flow there is a kind of organization, a hint of patterns forever shifting and disintegrating. Leonardo intuited what scientists now recognize: turbulent water is not mere chaos, but a mesmerizing mixture of order and disorder. Leonardo's intricate drawings of flow testify to his powers of observation, but there is something a little too regular about them that doesn't quite match what we see. It is as if Leonardo felt that, in order to grasp the flow forms, he had to edit what he saw, making it more tangible and familiar. His images are what art historian Martin Kemp called structural

intuitions. Through such intuitions, Kemp suggests, we try to make sense of the world we perceive. They guide us toward similarities and correspondences in the patterns of nature.

There really is a kind of order in flow, but to see it more clearly, we need to slow the flow down. Most flows in nature are turbulent: they are so swift that all that remains of this order are glimpses, mesmerizing because of their very transience. If, however, we look at much gentler flows, the patterns are obvious—and stunning.

Think of water coursing down a long, shallow channel with smooth, flat sides. If the water's speed is low—if it descends a very gentle gradient, say—then the flow follows more or less straight paths, as you can see by placing visible objects within it, such as a scattering of fine powder or blobs of colored ink. The water moves in flat, parallel layers, a type of flow called laminar.

Now imagine an obstacle in the flow—a dangling branch dips into the river, a boulder on the river bed pokes up through the surface.

FOOTSTEPS IN THE FLOW
As a water strider paces across the surface of water, held up by surface tension, it leaves an ornate wake behind it, each step dragging the water into pairs of oppositely rotating vortices that evolve with baroque elegance (revealed here with blue dye).

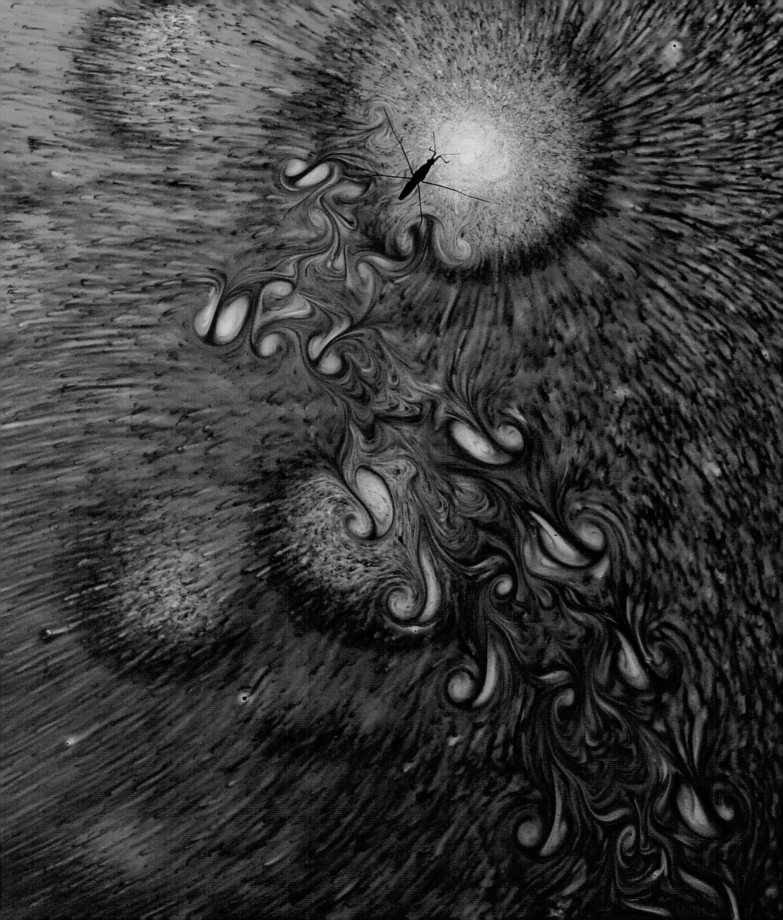

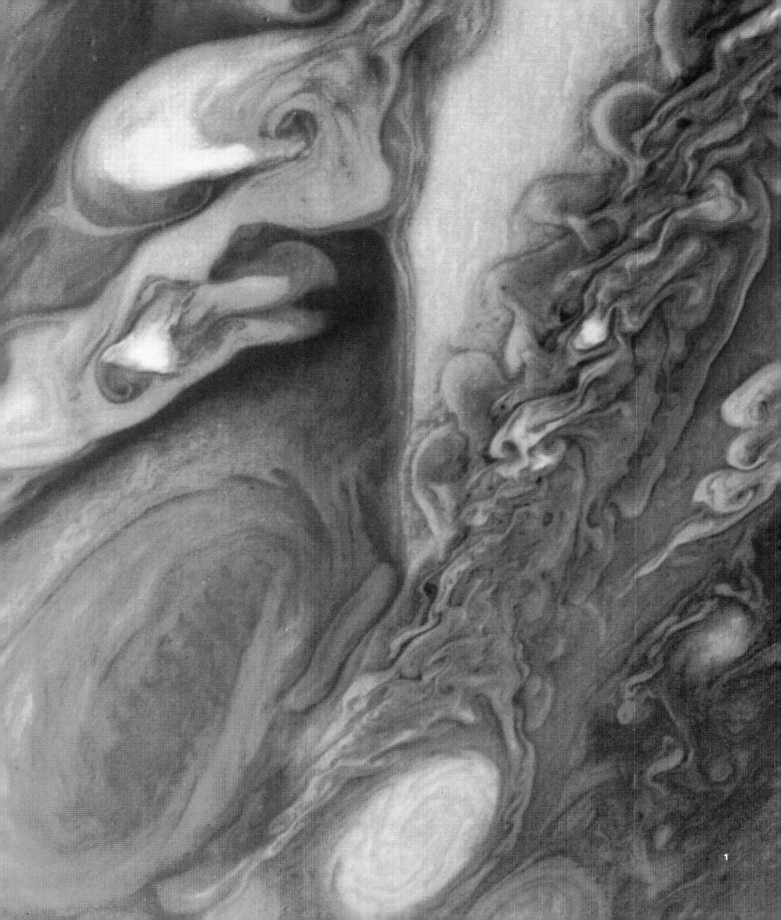

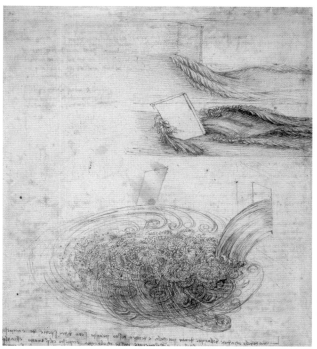

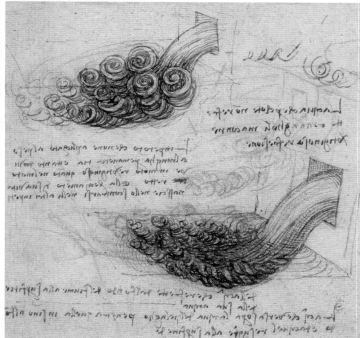

1 JUPITER'S GREAT RED SPOT
This storm, which is bigger than the Earth, has lasted for centuries and hints at the regularity that can emerge from chaotic flow. This image was taken by the Voyager 2 spacecraft from a distance of about 4 million miles (6 million kilometers).

2 and 3 STUDIES OF FLOWING WATER
Leonardo da Vinci's sketches of flowing water came from many hours of careful observation, and show the artist's determination to discover the "essential forms" behind the superficial appearance of disorder.

How does it disturb the smooth laminar flow? That depends on several things: the size of the obstacle, the viscosity of the liquid (water and syrup respond differently), and in particular the speed of the flow. If it is slow enough, the fluid may pass gently around the obstacle and come together again on the far side, so that the paths revealed by the tracer material—the powder or ink—are smoothly bent to either side before becoming parallel again. But if the flow is a little faster, a pair of spinning eddies appears in the wake behind the obstacle. Faster still, and the wake develops a persistent wavy undulation. As the flow speed increases, these waves grow and acquire crests that "break" and curl over, twisting into a regular train of vortices that turn first one way and then the other.

This baroque pattern is known as a Kármán vortex street. The vortices spring from the sides of the obstacle itself, as the fluid flowing past is dragged inward by friction and begins to turn on itself. Vortex streets are common in the natural world. They can be seen in cloud formations as air streams past some disrupting influence such as a region of high pressure. They spring from the moving feet of a water strider propped up by surface tension on a pond surface, and they are shed by the flapping wings of insects, which cleverly maneuver the wings so as to harvest a little push from the eddies to give them extra lift.

The growth of wavy patterns in smooth laminar flow is said to be a kind of flow instability: it signals the onset of the less regular and more turbulent motion that will appear at still greater flow speeds. Something similar can be found when two layers of fluid move past each other in opposite directions, or more generally, when they move at different speeds, so that one drags against the other. This situation is called a shear flow, and again it is ubiquitous in nature, especially in the atmospheric flows of our planet and others, such as the swirling gaseous atmospheres of Jupiter and Saturn. The wavy disturbance is self-amplifying: as soon as it appears, it has a tendency to grow, the waves deepening and sharpening. This self-amplification is a common condition of pattern formation.

Finding order in chaos

Jupiter's atmosphere is turbulent. Aside from the parallel bands called zonal jets, the flows are fast enough to wash away any truly regular pattern, and the shapes and forms of the vortices are constantly changing and shifting. Yet the flow doesn't look simply random: there is a kind of elegant beauty to it, punctuated as it is with

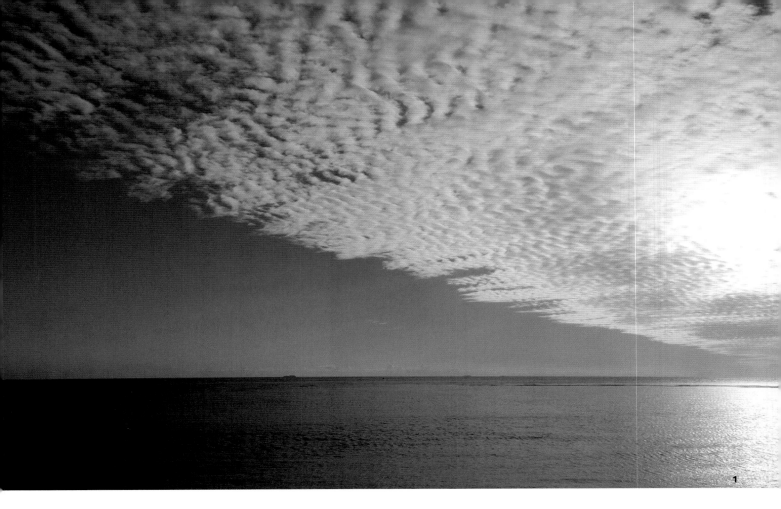

pockets of organized motion. The famous Great Red Spot is the most prominent: an enormous storm with winds of up to 350 miles an hour, which has been raging for at least two centuries, possibly several more. Smaller vortices come and go, some lasting decades before they are dissipated or swallowed.

That's just how it is with turbulence: it might not have a pattern in the usual sense but, like the branches of a tree or the ever-diminishing echoes of a fractal, it seems to hint at some deep structure beyond bewildering chaos. Can we make this impression more precise? Can we describe the shapes of turbulence?

Scientists have studied turbulent flow for hundreds of years, and yet still they cannot claim to fully understand it. It's one thing to have the right equations that describe the motion, but quite another to solve them. The basic challenge of fluid flow, especially with turbulence, is that everything seems to affect everything else. This acute sensitivity of the flow to every tiny nuance makes the situation chaotic: it becomes impossible to predict, by looking at the flow pattern at one point in time, how it will look at a later stage.

Given this unpredictability, can we hope to say anything at all about the "shape of turbulence"? Yes, we can. Even if we can't predict exactly what a particular flow will look like, we might say something about its average properties.

One of the first people to make headway with this question was Lewis Fry Richardson, the mathematician who first discerned the general concept of what we now call fractal structure. Richardson was interested in turbulent flow partly because he was working on weather prediction, and he suggested that it might be imagined as a "cascade" in which the energy of the moving fluid is passed down from large eddies to ever smaller ones, until finally it gets dissipated as heat in the random motions of the fluid molecules. It was later shown that this energy cascade obeys a mathematical law in which the amount of energy bound up in eddies of a particular size is related to that size via a rather simple equation. As with fractals themselves, this mathematical law

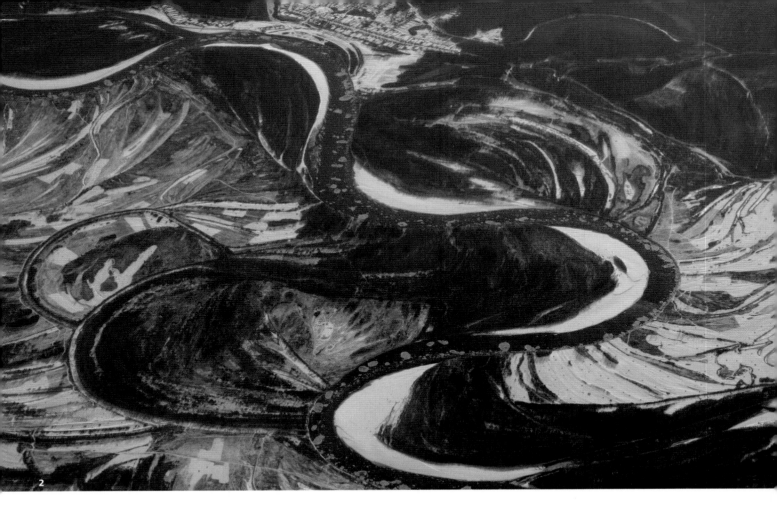

encodes a kind of "hidden regularity" among the apparent disorder—a cryptic pattern, if you like. The basic idea seems sound, although there are still debates about, for example, how quickly (if at all) a turbulent flow can be restored to a more orderly state, or whether there is more than one type of turbulence.

Turning over

The Earth's atmosphere is never still. Air is always on the move somewhere as winds bear it from regions of high to low pressure. But the cause of this flow is, at root, not so much variations in pressure as in temperature. Close to the surface, heat radiating from the land or sea warms the air, and as it heats up it expands and becomes less dense. This gives it buoyancy, and it rises. Higher in the atmosphere it cools again, becomes more dense, and sinks. This rising of warm, less dense air and sinking of cool, denser air is called convection. It doesn't happen at random, but is organized into three vast conveyors in each hemisphere—belts parallel to the equator in

which air rises along one edge and sinks along the other. They carry heat and moisture with them, governing the climate regimes of the planet.

Convective flow often adopts states of patterned self-organization. Imagine a shallow layer of water heated in a pan. The warm liquid on the bottom is buoyant and "wants" to rise—but how is it to get past the denser liquid above? The answer is that there is spontaneous symmetry-breaking: the uniform layers of liquid break up into circulating cells of more or less regular shapes, with the warm liquid rising in some parts and cooler liquid sinking in others. Some of these patterns can become astonishingly well ordered. In the atmosphere, their shapes can impose order on the clouds, creating the parallel stripes of "cloud streets," sometimes called a mackerel sky because of its resemblance to the striped markings of those fish. Even the ferocious convection on the Sun doesn't just result in disarray. The Sun's surface is covered with so-called "solar-granules," patches that are darker at the edges than in the middle, and which change and shift every few minutes.

3 SUNSPOT
Even the seething surface of the Sun is patterned. Convection in the hot plasma creates this "granulated" structure of bright spots in a web of slightly dimmer (cooler) regions. The black structure in the center is a sunspot, which is even cooler still.

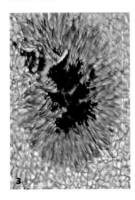

Flocking and swarming

As dusk dims the fall sky, starlings gather and flock in search of a place to roost. They are looking for woodlands, buildings, piers, and reed beds where they can find shelter from harsh weather and predators. The flock might swell to many thousands—even hundreds of thousands—of birds, and as it grows it displays one of the most astonishing sights in nature. Twisting and turning, shifting from near transparent to opaque as the angles of the birds' bodies change in our line of sight, the flock becomes a so-called "murmuration" in which these creatures seem to have acquired a group mind as they maneuver in unison.

How do they do it? All it takes is for each bird to observe some rather simple rules of motion. They avoid crashing into each other or getting too close. They try to match their direction of movement to the average direction of their neighbors. And they try not to drift too far apart. A bird in one part of the flock has not the slightest idea of what others far away are doing; it is merely attentive to those close by.

The same sort of behavior can be seen in schooling fish and swarming locusts or bats. The coherent movements are very effective at communicating information fast: waves can ripple quickly through the crowd, so that the alarm signs of an approaching predator are rapidly sent to fish far from the danger spot.

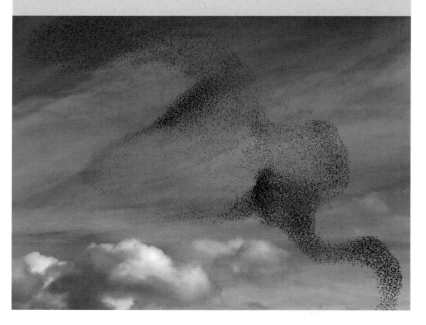

Convection can create order in frigid conditions, too. In the remote frozen wastes of Alaska and Scandinavia, you might come across stones seemingly arranged into patterns on the tundra by frost giants—ring-shaped mounds as tall as a person is high, or great pebbles disported in rows and stripe formations as though shepherded by a massive rake. Needless to say, no intelligent beings have carried out such a pointless feat of landscaping. The stones have been heaved into place by convection currents in water that freezes and thaws cyclically just beneath the ground surface.

River's edge

Fluid flow can become not just a patterned phenomenon but a patterning agent itself: the shapes and forms of the water leave permanent traces. Streams, rivers, and oceans pick up sand, silt, and stones and shift them in the current, and the resulting processes of erosion and deposition rearrange the landscape into patterns that are as pleasing as they are surprising. The meanders of a river are one of the best-known examples of how feedback processes create order and structure. Because the water flows faster on the outside edge of a meander, and slower on the inside, the river bank becomes more eroded on the outer bend while silt gets deposited on the inside. This means that bends, once they appear, bulge ever outward as though a bubble is being blown in the river's course. Eventually the two sides of the loop meet and coalesce, and the bulge is pinched off into an ox-bow lake.

If sediment erosion and deposition are particularly strong, this restructuring creates a much more complex river form than a lone, meandering thread. Channels branch off, intersect, and reconnect, and the water's course becomes a delicate, many-stranded braid in which there is a constant dialog between flow and stasis, between water and earth. We can see these patterns in the tapestry of shallow water running across the sand into the sea. The slightest impediment of pebble or shell sets up chevron-like shapes that overlap and interfere. One way or another, the river reaches the sea, flowing to the pattern of its own inexorable and beautiful logic.

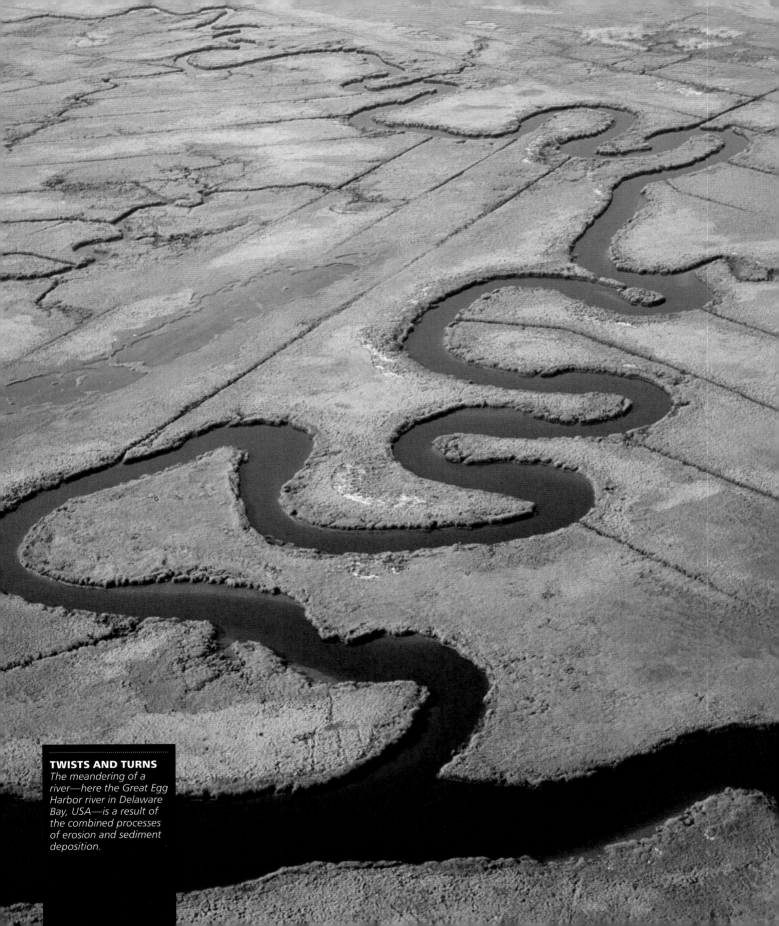

TWISTS AND TURNS
The meandering of a river—here the Great Egg Harbor river in Delaware Bay, USA—is a result of the combined processes of erosion and sediment deposition.

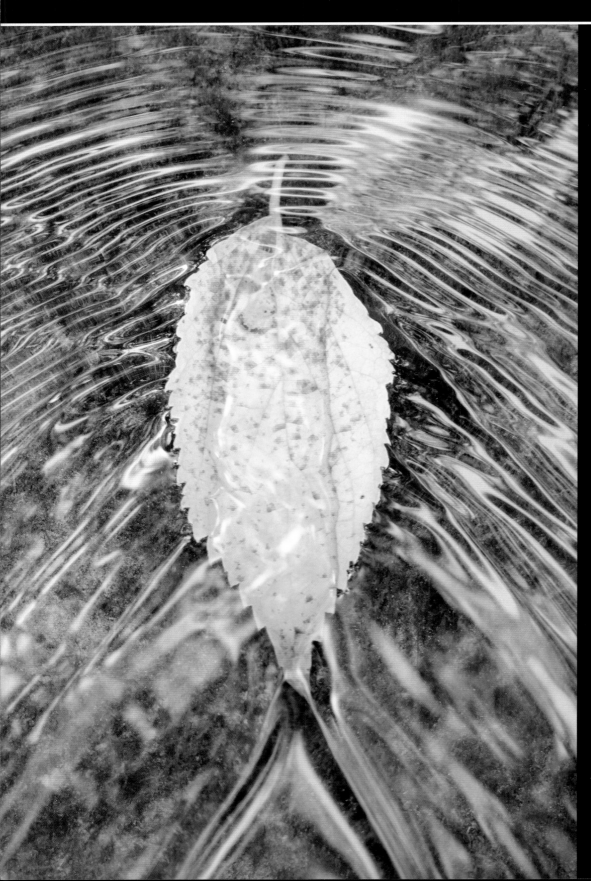

BREAKING THE FLOW
The wake of a floating leaf borne along with the flow of a river illustrates the regularity of this flow form, which echoes that of the leaf itself.

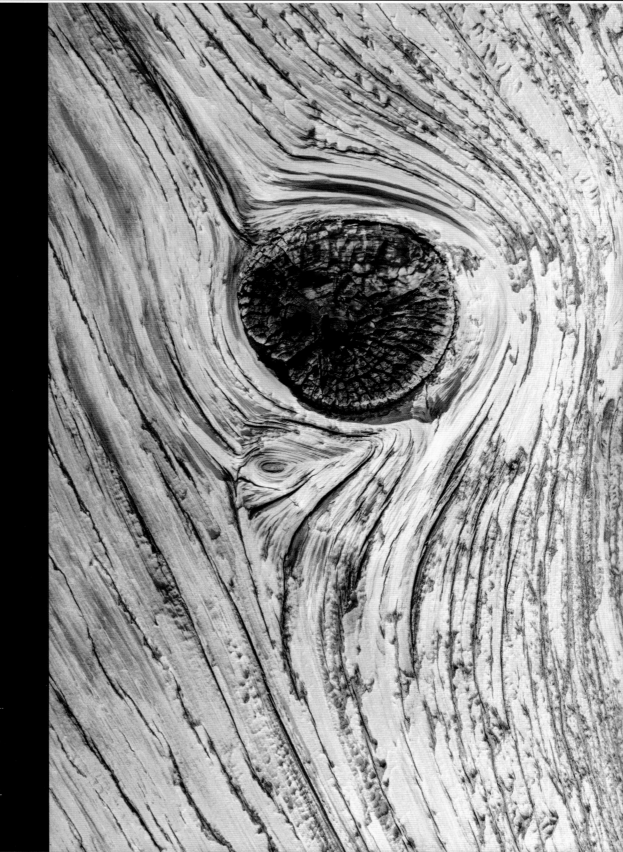

NEGOTIATING KNOTS
The grain patterns in wood around "obstacles" such as knots and new branches look strangely like the "streamlines" used to depict fluid flows.

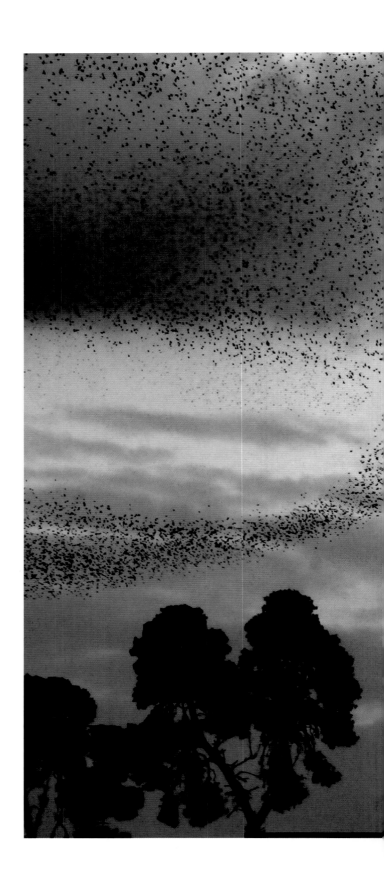

MOVING TOGETHER
*Flocking birds, such as
these starlings, show a
complex and mesmerizing
coherence.*

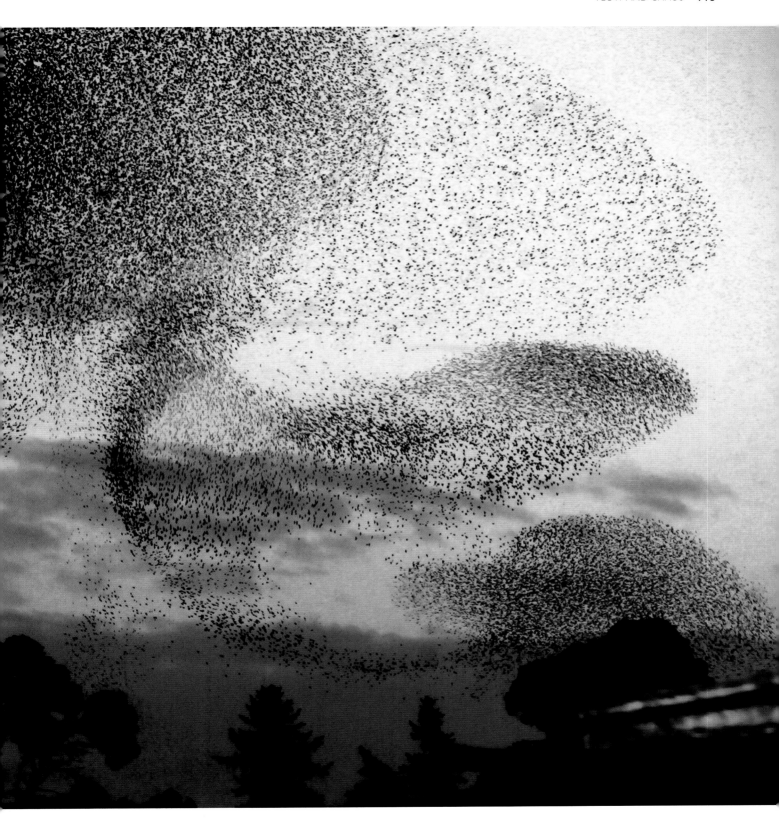

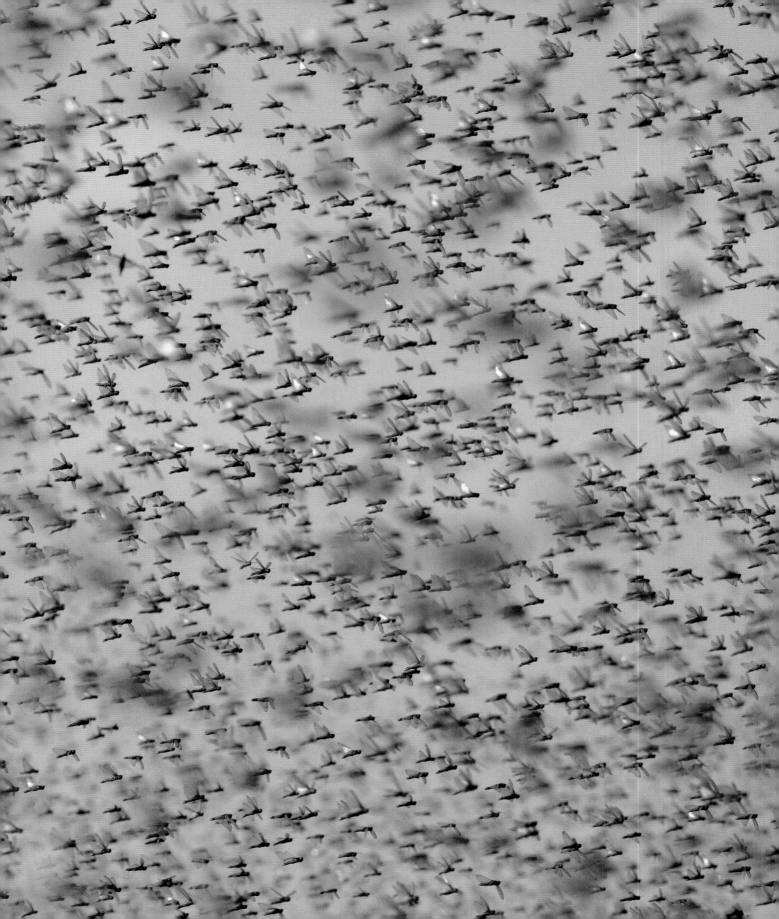

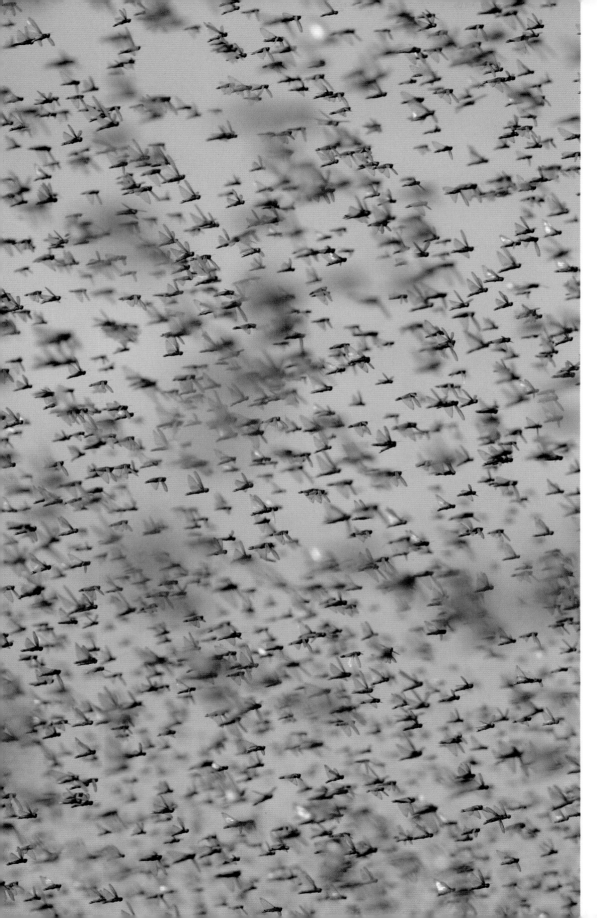

**LOCUSTS,
MADAGASCAR**
*Some swarming
creatures, such as these
migratory locusts, don't
display quite such tightly
orchestrated patterns
as fish or birds, but
nevertheless have a high
degree of order in the
direction and spacing of
individuals that prevents
collisions in the densely
packed throng.*

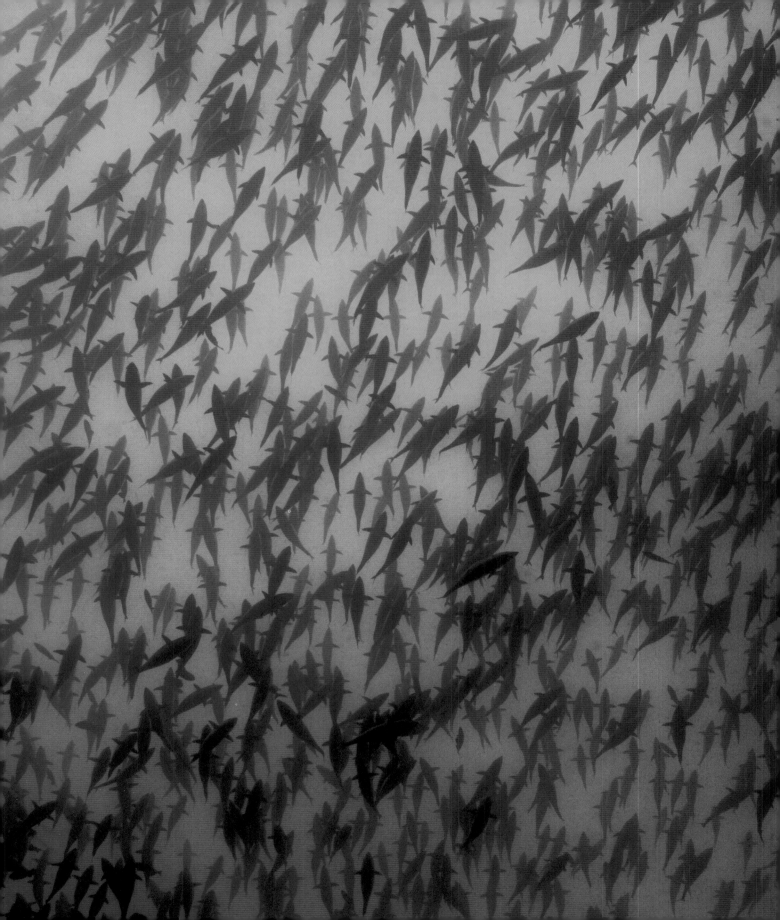

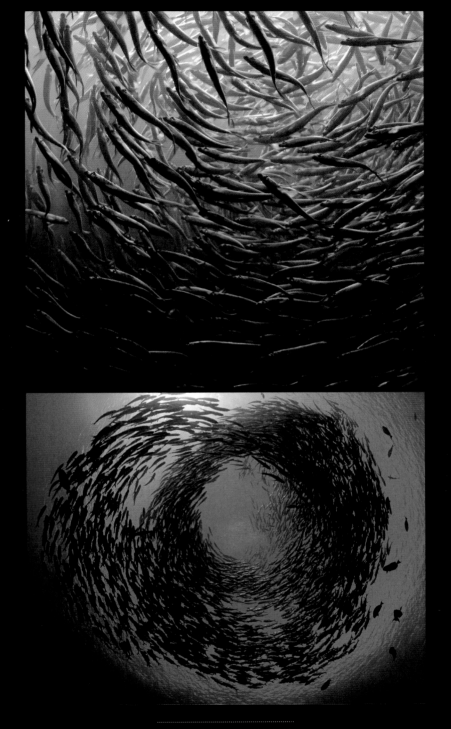

STRENGTH IN NUMBERS
*Schooling fish form highly
organized patterns of motion,
including donut-shaped,
circulating tori.*

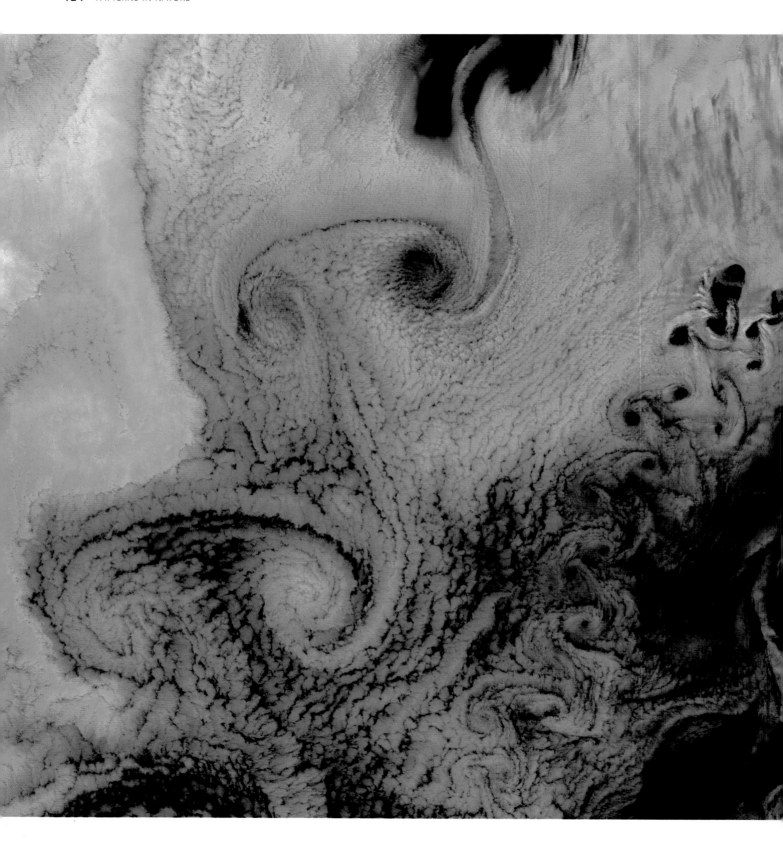

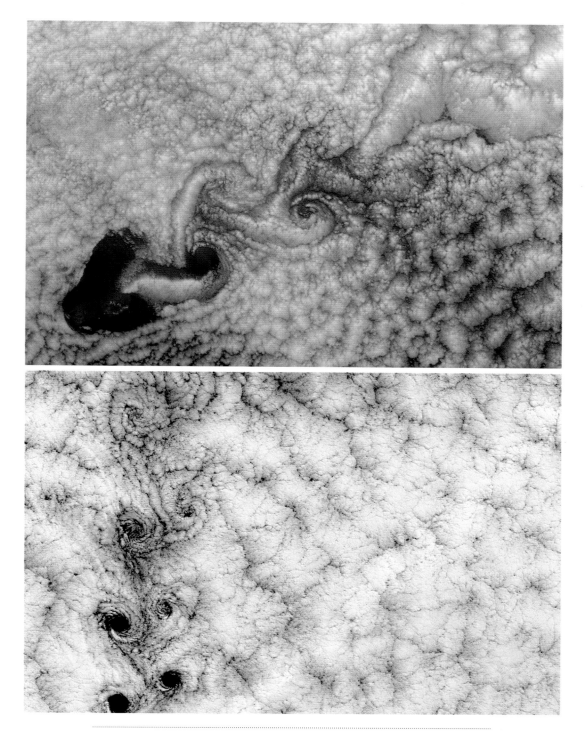

AIRFLOW TRAILS REVEALED BY CLOUDS

These organized vortices form in the air above the ocean (as traced by clouds) when winds are disturbed by obstacles such as islands protruding from the water's surface. Here, the flow patterns include mushroom-shaped "dipole" vortices and a tight succession of vortices alternating in direction, called a Kármán vortex street. Note that these flow structures can also form without the clouds, but they will not then be visible.

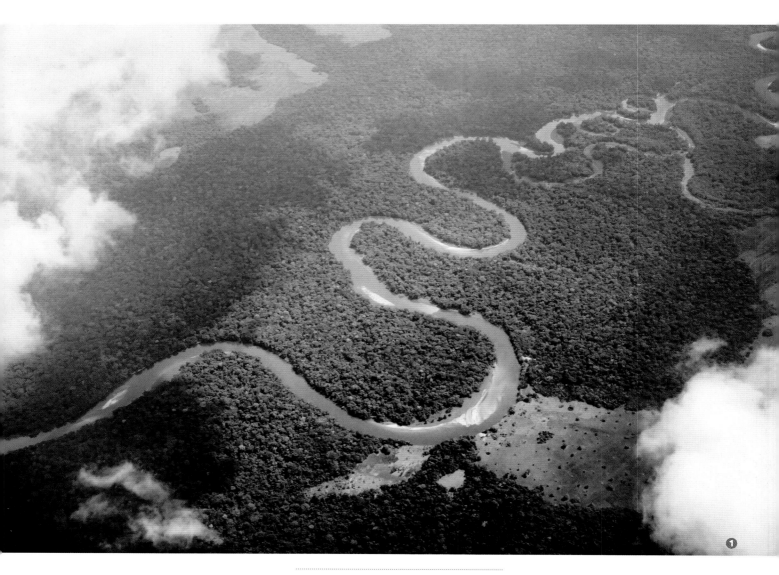

BENDING LAWS
There's a subtle logic to the forms of river meanders, which dictates that as the river channel gets narrower, the bends get tighter and their "wavelength" decreases. In other words, the ratio of river width to meander wavelength stays more or less the same. Republic of Congo (1); the Netherlands (2).

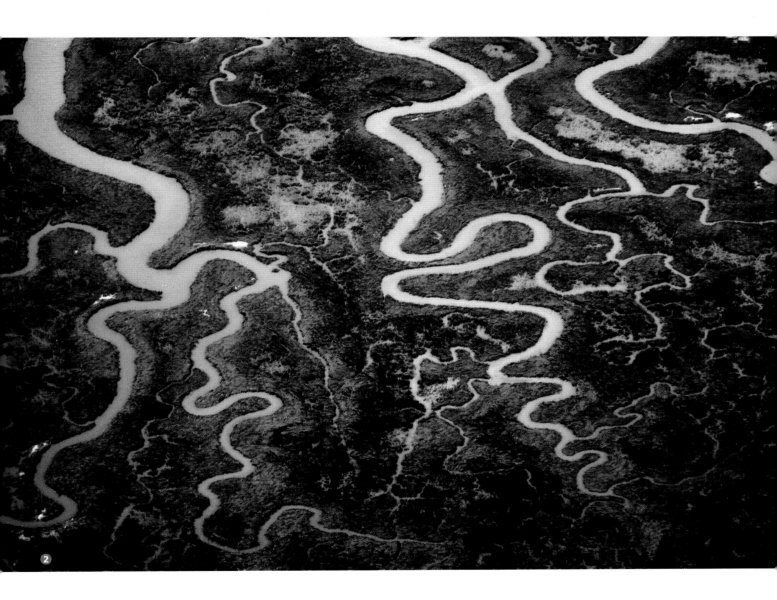

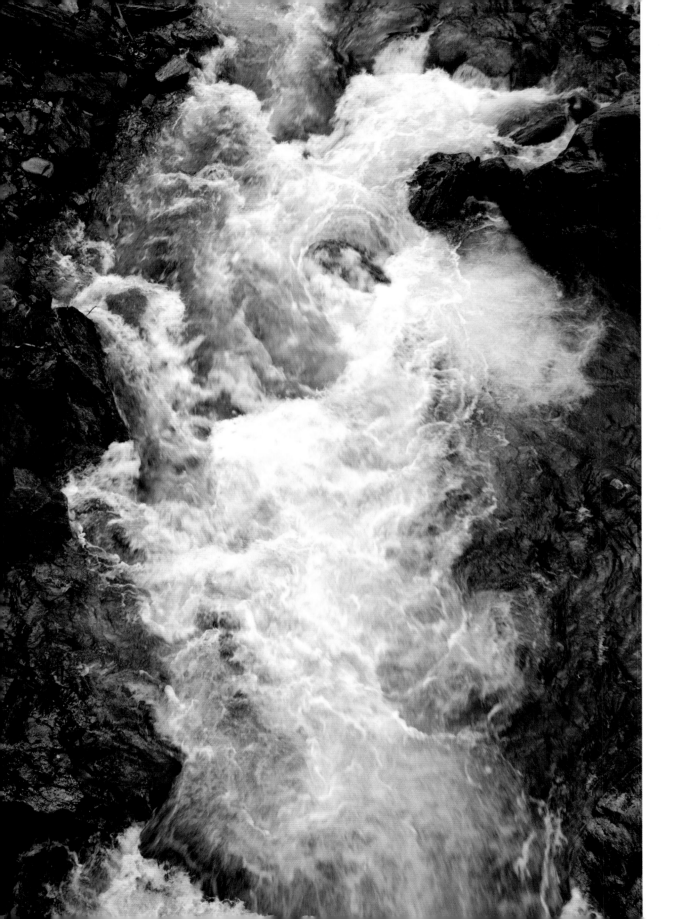

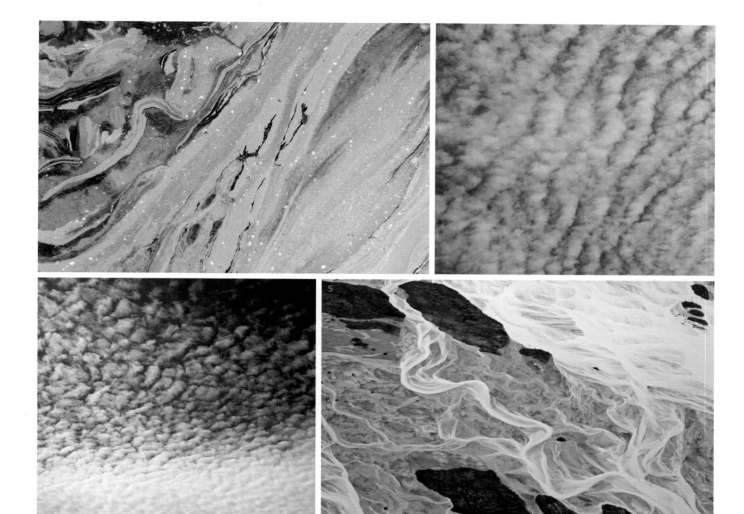

1 ICY WATER, HIMALAYAS

Fast-flowing water is fully turbulent. What order can survive in such seeming chaos? To find it, we have to look deep into the mathematics of fluid flow.

2 POLLUTION IN THE BAY BARATARIA, GULF OF MEXICO

It could almost be the swirling, banded atmosphere of Jupiter. But no, this is oil floating on water—hinting at the universality of flow forms at many different scales.

3 CIRROCUMULUS CLOUD

Regular stripelike features in this type of cloud are caused by patterns of convective flow in the atmosphere.

4 RUFFLED SKY

Here, the cloud patterns are less stripelike than in a classic mackerel sky, but still evidently have a characteristic "size."

5 BRAIDED RIVER, ALASKA

The structures of a braided river, in which extensive deposition of sediment creates a complex skein of overlapping channels, are reminiscent of hair or silk entrained in flowing water.

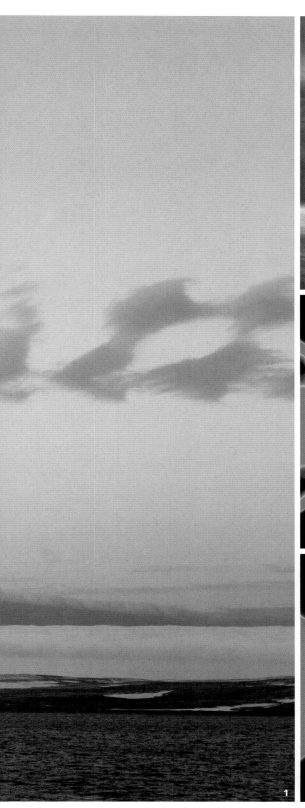

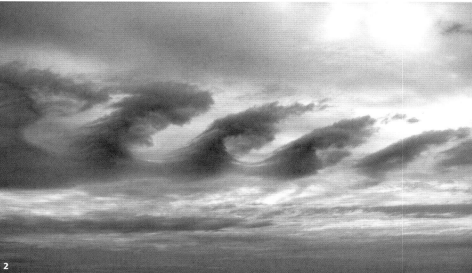

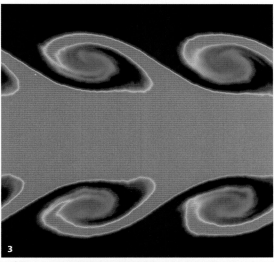

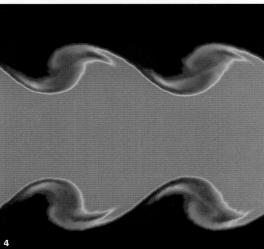

RIPPLES AT THE BORDER

When one stream of a fluid—air or water, say—passes past another at a different speed, the interface between the two can develop a wavy shape. The different flow speeds create a difference in pressure across the boundary, which can amplify any random ripple into a more pronounced wave. Eventually this wave can peak, crest, and break into a series of curlicue vortices, as seen here traced out by clouds in the atmosphere (1 and 2) and in computer simulations of flow (3 and 4). The emergence of these wavy patterns is called a Kelvin-Helmholtz instability, after the two scientists who explained it.

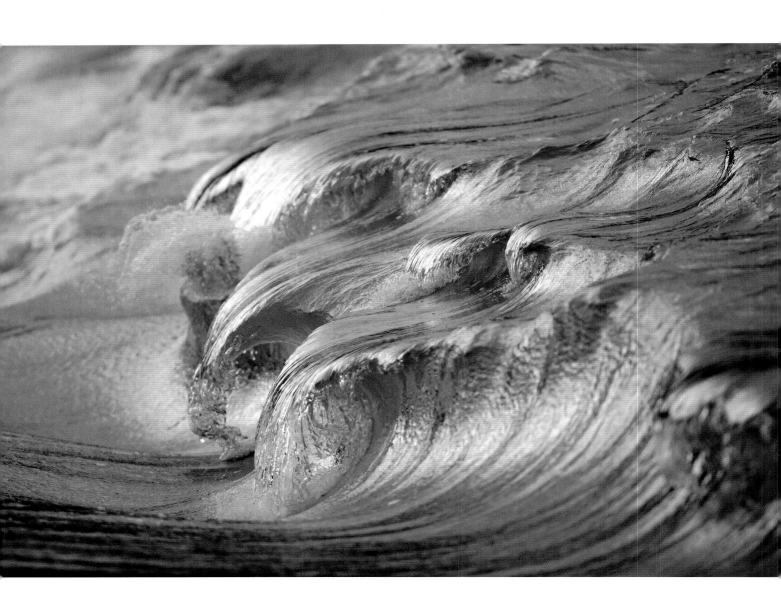

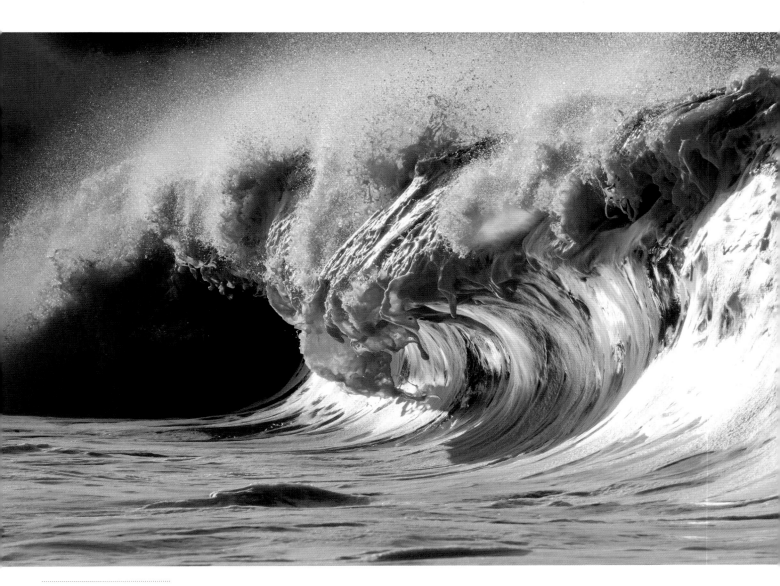

THE POWER OF WAVES
High-speed photographs of breaking waves capture the extraordinary elegance and coherence of the flow— a degree of organization normally all but invisible to the naked eye, but the kind of "deep order" that Leonardo da Vinci sought to intuit and illustrate.

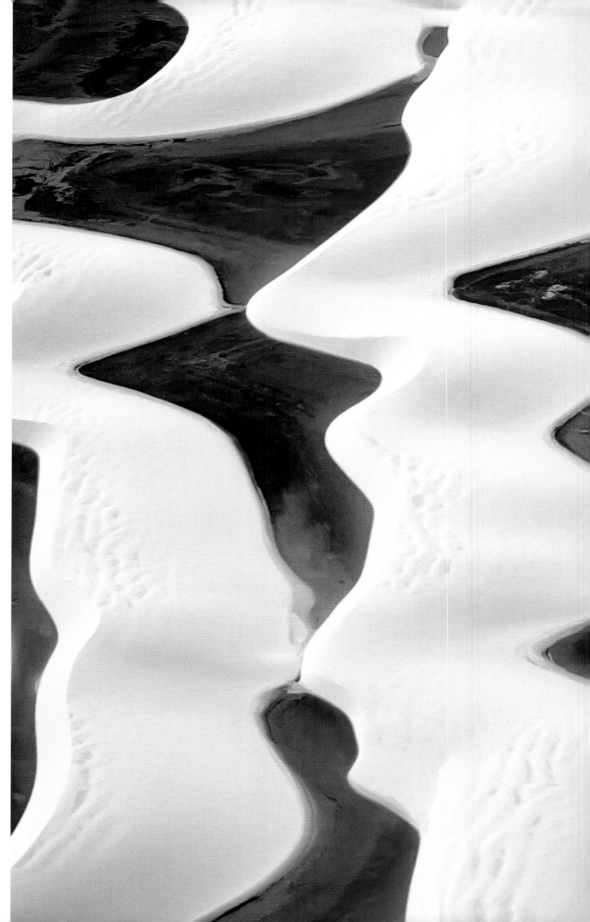

SAND DUNES, BRAZIL
The wavy forms of these dunes in Lencois Maranhenses National Park in Brazil are highlighted by captured pools of water. Here again there is a preferred length scale in the self-organized patterns, corresponding to the wavelength of the undulations.

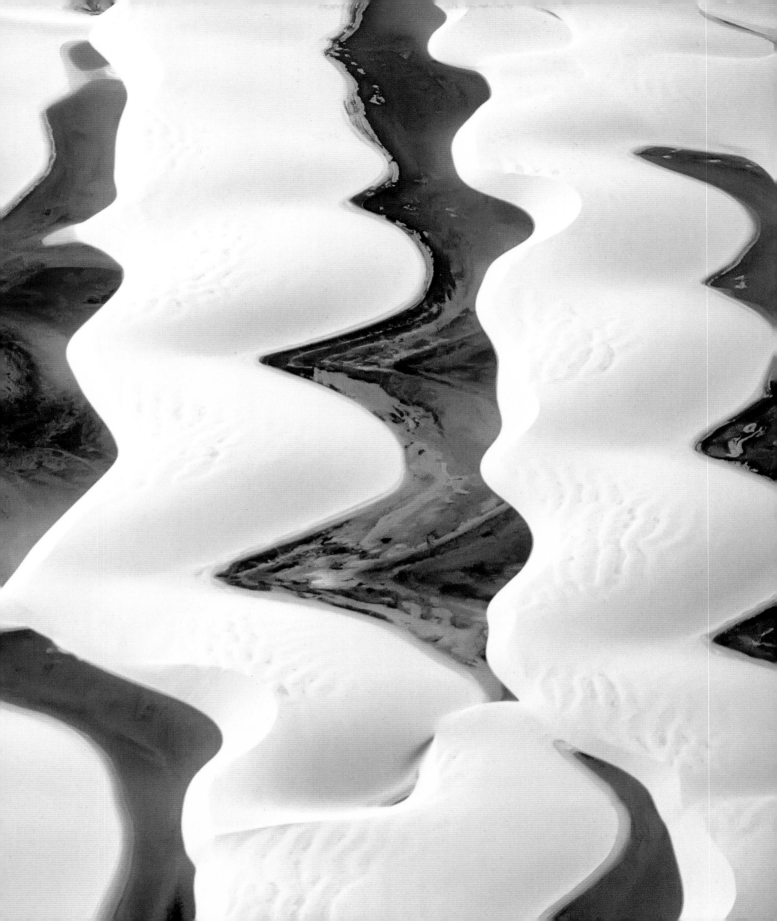

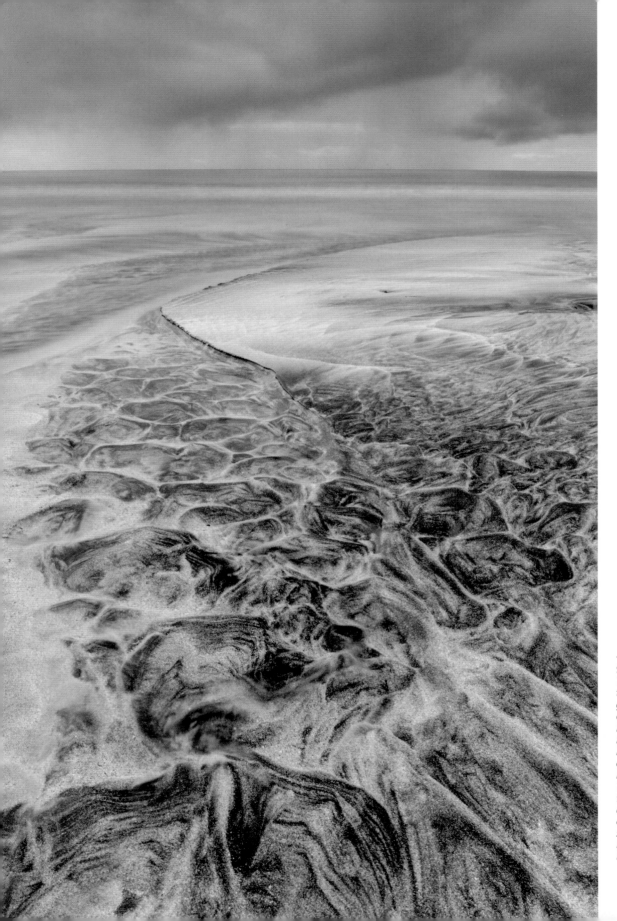

SAND PATTERNS
The range of patterns that can stem from sand grains being eroded, carried, and rearranged by flowing water is immense. Some are braided, some branched or ridged, or shaped like fanning chevrons. They depend on many factors—the speed and depth of the flow, say, or the cohesion of the sand grains, or how readily the slopes tumble in little avalanches.

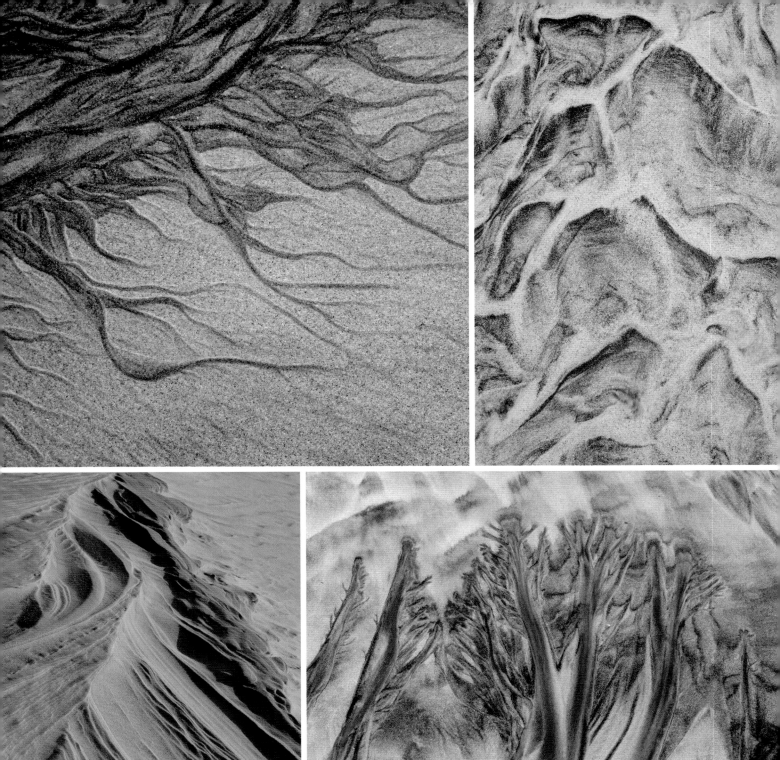
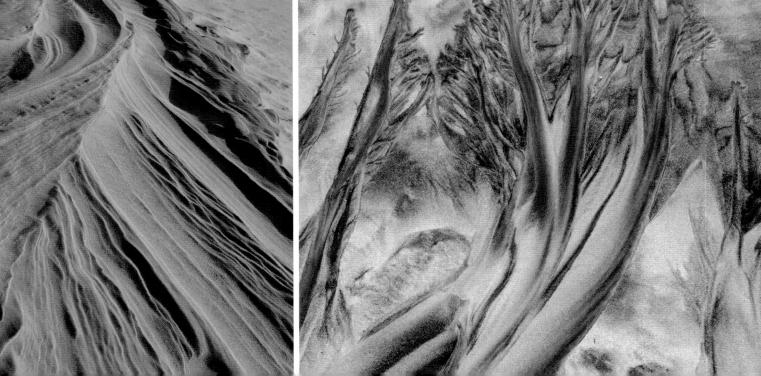

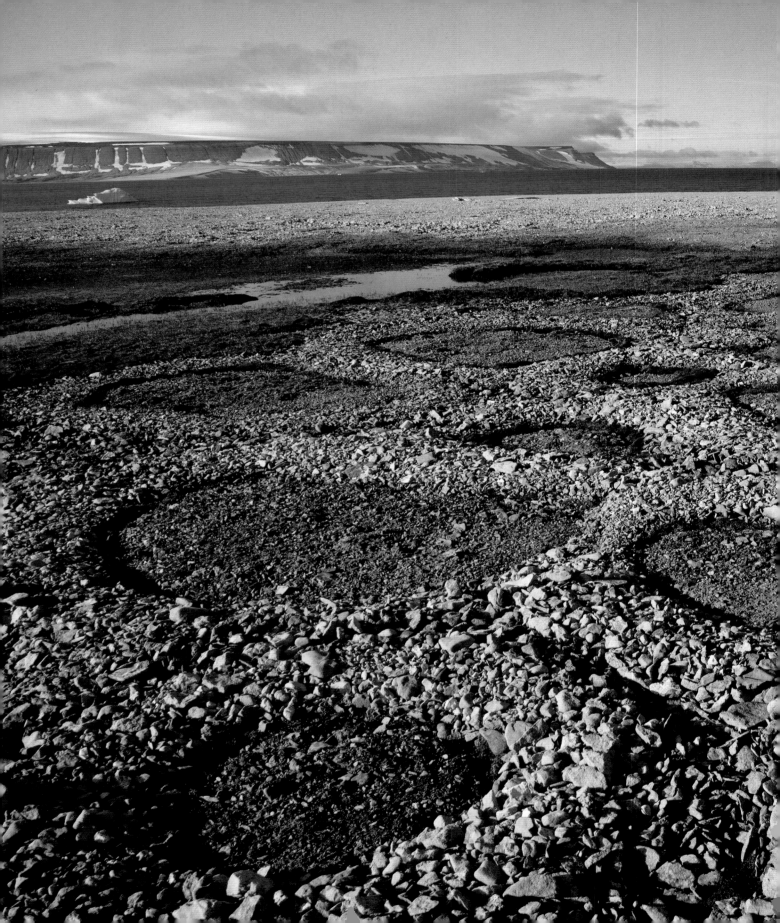

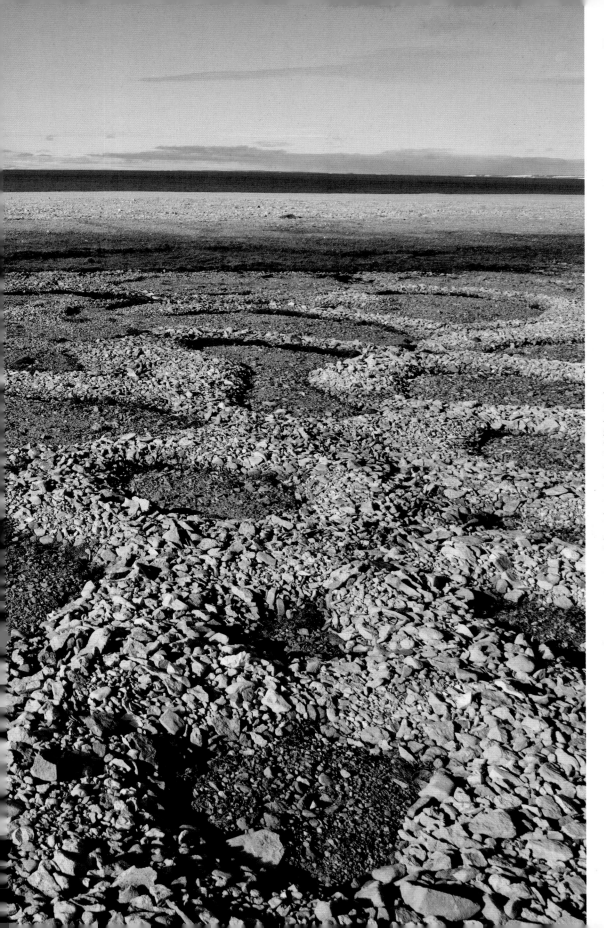

STONE CIRCLES
So-called "patterned ground," like the rings of stones seen here in the Norwegian tundra, is created by convection currents in the water that freezes and thaws underground over the seasonal cycle. Because water has the peculiar property of being denser a few degrees above freezing point than just before it freezes, water that thaws and warms close to the surface becomes denser than the almost-frozen water below, and it sinks. This produces convective circulation, which becomes organized into more or less regular "cells." Stones in the ground are corralled by the circulation into sub-surface clusters such as clumps or rings, which may then be brought to the surface by the well-known process of "frost heaving," familiar to farmers (since it scatters their fields with stones), when the ground freezes. Sometimes the convection patterns produce stripes of stones rather than these rings.

5 | WAVES & DUNES

How to make a chemical clock

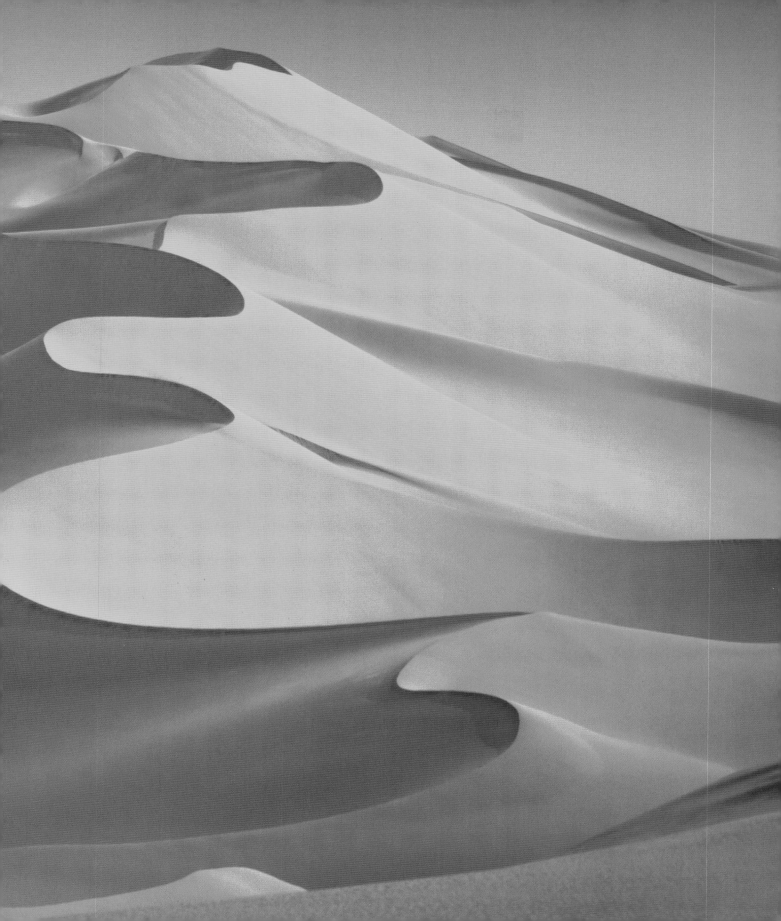

In a real sense, all of nature is waves. Light and sound are undulations, the oceans and the atmosphere support oscillations, and pulses of activity quicken the heart and the brain. Quantum physics tells us that the smallest particles of matter may act like waves in the right circumstances. The wave is a pattern in time as well as space: it is a constant pulse, a periodic coming and going. When one wave meets another, their interference can create spectacular new patterns. But perhaps most astonishing of all are waves that organize themselves from sheer disorder or from seemingly inexorable, one-way processes: from the chemical reactions between molecules moving at random, say, or the collisions of wind-blown sand. In such cases, waves can imprint themselves on matter with a flamboyant ebullience.

The slime mold *Dictyostelium discoideum* leads an undistinguished life. It lives in soil and rotting leaves, where it feeds on bacteria. It exists as single-celled organisms visible only under a microscope: fifty of them head to toe would stretch for just a millimeter. But if these primitive cells find themselves short of nutrients, heat, or moisture, they do a remarkable thing. They become artists.

That's a bit of a fanciful way to put it, perhaps—but there's no denying that the patterns formed by *Dictyostelium* cells under stress are beautiful. The colony organizes itself into ranks: lines of cells densely clustered, separated by more sparsely populated gaps. These ranks aren't straight, but are curved into delicate spiral forms. As the cells march forth in regular array, the spirals spread outward like rippling waves, turning as they do so. Where two spiral waves meet, they destroy one another. The result is mesmerizing.

This behavior can be regarded as the cells' attempt to dance their way out of danger. The wave patterns are just the first stage in a process in which cells gradually crawl toward one another and clump together in a mound resembling a tiny slug. This mass of perhaps a hundred thousand cells starts to act like a single organism, wriggling its slimy way in search of water or warmth. Once it finds a better environment, it forms into a finger that stands upright, at the tip of which a bulbous, fruitlike shape balloons out that contains hardy spores in suspended animation, ready to germinate into new cells.

As survival mechanisms go, it's impressive and inventive. But how do the cells manage such a collaborative feat? They do it by communicating chemically. Under stress, they start to emit a chemical compound that attracts other cells nearby, much as some animals emit pheromones to attract mates. But crucially, this chemical attractant is released in regular pulses, and it's this rhythmic emission that creates the waves among the slime-mold population.

If that steady pulse reminds you of a heartbeat, so it should. With its coordinated waves of activity, the *Dictyostelium* colony is

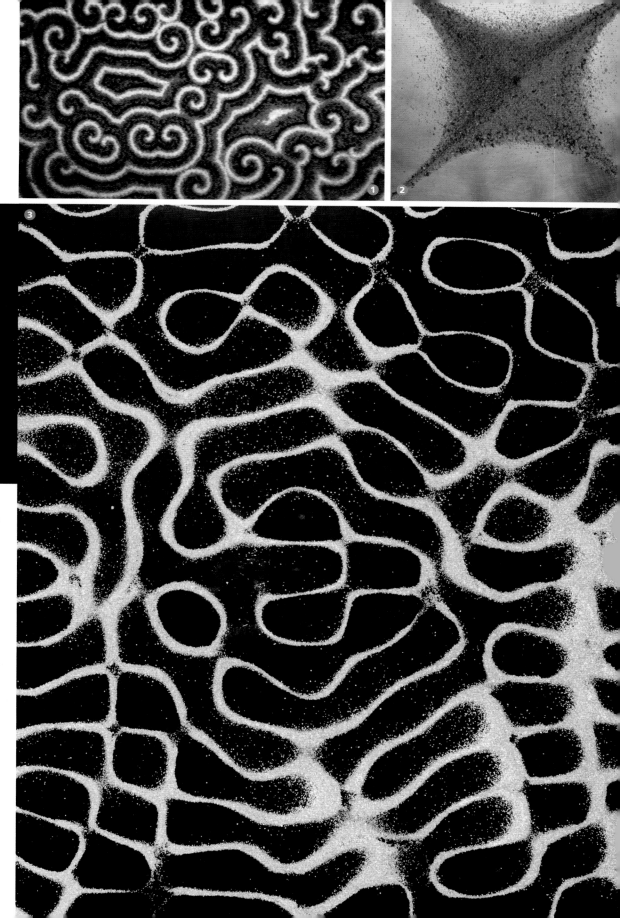

1 CELLULAR SCROLLS
The soil-dwelling slime mold Dictyostelium discoideum *will, when stressed by lack of water or nutrients, aggregate into clumps of cells. This occurs as the cells emit regular pulses of a chemical attractant, which makes the colony organize itself into concentric and spiral wave forms like these.*

2 and 3
CHLADNI FIGURES
Waves are at the root of the patterns called Chladni figures, made by vibrating a flat plate onto which fine grains are scattered—for example, using sound waves.

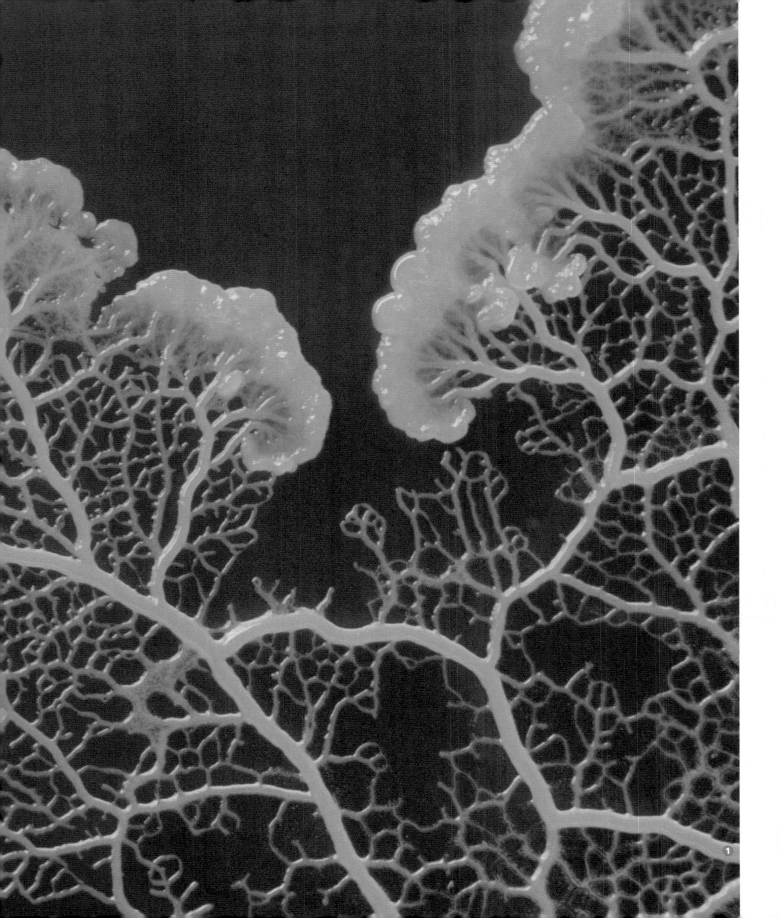

behaving like the cardiac cells of the heart, which generate regular pulses of electrical activity that enable the muscles to contract with a steady beat, pumping blood. The comparison is deeper than you might imagine, for the electrical waves of the heart can also take on a spiral formation. If they do, however, it's bad news: this particular pattern of "heart-wave" activity signals the onset of rapid pulses, faster than the normal heartbeat, that may then break down into quite random, shallow muscular spasms, producing the life-threatening condition called atrial fibrillation. Spiral waves in *Dictyostelium* are a survival stategy; in the heart they can be fatal.

Waves permeate all of nature—quite literally. Sound waves are vibrations of the air, while light is a wave of oscillating electrical and magnetic fields, supporting one another as they advance through space faster than anything else. When they encounter one another, waves may "interfere." Depending on whether they are in or out of step, their peaks and troughs might reinforce one another or cancel out, and the resulting interference patterns can be beautiful, as when water waves bounce off the edges of walls, bathtubs, and river banks. Interference of light waves gives rise to spectacular colors, like those of soap films or oil films on the surface of a wet road. When waves are confined within a fixed space, like sound waves in an organ pipe, certain frequencies and patterns may be picked out in the phenomenon of resonance. The eighteenth-century scientist and musician Ernst Chladni discovered that resonances in a metal plate, when it is vibrated by drawing a violin bow across one edge, can usher fine grains scattered on the surface into ornate patterns that follow the nodes, where there is no up and down vibration.

Chemical clocks

But the waves of *Dictyostelium* and the heart are different from these. They are not vibrations in any real sense: nothing is "shaking" the slime mold or the heart tissue. The waves are self-organized: they spring right out of the medium that carries them. It's as if a cup of coffee suddenly separated out into rotating spirals of cream in the dark liquid.

If it seems unlikely to you that such things could happen, your intuition would be justified—but wrong. That's exactly how chemists felt when, in the 1950s, spontaneous wave formation was discovered by a Soviet chemist in a mixture of apparently innocuous ingredients. Their discoverer, Boris Belousov, was accused of incompetence, because what he had found didn't seem possible: a chemical reaction that seemed to proceed spontaneously first in one direction, then in the opposite direction. In other words, it oscillated, as if time were swinging back and forth. In the 1960s a young Russian biochemist named Anatoly Zhabotinsky made some changes to Belousov's recipe that switched the mixture, more strikingly, between red and blue. There was no denying it now: the reaction really did oscillate back and forth. This mixture has become known as the Belousov-Zhabotinsky (BZ) reaction.

The oscillations don't last forever. Left in a beaker, the reaction will, after a long time, eventually settle down into a single state and stay there. But you can keep the color changes going indefinitely if you keep feeding the mixture with fresh ingredients and flushing away the ones that have reacted—in other words, if you keep up an input of matter and energy, which can stop the reaction from reaching its final or "equilibrium" state. The oscillations are a non-equilibrium phenomenon. This is a common feature of many

1 BRANCHING OUT
The cells of slime molds often gather together into a mass called a plasmodium, which can take on complex shapes because of the chemical signals that the cells exchange. This is a plasmodium of the mold Fuligo septica, *sometimes called scrambled egg slime.*

2 LIESEGANG ROCKS
These patterns are not lichen growing on the rocks, but are part of the rock itself. They are created by a wavelike crystallization process when the rock is formed—notice how the wave fronts annihilate one another when they intersect. These structures are called Liesegang rings, after the German scientist who first identified the pulsating precipitation phenomenon.

Wind arranges sand grains into regular structures such as these parallel ripples. They are self-organized patterns arising from the amplification of small random bumps —a process that can only proceed when one bump is a certain minimum distance from the preceding one. As a result, the ripples have a preferred wavelength, picked out by the particulars of the wind speed and the average grain size.

of the pattern-forming processes in nature: they are far from their equilibrium state, kept there by a constant influx of energy. The perpetual repetitive circulating motions of the oceans, for example, are driven by the heat of the sun.

In 1910, an Austrian-American ecologist named Alfred Lotka described a theory of oscillating chemical reactions in which he showed that a combination of particular reactions between the different ingredients can lead to a seesawing alternation between different states. In one state one ingredient is present at a high concentration, so the mixture might be one color; in the other state a different reagent might dominate, producing a different color.

Lotka wasn't, in fact, particularly interested in chemistry. As an ecologist he was trying to understand animal populations—he was just using chemical reactions as an analogy. Imagine a population of rabbits preyed on by a population of foxes. Rabbits are noted for their ability to replicate, and the more of them there are, the more they breed. This can lead to a population explosion. If rabbits were molecules, they would be called auto-catalysts. A catalyst is a molecule that speeds up the rate at which a reaction happens: an auto-catalyst is one that speeds up the rate of its own production. Auto-catalysis is a positive feedback process: it can produce a runaway effect, blowing up out of control. Unchecked, the rabbit population will grow until it has consumed all the food (grass), and then it crashes to extinction.

But the foxes keep this runaway process in

check. The more rabbits there are, the more the foxes thrive by eating them. It's a delicate balance. If the foxes are too ravenous, they will eat all the rabbits; then they will starve.

Alternatively, the ecosystem might develop an oscillating state. The foxes eat so many rabbits that there's little prey left, and the fox population declines. This gives some respite to the remaining rabbits, and their population grows. That creates an abundance of prey for the surviving foxes, and their numbers grow until they have overwhelmed the rabbits and they go into decline again through lack of food… and so on. At one point in the cycle, there are plenty of rabbits but few foxes; at another point, the reverse is true.

This was basically the scheme devised by Lotka, although he expressed it in terms of chemicals that are auto-catalytic or react with and "consume" other chemicals. Several decades later it was pointed out that in a chemical mixture in which the ingredients aren't perfectly mixed so that their concentration is the same everywhere, the oscillations depend on two things: how fast the molecules react (which consumes them) and how fast they move by random diffusion from place to place (which replenishes the ingredients). Because of the two competing processes, these are called reaction-diffusion systems.

Ripples in nature

The clock like switching between a red-filled and blue-filled flask is pretty to behold, but the process is capable of more than this. If you mix the components of the BZ reaction, pour them into a flat dish, and leave them to do their thing, you see something considerably more spectacular than a uniform color change. Instead, the switch to a new color starts at a few specific spots in

"Waves permeate all of nature—quite literally."

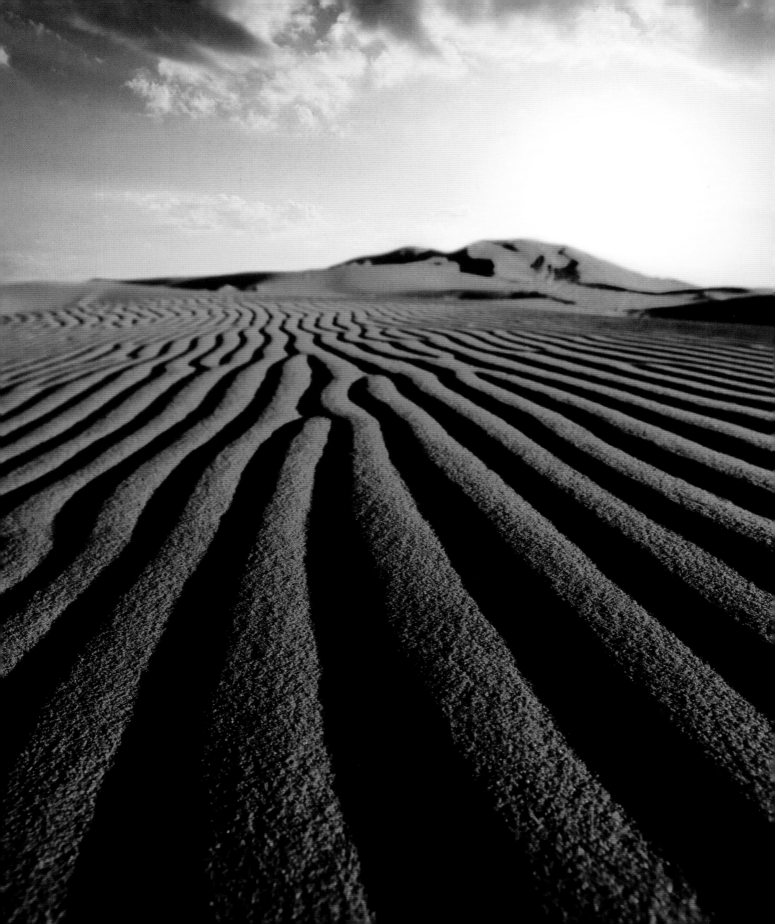

the liquid and spreads out from there, producing circular patches. In the wake of this spreading wave, the mixture starts to revert to the other color. But then a new wave springs from the same spot in the next cycle of the oscillation. The process repeats again and again with a regular pulse, producing concentric circular waves of color that grow like ripples on a pond where a stone has fallen in. These are chemical waves, driven by the competition of reaction and diffusion.

Patterns produced by chemical waves are seen in a wide range of different chemical systems. They are formed on the surfaces of metals that catalyze the reactions between gas molecules sticking to the metal; here the patterns are generally microscopically small. And if the concentric bands remind you of the patterns found in minerals such as onyx and agate, that seems to be no coincidence. These bands are

formed by the crystallization of different mineral types when the stones grow from warm, salt-laden fluids in the Earth's crust as the fluids cool. It seems that this crystallization process happens in waves that are much like the chemical waves of the BZ reaction, only in this case frozen in place for millennia.

The target and spiral patterns of the BZ reaction look just like those made by *Dictyostelium discoideum* as the slime-mold cells search each other out to form their life-preserving "mushroom." Both are chemical reactions of a kind, but very different: in one case there's just a soup of simple ingredients, in the other there are swimming cells that are emitting pulses of chemical attractant. And as we saw earlier, the surges in these systems also look like the waves of electrical activity that pass through heart muscle to trigger the rhythmic contractions of the

1 CHEMICAL WAVES
A mixture of chemical ingredients called the Belousov-Zhabotinsky reaction undergoes oscillations, first producing products of one color (red) and then another (blue) as time ticks by (see above). If the reaction is left to proceed in an unstirred, flat dish, the oscillations create waves that emanate from some central point, making these concentric target and spiral patterns. The wave fronts annihilate each other when they touch.

heartbeat. How come the patterns are so similar in such diverse systems?

That's because in all cases the basics are the same, irrespective of the details. The whole "fabric" of these systems—the solution of chemicals, the colony of cells, the heart tissue—is capable of switching between two different states, and that switching involves feedback processes and auto-catalysis. It's even the same for the foxes and rabbits: if, say, the initial rabbit population varies slightly in number from one place to another in the landscape, at random, then patches where the population is denser might become the source of waves of population growth that radiate outward—followed close after by waves of glutted foxes.

Reaction-diffusion processes can explain the wavy pigment patterns formed on the shells of mollusks such as shellfish and snails (invisibly small spirals may also appear among the microscopic terraces of the shell mineral itself). The positive feedback that produces such pattern features also seems to be at work in the formation of dunes and ripples in wind-blown desert sand. Dunes can take on many forms: the parallel ranks of longitudinal dunes; seif dunes that undulate like snakes; isolated crescent-shaped mounds called barchan dunes; and star dunes, with several arms radiating from a central peak rather like a starfish. Dunes have been seen on Mars, which also has vast sandy deserts stirred by winds—but the different planetary conditions may produce patterns found nowhere on Earth. There are even dunes on Saturn's moon Titan, with grains made not of sand but of frozen hydrocarbon compounds, a bit like wax, perhaps coated with ice. They are a striking reminder that self-organized pattern formation is a feature of the cosmos: the details may change but the basic processes stay the same. It's for this reason that no world is likely to be totally alien to us.

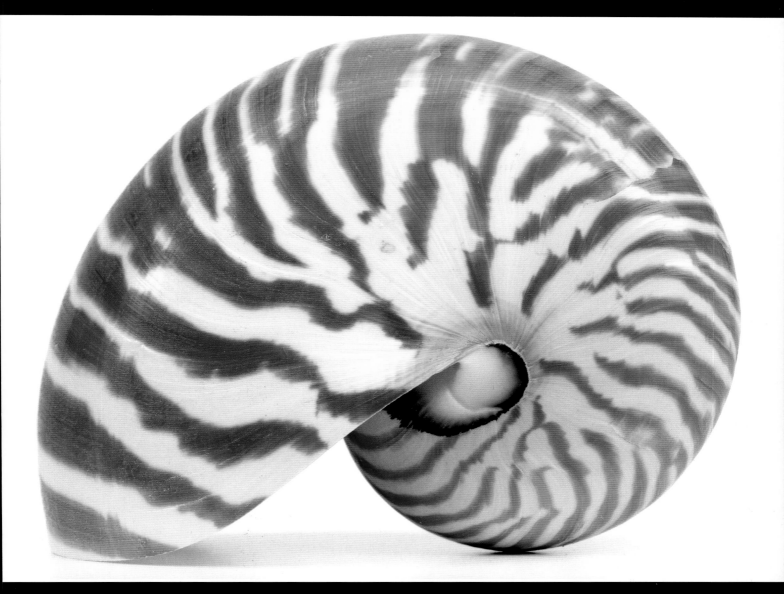

RIPPLING PATTERNS

Ridges in wind-blown sand and pigmentation patterns on mollusk shells are both a kind of frozen wave. The sand ripples are in fact still slowly changing, as fresh sand is deposited by the wind. The regular spacing is dictated by interactions between each ripple. The shell patterns are produced by waves of pigmentation moving along the rim of the shell as it is formed, in a process thought to bear some similarities to the way chemical waves arise in the Belousov-Zhabotinsky reaction.

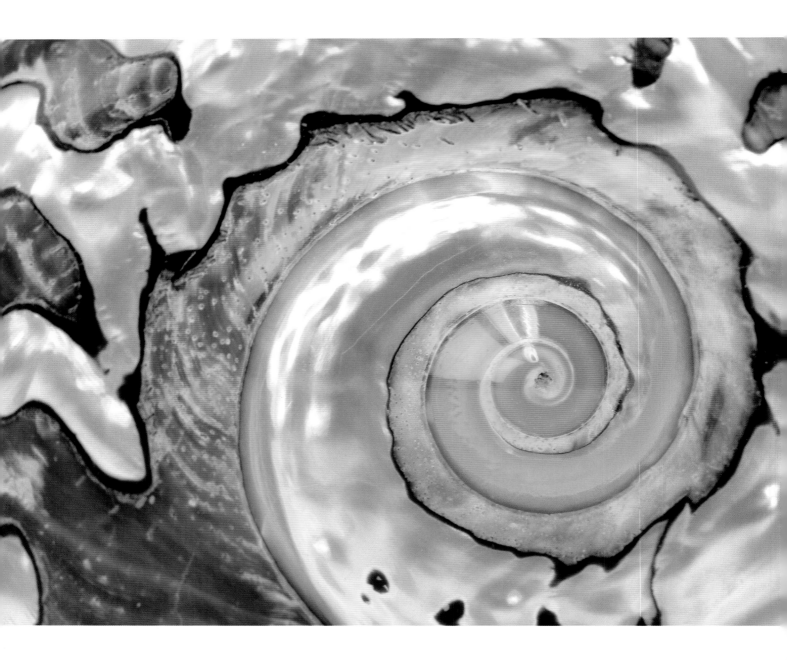

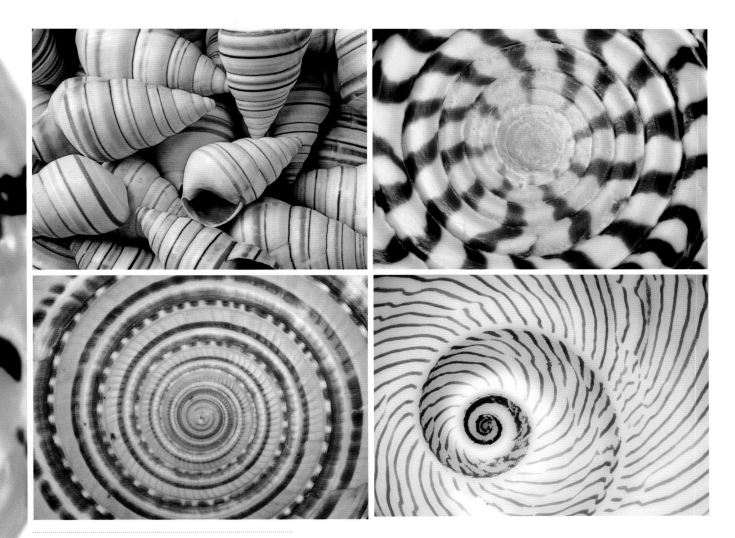

WAVES OF PIGMENTATION

As mollusk shells grow, pigmented material is sometimes laid down along the rim. If there are periodic bursts of pigmented and unpigmented growth, the result is banding perpendicular to the axis of the conical shell. If pigmentation happens at fixed spots around the rim, the result is stripes parallel to this axis. And if the pigmentation occurs as waves that progress steadily around the rim, it produces slanting stripes. All of these are akin to the way chemical-wave patterns form.

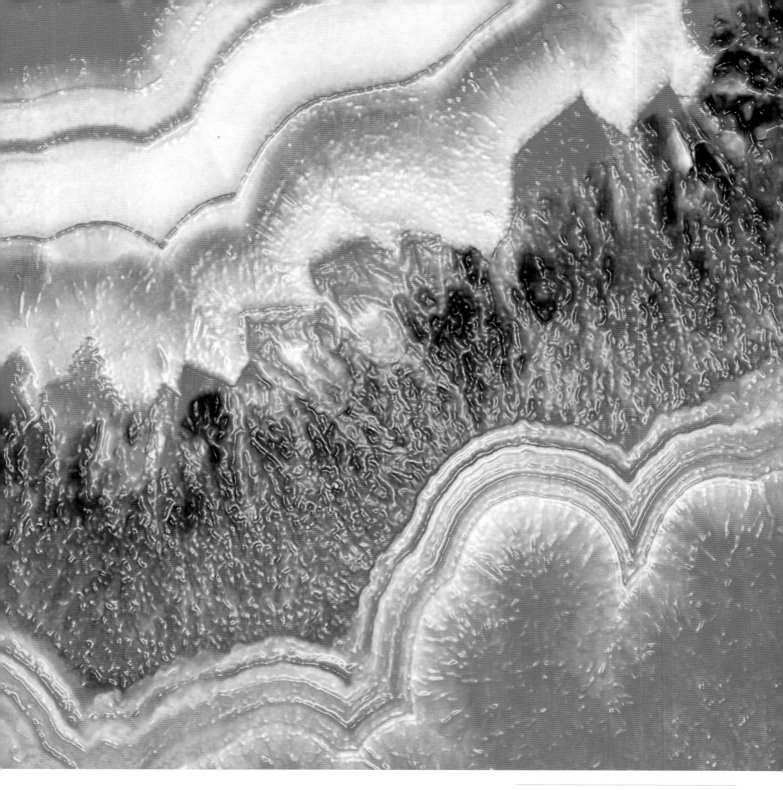

ROCK PATTERNS
In some minerals, such as the agates shown here, waves of crystallization as the mineral is formed produce a frozen record of the so-called "reaction-diffusion" process underlying it.

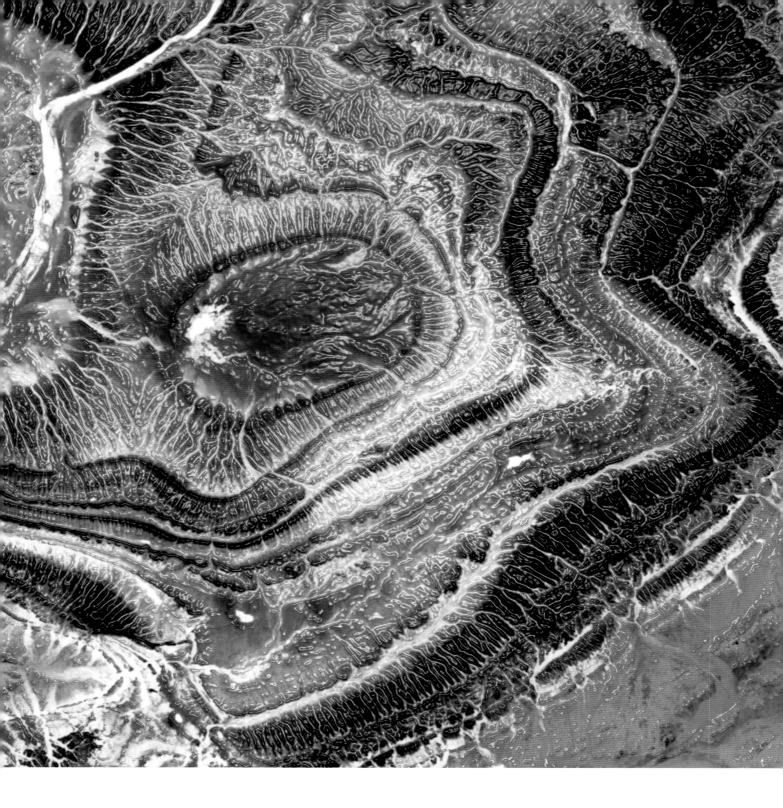

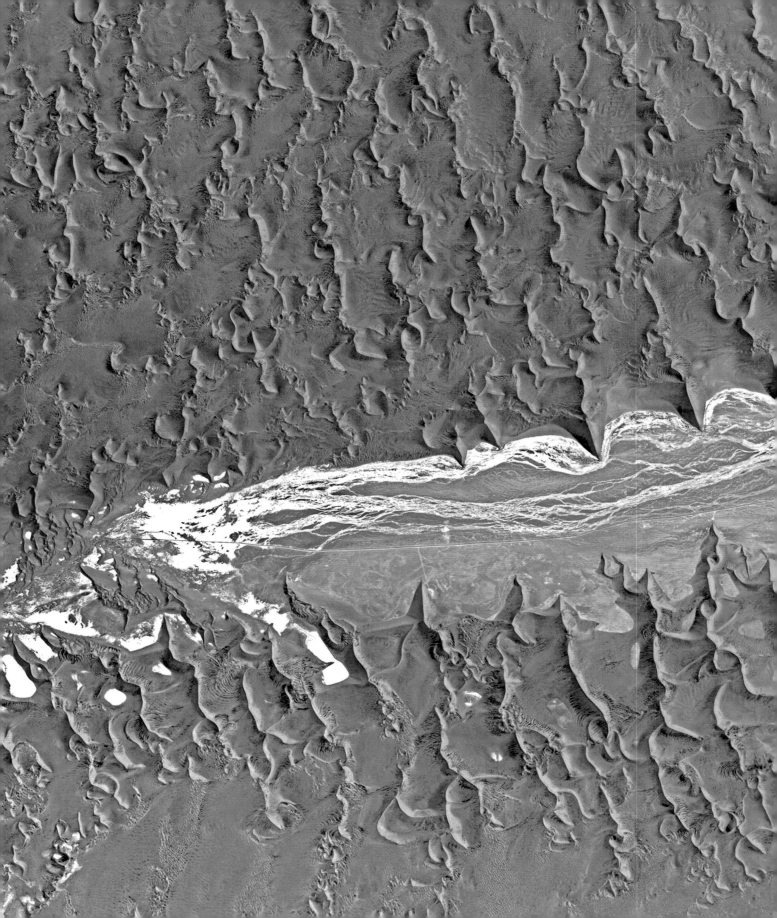

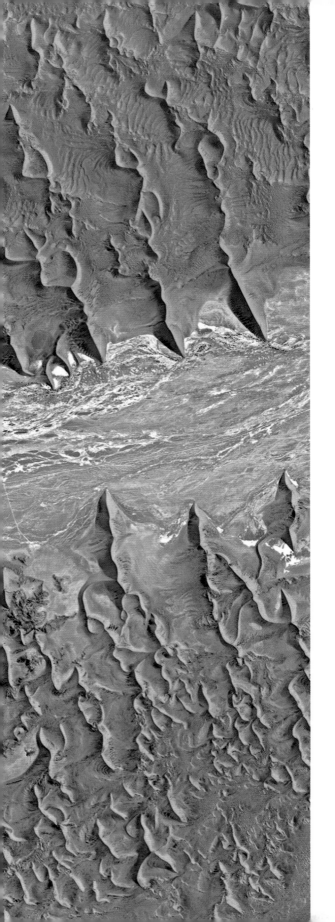

DESERT'S TEETH
These irregular, wavy dunes in the Namib desert of Namibia are among the highest in the world, reaching up to 984 feet (300 meters). The bluish region is a dried-up river bed, with white encrustations of salt. A road is just about visible as a narrow light-blue line running through its center.

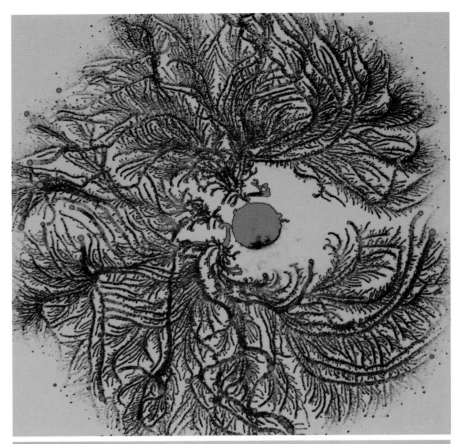

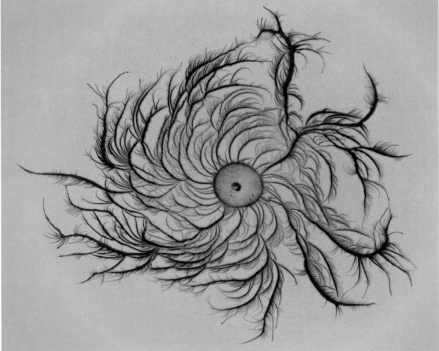

BACTERIAL ART
Chemical communication between bacterial cells can make the colony grow into complex shapes, such as these intricately branched structures. Occasionally a random genetic mutation in the colony might convey an advantage that suddenly switches the shape of growth, as the mutant proliferates faster than the others.

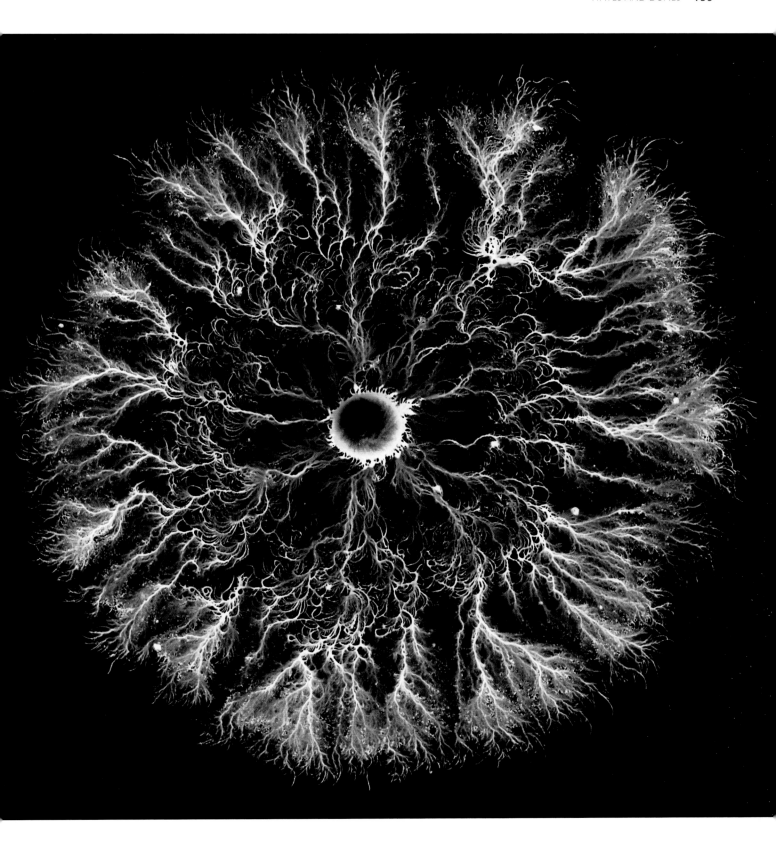

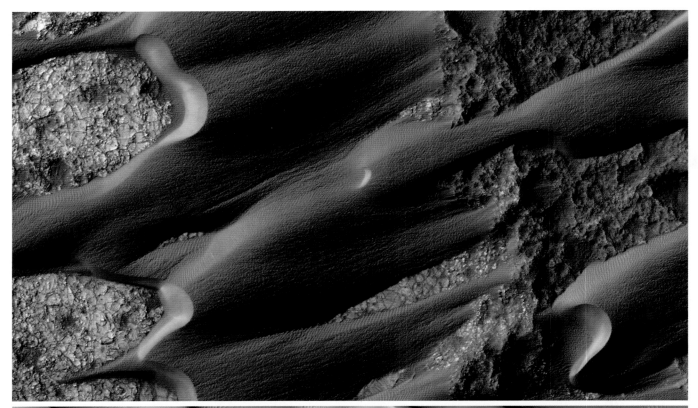

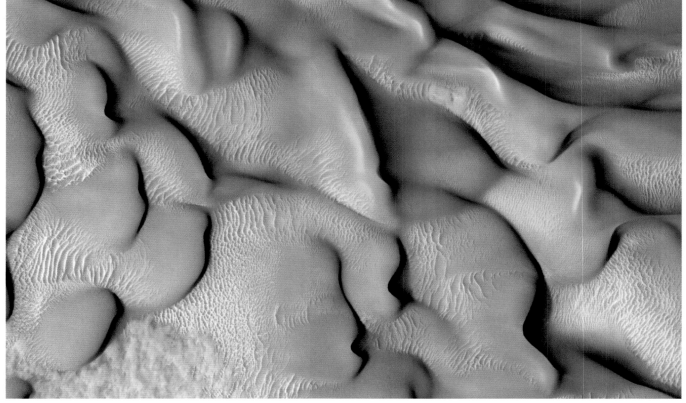

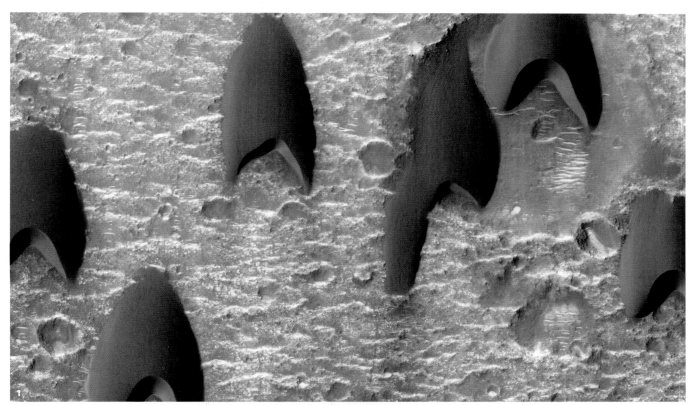

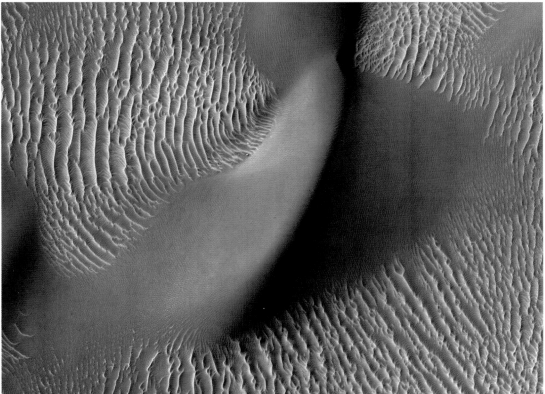

DUNES ON MARS

Winds blow across the sandy deserts of Mars, and form dunes and other patterns just as they do on Earth. Some of these echo the dune shapes seen on Earth, such as the crescent-shaped barchan dunes (1), but others have shapes not found on our planet. That's because there are different conditions on Mars that affect the way grains are transported and how they bounce: the gravity is weaker, the atmosphere is thinner, and the winds can be much faster.

6 | BUBBLES & FOAM

Why bees know best and
why froth inspires architects

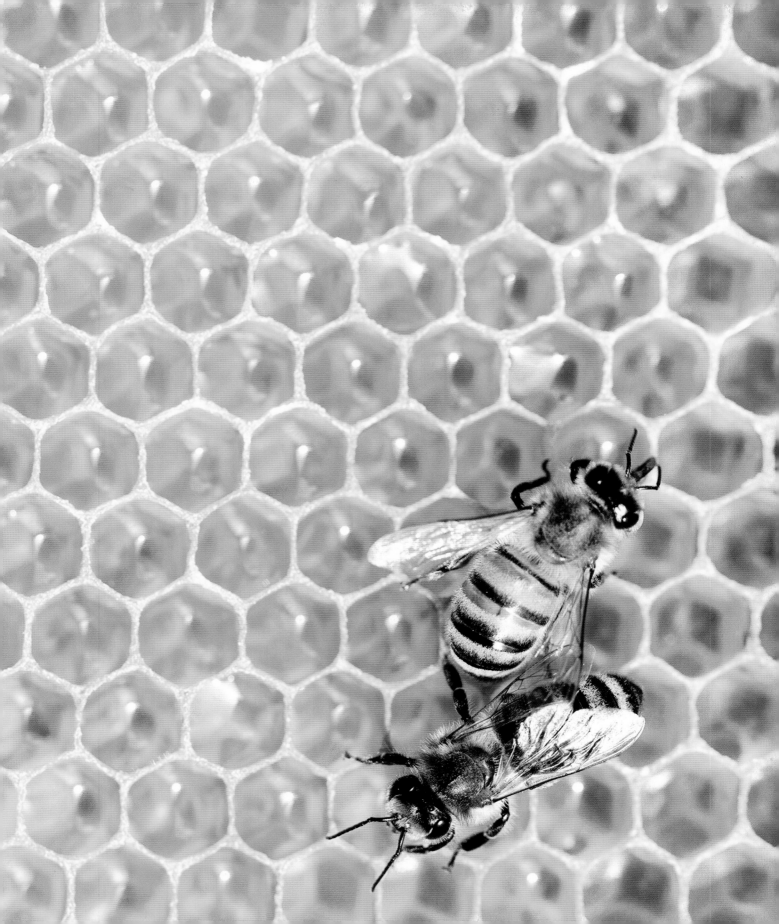

"To the natural philosopher there is no natural object unimportant or trifling," wrote the English scientist John Herschel in 1830. "A soap bubble…an apple…a pebble. He walks in the midst of wonders." Soap bubbles might indeed seem like trifling child's play, but some of the finest minds in science have been captured by their charm and beauty, as well as perplexed by their shapes. Soap films and foams observe a particular economy, a precise balance of shaping agencies that stretches and pushes them into graceful curves and frameworks. Nature sometimes makes ingenious use of these patterns to build architectures that are both useful and extravagant.

How do bees do it? The honeycombs in which they store their amber nectar and nurture their larvae are marvels of precision engineering, an array of prism-shaped cells with a perfectly hexagonal cross-section. The wax walls are made with a very precise thickness, the cells are gently tilted from the horizontal to prevent the viscous honey from running out, and the entire comb is aligned with the Earth's magnetic field. Yet this structure is made without any blueprint or foresight, by many bees working simultaneously and somehow coordinating their efforts to avoid mismatched cells.

The ancient Greek philosopher Pappus of Alexandria thought that the bees must be endowed with "a certain geometrical forethought." And who could have given them this wisdom, but God? According to William Kirby in 1852, bees are "Heaven-instructed mathematicians." Charles Darwin wasn't so sure, and he conducted experiments to establish whether bees are able to build perfect honeycombs using nothing but evolved and inherited instincts, as his theory of evolution would imply.

Why hexagons, though? It's a simple matter of geometry. If you want to pack together cells that are identical in shape and size so that they fill all of a flat plane, only three regular shapes (with all sides and angles identical) will work: equilateral triangles, squares, and hexagons. Of these, hexagonal cells require the least total length of wall, compared with triangles or squares of the same area. So it makes sense that bees would

choose hexagons, since making wax costs them energy, and they will want to use up as little as possible—just as builders might want to save on the cost of bricks. This was understood in the eighteenth century, and Darwin declared that the hexagonal honeycomb is "absolutely perfect in economizing labor and wax."

Darwin thought that natural selection had endowed bees with instincts for making these wax chambers, which had the advantage of requiring less energy and time than those with other shapes. But even though bees do seem to possess specialized abilities to measure angles and wall thickness, not everyone agrees about how much they have to rely on them. That's because making hexagonal arrays of cells is something that nature does anyway.

Releasing the tension

If you blow a layer of bubbles on the surface of water—a so-called "bubble raft"—the bubbles become hexagonal, or almost so. You'll never find a raft of square bubbles: if four bubble walls come together, they instantly rearrange into three-wall junctions with more or less equal angles of 120° between them, like the center of the Mercedes-Benz symbol.

Evidently there are no agents shaping these rafts as bees do with their combs. All that's guiding the pattern are the laws of physics. Those laws evidently have definite preferences, such as the bias toward three-way junctions of bubble walls. The same is true of more complicated foams. If you pile up bubbles in three dimensions

HEXAGONAL NEST CELLS
A wasp (Vespula vulgaris) *working on its nest. Why and how does it make the cells hexagonal?*

by blowing through a straw into a bowl of soapy water you'll see that when bubble walls meet at a vertex, it's always a four-way union with angles between the intersecting films roughly equal to about 109°—an angle related to the four-faceted geometric tetrahedron.

What determines these rules of soap-film junctions and bubble shapes? Nature is even more concerned about economy than the bees are. Bubbles and soap films are made of water (with a skin of soap molecules) and surface tension pulls at the liquid surface to give it as small an area as possible. That's why raindrops are spherical (more or less) as they fall: a sphere has less surface area than any other shape with the same volume. On a waxy leaf, droplets of water retract into little beads for the same reason.

This surface tension explains the patterns of bubble rafts and foams. The foam will seek to find the structure that has the lowest total surface tension, which means the least area of soap-film wall. But the configuration of bubble walls also has to be mechanically stable: the tugs in different directions at a junction have to balance perfectly, just as the forces must be balanced in the walls of a cathedral if the building is going to stand up. The three-way junction in a bubble raft, and the four-way junctions in foam, are the configurations that achieve this balance.

But those who think (as some do) that the honeycomb is just a solidified bubble raft of soft wax might have trouble explaining how the same hexagonal array of cells is found in the nests of paper wasps, who build not with wax but with chewed-up wads of fibrous wood and plant stem, from which they make a kind of paper. Not only can surface tension have little effect here, but it also seems clear that different types of wasp have different inherited instincts for their architectural designs, which can vary significantly from one species to another.

Although the geometry of soap-film junctions is dictated by this interplay of mechanical forces, it doesn't tell us what the shape of the foam will be. A typical foam contains polyhedral cells of many different shapes and sizes. Look closely and you'll see that their edges are rarely perfectly straight;

REPEATED SHAPES
Soap foams are made up of polyhedral bubbles, with flat faces and more or less regular shapes. Their geometry is determined by a small set of approximate rules.

they're a little curved. That's because the pressure of the gas inside a cell or bubble gets bigger as the bubble gets smaller, so the wall of a small bubble next to a larger one will bulge outward slightly. What's more, some facets have five sides, some six, and some just four or even three. With a little bending of the walls, all of these shapes can acquire four-way junctions close to the "tetrahedral" arrangement needed for mechanical stability. So there's a fair bit of flexibility (literally) in the shapes of the cells. Foams, while subject to geometrical rules, are rather disorderly.

Suppose that you could make a "perfect" foam in which all the bubbles are the same size. What then is the ideal cell shape that makes the total bubble wall area as small as possible while satisfying the demands for the angles at the junctions? That has been debated for many years, and for a long time it was thought that the ideal cell shape was a 14-sided polyhedron with square and hexagonal faces. But in 1993 a slightly more economical—although less orderly—structure was discovered, consisting of a repeating group of eight different cell shapes. This more complex pattern was used as the inspiration for the foam-like design of the swimming stadium of the 2008 Olympic Games in Beijing.

The rules of cell shape in foams also control some of the patterns seen in living cells. Not only does a fly's compound eye show the same hexagonal packing of facets as a bubble raft, but the light-sensitive cells within each of the individual lenses are also clustered in groups of four that look just like soap bubbles. In mutant flies with more than four of these cells per cluster, the arrangements are also more or less identical to those that bubbles would adopt.

The economics of surfaces

Because of surface tension, a soap film stretching across a loop of wire is pulled flat like the springy membrane of a trampoline. If the wire frame is bent, the film also bends with an elegant contour that automatically tells you the most economical way, in terms of material, to cover over the space enclosed by the frame. That can show an architect how to make a roof for a complicated structure

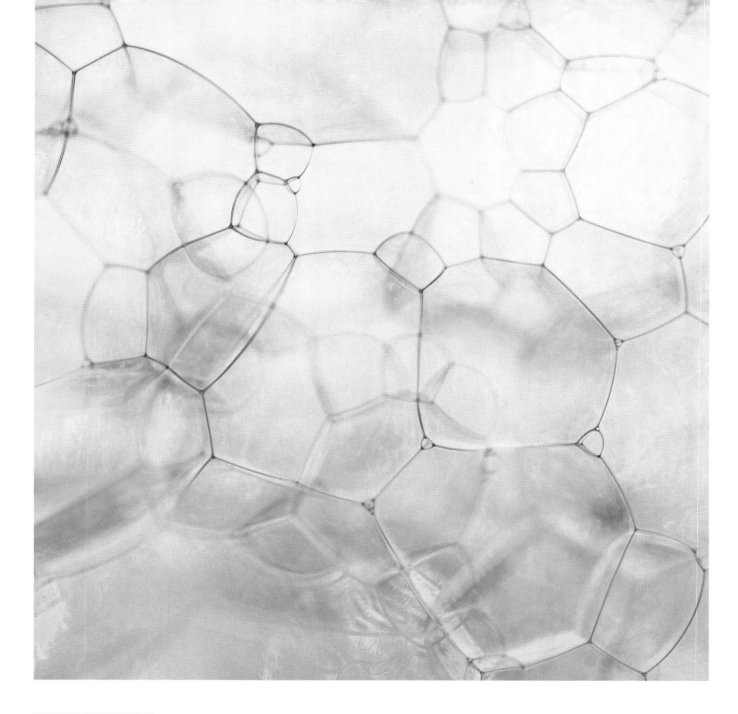

BUBBLE GEOMETRY
The junctions of soap films in the bubbles of a foam are generally fourfold, with the four edges pointing roughly to the corners of a tetrahedron. Note that some bubble faces are curved rather than flat, because of the differences in gas pressure within the bubbles.

using the least amount of material. However, it's as much because of the beauty and elegance of these so-called "minimal surfaces" as because of their economy that architects such as Frei Otto have used them in their buildings.

These surfaces minimize not only their surface area, but also their total curvature. The tighter the bend, the greater the curvature. As we saw in Chapter 1, curvature can be positive (bulges) or negative (dips, depressions, and saddles). A curved

surface can therefore have zero mean curvature so long as the positives and negatives cancel each other out.

So a sheet can be full of curvature and yet have very little or even no mean curvature. Such a minimally curved surface can divide up space into an orderly labyrinth of passageways and channels—a network. These are called periodic minimal surfaces. (Periodic just means a structure that repeats identically again and again, or in other

FOAM CRYSTALS

Diatoms, a kind of algae, are encased in a cage of hard, mineral silica called a frustule. This is often intricately patterned with grooves, ridges, and holes, rather like a solidified foam. It's thought that a foam made from soft bubblelike tissue acts as a mold during the growth of the frustule.

words, a regular pattern.) When such patterns were discovered in the nineteenth century, they seemed to be just a mathematical curiosity. But now we know that nature makes use of them.

The cells of many different types of organisms, from plants to lampreys to rats, contain membranes with microscopic structures like this. No one knows what they are for, but they are so widespread that it's fair to assume they have some sort of useful role. Perhaps they isolate one biochemical process from another, avoiding crosstalk and interference. Or maybe they are just an efficient way of creating lots of "work surface," since many biochemical processes take place at the surface of membranes, where enzymes and other active molecules may be embedded. Whatever its function, you don't need complicated genetic instructions to create such a labyrinth: the laws of physics will do it for you.

Some butterflies, such as the European green hairstreak and the emerald patched cattleheart, have wing scales containing an orderly labyrinth of the tough material called chitin, shaped like a particular periodic minimal surface called the gyroid. Interference between light waves bouncing off this regular structure within the wing scale causes some wavelengths—that is, some colors—to disappear while others (in this case, green) reinforce each other. So here the patterns offer a means of producing animal color.

Breaking the mold

The skeleton of the sea urchin *Cidaris rugosa* is a porous mesh with the shape of another kind of periodic minimal surface. It's actually an exoskeleton, sitting outside the organism's soft tissue, a protective shell that sprouts dangerous-looking spines made from the same mineral as chalk and marble. The open lattice structure means that the material is strong without being too heavy, rather like the metal foams used for building aircraft.

To create orderly networks from such hard, stiff mineral, these organisms apparently make a mold from soft, flexible membranes and then crystallize the hard material inside one of the interpenetrating networks. Other creatures may cast orderly mineral foams this way for more sophisticated purposes. Because of the way that light bounces off the elements of the patterned structure, such trellises can act rather like mirrors and conduits to confine and guide light. A honeycomb arrangement of hollow microscopic channels within the chitin spines of a peculiar marine worm known as the sea mouse turn these hairlike structures into natural optical fibers that can channel light, making the creature turn from red to bluish green depending on the direction of the illumination. This color change might serve to deter predators.

The principle of using soft tissues and membranes as molds for forming patterned mineral exoskeletons is widely used in the sea. Some sponges have exoskeletons made of bars of mineral linked like climbing frames, which look remarkably similar to the patterns formed by the edges and junctions of soap films in foam—no coincidence, if surface tension dictates the architecture.

The formation of hard tissue, known as biomineralization, generates spectacular results in marine organisms called radiolarians and diatoms. Some of these have delicately patterned exoskeletons made from a mesh of mineral hexagons and pentagons: you might call them the honeycombs of the sea. When the German biologist (and talented artist) Ernst Haeckel first saw their shapes in a microscope in the late nineteenth century, he made them the star attraction of a portfolio of drawings called *Art Forms in Nature*, which were very influential among artists of the early twentieth century and still inspire admiration today. To Haeckel, they seemed to offer evidence of a fundamental creativity and artistry in the natural world—a preference for order and pattern built into the very laws of nature. Even if we don't subscribe to that notion now, there's something in Haeckel's conviction that patterns are an irrepressible impulse of the natural world—one that we have every right to find beautiful.

"Periodic minimal surfaces seemed to be just a mathematical curiosity. But now we know that nature makes use of them."

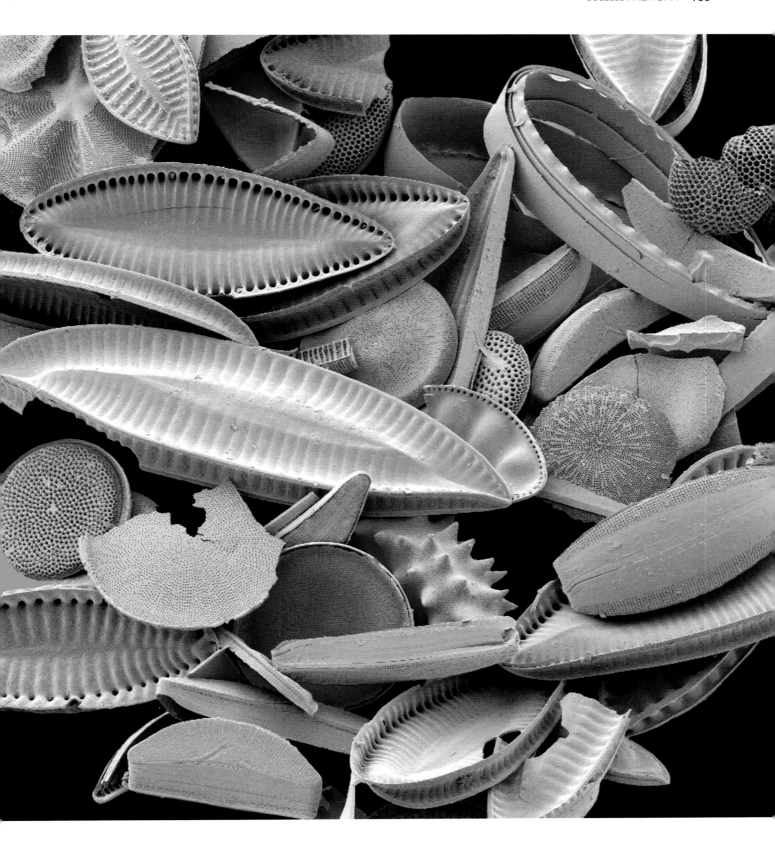

FITTING IN
A single layer or "raft" of bubbles contains mostly hexagonal bubbles, albeit not all of them perfect hexagons. There are some "defects"—bubbles with perhaps five or seven sides. Nonetheless, all the junctions of bubble walls are threefold, intersecting at angles that are close to 120°.

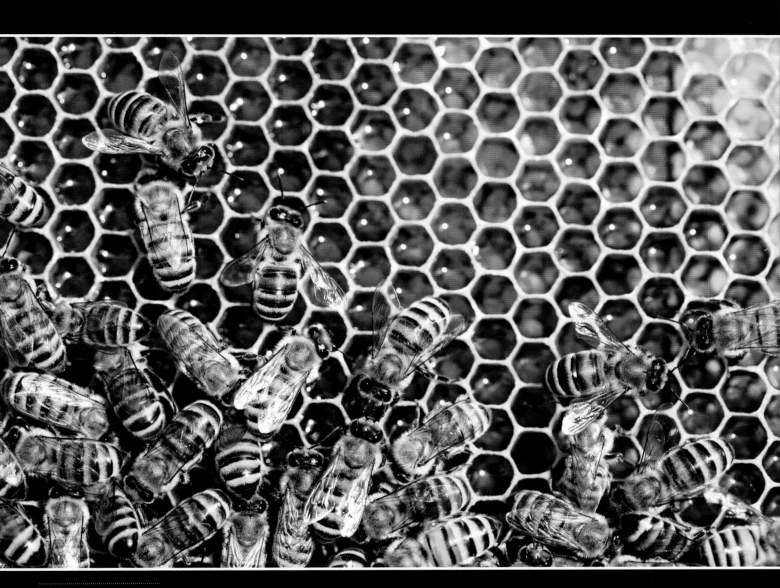

FORCES AT WORK
*Bees seem to have
evolved capabilities
for making perfectly
hexagonal cells from
the soft wax that they
secrete. However, some
researchers believe
that surface tension in
the soft wax might be
sufficient to pull the cells
into shape, in much the
same way as it organizes
bubbles in a bubble raft.*

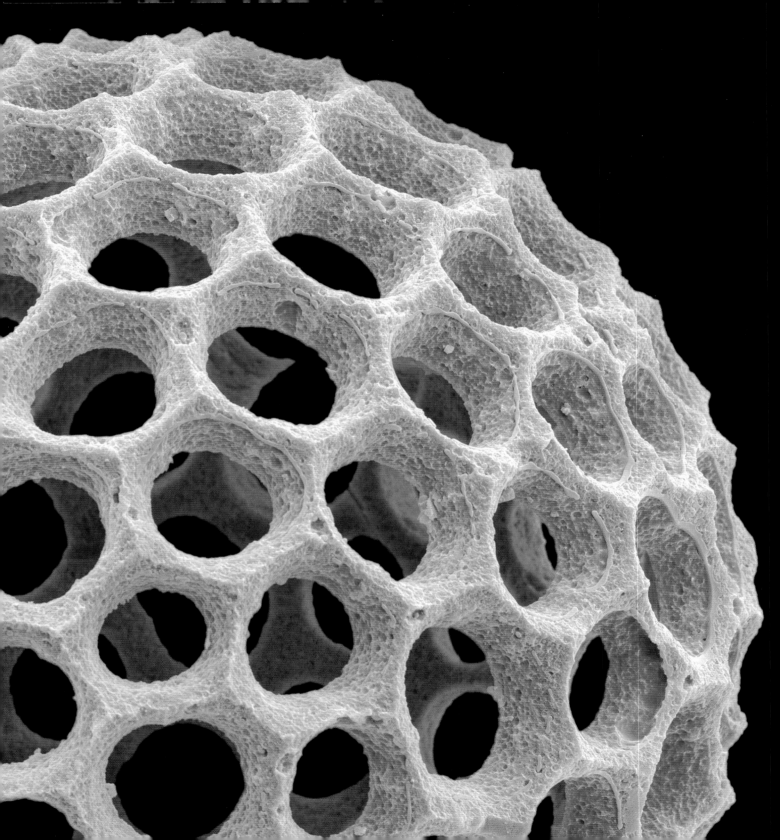

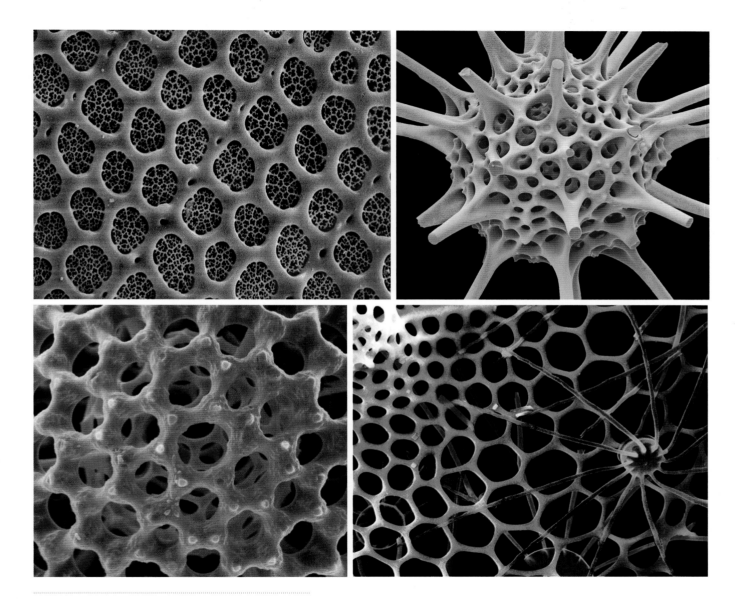

MICROSCOPIC HONEYCOMBS OF THE SEA
The complex, perforated exoskeletons of radiolarians are like "frozen foams": they are made by the crystallization of a hard mineral at the junctions between bubblelike vesicles that are temporarily formed as the structure is deposited. It's no surprise, then, that they observe some of the "rules" of bubble layers, forming a roughly hexagonal arrangement in which the edges join in threes at approximately 120°. These basic principles are elaborated in many different ways in different species. Radiolarians like this are typically about 0.1–0.2 mm wide.

MAKING USE OF BUBBLES
Bubbles and foams are put
to use in nature. Here the
common purple snail (Janthina
janthina) hangs onto the
surface of the sea from a
buoyant raft made of bubbles
coated with mucus. This
enables the snail to feed on
small creatures that live at the
water's surface.

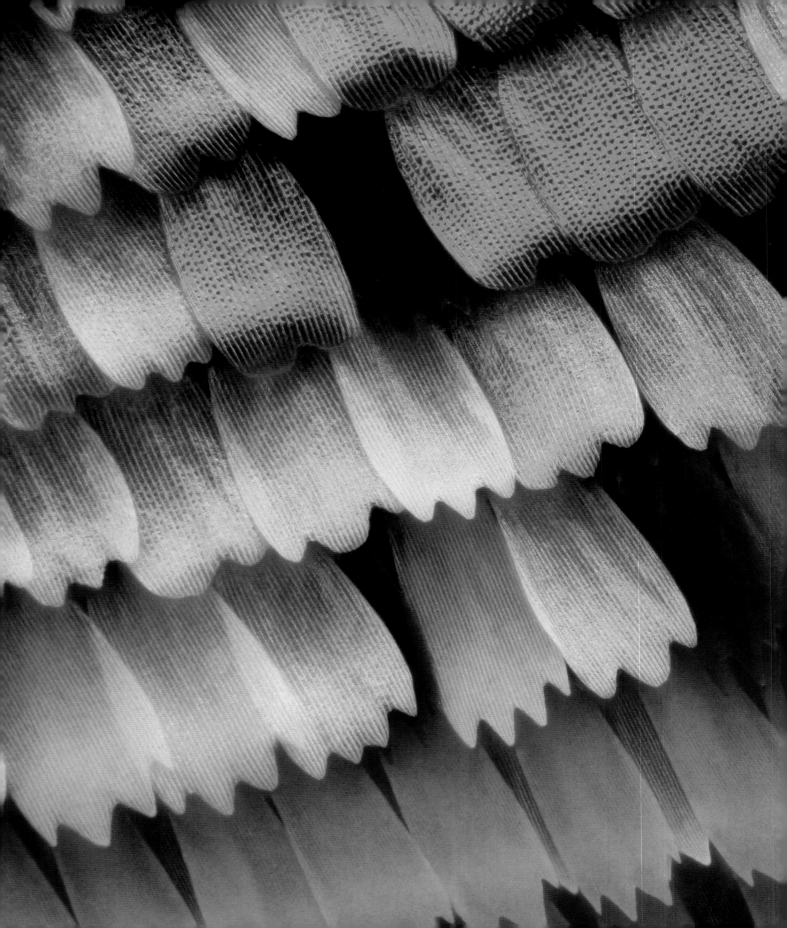

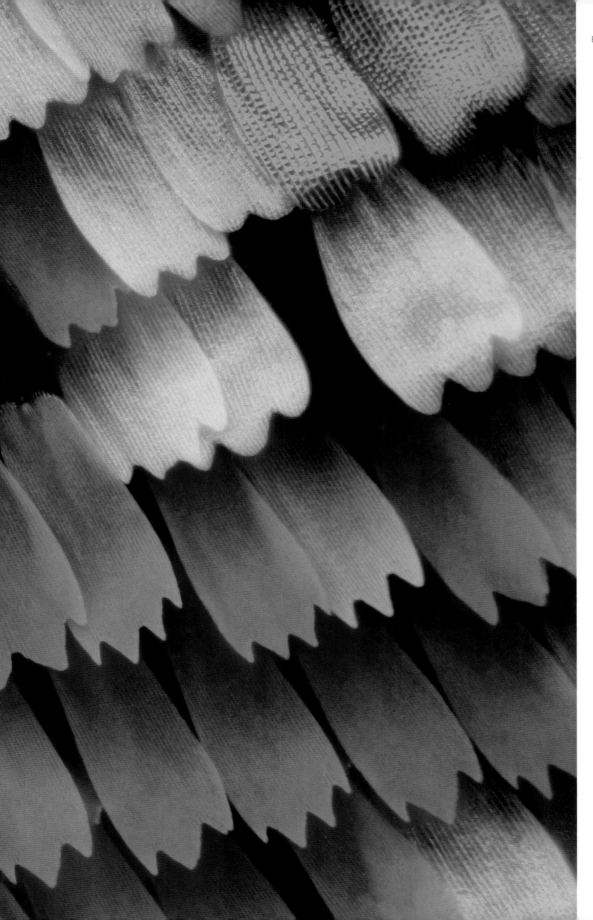

STRUCTURAL COLOR
Tiny parallel ridges on the surfaces of the scales of butterfly wings cause interference in the reflected light that picks out certain colors—in other words, some of these colors (particularly the iridescent blues and greens) are made not by light-absorbing pigments but by light-scattering structural patterns. However, even closer inspection of the wing scales of some butterfly species shows a still finer and more intricate structure, as we will see on the next page.

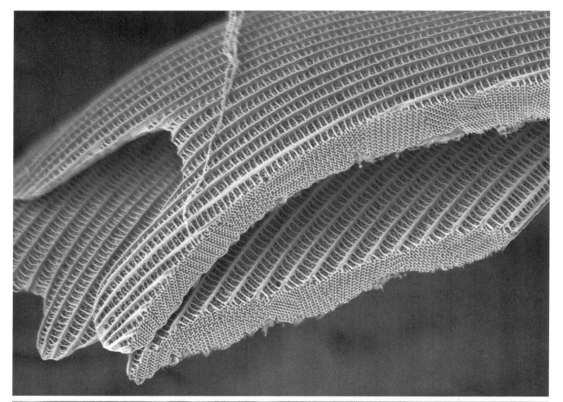

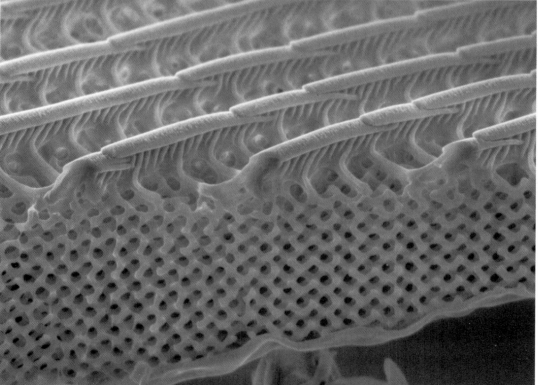

BUTTERFLY FOAM
These cross-sections of the wing scales of the green hairstreak butterfly (Callophrys rubi) show that the fabric, made from the glucose-based material chitin, is perforated with an ordered, three-dimensional labyrinth of channels that has the same structure as a mathematical "periodic minimal surface" known as a gyroid. It is thought to be formed on a foamlike template made of soft membrane. The structure is strong and lightweight, but its key function is to cause interference of the reflected light rays so as to make the wing scales appear green.

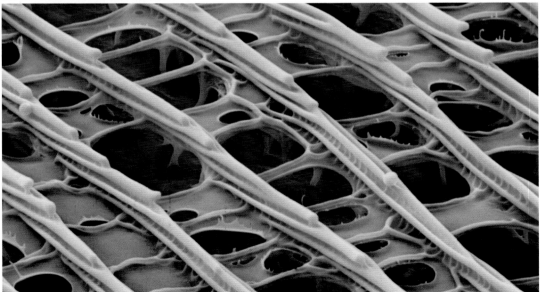

MINERAL MESH
The filigree porous skeletons of sponges, such as this Venus's flower basket, are made from spines or "spicules" of glasslike material woven together.

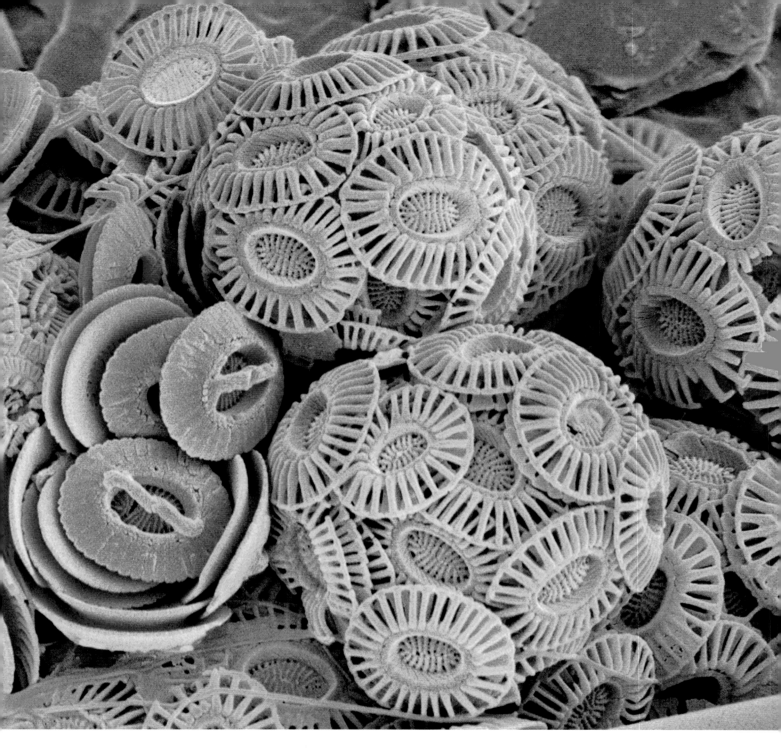

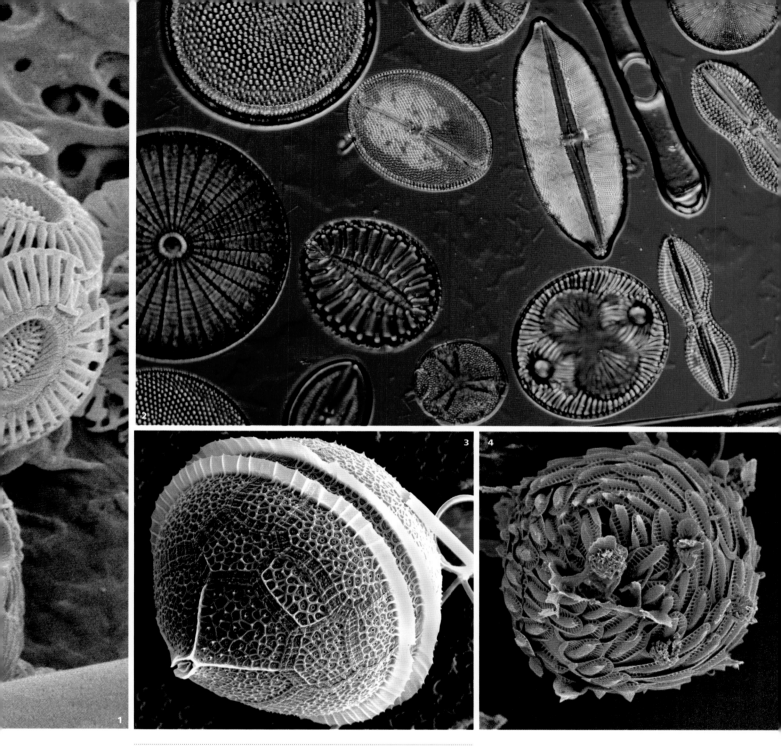

SEA SCULPTURES
*Many marine organisms, including coccolithophores (1), diatoms
(2 and 4), and dinoflagelletes (3), have hard exoskeleton shells that are
delicately patterned, often with a porous, foamlike appearance. While
it seems likely that they, too, are created by the deposition of a hard
mineral on a template of soft organic material, the details of this process
are in many cases not fully understood.*

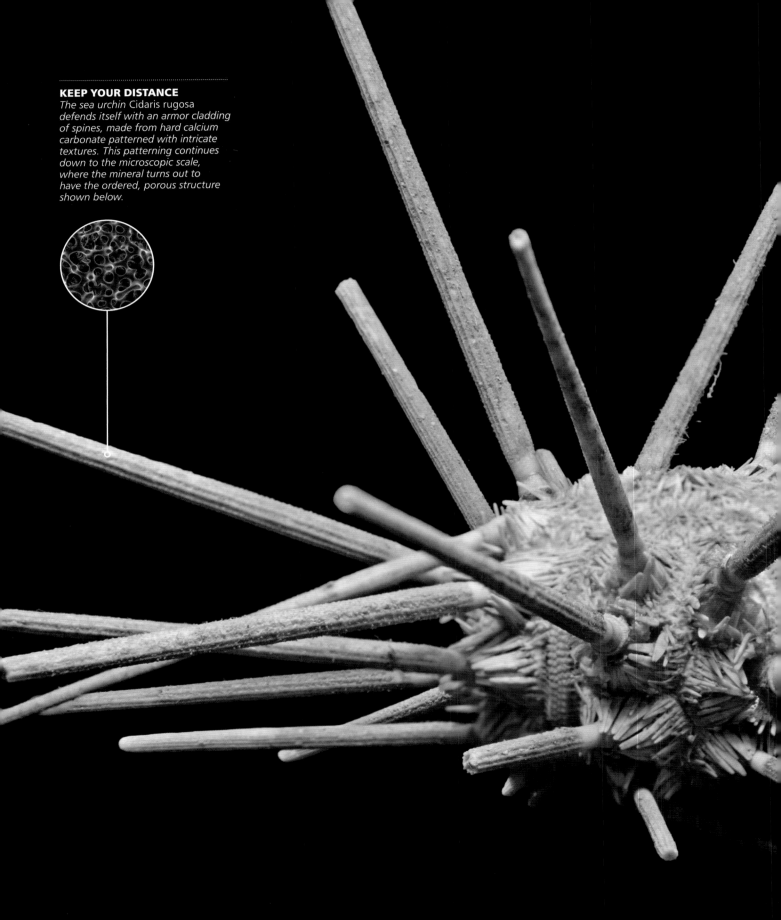

KEEP YOUR DISTANCE
The sea urchin Cidaris rugosa
defends itself with an armor cladding
of spines, made from hard calcium
carbonate patterned with intricate
textures. This patterning continues
down to the microscopic scale,
where the mineral turns out to
have the ordered, porous structure
shown below.

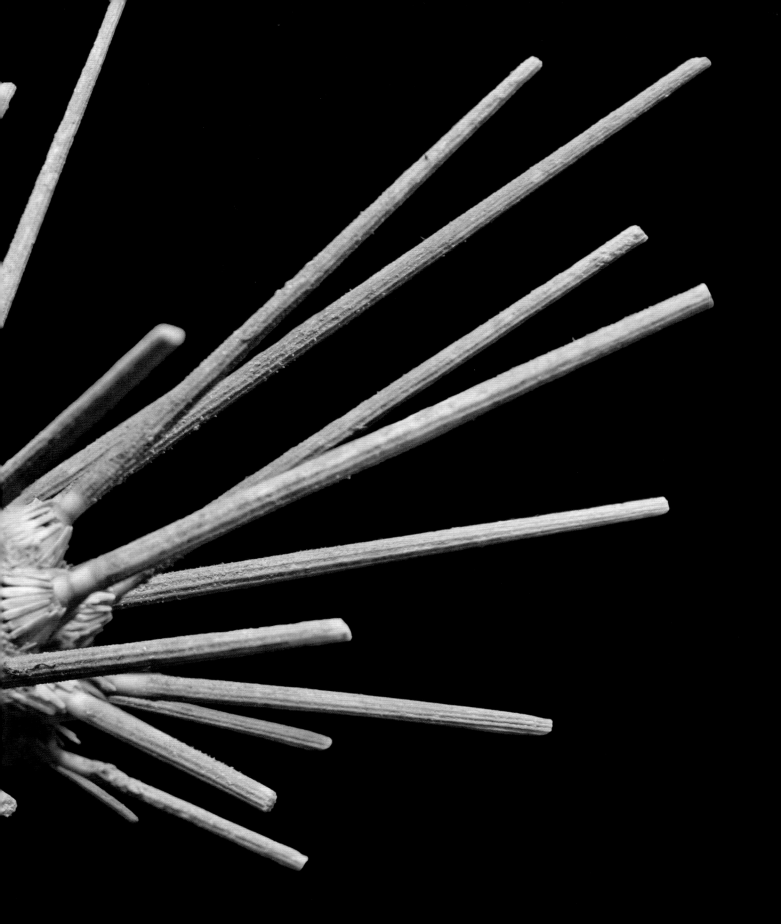

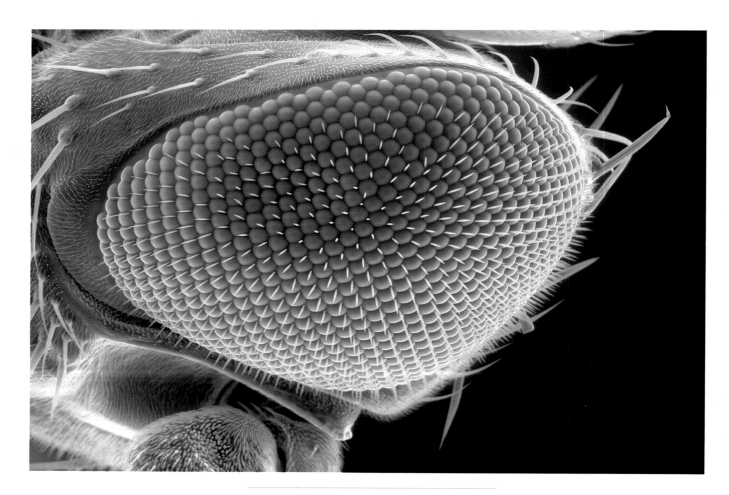

BUBBLE VISION

The compound eyes of insects are packed hexagonally, just like the bubbles of a bubble raft—although, in fact, each facet is a lens connected to a long, thin, retinal cell beneath. The structures that are formed by clusters of biological cells often have forms governed by much the same rules as foams and bubble rafts—for example, just three cell walls meet at any vertex. The microscopic structure of the facets of a fly's eye—beyond what is visible here—supplies one of the best examples. Each facet contains a cluster of four light-sensitive cells that have the same shape as a cluster of four ordinary bubbles.

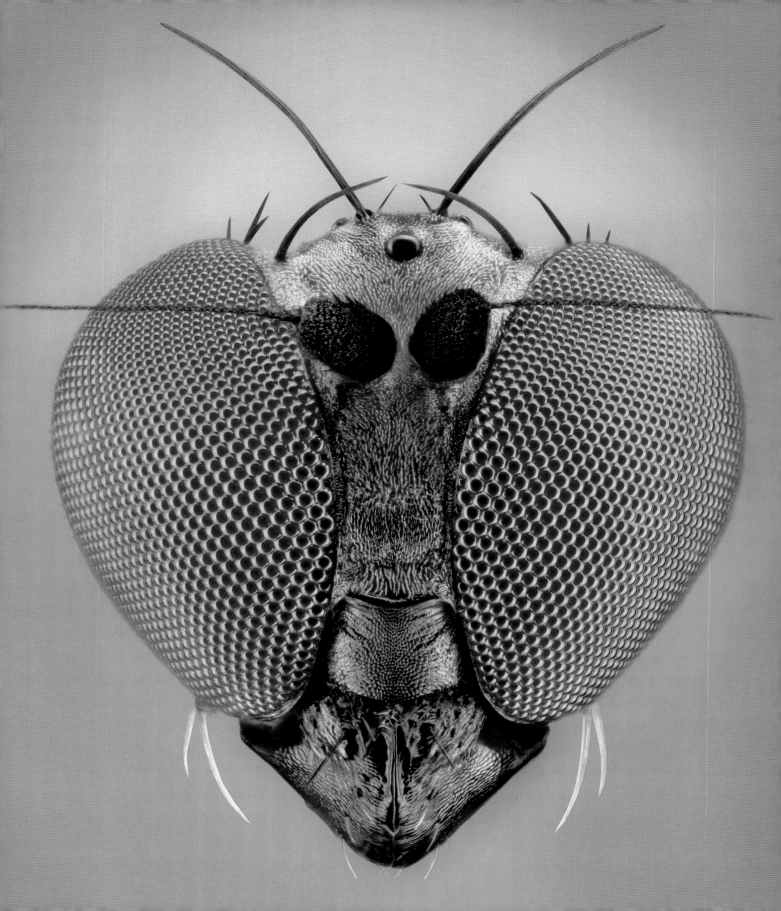

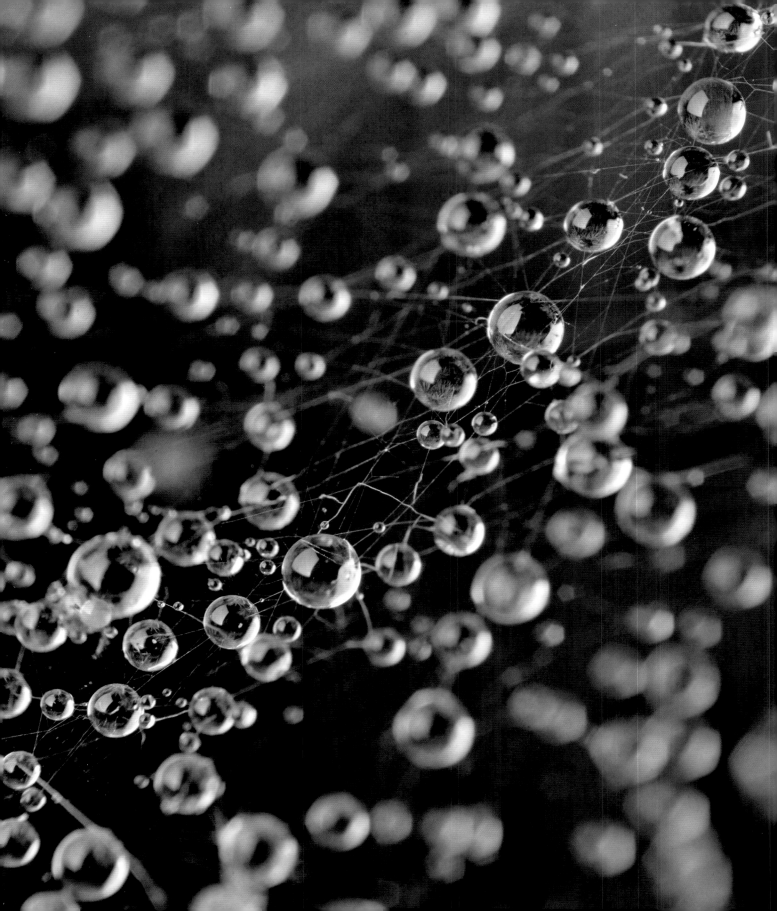

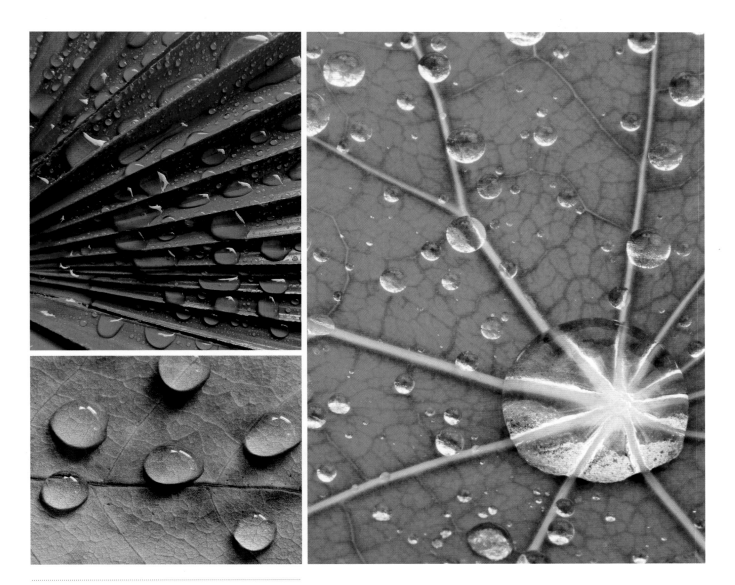

SHAPING A DROPLET

When water sits on a water-repellent surface, it may break up into droplets. The shapes of these drops are governed by surface tension, which pulls them into roughly spherical shapes, as well as by gravity (which will flatten a droplet on a horizontal surface) and the forces that act between the water and the underlying surface. If those latter forces are strong enough, the droplets are pulled into lens-shaped pancakes. And if the surface isn't strongly water-repellent, the droplets may spread out into a flat, smooth film.

7 ARRAYS & TILINGS

Why crystals aren't five-sided—and
how to make impossible ones that are

Some early philosophers suspected that the world was, at root, geometric: built by God according to simple mathematical rules. It was an understandable assumption if you think about crystals—the very stuff of the earth—with their orderly, faceted shapes. Miners and explorers of underground caverns could find themselves in a geometric universe, where all around nature was organized into glittering mathematical perfection. Wasn't this evidence of nature's fundamental order imprinting itself on matter?

In the early seventeenth century, German astronomer Johannes Kepler wondered if there was a more tangible reason than God's will for the shapes of crystals. In particular, he asked why snowflakes always have six points. He knew that if cannonballs are stacked compactly together, each ball is surrounded by six others at the corners of a hexagon. Might the sixfold symmetry of the icy snowflake come from the stacking of "globules" of frozen water?

Kepler never got to the bottom of the snowflake problem—that took another four centuries. But his intuition about the cause of crystals' regularity was right. The eighteenth-century French priest and botanist René Just Haüy figured that crystal shapes are indeed dictated by the arrangements of their atoms. In his book on mineralogy in 1801—the founding text of the science of crystallography—Haüy showed how atom-stacking produces facets rather like the triangular faces of an ancient stepped pyramid.

Because of this atomic-scale structure, the shapes of crystals often echo those of the smallest repeating cluster of atoms in the crystal lattice. For ordinary rock salt (sodium chloride) this cluster is cube-shaped, and so are the crystals—as you can see by looking at table salt under a microscope. Calcite, a mineral form of the compound calcium carbonate, has rhombus-shaped facets because that, too, is how the atomic building blocks

are arranged. These crystal shapes, or so-called "habits," of minerals are diverse and beautiful, but all in some way bear the imprint, at scales we can see and touch, of the arrangements of the atoms that constitute them.

These crystal structures can be classified by their symmetry properties, just like the forms we looked at in Chapter 1—whether they can be rotated or reflected, say, to leave their appearance unchanged. There are only a fixed number of ways of arranging objects so that they will repeat again and again in perfect array. Each of these distinct repeating patterns is called a group, because it has an associated group of symmetry operations. In two dimensions, for example, we can pack together squares, hexagons, and equilateral triangles this way into "tiling" patterns. If the tiles are not regular polygons of this sort—if they are rectangles, say, like the arrangement of bricks in a wall—then there are other tiling groups, too. There are precisely 17 of these two-dimensional "wallpaper" groups, many of which have been used in decorative schemes for walls and floors by various cultures since ancient times.

Crystals are made by stacking atoms in three dimensions. In this case, there are 230 symmetry groups (called space groups): 230 different ways of arranging objects into regular 3-D arrays. All crystals must belong to one of these groups—otherwise they couldn't be true crystals, because

CRYSTAL TAPESTRY
Crystals of magnesium chloride, seen under polarized light.

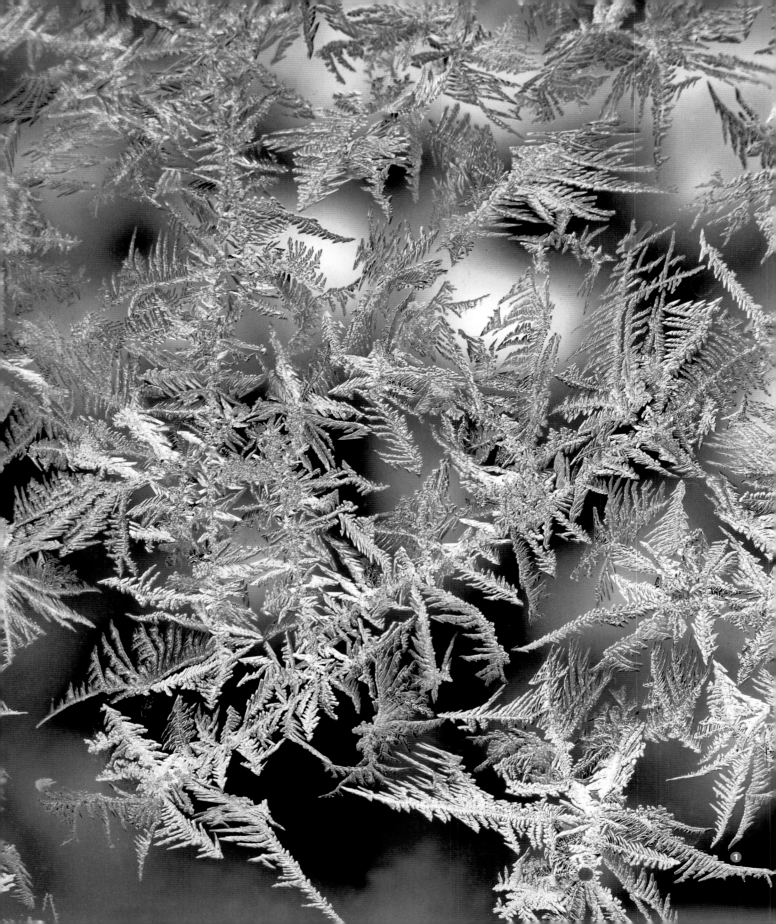

they wouldn't be made up of elements whose arrangement repeats again and again. (As we'll see, though, this depends on how you want to define a crystal.)

The simplest crystals, such as metals, are made of identical atoms. Since all the atoms are the same size, they can be efficiently packed together into hexagonal arrays, like the cannonball piles noted by Kepler. This is the densest possible way to stack spheres—a fact proved only in 1994— and it is called hexagonal close-packing. It has only about 25 percent empty space between the spheres. Some metals, such as iron, chromium, and tungsten, instead adopt a so-called "body-centered cubic lattice", in which the repeating unit consists of eight atoms at the corners of a cube and one in the middle. For cannonballlike spheres, this has 32 percent empty space. In diamonds, carbon atoms are packed into repeating patterns of eight atoms, again with a cubic shape, which for spheres leaves as much as 66 percent of the space empty. For crystals containing several or many different types of atoms, the atomic-scale structures can get pretty complicated, but the repeating patterns still have to correspond to one of the 230 space groups.

The interference between X-rays bouncing off regular arrays of atoms and molecules produces a pattern of bright spots in the scattered beam from which the positions of the atoms can be deduced. This technique, called X-ray crystallography, was first used in the early twentieth century to deduce the crystal structures of simple minerals, but from the middle of the century it began to reveal the atomic structures of complex biological molecules such as proteins, enabling scientists to understand how life works at the molecular scale. In 1953 X-ray crystallography was used to study the crystals formed by DNA, and thereby to show that this vital biomolecule has its famous double-helix structure.

When a crystal melts to a liquid, it loses its atomic-scale order; there is no longer any regularly repeating array. However, some substances can melt in one direction while remaining ordered in others. In particular, some long, rod-shaped molecules may form liquids that flow, even though the molecules stay lined up roughly parallel to each other, a little like logs floating on

a river. These are liquid crystals. In some liquid crystals the aligned molecules stack up in regularly spaced layers even though, within a given layer, the molecules move around and jostle like people in a crowd. The alignment of molecules in liquid crystals can make them scatter polarized light into spectacular patterns, from which it is possible to deduce something about the molecular order that the liquid crystal contains.

The law of tiling, and how to break it

The patterns of crystalline lattices are governed by strict geometrical rules that "forbid" certain types of symmetry. For the 17 two-dimensional tiling patterns, for example, the tiles can have the same symmetry as squares, rectangles, hexagons, rhombi, or triangles. You can rotate the pattern symmetrically by half a full revolution (for rhombic or rectangular tiles), or a quarter, a third, or a sixth—but not a fifth. There are no tile shapes that can be fitted together perfectly, with no gaps, to create a tiling lattice with fivefold symmetry: you can't tile pentagons perfectly. The same is true for all tiles with more than sixfold symmetry (sevenfold, eightfold, and so on). This applies to 3-D space groups, too: you can't make an orderly framework in three dimensions from units with fivefold symmetry. This might seem unfair on the pentagon, but it's just a fact of basic geometry.

At least, so we thought until three decades ago, when a material that seemed to be crystalline was found to have one of these "forbidden" symmetries. In 1984, researchers working in the USA discovered an alloy of aluminum and the metal manganese that, according to X-ray crystallography, seemed to have tenfold crystal symmetry: X-rays bounced off this material to produce rings of ten equally spaced spots. That seemed to imply a crystal lattice with tenfold (or fivefold) symmetry, which was impossible according to the laws of geometry. What was going on?

This material was the first so-called "quasicrystal." Over the following decade or so, scientists realized that it is possible to organize atoms into patterns with fivefold (and eightfold, tenfold, and twelvefold) symmetry that don't

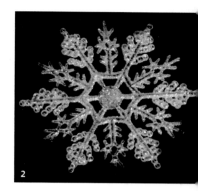

2

1 GROWING ICE
Ice crystals, like these on a window in winter, can grow into beautiful and complex branched shapes in a process called dendritic growth. The same process creates the shape of snowflakes.

2 STAR QUALITY
Snowflakes display sixfold (hexagonal) symmetry. This reflects the hexagonal arrangement of water molecules in the ice crystal, translated to a scale that can be seen (just) with the naked eye—but also elaborated into exotic patterns by the growth process of the flakes.

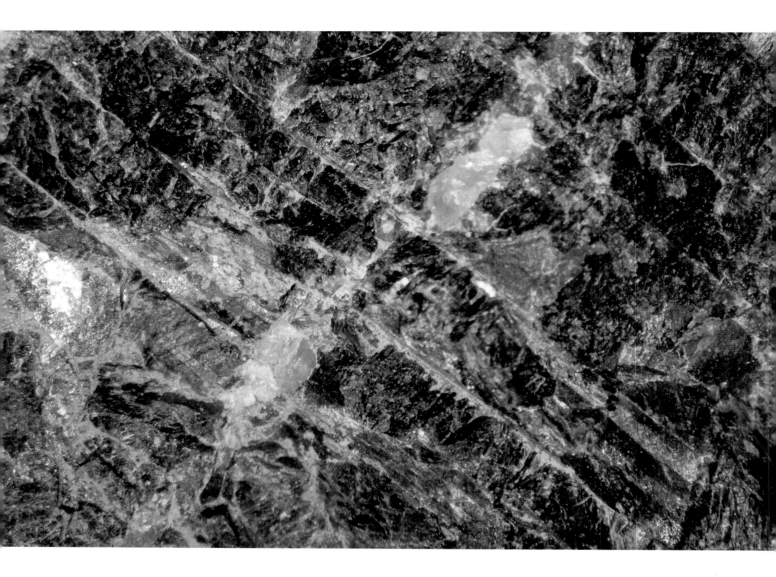

**MINERAL
LANDSCAPES**
*Crystals may form
complex structures and
patterns over many
different size scales, from
the atomic level up, as
seen in this sample of
the mineral sphalerite
(zinc sulfide).*

quite repeat *exactly,* as crystals were known to do. These patterns look at a casual glance as though they are pentagonlike lattices, but every so often the pattern slips, so that it is never possible to rotate or move it in a way that superimposes it exactly on itself. Despite this lack of perfect regularity and order, the pattern (when built from atoms) is orderly enough to produce bright spots in the reflected X-rays. The International Union of Crystallography has, in fact, now broadened the very definition of a crystal so that it can include quasicrystals.

The easiest way to understand quasicrystal patterns is again to think of tilings in two dimensions, although the actual crystals are three-dimensional. You can't tile pentagons, but in the

1970s the mathematical physicist Roger Penrose discovered a set of two rhombus-shaped tiles that can be fitted together without gaps to create a lattice filled with fivefold symmetric shapes: five-pointed stars and decagons, for example. This tiling never quite repeats its pattern exactly, but if it is built up while applying a few simple rules about which tile can lie next to which, it can be extended forever. If you imagine putting an atom at the corner of each tile (or the equivalent rhomboids in three dimensions), you end up with an array that appears to be very much like the atomic lattice of a quasicrystal.

Such patterns, which seem to bend the rules of geometry, were already known to Islamic artists hundreds of years ago, who explored them in

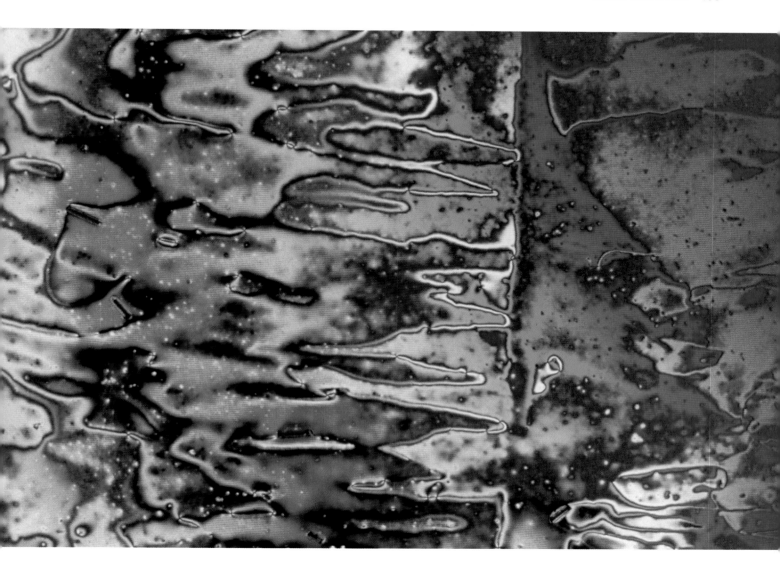

complex designs and mosaic tilings. Both because
of religious restrictions on depictions of the
natural world and because Islamic philosophers
were deeply interested in mathematics, these
tiling patterns were developed into a highly
sophisticated art that can be found decorating
shrines, mosques, and palaces throughout the
Islamic world. One design on the Darb-i-Imam
shrine in Isfahan, Iran, made in 1453, is almost
identical to a Penrose tiling, with its mesmeric,
never-quite-repeating pattern. The tiling patterns
were constructed from conceptual building blocks
called *girih* according to strict assembly rules
similar (but not identical) to those used to make
Penrose tilings.

Flowers of ice

Snowflakes show the pattern-forming potential
of crystals at its most exuberant. While Kepler
guessed at the underlying reason for the geometric
regularity of crystals, in the snowflake this
orderliness is taken to kaleidoscopic extremes,
creating shapes in which the symmetry of the
hexagon is embellished almost to an absurd
degree. If the packing together of atoms and
molecules generates blocky facets, why then
do these ice crystals take on such delicate and
ornate shapes?

Some snowflakes are fancier than others. The
spectacular frondlike flakes commonly shown
in snowflake pictures are usually cherry-picked
from among less-perfectly symmetrical examples

LIQUID CRYSTALS
*These crystals have a
liquidlike ordering of
their molecules in one
or two directions,
while being disorderly
and liquidlike in the
others. The molecular
arrangements can
twist polarized light,
resulting in these
colorful textures when
seen under a polarized-
light microscope.*

Chemical gardens

Isaac Newton was convinced that metals and minerals possess what he called a "vegetative soul," because of the way they could grow into structures that looked more like plants than crystals. Newton experimented with what are now often called chemical gardens—metal salts precipitated in a solution of what in Newton's day was known as oil of sand, which is sodium or potassium silicate (water glass). The salts grow into weird tentacles and branching fronds, because the silicate forms a tough but flexible and water-permeable skin, through which the salt repeatedly bursts out upward. The structures that result are peculiarly lifelike: they could be bizarre, bulbous root vegetables from an alien world. Some scientists speculate that complex mineral structures like this, wrapped in membranes, might have played a part in the origin of primitive life on Earth at deep-sea hydrothermal vents where warm mineral-rich fluids spew out from the Earth's crust.

A team of researchers at Harvard University has devised a particularly floral variant of the chemical garden process. They adjusted the acidity and concentration of dissolved carbon dioxide in the solution as crystals precipitated in water glass. This caused the tips of growing tendrils to blossom into curved and ruffled conelike shapes that, when examined under the microscope, look like flowers or corals—a chemical garden truly worthy of the name, and an indication that even crystals can escape from the chains of geometry to offer patterns of vivid, uninhibited artistry.

and, depending on the precise meteorological conditions (the air temperature and humidity), snow can also fall as simpler hexagonal plates or prisms. All the same, the variety and complexity of snowflakes can be stunning, and it is a mystery even now why so often each arm mirrors the others down to the finest detail.

A typical snowflake arm is a needlelike ice crystal decorated by smaller needles that branch off at the "hexagonal angle" of 60°. Why this branching? And why this hexagonality?

Although no other kind of crystal comes close to snowflakes for elaborate beauty, their pattern is not totally unique. When some molten metals solidify quickly, they too can sprout Christmas-treelike arms. This phenomenon is called dendritic growth, after the Greek word for branch. Dendritic growth is an example of a growth instability, which basically means that something gets blown up out of control as a shape or pattern grows. We saw in Chapter 2 how aggregation due to the sticking of randomly drifting particles produces the tenuous forms of fractals. Any bump that appears by chance on the surface of the cluster grows faster than the rest simply because it is more exposed. So randomness at the surface quickly gets amplified and the cluster sprawls into its monstrous, tendriled form.

Something similar happens in dendritic growth during freezing of a liquid: a random bump grows faster than the surface around it, this time because the bump is better at radiating away heat so that more crystal can grow there. But this alone would make snowflakes ragged fractals. What about the hexagonal regularity? This comes from the crystal structure of the ice itself, which contains water molecules linked into hexagonal rings. This structure means that the branching instability happens on a kind of microscopic hexagonal grid that sets up a bias for the directions in which the branches grow: they surge ahead faster at the hexagonal angles than at others. The combination of random branching and orderly underlying lattice creates the exquisite complexity of the snowflake, poised on the brink of chaos and minutely sensitive to tiny variations in the temperature and humidity of the air. This acute sensitivity ensures that no two snowflakes seem to be exactly alike: they are endless variations on a theme, as if trying to convince us of nature's intrinsic creativity.

CRYSTAL FLOWERS
Careful control of the growth conditions—temperature, acidity, and concentration of dissolved gas—gives rise to these ornate and diverse crystal shapes of barium carbonate and silica precipitated in a solution of metal salts. The basic forms are shaped like stems, vases, and corals; by switching the conditions during growth, the crystals can be guided into these and other flowerlike structures. The colors have been added to the image artificially to enhance the "botanical" appearance.

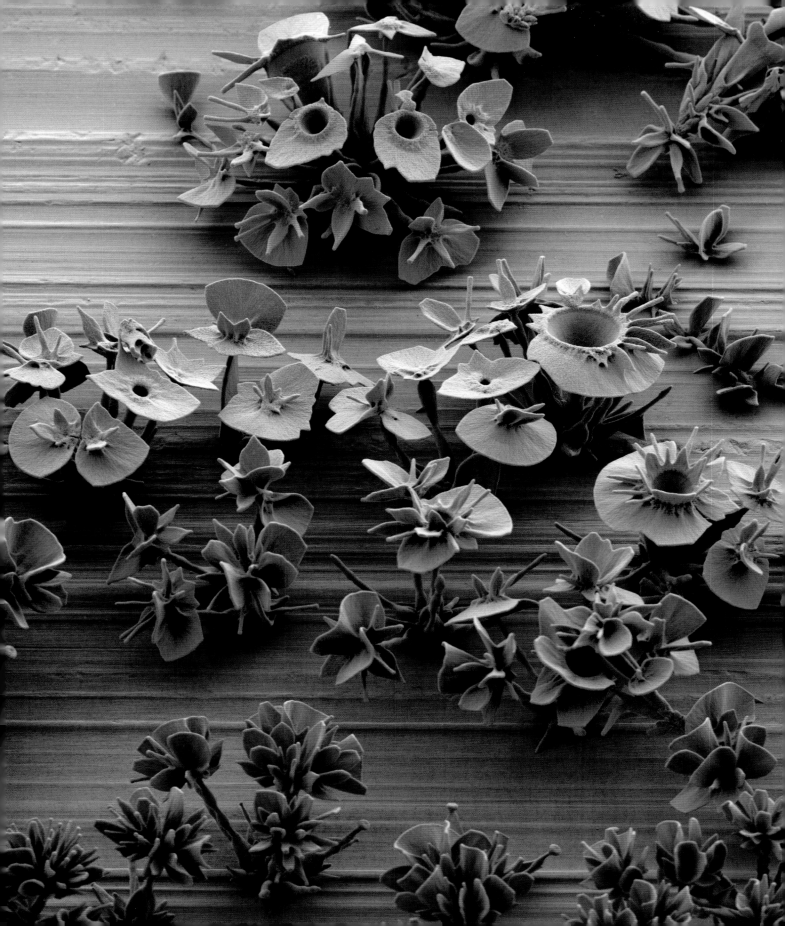

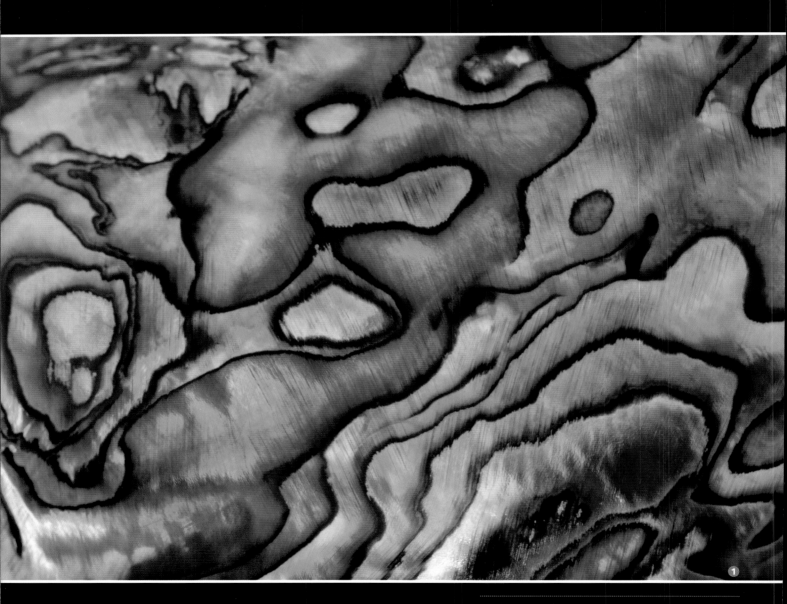

INTERFERENCE

The colors of this complex layered crystal in the shell of the New Zealand paua mollusk (1) and in the texture of this liquid crystal (2) are produced by interference effects in light. These may pick out the microscopic structures of the material. In the shell, we can see the terracelike layering of the hard mineral, organized by soft organic tissues during shell growth, while in the liquid crystal the microscopic structure comes from the shared orientation of rod-shaped molecules packed together.

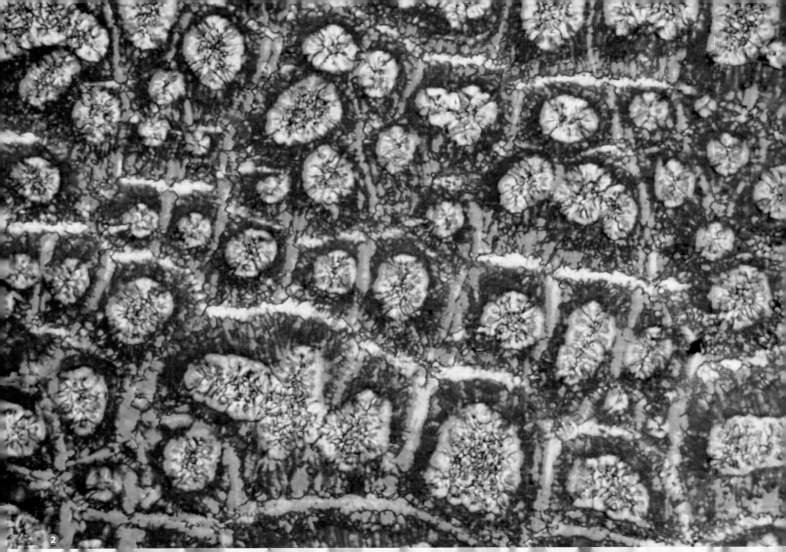

CRYSTAL TREES
In the process known as dendritic growth, seen here in magnesium citrate (1) and ice (2), a growing crystal acquires a needlelike shape that is then decorated with side branches at successively finer scales. This process happens when tiny random bumps at the surface of the solidifying crystal get amplified and sharpened, because they are better at radiating the heat that needs to be shed for crystallization to occur. This, then, is another feedback process that generates pattern from randomness—in this case, given a degree of regularity by the order in the underlying atomic structure of the crystal.

2

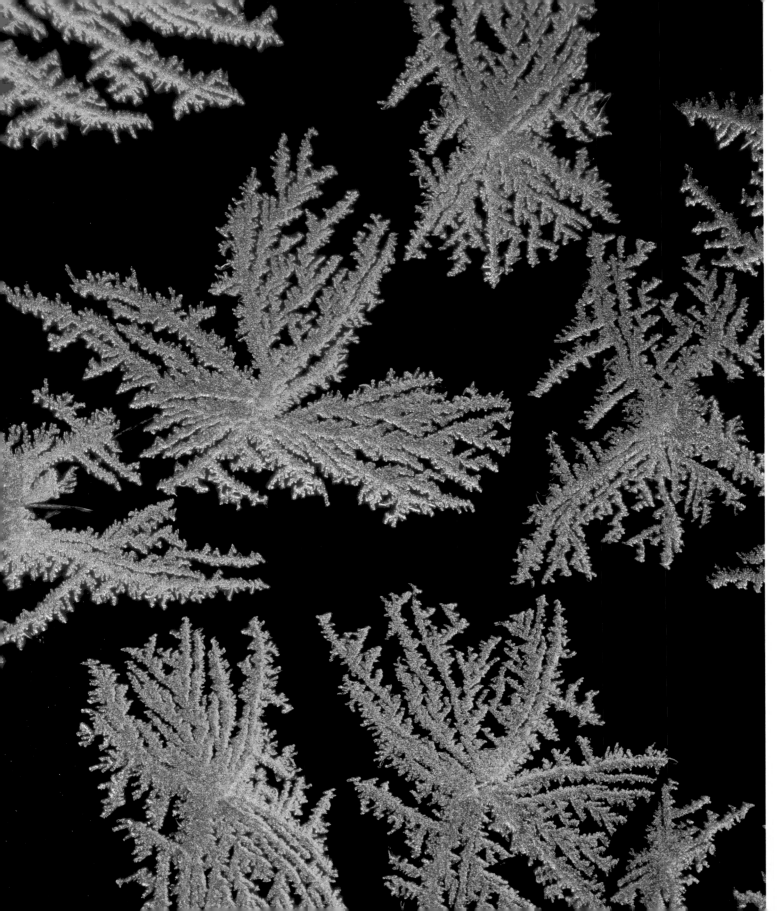

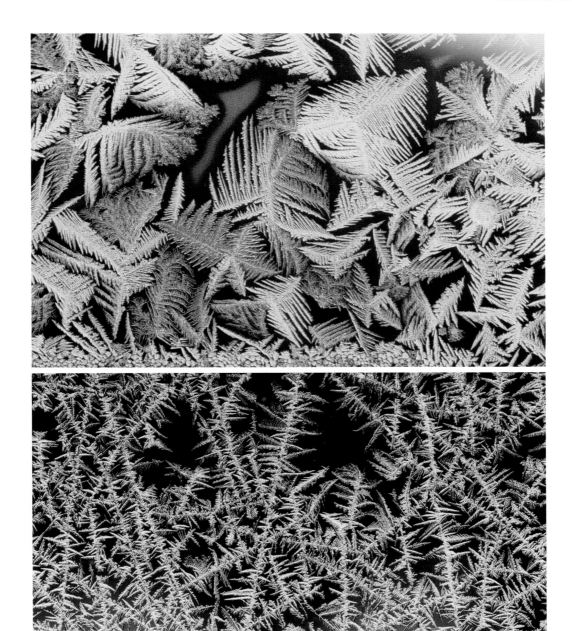

FORMING ICE PATTERNS
*The precise patterns formed by dendritic growth
of ice on surfaces are a combination of chance
and determinism. In general, the crystals branch
repeatedly, but each individual crystal is often seeded
by an impurity or defect on the solid surface—so
that, for example, they might follow the tracks of
almost invisible scratches on glass.*

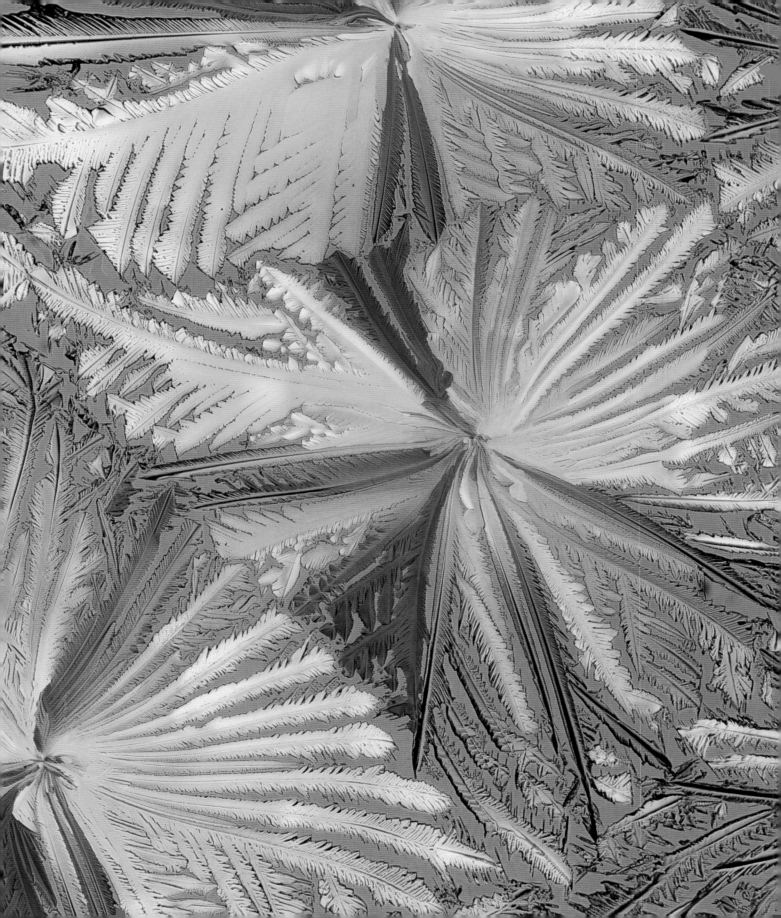

CRYSTAL RAINBOWS

Some crystals, particularly those of organic compounds such as vitamins and amino acids, have a property called birefringence, which means that light rays passing through them can be split into two. These two beams can then interfere with each other, picking out particular colors from the visible spectrum when the crystals are viewed with polarized light. The spectacular color displays accentuate the shapes and textures of the crystals, which are formed as they grow. The examples shown here are magnesium citrate (1), vitamin C (2), and cholesterol (3).

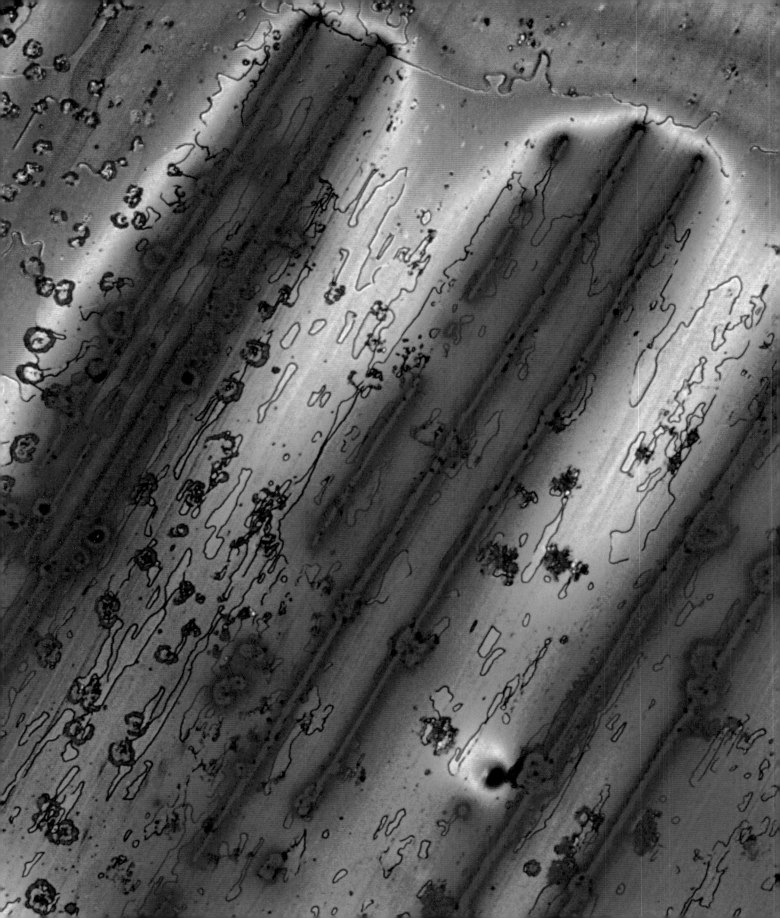

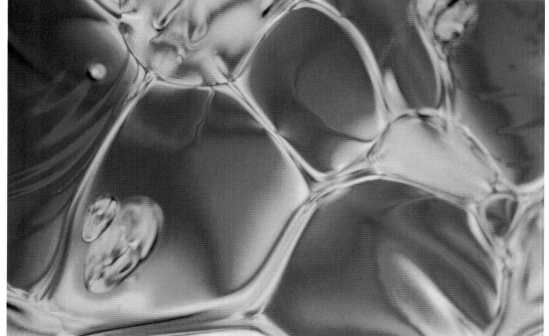

MOLECULAR MEETINGS
The textures of liquid crystals, revealed by interference of polarized light, are wonderfully varied. Some of the structures in these patterns comes from so-called "defects" where the stacking arrangement of the molecules contains an irregularity—for example, boundaries where side-by-side molecules slant in different directions (like partings in hair) or singularities where molecules radiating in different directions converge at a point (like the crown in hair, or the poles of the Earth's magnetic field).

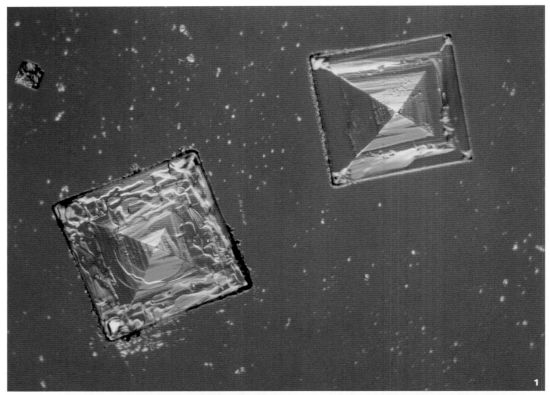

1 and 2 THE MANY FACETS OF CRYSTALS
The shapes of crystals often reflect the symmetries of the stacking arrangements for their constituent atoms and molecules. Thus the square shapes of crystals of common salt (1) stem from the cubic arrays of the sodium and chloride ions from which they are made. Likewise for the rhombus-shaped cross-section of magnesium sulfate crystals (2).

3 CHANGE OF STRUCTURE
Here crystals of copper sulfate—the light blue blobs—are embellished with white needlelike crystals, which are also copper sulfate but lack the water molecules that are incorporated into the blue material. This white form grows more quickly and in a different shape.

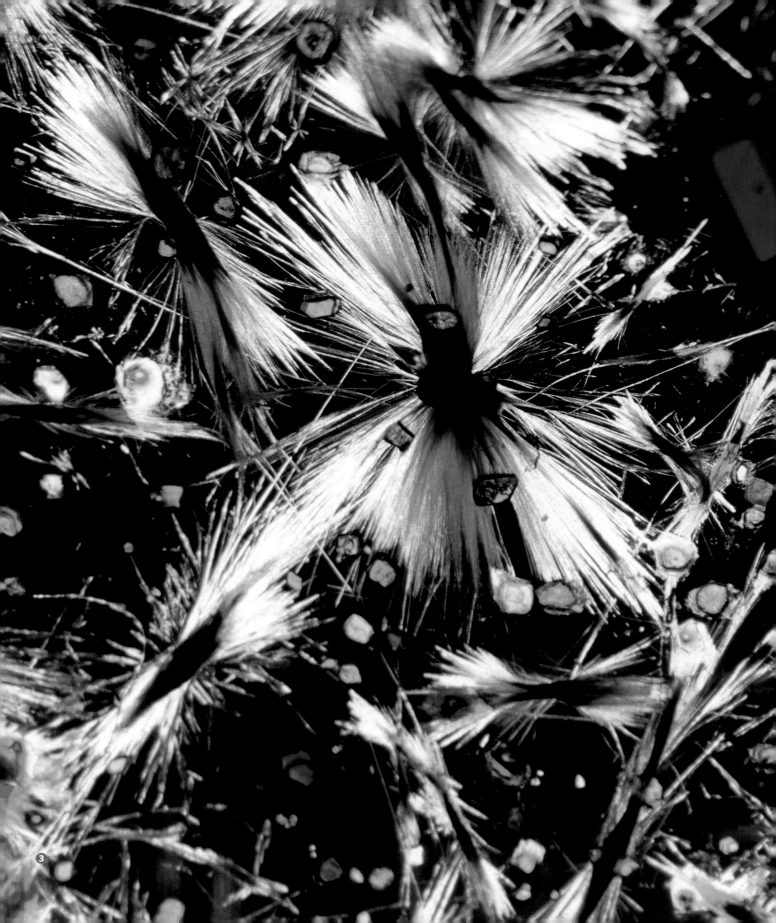

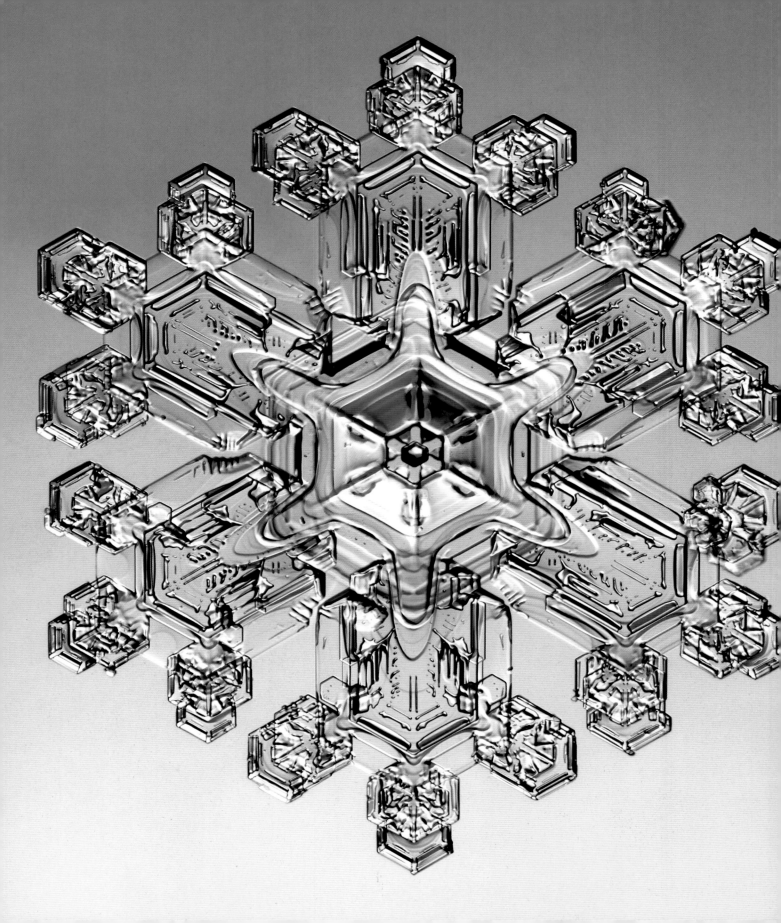

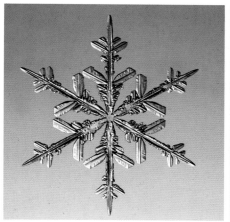
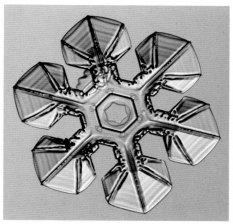
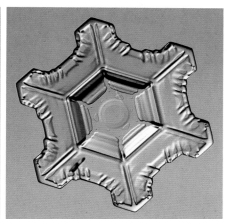

HEXAGONAL BRANCHING

*Snowflakes seem to provide inexhaustible
invention on the hexagonal theme. The branching
of arms and hexagonality of the pattern are
now well understood, but mysteries remain. It's
not fully obvious why the ice crystals grow as
flat plates (other shapes are also possible under
different conditions of air temperature and
humidity), nor why all the branches are nearly
identical. Not all snowflakes are this perfectly
symmetrical, however.*

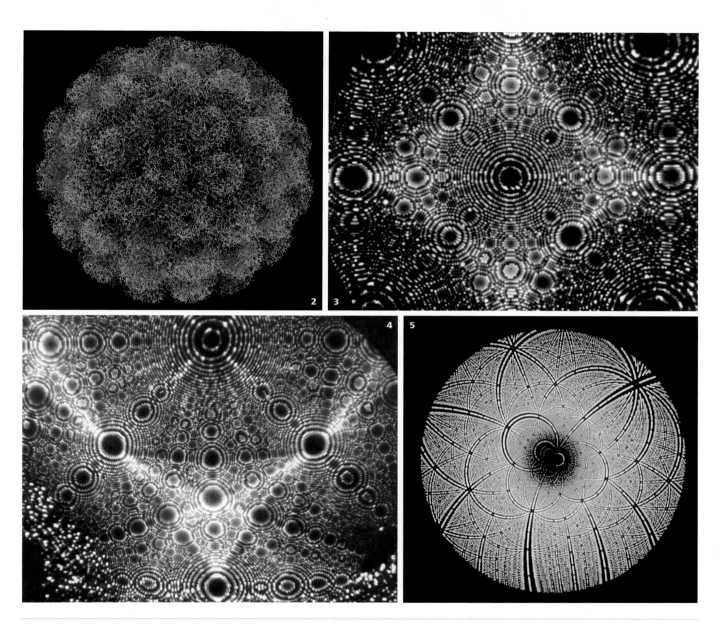

1 and 2 VIRAL SYMMETRY
*Even some biological objects
have a crystallike regularity at
the molecular scale. Viruses,
such as the West Nile virus (1)
and simian virus 40 (2), are
particularly good examples: they
are made of protein molecules
packed together in a shell
called a capsid, with the genetic
material packaged inside. The
capsids commonly show fivefold
symmetries.*

**3 and 4 DISCOVERING
ORDER**
*The atomic-scale order of
crystals was first seen directly
using techniques called field
emission microscopy and field ion
microscopy, in which each bright
dot (seen here for the metals
iridium [3] and platinum [4])
corresponds to a single atom at
the surface of a fine tip.*

5 X-RAY REVELATION
*The most common way to figure
out the atomic-scale structure
of a crystal is called X-ray
diffraction. The interference of
X-rays bouncing off different
layers of atoms in the crystal
creates a series of bright X-ray
spots, which can be recorded
(originally on photographic film)
and decoded mathematically to*

*deduce where the atoms are. The
technique was invented over a
hundred years ago, and can now
be used to reveal the structures
even of complicated biological
molecules, such as the enzyme
that produced this diffraction
pattern. This is how the double-
helix structure of DNA was
deduced in 1953.*

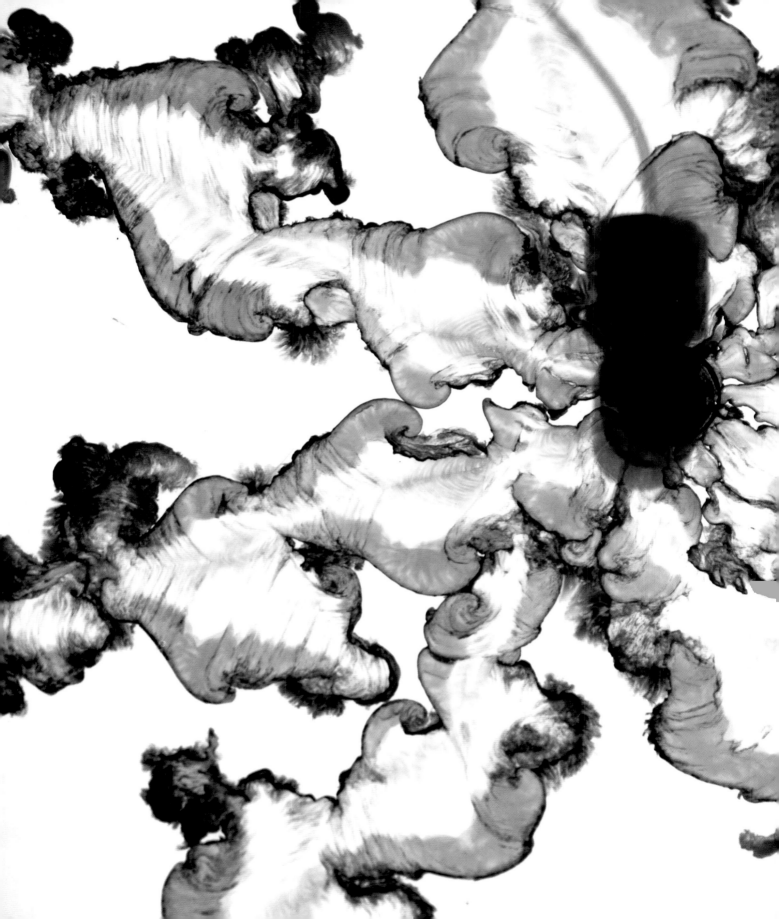

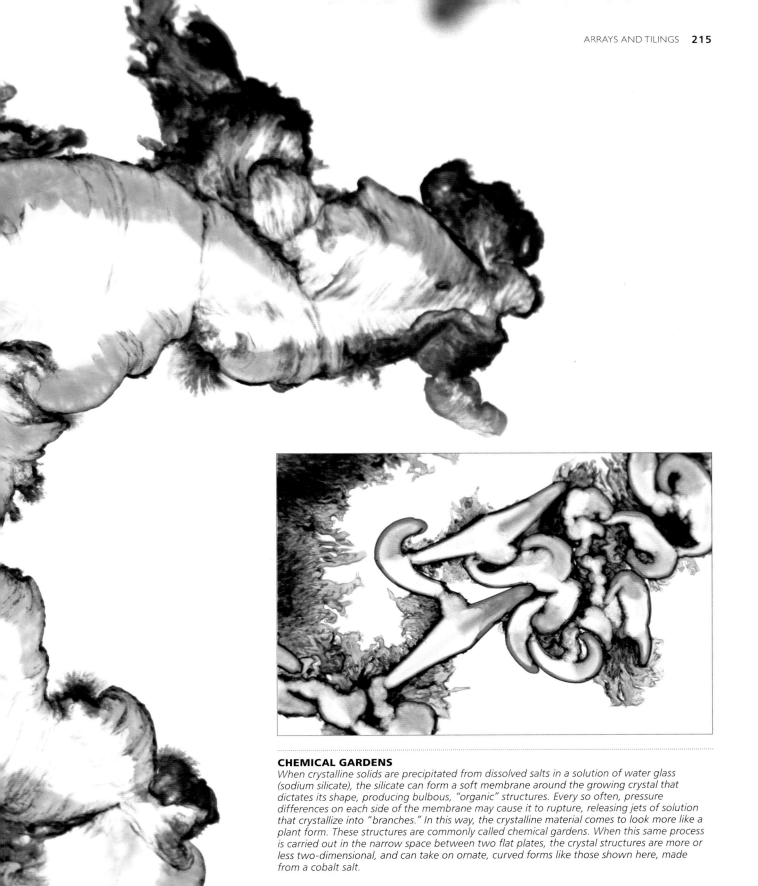

CHEMICAL GARDENS

When crystalline solids are precipitated from dissolved salts in a solution of water glass (sodium silicate), the silicate can form a soft membrane around the growing crystal that dictates its shape, producing bulbous, "organic" structures. Every so often, pressure differences on each side of the membrane may cause it to rupture, releasing jets of solution that crystallize into "branches." In this way, the crystalline material comes to look more like a plant form. These structures are commonly called chemical gardens. When this same process is carried out in the narrow space between two flat plates, the crystal structures are more or less two-dimensional, and can take on ornate, curved forms like those shown here, made from a cobalt salt.

MINERAL FILAMENTS
These are some of the delicate crystal structures produced in the chemical gardens described on page 196. Several different types of crystalline salt are growing in these gardens (not all of which are visible). Each has a characteristic color: copper nitrate (light blue), cobalt chloride (dark blue), ammonium iron sulfate (brown), magnesium nitrate (white), and iron sulfate (green).

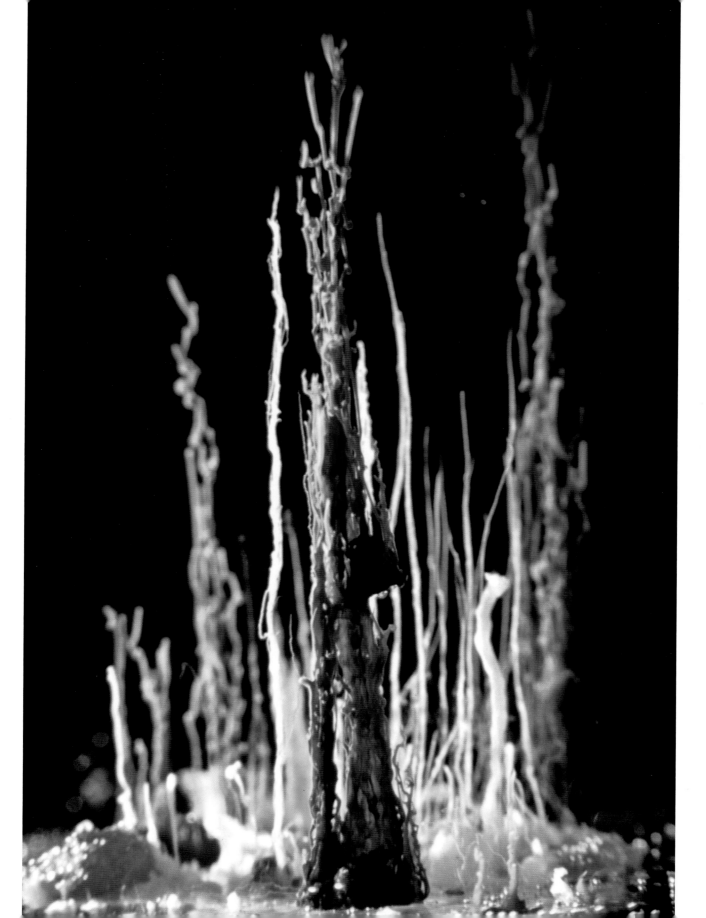

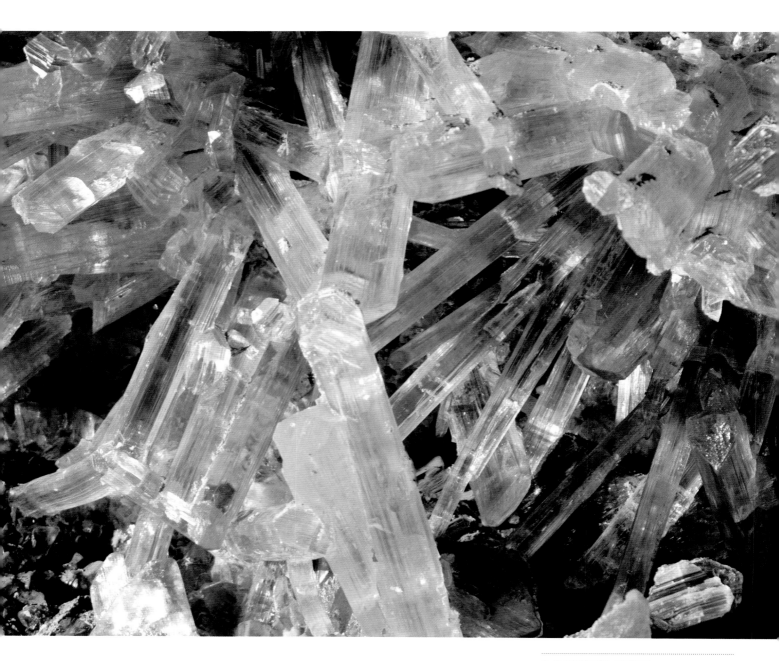

1–3 CRYSTAL CAVES
When minerals grow slowly underground from the cooling of warm fluids rich in dissolved salts, the crystals can grow to immense sizes, such as these pillars of selenite (a kind of gypsum) in the Naica mines of Mexico.

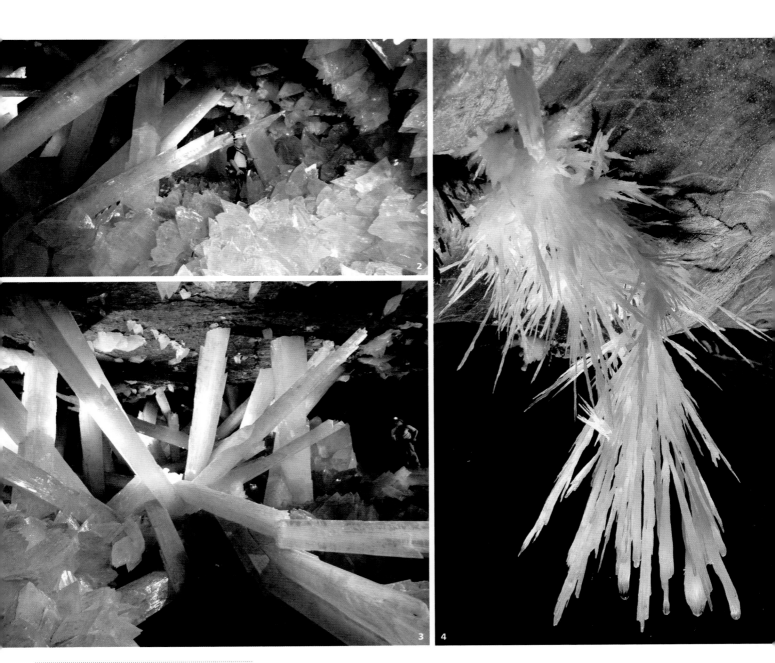

4 NEEDLE WORK
Crystals of aragonite, a form of calcium carbonate, grown slowly in a French cave. The shapes of crystals like this depend on the precise arrangements of the constituent atoms and ions—but the growth must be very slow to allow such large, perfect crystals to develop.

8 CRACKS

How things fall apart and how a
giant made his staircase

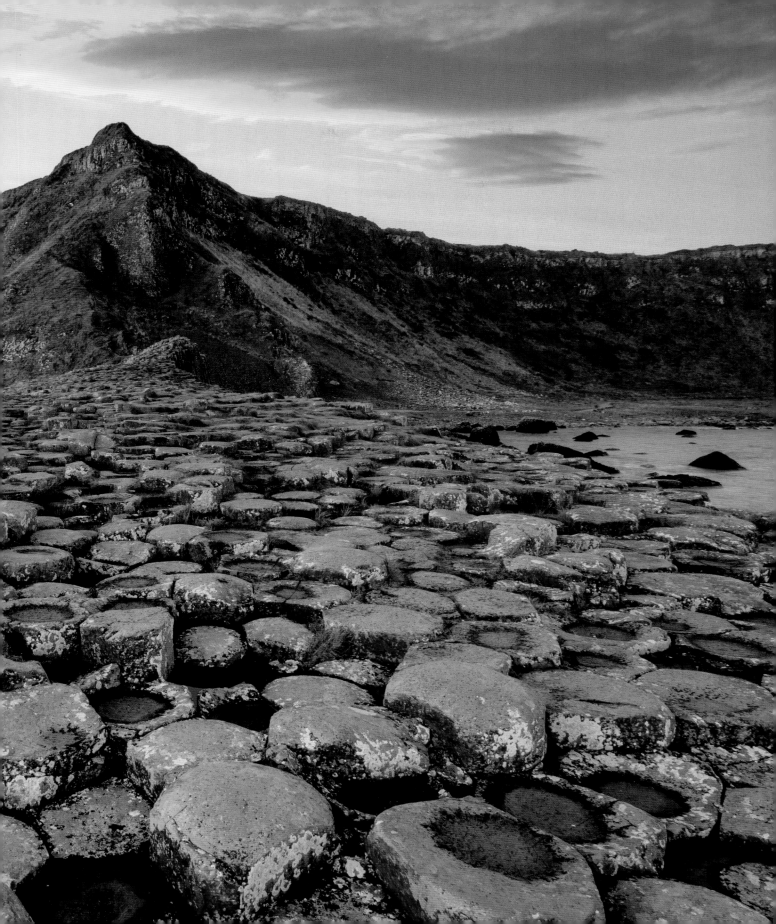

Breakage and decay seem like the very antithesis of order and organization, but surprisingly they too can produce varieties of pattern and structure. In some cases it might not look that way; cracks have a jagged chaos that speaks of wild disarray. But even this form recurs in so many different situations that we have to suspect it is the signature of a deeper design, a universal outcome of natural laws. And other crack patterns, like the trellis of fissures in pottery glaze or old paint, have a pleasing geometry of the same stamp which captivates us in foams, spiders' webs, and wrinkle textures. We might even seek them out for their aesthetic appeal; cracking, far from being a nuisance, becomes a source of creative opportunity.

Crash! Lightning forks down from the sky. Crack! The ground splits apart in an earthquake. Smash! A pottery jug falls to the floor. All of these events produce similar shapes: branching, jagged, forked, fragmented. Coincidence? Of course not! The archetypal "geometry of failure"—the shapes that come from things breaking, splitting, cracking—is a fissure that branches, the branch tips splitting into ever more junctions and thereby generating another of nature's fractal forms. We see these patterns not only in the cracks of a pavement slab, but also in the pattern of river networks—a kind of "slow crack" made as a river's headwaters erode the landscape in which they form.

These majestic watercourses split apart the earth, carve out mountain ranges, nurture civilizations, and astonish us with their complexity. The similarity between their shapes and those of the veins that carry blood around the human body was noticed many centuries ago, and stimulated the idea voiced both in ancient China and in Renaissance Europe that rivers are the "blood of the earth." That's not just a superficial and misguided pre-scientific analogy: modern science shows that these correspondences in appearance are indeed more than coincidental.

Out of action

The explanation for the patterns in both cases may not be so different from that for the simple parabolic path of a golf ball soaring into the air and falling back to the green. But what, you might ask, can the jagged trajectory of water plunging down mountain slopes have in common with the smooth, graceful arc of a ball moving through empty space?

Both are bodies in motion, moving under the force of gravity. For the golf ball, that movement is described by Isaac Newton's laws of mechanics, which relate the velocity and acceleration of the ball to the forces acting on it. Solve Newton's equations and you predict the parabola.

But there's another way to do that reckoning. You can write down a quantity called the action, which depends on the energies of the ball's motion—its gravitational energy, due to being high in the sky, and its kinetic energy due to its movement. Then, to deduce the ball's trajectory, you have to figure out which path produces the smallest amount of this quantity called action. Think of this as something loosely like "effort." Which path do you take to go to the store? The one (probably) that requires the least effort. Which path does the ball take? The one that requires the least action.

Just as the "law of least action" defines the parabola of a falling ball, so is there a law of "least something" that defines the path of water flowing down a hill. That "something" is the rate at which the water's gravitational energy, due to its initial position high up on the slope, is expended and dissipated. This prescription produces a trajectory of water flow that looks just like the fractal network of a river basin. But how does all the water "know" which network

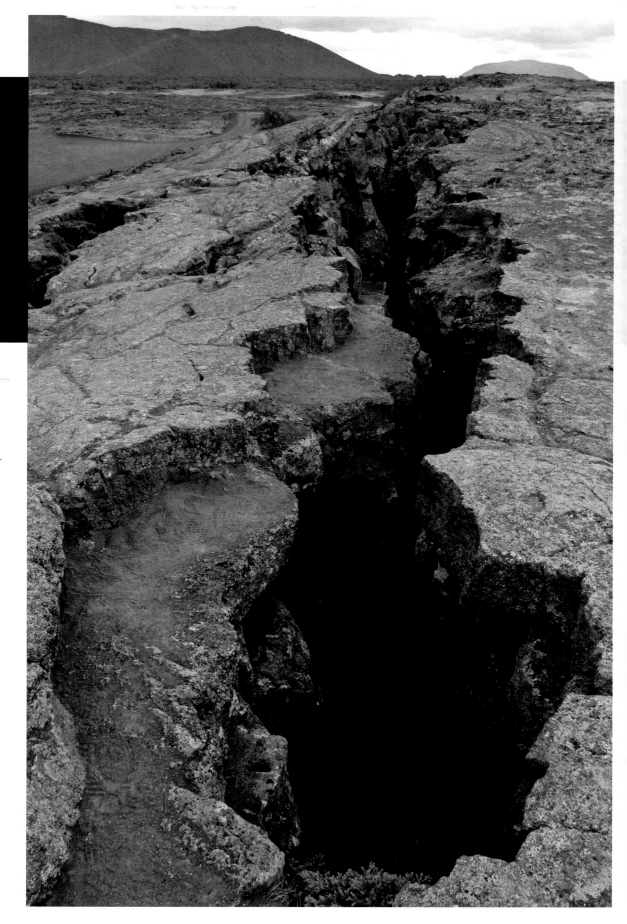

THE EARTH MOVES
Cracks are typically ragged-edged; some have a fractal profile. But there's a particular direction to them, too; here again is the familiar balance of chance and determinism.

CRYSTAL CLEAR
*A lacework of cracks
threads and weaves
through ice.*

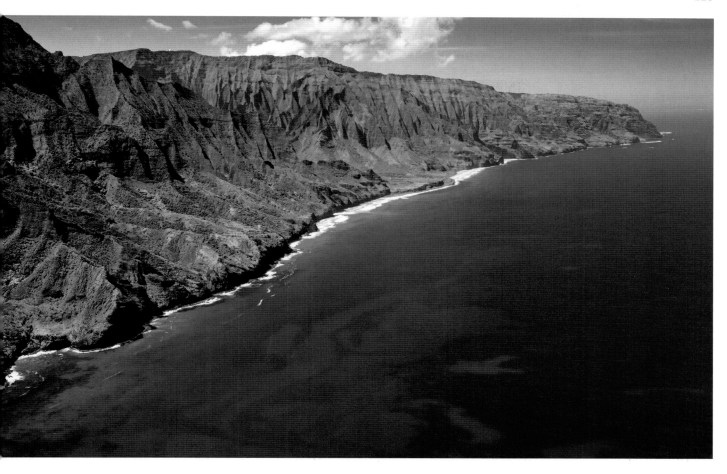

COASTAL EROSION
Erosion by water (sea and surf) sculpts many coastlines into complex, irregular shapes with a fractal structure.

dissipation? It doesn't, of course. If we assume only that the water falls on a randomly bumpy surface and flows down the steepest gradient, *and* that this flow will, if fast enough, erode and carry away some of the ground, then we find that the pattern of flow spontaneously evolves into a "minimal network." From simple "local" rules that describe how each little part of the flow behaves, a grand design emerges: the design we see for the Yangtze, the Amazon, the Rhine. Not only does it produce the characteristically branched aerial view of a river basin, but at the same time it wears away a bland, randomly rough landscape into one graced with soaring peaks, plunging precipices, and sharply incized valleys—all from a single generative principle.

On the edge

There's not so much difference between a river eroding a mountain and a sea eroding a coastline: in both cases, the energy of the water's movement batters and abrades the rock, breaking off little particles and carrying them away to carve out a particular shape. And in both cases, a combination of randomness and feedback turns what was once uniform into something pitted, uneven, and fractal.

Coastlines have a special place in the story of fractal patterns, for they were one of the natural forms that prompted Benoit Mandelbrot to come up with the concept of self-similarity, this elaboration on ever smaller scales. And yet it wasn't until rather recently that a good theory of how coasts get their shape was cooked up.

Imagine a coastline that is randomly shaped (remember, that's not the same as fractal) and where the rock type—and therefore resistance to erosion—varies randomly from place to place. There's some gradual and constant erosion as the rocks slowly dissolve in water, and also some fast, sporadic erosion caused by storms.

How does the shape of the coast evolve under these conditions? What begins as random becomes ever more irregular and fractal, as little

ever more irregular and fractal, as little dips are hollowed out into big bays while small protrusions are sculpted into jutting headlands. Whether a section of coast is removed depends partly on how strong the rock is, but also on how exposed it is. By the same token, the coastline's shape feeds back on the ocean forces that generate it: the more convoluted it becomes, the more it disrupts and damps down the waves, slowing the erosion. Out of this complex interplay of effects come structures that resemble the true forms of the land's end, with their islands, fjords, and peninsulas.

These geological processes of erosion happen over decades, centuries, millennia. Can they have much in common with the kind of breakdown that takes place in the blink of an eye, as a window shatters or a lightning bolt forks through the torpid summer sky? That's not obvious, and yet the patterns seem to insist on the analogy—for doesn't lightning take on the same branched, fractal form as a river network?

The splitting of a material as high-voltage electricity courses through it is called dielectric breakdown. The pattern of the crack is like a frozen replica of the spark that caused it, and is called a Lichtenberg figure, after the German scientist who first investigated this kind of breakdown. In a three-dimensional block of clear plastic it is like a barren tree or fantastic marine weed, extending its fingers throughout the material. Here is a real marriage of lightning and cracking, a substance split by electricity into a rich record of fractal failure. Can we account for it?

Imagine dumping a dollop of electrical charge into the center of a slab of material, so that it wants to flow out to the edges as the charged particles repel one another. Which path does the flow of electricity take?

Like water on a hillslope, it seeks out the steepest gradient; that's to say, it will advance from wherever the electric field at the boundary of the discharge is strongest. And those places are where the boundary is the sharpest: at bulges and tips. That's why lightning conductors on buildings are sharp spikes: they encourage the electrical discharge to happen there.

This forward surge of a tip is complicated by randomness—by little chance fluctuations in the electric field or in the material's structure that can generate new bumps that themselves then rapidly sprout into a new tip. So the tips split as they advance, and the result is a treelike, branching form. Depending on the atmospheric conditions, this elaboration of a lightning bolt can create dramatic, spectacular, natural rivers of electricity.

This description of dielectric breakdown can be modified to account for cracking, too. Here, instead of thinking about the path of the electrical current, we think of the path opened up by breakage of the material. Again that breakage is most likely at the crack tips, because this time it is the *stress* that is greatest at the tip. And once more, randomness—variations in the strength of the material, say, or pre-existing little cracks and flaws—induces tip-splitting and branching.

Crazy paving

If a lake dries up, or if the moist soil of a pasture or garden becomes parched, the ground contracts as the water evaporates from between the soil particles. This means that the dry layer at the surface tries to shrink relative to the still-moist layer below, and the ground becomes laced with tension throughout. Then the surface breaks apart not with the appearance of a single, branching crack but by the formation of an interconnected network of fissures that split it into isolated islands.

These patterns, so familiar as a kind of pictorial shorthand for tales of drought, are rather beautiful. They are also quite different from the fractal networks of dielectric breakdown and river erosion. The islands often have a polygonal shape defined by their flat edges, although sometimes the edges are less smooth and more erratic. The crack lines intersect rather cleanly, usually at relatively large angles of around 60–90°. There is a universal character to these patterns, too: we recognize them not just in dried-up lake beds but in pottery glazes such as *raku* and in the flaking of paint. The driving force is much the same in all cases: the glaze, say, bound to the ceramic surface, cracks

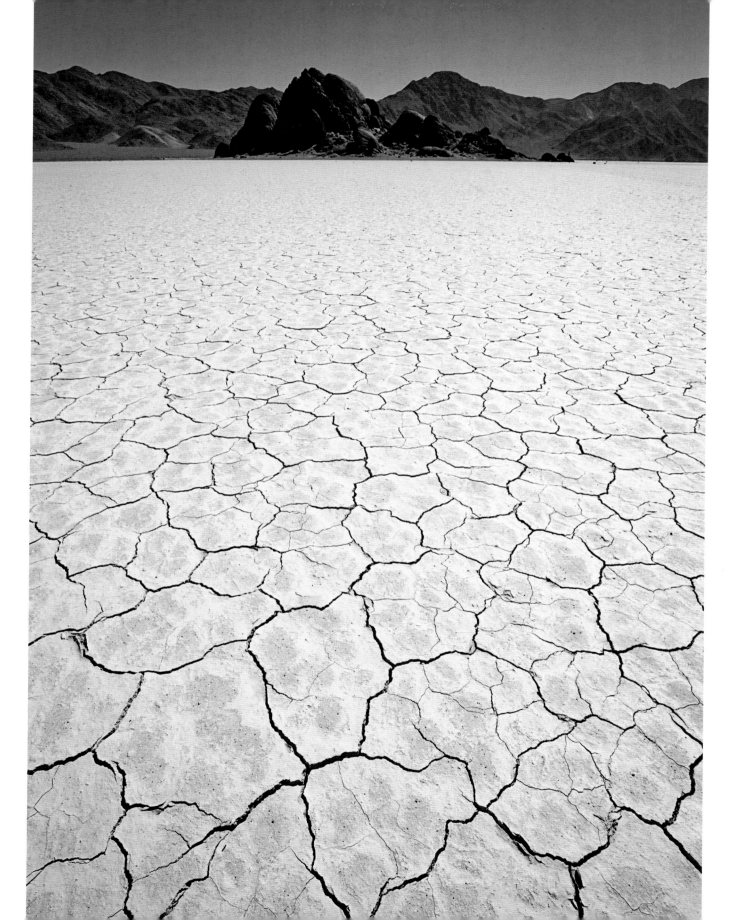

as it cools and contracts. The result is so pleasing that in pottery it may be induced on purpose.

What dictates this artful geometry? It seems again to be governed by a minimization rule: the cracks take paths that release the stress in the shrinking layer as effectively as possible. In glazes this happens when the cracks meet at right-angle junctions, and so the cracks are shaped and positioned to enable this, even if it means that one crack must bend as it approaches another.

Stress-relieving crack networks carve out some of nature's most spectacular fracture patterns: the hexagonal pillars of rock found at Fingal's Cave off the coast of Scotland, the Giant's Causeway in Northern Ireland, and the Devil's Postpile in California. How nature can produce formations so

seemingly ordered, geometrical, almost designed, has perplexed scientists and philosophers for centuries. It isn't hard to understand how these patterns, just like the hexagonal perfection of the bee's honeycomb, must have convinced scientists and naturalists of earlier ages that they were seeing the work of the divine—or the supernatural. Fingal's Cave was traditionally said to have been part of an immense paved causeway across the North Channel above the Irish Sea, stretching from Ireland to Scotland and built by the Irish giant Finn MacCool (Fingal) so that he could stride across to fight a rival Scottish giant. This bridge, it was said, began in County Antrim, where today the Giant's Causeway stands on the wild coast.

These geological formations were created as volcanic rock surged to the planet's surface and hardened around 60 million years ago. Why the stresses induced by cooling and contraction of the molten rock should have generated so orderly a system of fissures puzzled scientists for a long time.

"Stress-relieving crack networks carve out some of nature's most spectacular fracture patterns."

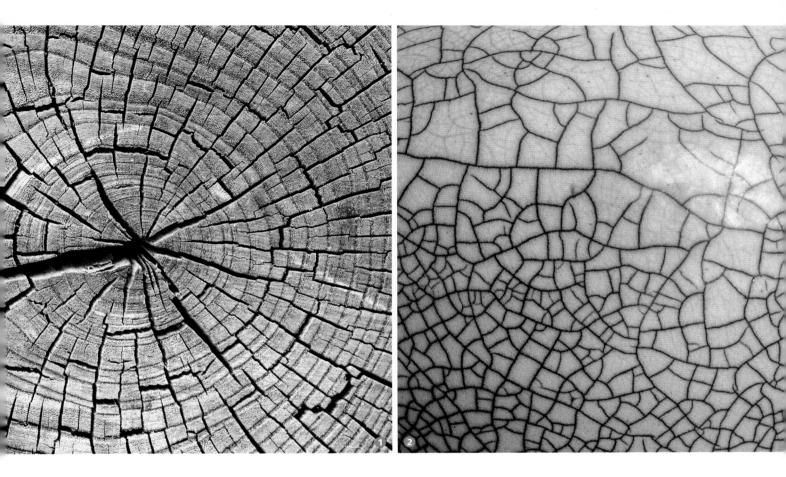

The key issue is that here nature gets time to experiment and refine the arrangement of cracks so as to gradually find the "best" (and most orderly) answer. Cracking appears first at the surface of the cooling rock, since it is here that the heat escapes most quickly and the molten material begins to harden. At first, the stresses that build up in the solid layer are relieved by fractures appearing more or less at random points, and the network looks rather jumbled. But as the cracks descend through the solidifying mass, the network adjusts to release stress more effectively. That happens when these cracks intersect in threes, with roughly equal angles between each of them—in other words, so that the junctions have the 120° angles characteristic of a honeycomb-shaped network of hexagons.

That's different from the case of a thin layer of glaze hardening on the surface of a pot, or of mud on a lake bed. For one thing, the cracks now are not just weaving horizontally across a flat layer, but are also descending through a thick slab of material as it cools or hardens. What's more, the pattern isn't constrained by the initial appearance of a few very long, smooth cracks, as it is in the glaze. For such reasons, hexagonal junctions are preferred over the right-angle junctions of *raku*. It's the same basic idea—how best to release stress caused by shrinkage—but the solution is different.

So as the crack network penetrates deeper down, it grows ever closer to an ideal honeycomb pattern. It never achieves that shape perfectly (many of the columns of the Giant's Causeway are rather irregular hexagons, and some have five or seven sides), because there's almost always a bit of disorder and randomness in the way nature makes its patterns. But the result is close enough to geometric perfection to astonish us. The topmost layers of the rock formation are far less orderly—but these will have been removed long ago by erosion. What now remains is one of the most striking tributes to the self-organizing powers of the natural world.

1 CRACKS IN WOOD
In old, dead trees, cracks caused by stresses in the dry and contracting wood radiate from the center, but they are also deflected sideways at the boundaries between different seasonal growth layers (the tree rings), where the wood fabric is relatively weaker.

2 GLAZED OVER
The network of cracks in pottery glaze is again caused by cooling and shrinkage of a thin layer, which sets up stresses. Here the process starts with some long, gently curving cracks, which are then interconnected by shorter cracks that generally join at right angles, producing polygonal islands.

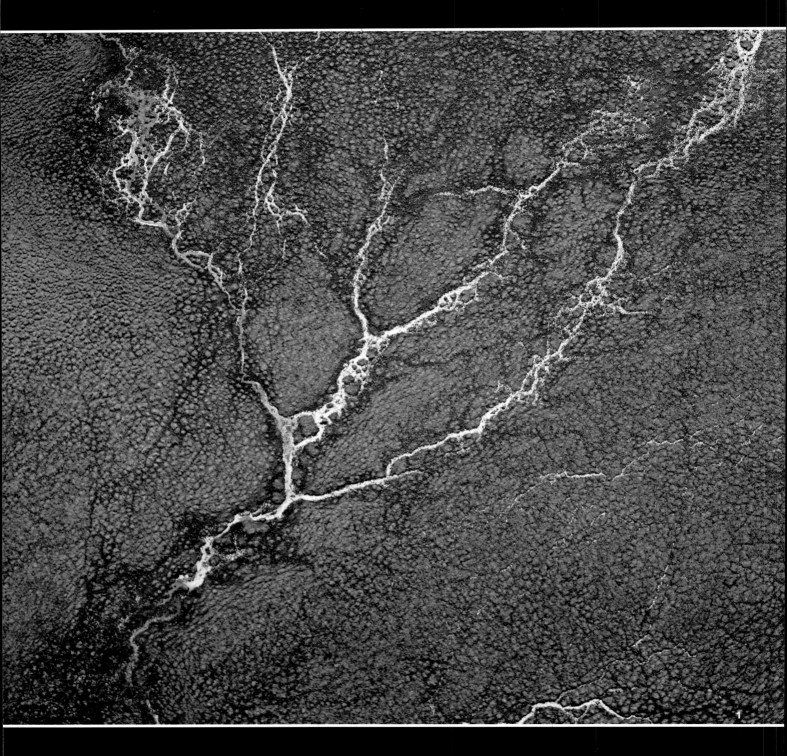

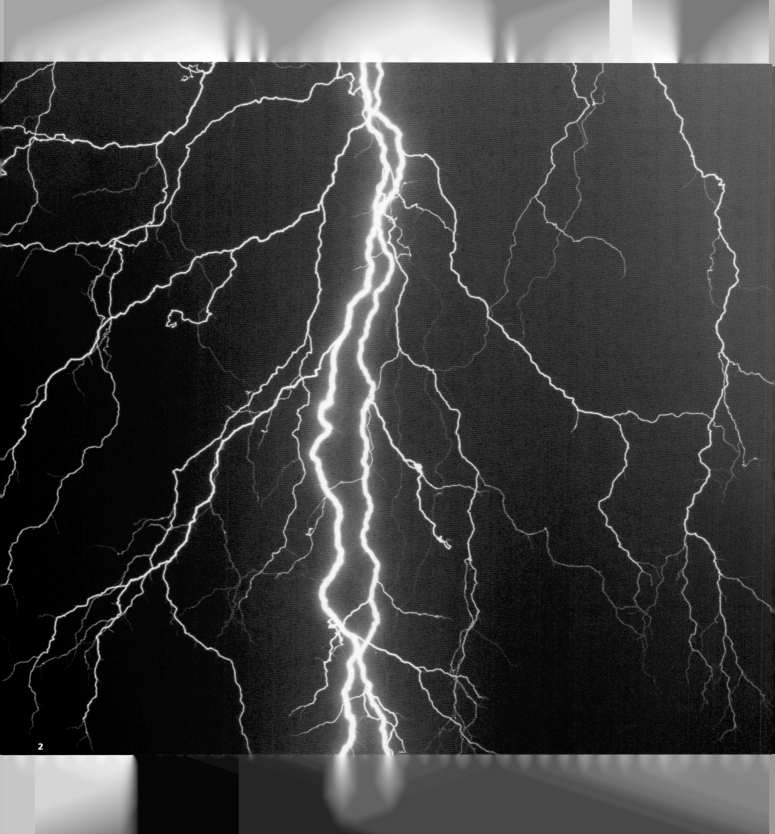

2

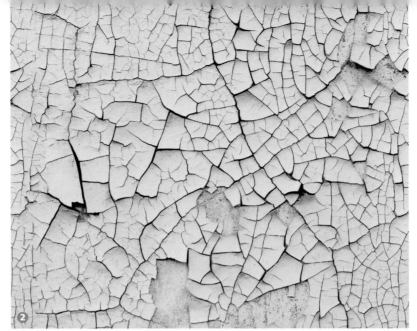

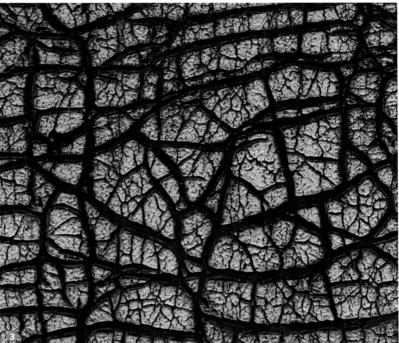

1 LAVA CRACKS

The initial stages in the formation of the Giant's Causeway probably looked a bit like this—a crack network forming in the crust of molten lava. The islands here are rather more diverse in size and shape than the polygons of the Giant's Causeway, but it's thought that the crack network gradually reorganized itself as it penetrated deeper to become more regular. The irregular top layers were then removed by millions of years of erosion.

2 and 3 FLAKING PAINT

As paint dries, the pigment particles are pulled closer together and the film cracks. The process is very similar to the cooling of a glaze film in pottery, and the pattern looks much the same, too.

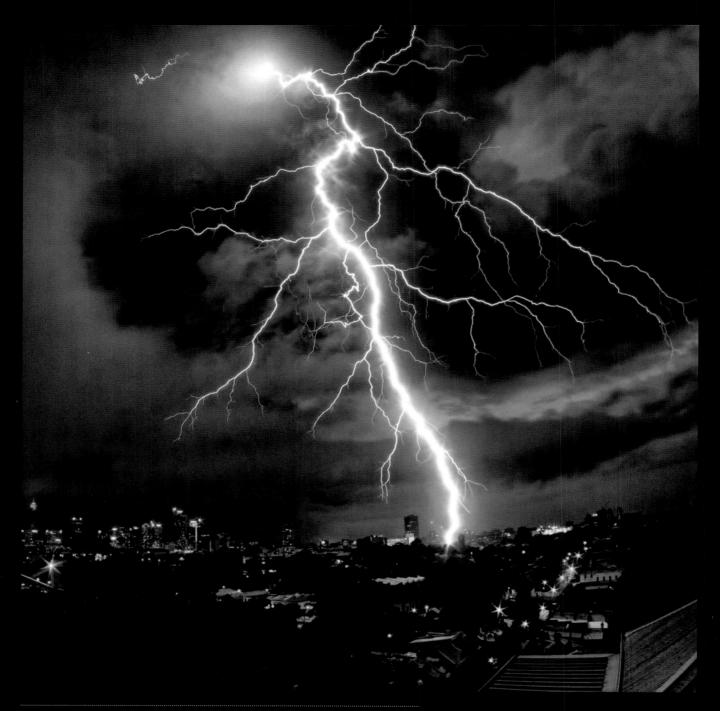

BRANCHING LIGHTNING

The forked branches of lightning are the result of another growth instability. As the electrical discharge passes through the air between the thundercloud and the ground, any small and random bumps at the tip become quickly amplified into a new branch, because the gradient of the electric field (how steeply the field changes over a given distance) is larger there and so the current is more likely to flow that way. As is the case for many patterns that experience these branching instabilities, the structure that results is a fractal.

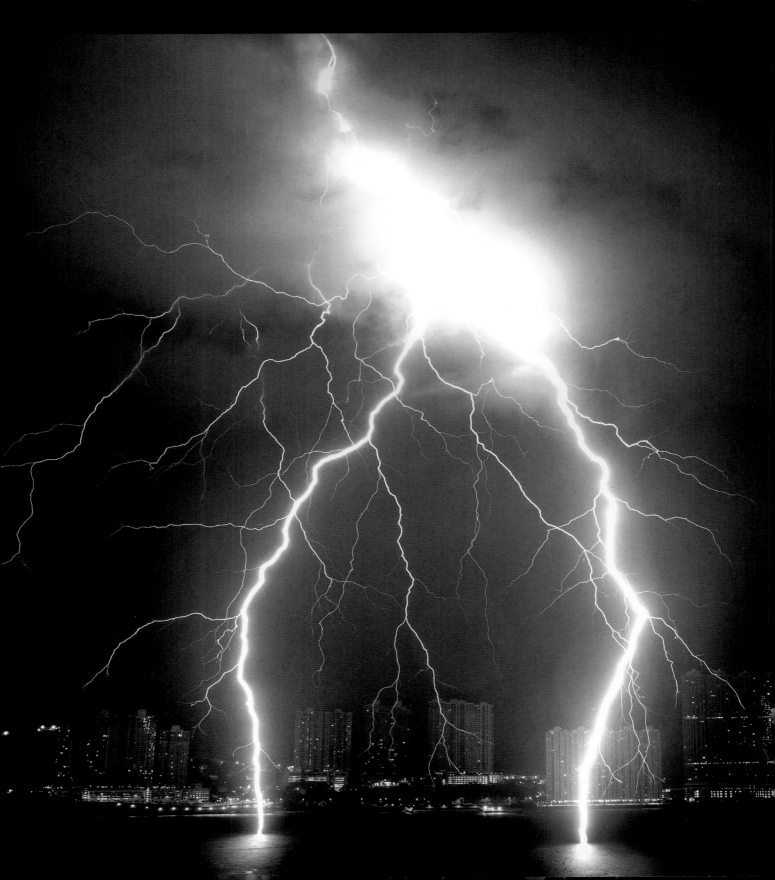

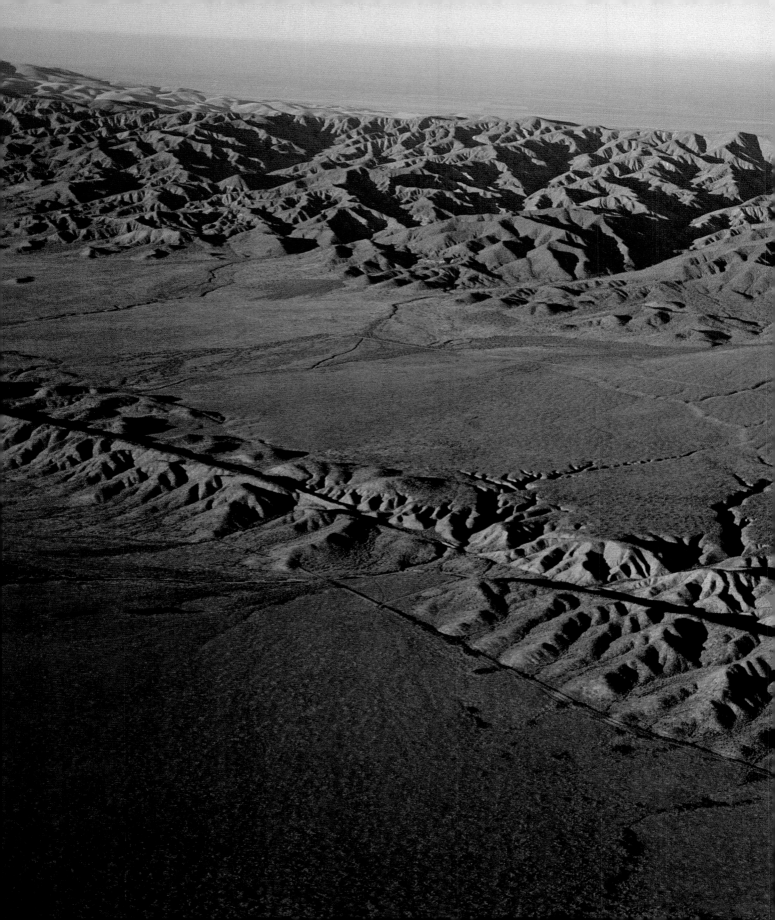

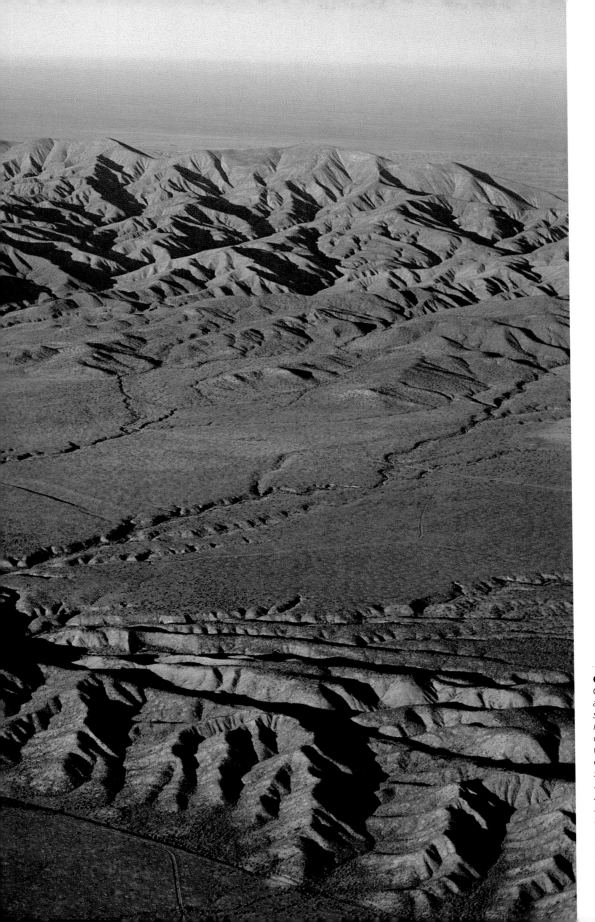

CRACKED CRUST
*Cracks may occur
at geological scales,
spreading over many
miles through the Earth's
crust in earthquake zones
where the movements
of tectonic plates create
stresses in the hard rock.
Such faults, like the San
Andreas Fault in California
shown here, are often
relatively straight and
unbranched. They are
cracks that extend deep
into the crust.*

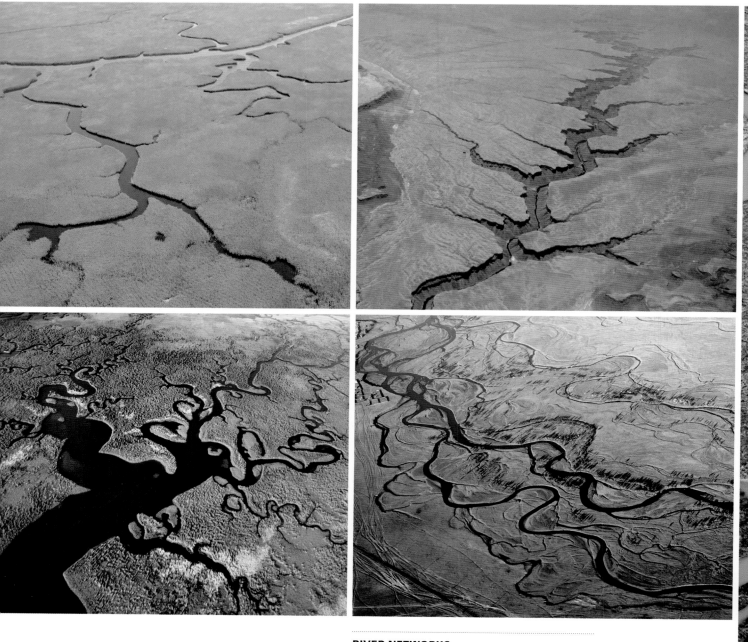

RIVER NETWORKS
These highly branched systems have more diverse and often more sinuous shapes than cracks in brittle material. That's because the pattern is produced from several processes operating at the same time, such as erosion and deposition of sediment (which combine to create river meanders). The shape might also depend on local differences in the strength and chemical nature of the underlying rock.

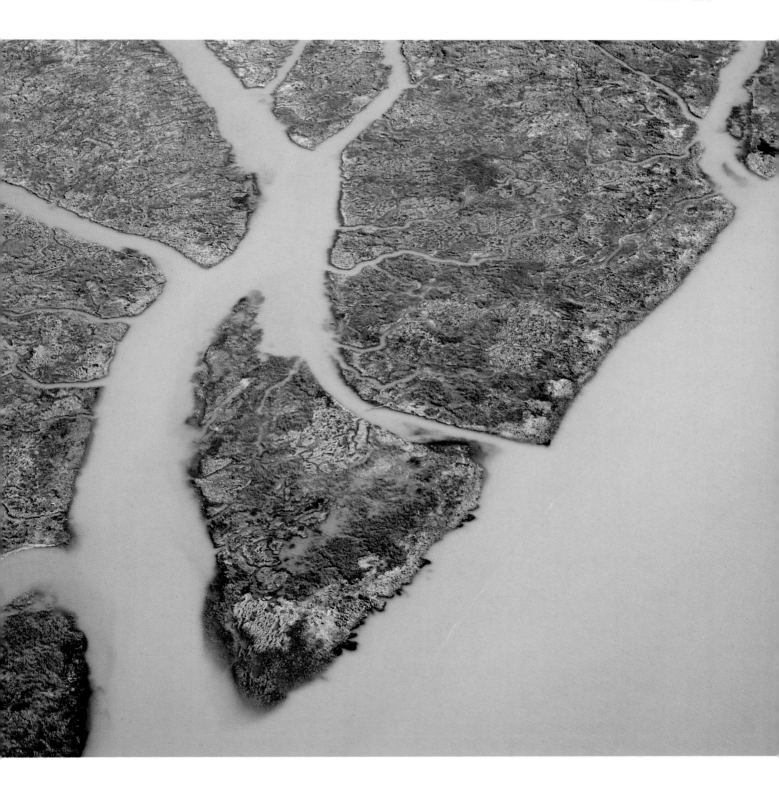

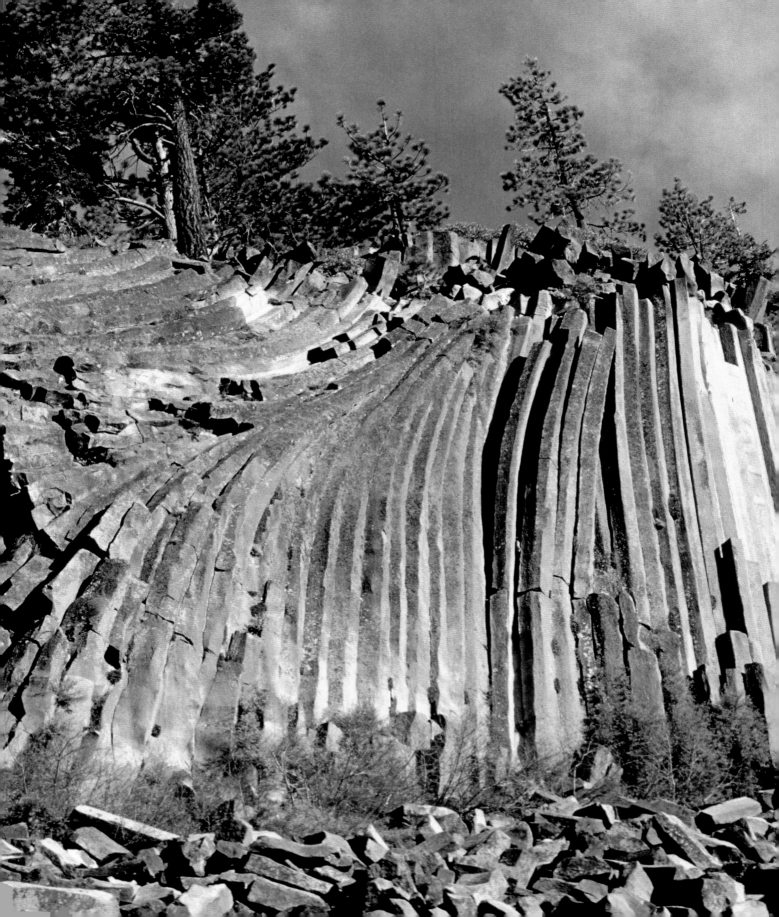

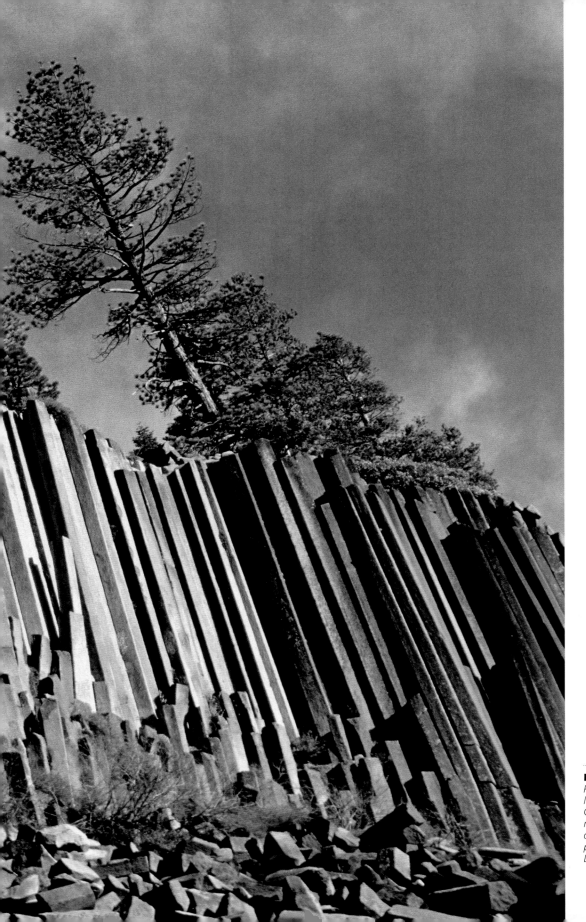

DEVIL'S POSTPILE, USA
Polygonal columnar cracks like those that produced the Giant's Causeway are rather rare in geology, but they do occur in a few other places—such as here, at the Devil's Postpile in California.

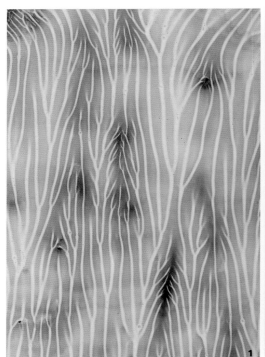

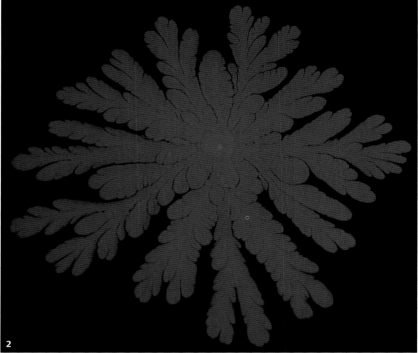

1 and 2 VISCOUS FINGERING

In this phenomenon, a less viscous fluid (such as air) is pushed or pulled under pressure into a more viscous one. When this happens, the boundary between the two fluids is subject to another branching growth instability: at any protrusion, the pressure in the invading fluid is greater, so it surges forward in a narrowing finger. Patterns like this are formed when a film of sticky fluid, like an adhesive or paint, between two flat plates is disrupted by pulling the plates apart, sucking air into the gap. The result is a tracery of fine channels, looking a bit like river networks (1). In some cases the fingering instabilty can be tempered by the force of surface tension, which acts to smooth a branch tip and make it less sharp. Then the pattern can become a series of thicker branches (2).

3 SINKING PLUMES

As a more dense fluid sinks through a less dense one, the blobs of the denser liquid split into fingers, which then split again and again, creating an inverted branching tree shape. This, too, is a process of viscous fingering, and can occur in the oceans when colder or saltier water sinks through warmer or fresher water below.

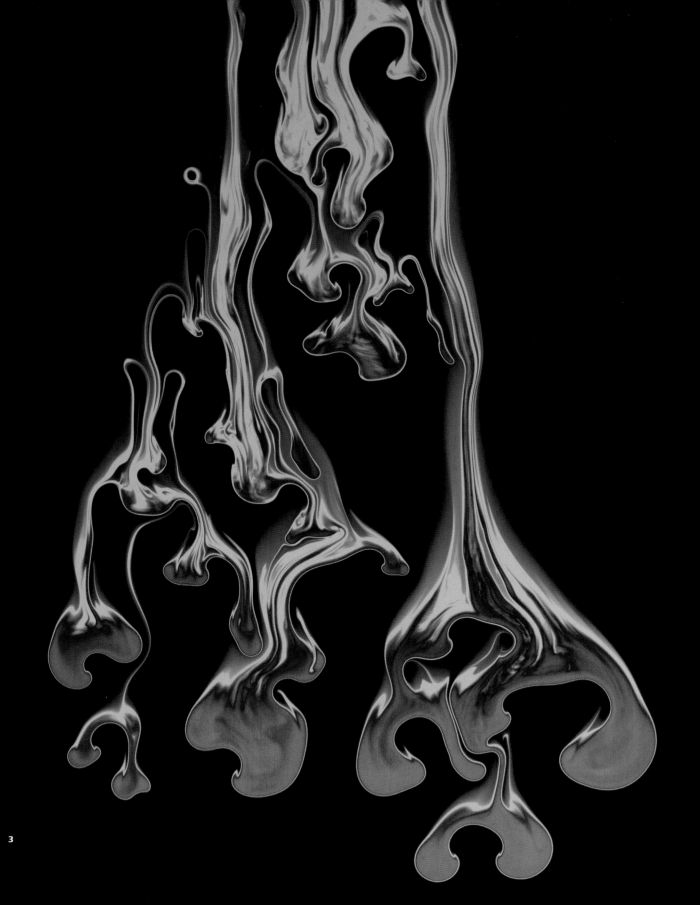

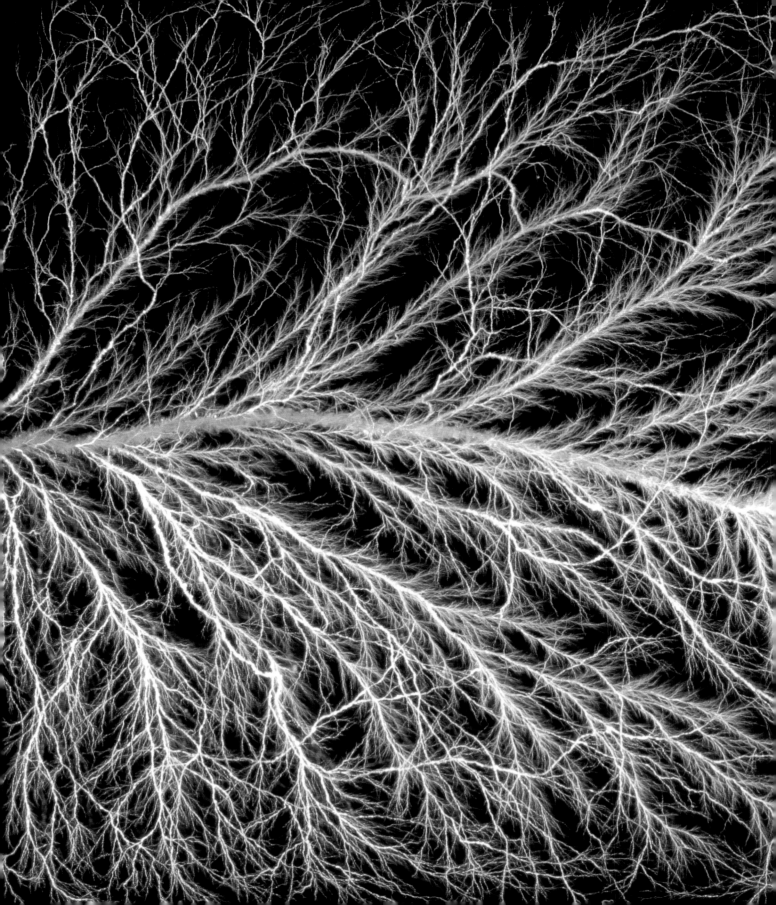

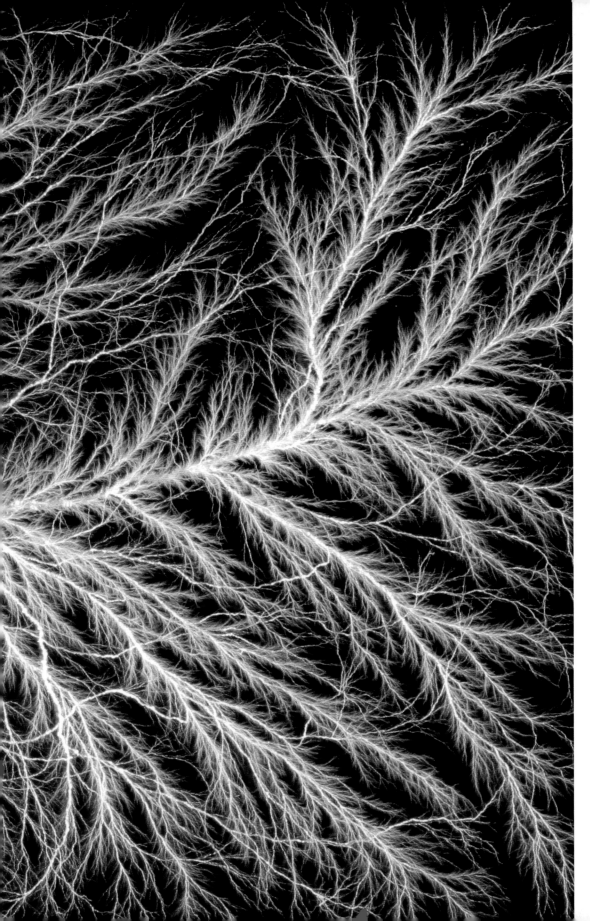

LICHTENBERG FIGURES
An electrical discharge passing through a solid block of transparent material can leave a trace of its lightninglike path as it cracks the material. Sometimes, dust or fragments attracted electrically to the crack surface make the structure more visible. These patterns are named after the eighteenth-century German scientist who first described them.

9 | SPOTS & STRIPES

How the zebra paints its coat

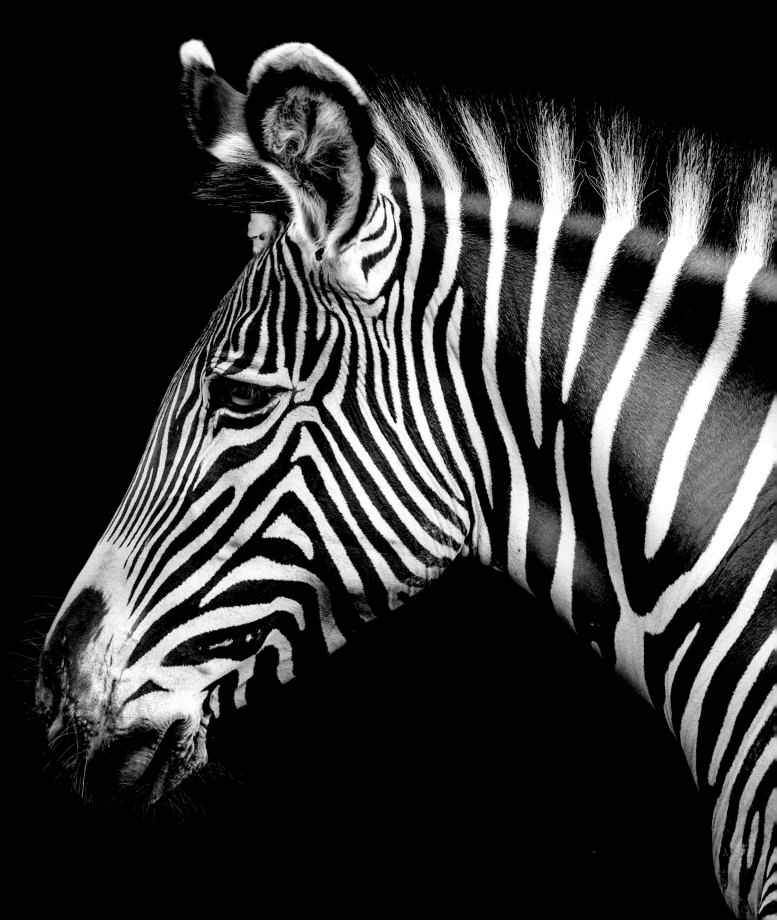

Rudyard Kipling explained in his *Just So Stories* how the leopard got its spots and the zebra its stripes. His answers were wholly fanciful, but at that time scientists could do little better. It was one thing to explain *why* animals have markings—for camouflage, for example—but quite another to explain *how* that comes about as the creature grows. The explanation now widely accepted is that these patterns are produced in a process of self-organization that also operates in very different kinds of natural phenomena. It finds analogies in the way sand ripples form or animals arrange their nests in colonies. In other words the description is, in the end, a mathematical one that doesn't depend on biological particulars, even if it is adapted and fine-tuned by natural selection.

Animals are exquisite masters of pattern, but they seem to follow particular fashions. The stripes of the zebra are a popular design: as you'd guess, the zebrafish has the same idea, and so does the angelfish, the tiger, some antelopes, frogs, caterpillars, and other creatures. Another favorite is spots, sported by the leopard, the spotted eagle ray, the ladybird, and the red spotted toad. Butterflies seem to recognize no limits: their patterns are dazzling, sumptuous, and seemingly endless.

It's not always easy to say what these patterns are for. The usual assumption among biologists and zoologists is that, if evolution has gone to the trouble of making an animal patterned, there's a reason for it that somehow works to the animal's advantage: in other words, it is a Darwinian adaptation that helps the creature to survive and therefore to reproduce. Maybe it's a warning signal to fool or deter predators. Or perhaps it helps members of the same species to recognize each other, or to impress the opposite sex in mating displays.

But although it seems likely that most markings do have an adaptive function like this, we can't always be sure what that function is. Evolutionary "explanations" for markings may come all too easily; evidence for them is harder. Take the zebra. It seems obvious that the stripes must help it to hide in the shadows, right? But zebras spend most of their time on open grassland, not among trees and bushes. And if stripes help you hide from predators like lions, why don't all their prey have them? The zebra's stripes might not be a form of camouflage at all, but could deter biting flies, or regulate body heat, or something else. We just don't know. It's the same story with wild cats; it's true that there are more spotty and mottled ones in habitats that create a mottled, patchy background, but there are exceptions, too.

And even if these patterns on skins, pelts, and scales do have some evolutionary function, that doesn't completely answer the question of where they come from. How does any particular zebra embryo get imprinted with stripes of pigment-producing skin cells, which produce dark hairs in some places but not in others? Until half a century

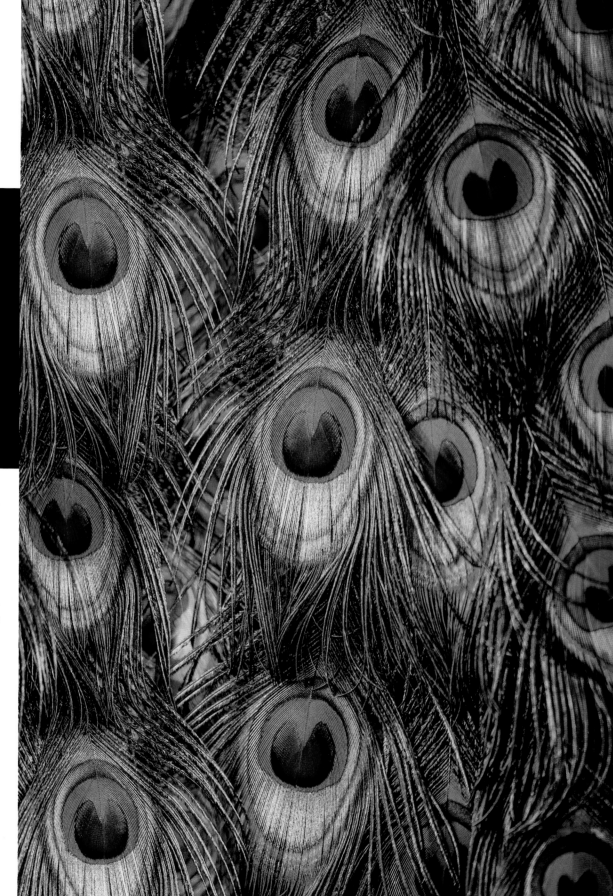

LOOK AT ME
Animals have markings for all kinds of reasons. Some markings make them inconspicuous, others—like the peacock's tail—have quite the opposite effect. The striking "eyespots" of the peacock's tail feathers are part of a sexual display, an exhibitionist effect that is designed to capture the attention of potential mates.

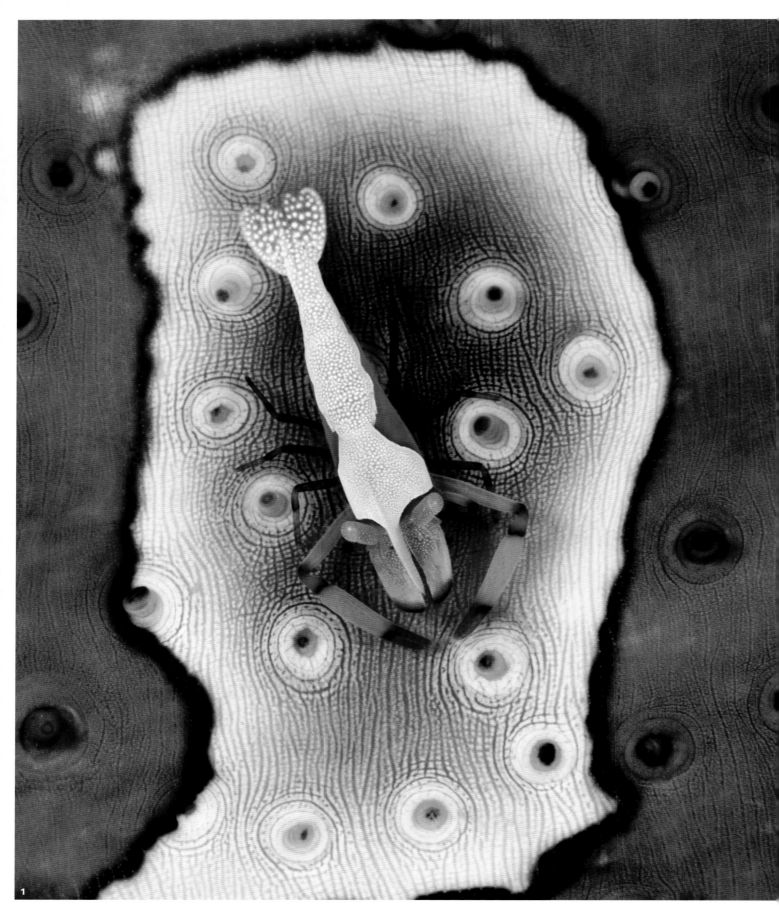

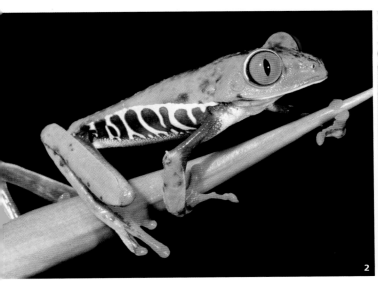

2 | 3

1 EXUBERANT DESIGN
The emperor shrimp on a leopard sea cucumber.

2 COMPARE AND CONTRAST
The stripelike markings of the red-eyed tree frog, native to Central America, look like dripping paint. The markings are covered by the green legs when the frog needs to camouflage itself against leaves.

3 BREAKING UP
The stripelike marking patterns on this sea slug are punctuated by rows of dots, where the pigmented structures break up rather like the way a jet of water fragments into droplets.

ago, we had no idea. But now we do—for spots and stripes can be created by clever chemistry.

Breaking out in pattern

The British mathematician Alan Turing offered the first theory of how animal patterns are formed. Turing is best known for his work on the notion of programmable computers and for his code-breaking exploits for the Allies at Bletchley Park during World War II, now made famous by the movie *The Imitation Game*. But his inquisitive mind took him down all kinds of paths, and in 1952 he described a theory of how embryos develop from a simple, spherical egg into a patterned body with organs and limbs. That question led Turing to discover one of the most lovely and versatile patterning processes in nature.

Turing imagined the embryo as a ball of cells full of biochemical ingredients that are drifting through the cell liquid and reacting with each other to turn on or off genes that control how particular cells will develop. He showed how such a soup of chemicals could spontaneously lose the blandness of a uniform mixture and adopt a patchy structure, with more of certain ingredients in some places than in others.

The key is feedback. What if, Turing said, some chemical reactions make substances that speed up the reaction that actually produces them—if they are, in other words, auto-catalysts? This can create a runaway effect, in which tiny, chance fluctuations in the concentration of the ingredients can become blown up into big differences, so

that the mixture becomes spontaneously patchy. On their own, auto-catalysts would multiply until they overwhelm the whole mixture. But in Turing's soup there were two kinds of ingredients, which he called morphogens ("shape formers"). Today researchers call one of these an activator, since it is auto-catalytic and boosts its own production, and the other an inhibitor, since it suppresses this self-amplifying growth of the activator. Molecules of the two components spread through the mixture like ink in water, but in Turing's scheme the inhibitor spreads faster than the activator.

When he wrote down and solved the equations describing this activator-inhibitor scheme, Turing found that blobs of activator may grow in some places, more or less at random, but constrained within little islands, separated by the effect of the inhibitor. He remarked that they looked like the dappled markings on some animals. Later, when Turing's equations could be solved by computer, it became clear that they generally produce two types of pattern: arrays of spots and stripes, all about the same size and spaced by the same distance, and arranged in a more or less orderly fashion. We now know that Turing's chemical patterns are a variation on the reaction-diffusion schemes described in Chapter 5, which generate chemical waves. In Turing's theory, the waves are "frozen" in place; they are stationary.

Whether or not Turing's theory told us anything about how embryos grow, it seemed to offer a good explanation for how animal markings—the spots of the leopard and the stripes of a zebra—

form. The idea is that there are biochemical morphogens produced in the skins of these creatures as they develop in the womb, which drift from cell to cell acting like Turing's activator and inhibitor. Where there's a lot of the activator, it can throw a genetic switch to turn on pigment production, and the pattern gets laid down in the embryo. As the animal grows, the pattern expands.

It wasn't until 1990 that researchers in France succeeded in making Turing patterns experimentally in a mixture of chemicals. Today there are various chemical recipes for making a wide range of Turing patterns based on spots and stripes. Some are almost crystallike in their regularity, while others are fabulous jumbled labyrinths. With some care in arranging the initial distribution of the activator and inhibitor, you can make a vast galaxy of different patterns.

Animal tales

Since the 1980s, researchers have shown how mathematical models of biochemical pigment patterning using Turing's ideas can produce the variety of markings we see in real animals. Zebra-style stripes are fairly easy to make, but many markings are more complicated. The leopard's spots, for example, are a little like clusters of fingerprints—not a single dark splodge, but groups of perhaps four or five blobs arranged like black petals around a central brownish patch. The jaguar's spots are still more complex: dark rings with a few little blobs in the center. And the giraffe doesn't so much have dark spots as an entirely dark pelt threaded by a network of unpigmented hairs, a bit like the pattern of cracks in dry mud.

With a bit of ingenuity, all of these patterns can be generated by Turing-type activator-inhibitor processes, although sometimes they need more than two ingredients. What's more, these mathematical models can explain how the patterns depend on the shapes of the bodies they cover. Spots on a large patch of fur, for example, might turn into stripelike bands on a tapering tail, as they do for some wildcats. Whether ladybird

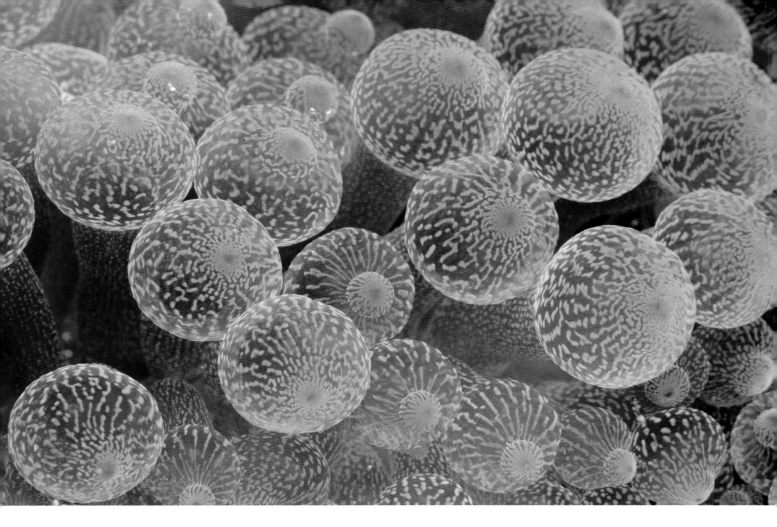

species have spots or stripes, and how big they are, may depend on how curved their domelike wing-covering shells are. And the mathematical models can mimic the kind of "unzipping" of stripes seen on the angelfish as it grows.

After reading Turing's paper on chemical patterns, the eminent biologist Conrad Waddington wrote to Turing to suggest that his theory might explain butterfly wing patterns. With their array of spots, stripes, chevrons, and other shapes, they seem like an obvious candidate. But it now appears that the process here is more complicated, involving a delicate interplay between diffusing biochemicals that act rather like morphogens, the vein structure of the wings themselves, and the complex genetic mechanisms that control the organism's development. In other words, they aren't exactly Turing patterns, but they are probably related. The idea is that the butterfly wing contains various "sources" and "sinks" of the morphogens— places where they are produced and destroyed, ultimately controlled by "patterning genes." Depending on how these sources and sinks are arranged, all the common pattern elements in butterfly wings can be mimicked in mathematical models.

All this is a good sign that Turing's process for producing animal markings is on the right track, but it's not yet proof that the idea is right. To prove it, we would need to find the actual biochemicals that act as morphogens of pattern formation. No one has yet managed to do that for pigment patterns. There is, however, pretty good evidence that several other biological patterns are made by the same kind of activator-inhibitor process: for example, the regularly spaced hair follicles of mice (and perhaps ours, too), the series of parallel barbs in bird feathers, the dunelike ridges in the mouth palate of mammals, and the stripelike segmentation of hands and feet in mammal embryos that leads eventually to the formation of the fingers and toes. It's possible that something like a Turing process of reaction and diffusion of morphogens happens in

PATCHY STRIPES
Patterns on the tentacles of a sea anemone from the Maldives.

plants, too, where it might produce the regular arrangements of leaves around a stem or florets and seeds in a flower head (see Chapter 3). That's a possibility that Turing himself foresaw.

And Turing's patterns might reach further still, into whole communities of organisms. The basic ingredients are, after all, quite simple: you need a process that amplifies itself by positive feedback and another process that inhibits this, both of which must spread throughout the system at different rates. Given these elements, the patterns that emerge are likely to be more or less the same in every case. In the semi-arid regions of Africa and the Middle East, you can find grass covering the dry ground in labyrinthine patches that look like the convoluted designs seen on some fish. The grassy patches are sustained by their ability to capture the water flowing over the land after rare bursts of rain: a clump of grass can accumulate run-off water at the cost of depriving the ground around it. A mathematical model of this process suggests that on sloping ground where the flow goes one way, the result should be stripes of vegetation, whereas on flat ground the flow is controlled more by random little topographical bumps and the pattern is more spotty. These models also predict—and observations of nature seem to confirm it—that the pattern can change from spots to interweaving stripes to carpets punctured by holes of bare ground, as the amount of rainfall increases.

The self-organized world

Turing's theory has been proposed as an explanation for patterns as diverse as the arrangement of "ant cemeteries" (where ants deposit the dead bodies of their peers), the arrangements of sand ripples in deserts, and the patchiness of plankton communities in the oceans and of crime incidence in cities. It seems likely to be one of nature's universal principles for converting bland uniformity to interesting,

sometimes useful, often beautiful patchiness. It's not too fanciful to say that it is a means by which nature exercises her creativity.

And it's a classic example of self-organization: how a system consisting of many components all interacting with one another according to some generally simple rules can become spontaneously structured into a complex design. In Turing's original theory these components were the morphogen molecules, which move around and react with each other. But they can also be grains of sand, plants and water, entire animals. So while Turing wrote down his theory in terms of equations that described what was happening to the morphogens everywhere, all at once, each component of the system really only needs to "know" about its own local environment: all it sees are its neighbors, and all it does is follow the rules in interacting with them. One particular set of interaction rules produces the static patterns that Turing described. Other rules can give different structures, such as the flocking motions of birds and fish.

This seems to be how much of biology works, whether at the level of molecules interacting to build a creature or of whole communities of such creatures building their habitat. By using chemical pheromones and other signals, for example, termites coordinate with one another to construct towering nests out of mud and spittle, taller in relative terms than our own skyscrapers, and laced with chambers for the queen and her eggs, "gardens" for growing fungal food, and passageways that allow for ventilation. No one plans these edifices; they "build themselves" as each termite labors away on its own little part. We, too, do this; our cities are best considered as organisms or ecosystems themselves, with their own metabolism, transport networks, and patterns. No one, on the whole, plans them; they have an organic vitality, but they can also sicken and decay. That's why we need to understand self-organization: it's what we depend on.

BODY MATH
This Christmas tree worm (Spirobranchus gigantus), a marine spirochaete found in tropical oceans, has a body plan of ornate yet almost mathematically regular design. How does such organized structure arise in a living organism?

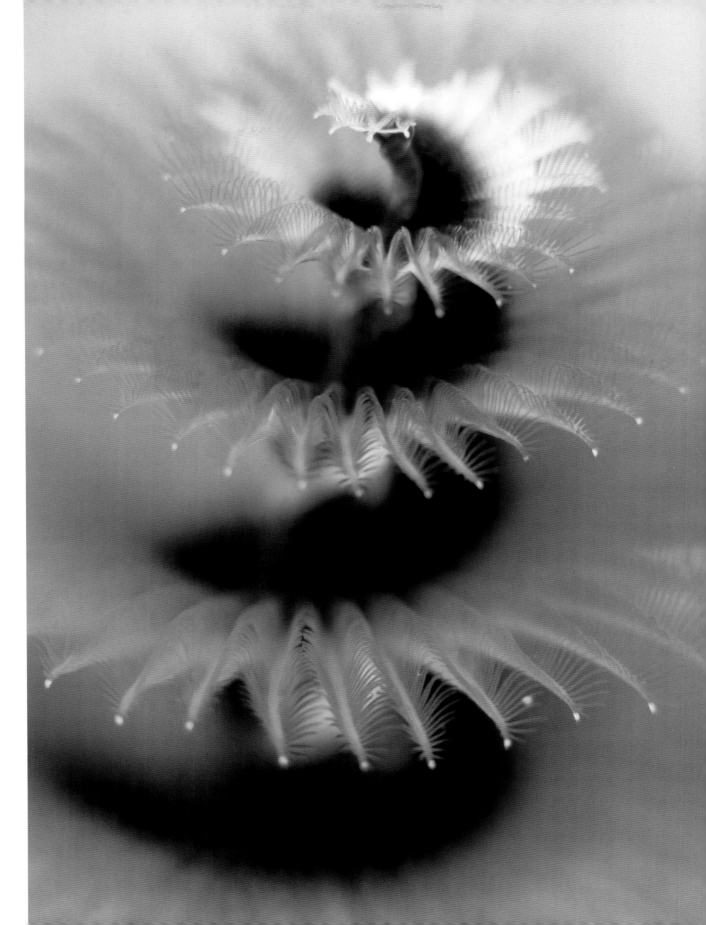

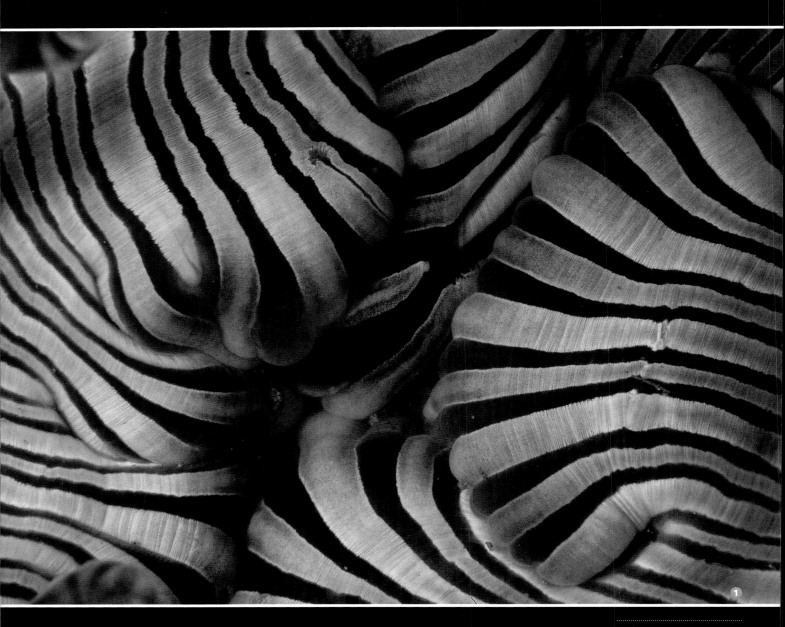

STRIPES
One of nature's universal
marking patterns, seen
here in an Indo-Pacific sea
anemone (1) and a herd of
Burchell's zebras (2).

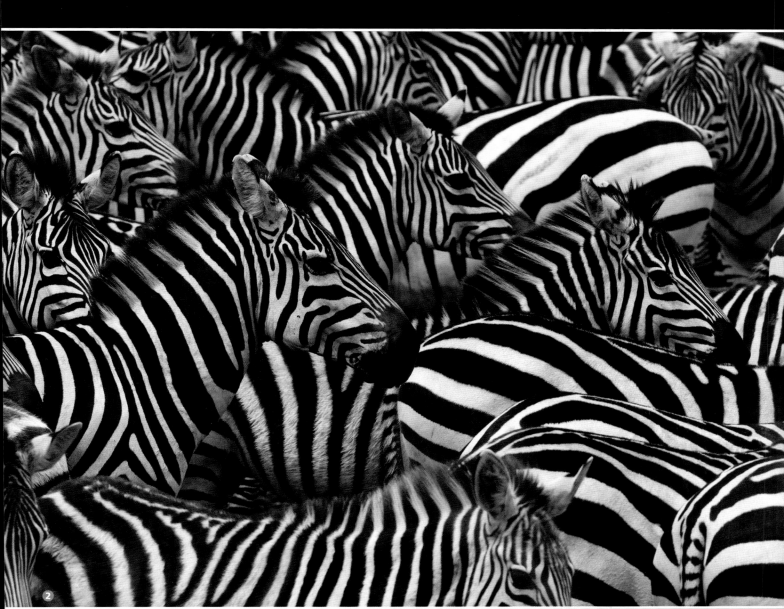

2

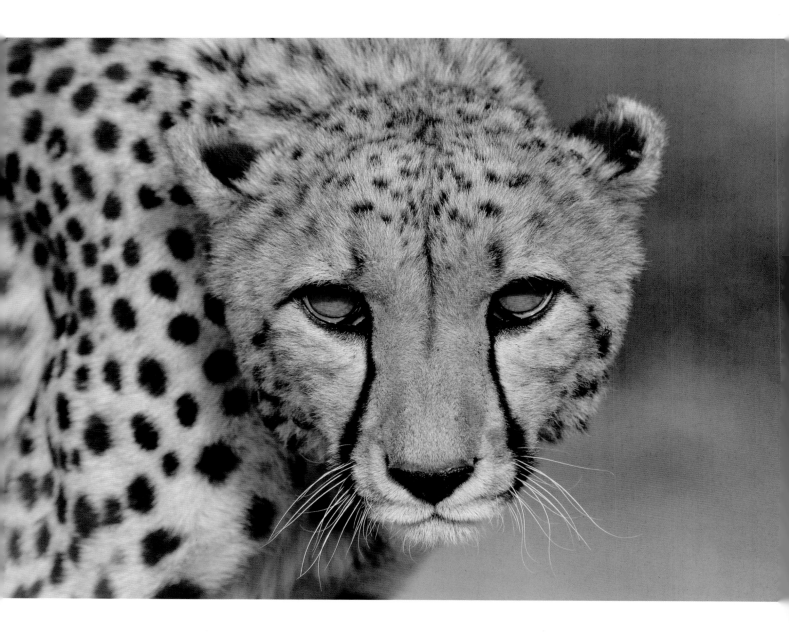

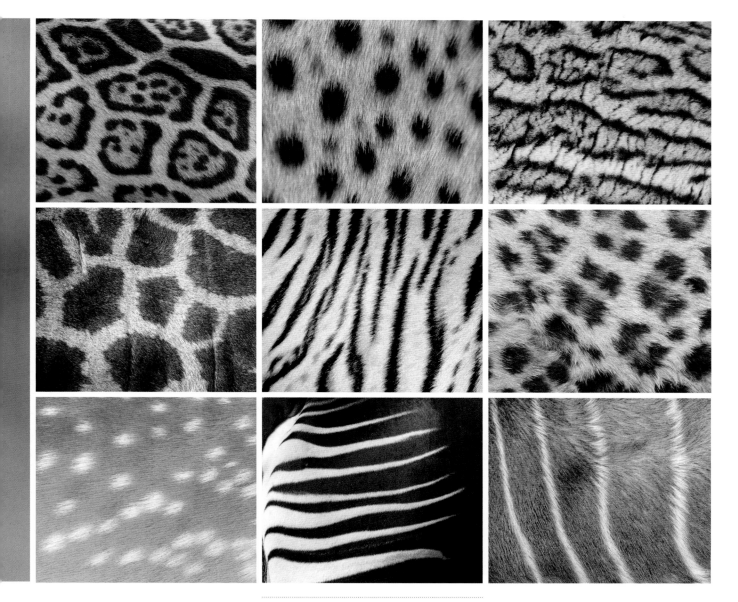

MARKED FOR LIFE

Pelt pigmentation on large mammals comes in a range of patterns, from spots and stripes to rosettes and polygonal networks. But all may stem from the same basic biochemical patterning process.

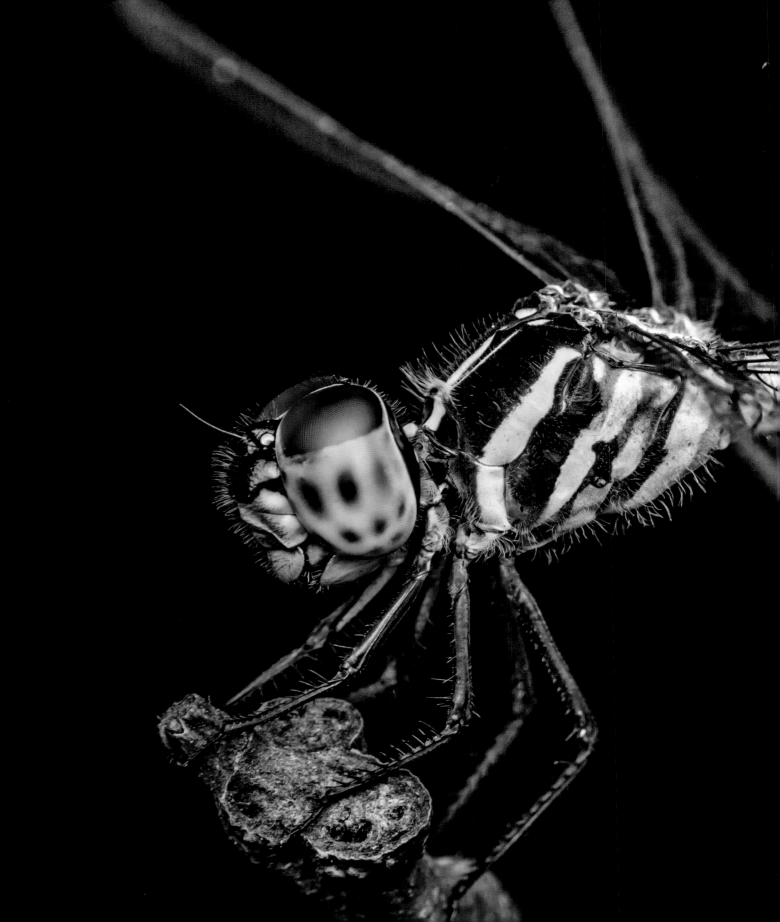

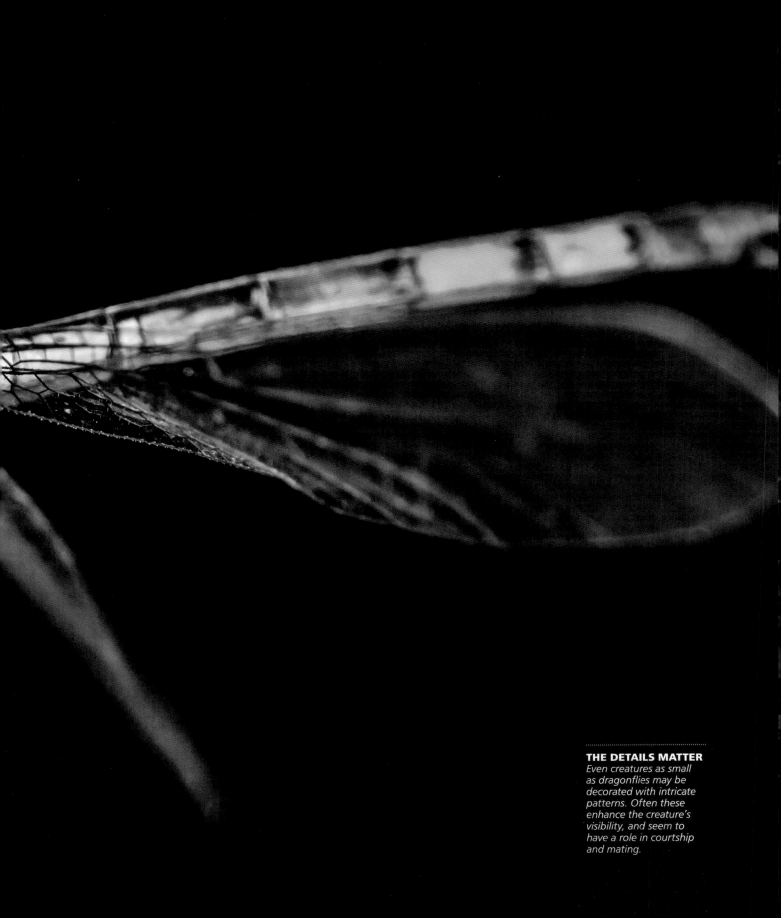

THE DETAILS MATTER
Even creatures as small as dragonflies may be decorated with intricate patterns. Often these enhance the creature's visibility, and seem to have a role in courtship and mating.

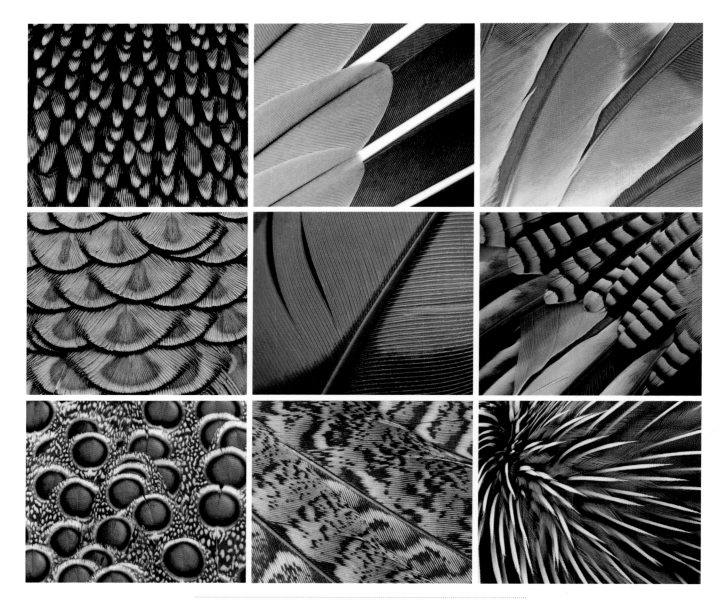

THE ART OF PLUMAGE

Bird feather patterns are among the most glorious displays in nature. Some of the colors here, especially the greens and blues, are not created by pigments, but by microscopic, regular structures in the barbs that reflect light of particular wavelengths—rather like the tiny ridges of butterfly wing scales. The colors are established during feather growth, before the nascent feather gets divided up into separate barbs, so that the pattern is continuous from one barb to the next. The regularly spaced rows of barbs are themselves also thought to be produced in a biochemical patterning process.

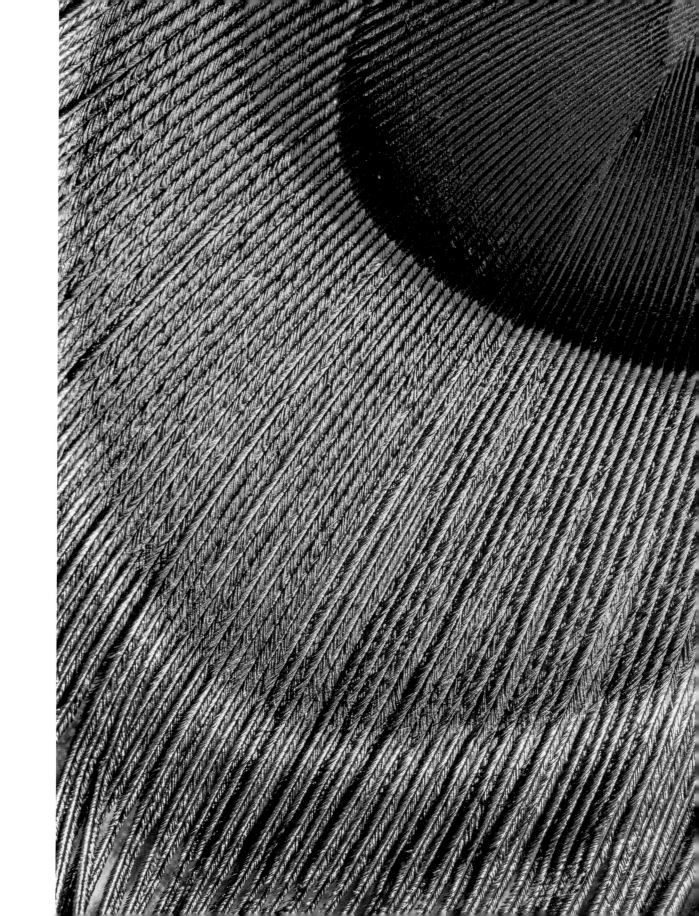

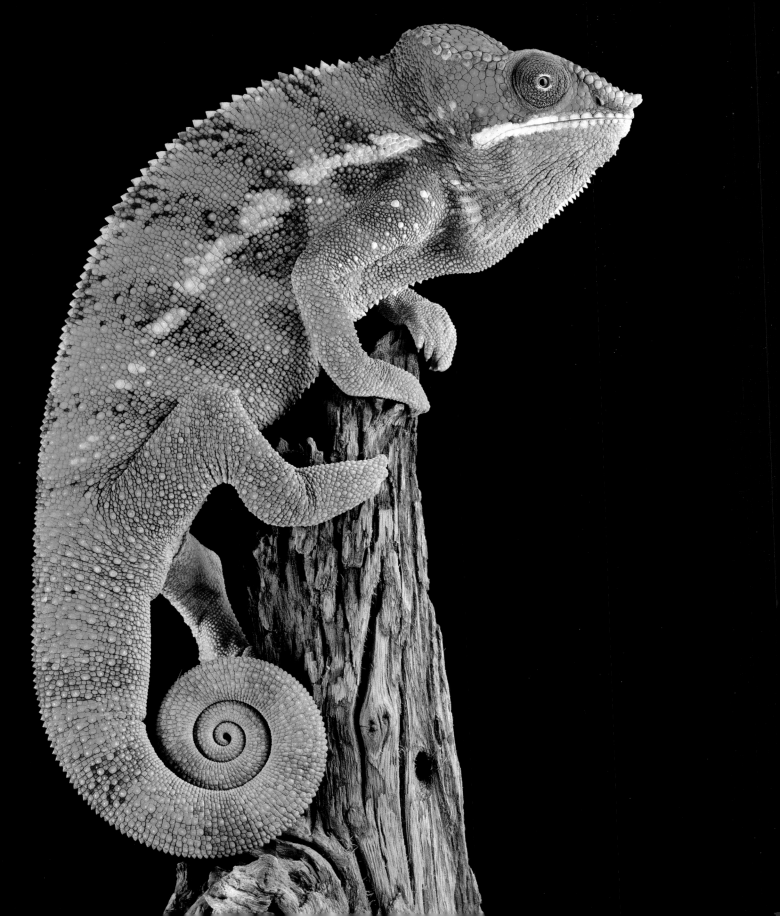

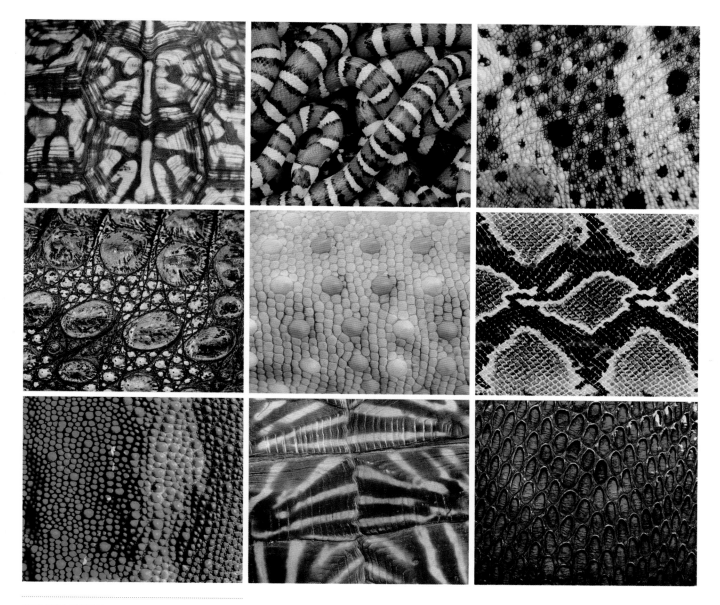

OFF THE SCALE

Reptiles and amphibians can sport particularly colorful markings. Some are picked out, pointillist style, in different-colored scales, as on some snake skins. Note that the underlying texture of the "canvas" is also characterized by a regular, almost geometric pattern: the polygonal divisions of a turtle shell, the tilelike arrays of scales, the warty bumps of a chameleon's skin.

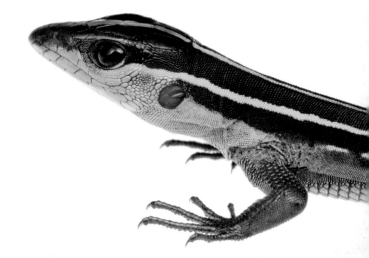

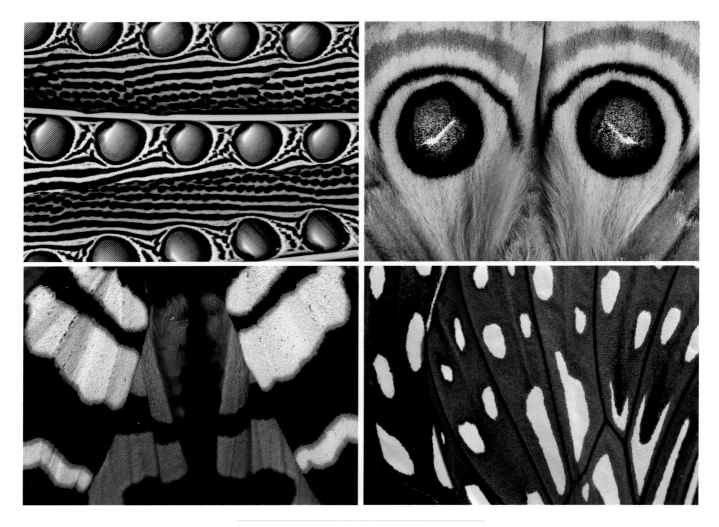

ON THE WING
*Butterflies (and sometimes their caterpillar precursors)
make inventive use of a small palette of pattern
elements, such as eyespots, chevrons, stripes, and
outlinings of veins. These are rearranged to suit many
purposes—for example, warnings to deter predators,
camouflage, mimicry, and species recognition.*

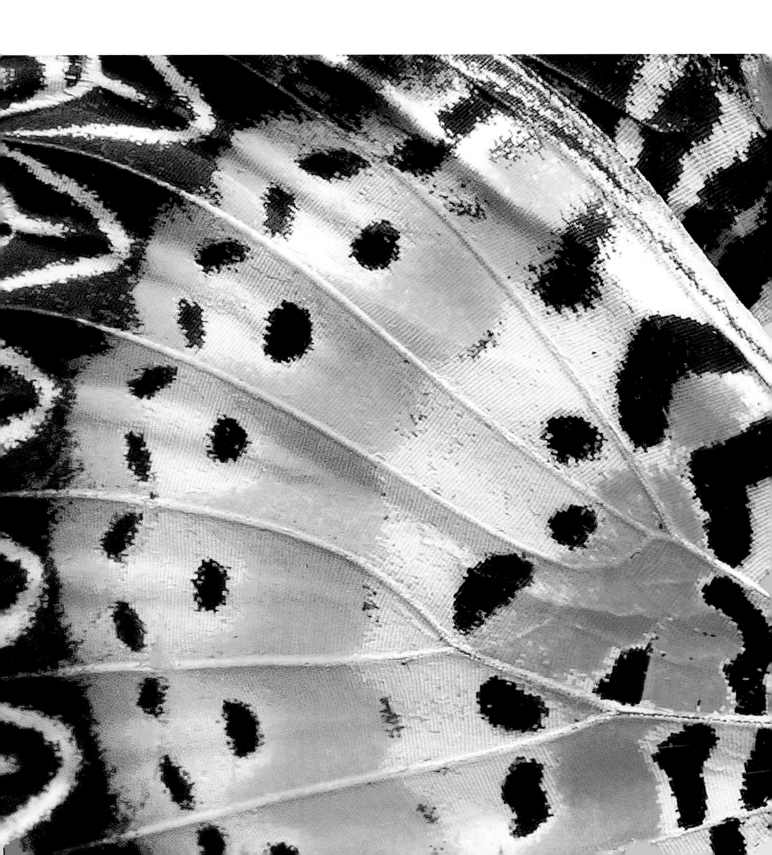

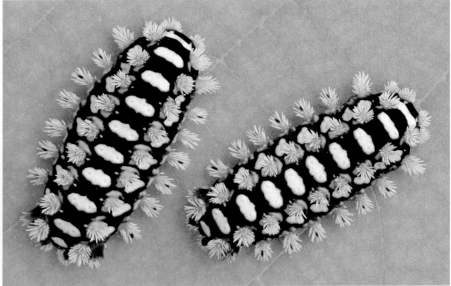
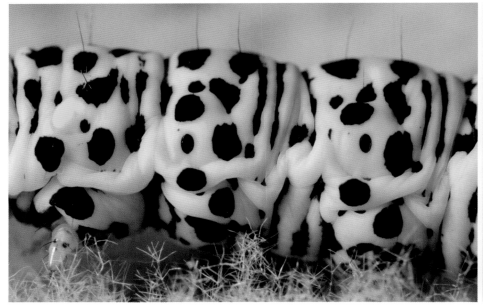

AGAIN AND AGAIN
Many insects have segmented bodies; on each segment a particular pattern might be repeated more or less identically.

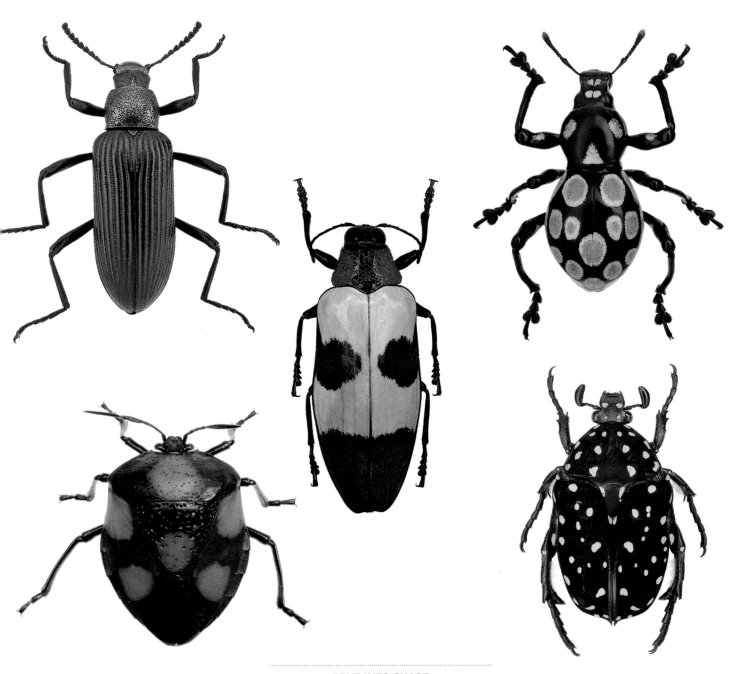

BENT INTO SHAPE
*The chemical patterning process outlined by
Alan Turing seems likely to underpin beetle
and weevil markings, where it observes precise
bilateral mirror symmetry. These patterns seem
to be constrained and shaped by the small size
and the curvature of the carapace.*

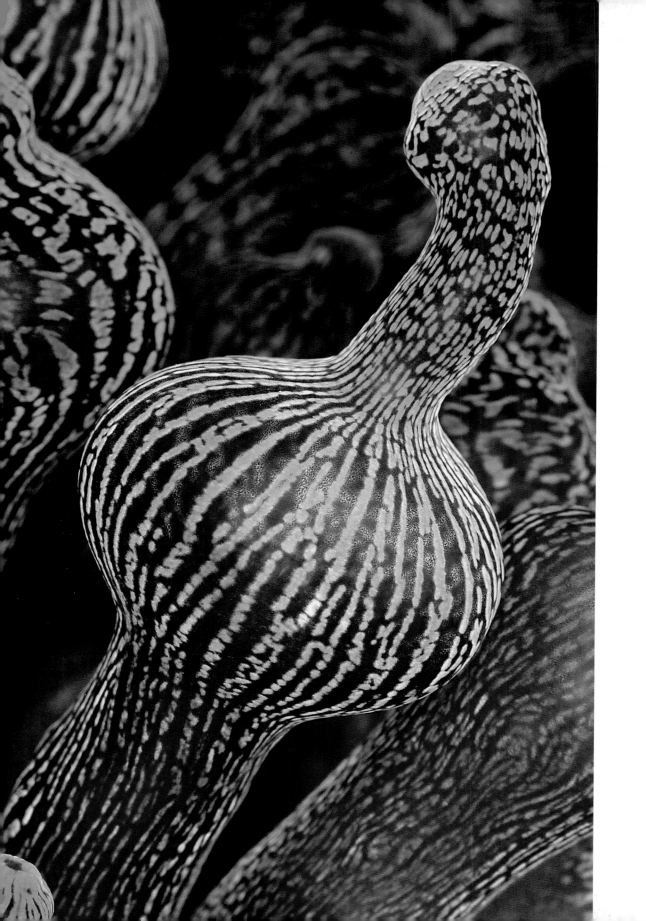

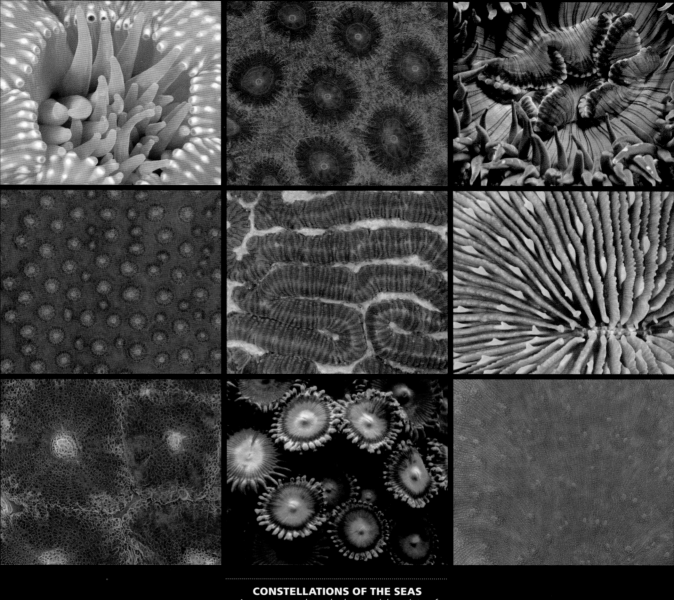

CONSTELLATIONS OF THE SEAS
Anemones and corals show a rich variety of
shape, pattern, marking, and texture. Some
of the regularity is produced by wrinkling and
buckling during growth, some is precisely
specified in the body shape by genetic
instructions, and some comes from self-
organization of the pigmentation.

SUBMARINE RAINBOWS

The markings on fish typify the generic spots and stripes of Turing patterns, although these may be elaborated or modified into more flamboyant designs.

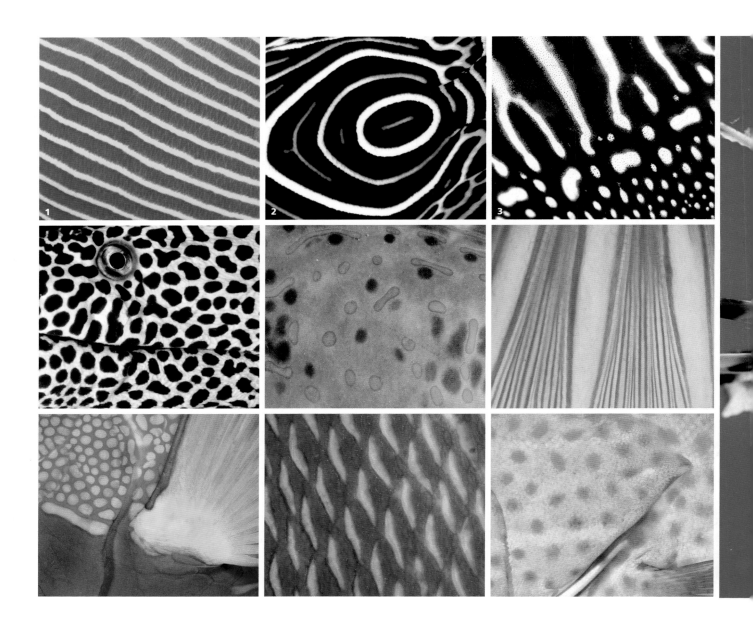

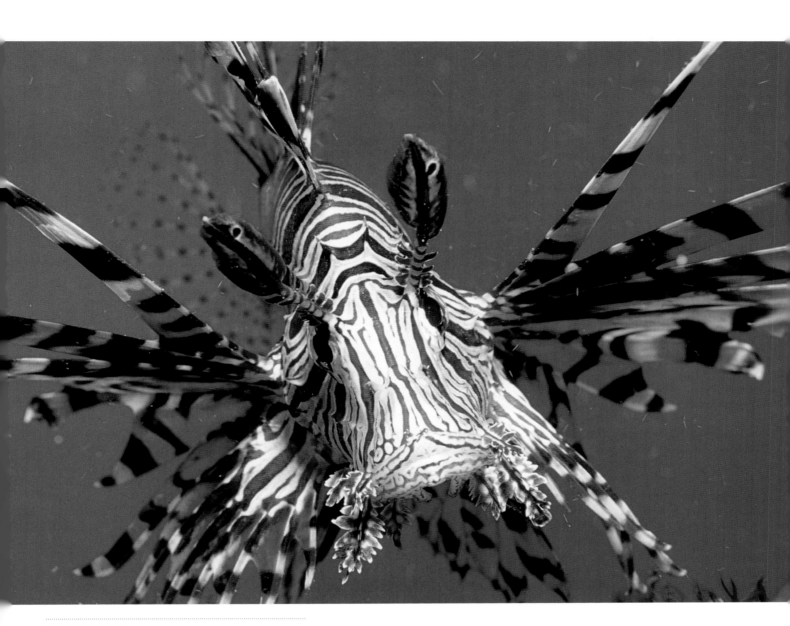

DEEP DESIGNS
*Some markings on fish are highly orderly, such as that
of the emperor angelfish (1). But the pattern produced
by a single Turing-type biochemical process might
change as the boundaries of the "canvas" change, so
that, for example, stripes might break up into spotty
markings at an edge (3). Some of these marking
patterns continue to develop and shift as the fish
grows, so that more stripes appear rather than a fixed
pattern just expanding with increasing body size. That's
what happens, for example, for the angelfish (1 and 2).*

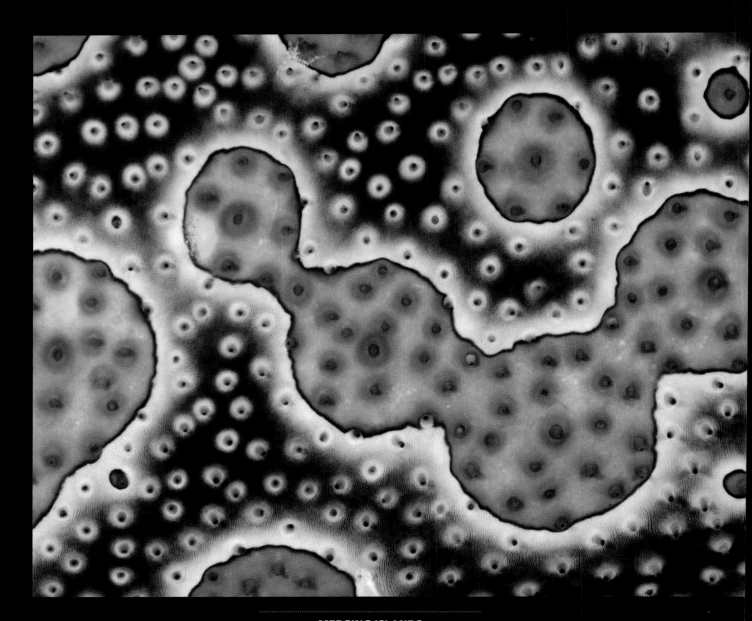

MERGING ISLANDS
The skin of the leopard sea cucumber is marked
by roughly circular islands that may merge
via narrow necks if they are close enough—
looking like cartoons of dividing cells. The
black borders, bright "coastal waters," and
superimposed eyespots make this pattern seem
all the more surreal, like the map of a strange,
crater-pocked planetary surface.

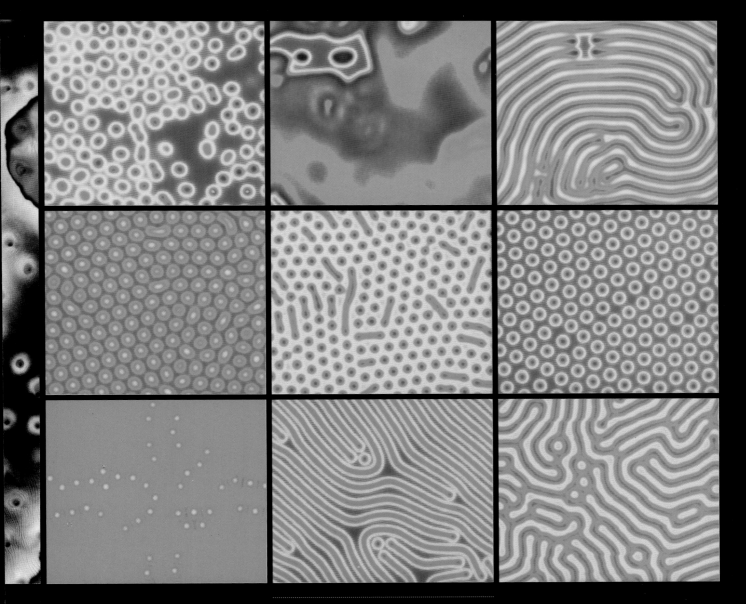

CHEMICAL MAZE
These patterns, produced in a Turing-type
mixture of chemical reagents, constantly
grow, shift, merge, and change like replicating
organisms, their precise shapes and forms
dependent on the exact conditions of
the reaction.

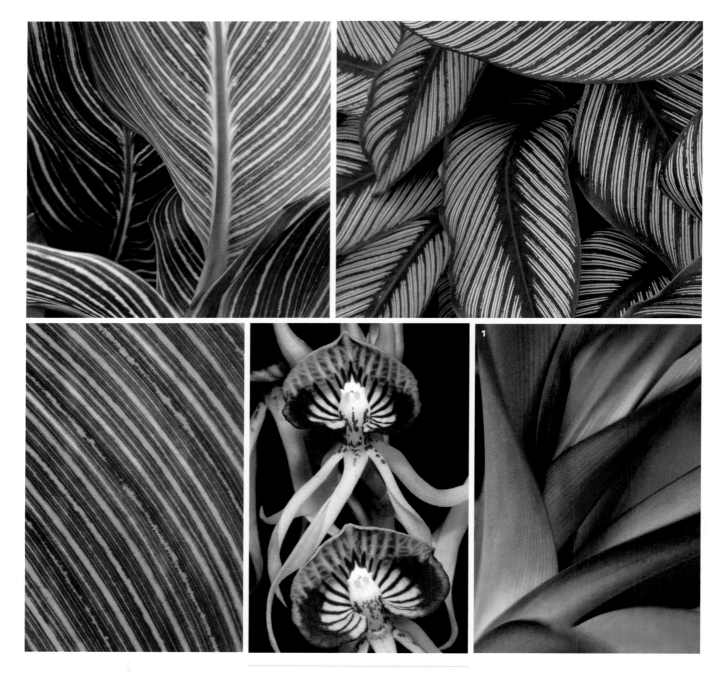

BLOOMING LOVELY
Leaves and flowers may be decorated with pigmentation, often to make them more visible to pollinating insects. The resemblance to bird plumage is explicitly acknowledged in the name of the bird of paradise plant (1).

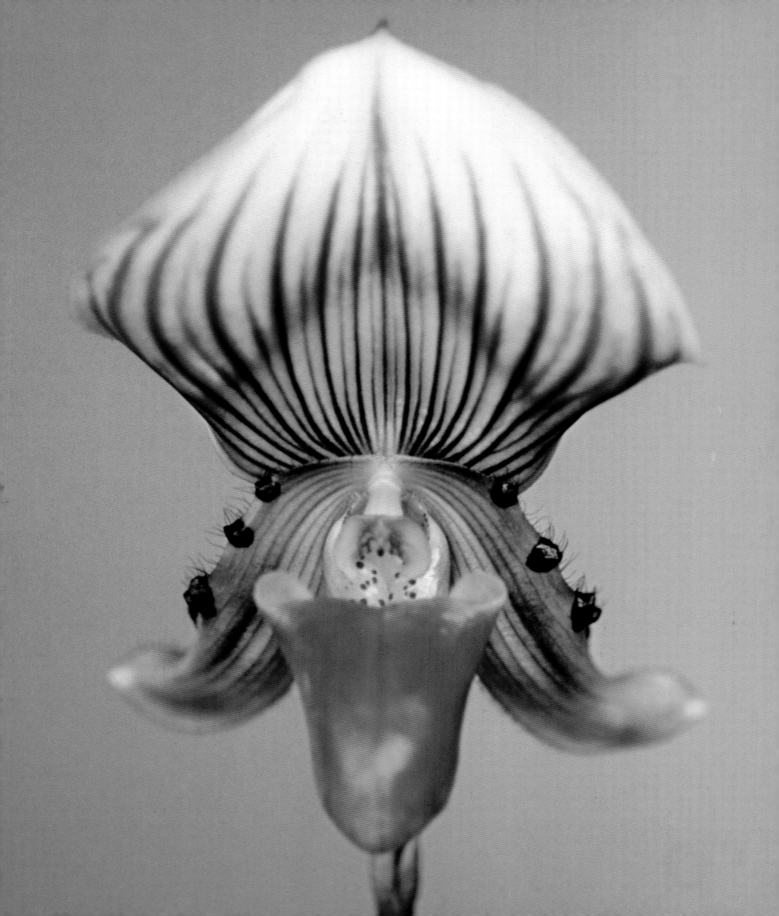

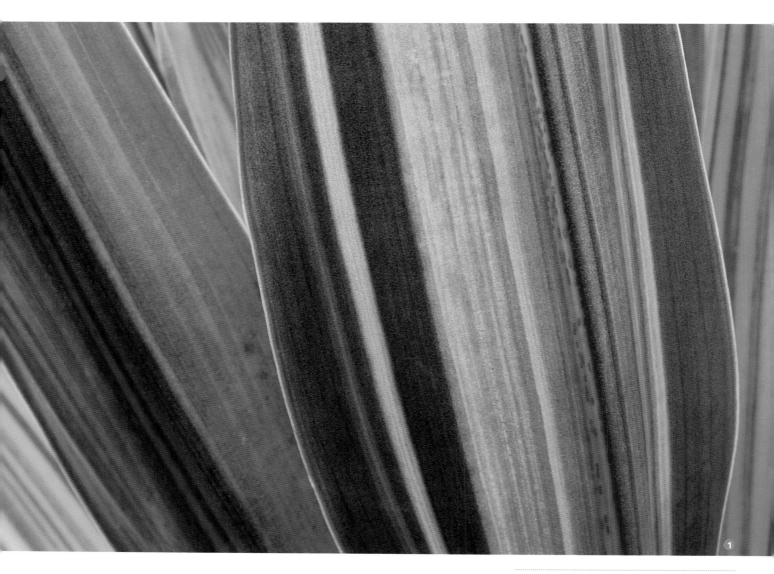

BANDING TOGETHER
Is nature more beautiful than it "needs" to be? It is hard to find an adaptive explanation for the richness of rainbow banding of this spiderwort plant (1), while the banding in bracket fungi (2) is simply an accidental result of its periodic spells of growth, not unlike the growth rings of a tree. As the zoologist D'Arcy Thompson pointed out, some things in nature look the way they do simply because of the details of how they got to be that way: form becomes a frozen memory of growth.

Glossary

Activator-inhibitor system
A pattern-forming system proposed in 1952 by Alan Turing, in which two (or more) patterning influences interact to produce patchiness, such as spots or stripes.

Convection
Movement of a fluid (a liquid or gas) usually caused by differences in density—which in turn often result from differences in temperature throughout the fluid.

Fractal
A structure or object whose shape repeats at ever finer scales.

Kármán vortex street
A regular train of vortices in a fluid flow, typically caused when the flow has to pass around some obstruction.

Logarithmic spiral
A spiral that gets "wider" with increasing distance from the center. (Strictly speaking, this spiral is a curve described by a particular mathematical equation involving logarithms.)

Phyllotaxis
The arrangement of leaves, petals, or other parts on a plant stem.

Periodic minimal surface
A surface that extends throughout three-dimensional space with zero mean curvature: the "positive" and "negative" curvature of the convolutions cancel out. The surface is generally labyrinthine, with a shape that repeats again and again (is periodic), like a crystal.

Quasicrystal
A material in which the atoms are arranged in a pattern that, while never quite repeating exactly, nevertheless is orderly enough to generate sharp "crystal-like" spots in X-ray diffraction. This pattern seems to imply that the material has a "forbidden" symmetry, such as five- or eightfold.

Reaction-diffusion process
A process that involves some kind of reaction between, or combination of, its components, while they move around by random diffusion. Such systems may generate a variety of patterns, such as moving waves or stationary patches.

Symmetry breaking
The switch from a high to a lower degree of symmetry in a system—as, for example, when a perfectly uniform system develops a pattern, which makes some directions in space different from others.

Self-organization
A process of patterning or organization arising solely from the interactions between the components of a system, rather than being imposed by some outside influence.

Self-similarity
The property in which a small part of an object looks like its whole—as, for example, with the branches of a tree. This is a typical property of fractals.

Turbulence
A state of fluid flow that is chaotic: it is impossible to fully predict, from the flow structure at one particular time, what the flow will look like at some later time. Although turbulent flow looks disorderly, some relatively orderly structures such as vortices may come and go. All flows are expected to become turbulent when they are fast enough.

Further reading

The ideas in this book are explored in more detail in my trilogy *Nature's Patterns: Shapes, Flow, and Branches* (Oxford University Press, 2009). Those books in turn arose from an updating of *The Self-Made Tapestry* (Oxford University Press, 1999).

Excellent general surveys of spontaneous pattern formation in science and nature are also provided by Ian Stewart in *What Shape is a Snowflake?* (Weidenfeld & Nicolson, 2001) and *Fearful Symmetry* (with Martin Golubitsky, Penguin, 1993). Nice discussions of some of the biological aspects of pattern formation can be found in Brian Goodwin's *How the Leopard Changed its Spots* (Princeton University Press, 2001), and in Goodwin's rather more technical collaboration with Ricard Solé, *Signs of Life* (Basic Books, 2000).

Even though a great deal has changed over the course of a century, nothing has diminished the scope, vision, and elegance of D'Arcy Thompson's 1917 classic *On Growth and Form*, available unabridged in a 1992 Dover edition. The abridged 1961 edition published by Cambridge University Press might be less daunting for some. And for a visual feast, it is still hard to beat (and sadly, equally hard to procure) Peter Stevens' *Patterns in Nature* (Little Brown, 1979).

Index

Credits

A. Martin UW Photography, Getty Images, p.39

Aabeele, Shutterstock.com, p.152

Abromeit, Jacqueline, Shutterstock.com, p.16tl

AlessandroZocc, Shutterstock.com, p.116

Alslutsky, Shutterstock.com, p.30tr/bl

AMI Images/SPL, p.24

Anderson, I., Oxford Molecular Biophysics Laboratory, SPL, p.213br

Andrushko, Galyna, Shutterstock.com, p.147l

Anest, Shutterstock.com, p.165

Anneka, Shutterstock.com, p.70br

Apples Eyes Studio, Shutterstock.com, p.83r

AppStock, Shutterstock.com, p.267

Arndt, Ingo, Getty Images, p.153bl

Arndt, Ingo, Shutterstock.com, pp.120–121

Artcasta, Shutterstock.com, pp.103br, 233b

Australian Land City, People Scape Photographer, Getty Images, p.234

Bell, James, SPL, pp.199, 207b

Ben-Jacob, Eshel, and Brainis, Inna, Tel Aviv university, pp.158–159

Beyeler, Antoine, Shutterstock.com, p.97br

Bidouze, Stephane, Shutterstock.com, p.71

Bildagentur Zoonar GmbH, Shutterstock.com, pp.114, 258, 265bl

Bipsun, Shutterstock.com, p.93

Breger, Dee, SPL, p.173br

Bridgeman Art Library, p.111l/r

Burdin, Denis, Shutterstock.com, p.141

Burrows, Chris, Getty Images, p.278bl

BusÁ Photography, Getty Images, p.238tr

Bush, John, Massachusetts Institute of Technology, p.109

BW Folsom, Shutterstock.com, p.15l

Cafe Racer, Shutterstock.com, p.64br

Cahalan, Bob, NASA, US Geological Survey, p.125t

Cahill, Alice, shutterstock.com, p.227

Carillet, David, Shutterstock.com, p.153tr

Carrie Vonderhaar/Ocean Futures Society, Getty Images, p.129tl

Checa, Antonio, University of Granada, p.182tl

Chua, Jansen, Shutterstock.com, pp.260–261

Chudakov, Ivan, Shutterstock.com, p.224

ChWeiss, Shutterstock.com, p.56tr

Clapp, David, Getty Images, p.137tr

Claude Nuridsany & Marie Perennou, SPL, p.208t

Clearviewstock, Shutterstock.com, p.232

CNES 2006 Distribution Spot Image, SPL, pp.156–157

Coffeemill, Shutterstock.com, p.247

Coleman, Clay, SPL, p.40br

Corbis, pp.49r, 58, 59l

Courtesy and photography by Florence Haudin, Experiments were performed in the Université libre de Bruxelles in Non Linear Physical Chemistry Unit, with Pr Anne De Wit, Dr Fabian Brau (ULB) and Pr Julyan Cartwright (University of Granada), pp.214–15

Cultura RM/Henn Photography, Shutterstock.com, p.230

Cultura Science, Alexander Semenov, Getty Images, p.40tr

Cultura Science/Jason Persoff Stormdoctor, Getty Images, pp.102

Cultura Travel/Philip Lee Harvey, Getty images, p.126

D. Kucharski K. Kucharska, p.186

D3sign, Shutterstock.com, p.235

Daniels, Ethan, Shutterstock.com, pp.38tl, 107

Dave, Fleetham, Shutterstock.com, p.271tl

Davemhuntphotography, Getty Images, p.34

Davidson, Michael W., SPL, pp.195, 206

Demin, Pan, Shutterstock.com, p.26bl

Depner, Joe, Vital Imagery Ltd, p.243

Dimitrios, Shutterstock.com, p.29tl

Dirscherl, Reinhard, Getty Images, p.275

Dmitrienko, Yury, Shutterstock.com, pp.82l, 104–105

Domnitsky, Shutterstock.com, p.265br

Donjiy, Shutterstock.com, p.35tr

Downer, Nigel, SPL, p.278bc

Dr Kessel, Richard & Dr Shih, Gene, Getty Images, p.94tr

Dr Wheeler, Keith, SPL, p.191

Dr Winfree, Arthur, SPL, pp.147r, 148l

Durinik, Michal, Shutterstock.com, p.70cl

Easyshutter, Shutterstock.com, p.96

Education Images, Getty Images, p.112

Edwards, Jason, Getty Images, p.128

Eetu Lampsijärvi, Getty Images, pp.88–89

Eremia, Catalin, Shutterstock.com, p.67

Esolla, Shutterstock.com, p.13

Evadeb, Shutterstock.com, p.86tr

Eye of Science, SPL, p.179b

Filip Gmerek, Michal, Shutterstock.com, p.84

Fisher, Trevor, Shutterstock.com, p.193

Fleetham, Dave, Design Pics, Getty Images, pp.4c, 123b, 273bc

Fleetham, David, Visuals Unlimited, Inc., Getty Images, p.271cr

Flood, Sue, Getty Images, pp.138–139

FLPA/Alamy Stock Photo, p.130

Foto76, Shutterstock.com, p.64bc

Fox, Tyler, Shutterstock.com, p.38tr

Fox, Tyler, Shutterstock.com, pp.271tc/cl/c/bl/bc/br

Frans Lanting, Mint Images, SPL, pp.262tl/tc/bl/bc/, 278tr, 279

Furlan, Borut, Getty Images,

pp.29bl, 273c/cl, 274bl,
Gadal, Damian P., Getty
 Images, p.137bl
Gam1983, Shutterstock.com,
 p.38br
Gay, Garry, Shutterstock.com,
 p.153tl
Gil.K, Shutterstock.com, p.87
GingerOpp, Getty Images,
 p.137tl
Gmsphotography, Getty
 Images, p.228
Gram, Ana, Shutterstock.com,
 p.51tr
Gregory, Fer, Shutterstock.
 com, p.100–101
Gschmeissner, Steve, SPL,
 pp.173tl/tr
Guido Amrein, Shutterstock.
 com, p.81l
Guilliam, James A.,Getty
 Images, p.278tl
Gulin, Darrell, Getty Images,
 pp.32bl, 262tr
Gurfinkel, Vladislav,
 Shutterstock.com, p.98
GustoImages, SPL, p.28
Guzel Studio, Shutterstock.
 com, p.54
Haarberg, Orsolya, Getty
 Images, p.137br
Haase, Andrea, Shutterstock.
 com, p.92bl
Hagiwara, Brian, Getty
 Images, p.95
Hallas, Tony & Daphne, SPL,
 pp.5, 74–75
Hanus, Josef, Shutterstock.
 com, p.238bl
Hart-Davis, Adam, SPL,
 p.143tr
Hasrullnizam, Shutterstock.
 com, p.38cr
Haudin, Florence, Paris
 Diderot University,
 pp.214–215
Hill, Chris, Shutterstock.com,
 p.90

Hinsch, Jan, SPL, p.181t
Homemade, Getty Images,
 p.203b
Hunta, Aleksandr,
 Shutterstock.com, p.65
Hunter, Butterfly, Shutterstock.
 com, pp.38cl, 265c
Huyangshu, Shutterstock.
 com, p.238tl
Hye, Alex, SPL, p.41
Igor Siwanowicz/SPL, pp.21, 31
Isselee, Eric, Shutterstock.
 com, pp.1, 35br, 36, 265tr
iStock Photos, p.7, 103tl
Ittipon, Shutterstock.com,
 p.16b
Izmaylov, Midkhat,
 Shutterstock.com, p.238br
Jack Photo, Shutterstock.com,
 p.38bc
Jackson, Alex, Shutterstock.
 com, p.70cr
Janicki, Sebastian,
 Shutterstock.com, p.30tl
Javarman, Shutterstock.com,
 p.66
Jencks, Charles, p.145
Jongkind, Chris, Getty Images,
 p.123t
jps, Shutterstock.com, p.22
Jupiterimages, Getty Images,
 p.239
K.Narloch-Liberra,
 Shutterstock.com, p.70tc
Kaewkhammul, Anan,
 Shutterstock.com,
 pp.259bl/c
Kage, Manfred, SPL, p.173bl
Kapor, Goran, Shutterstock.
 com, p.30br
Keattikorn, Shutterstock.com,
 p.64tr
Keifer, Cathy, Shutterstock.
 com, p.264
Kinsman, Edward, SPL,
 pp.5bl, 244–245
Kinsman, Ted, SPL, pp.143b,
 148l

Kletr, Shutterstock.com, p.29tr
Krahmer, Frank, Getty Images,
 p.198
kuleczka, Shutterstock.com,
 p.92tr
Kundej, Sarawut,
 Shutterstock.com, p.17l
Kyslynskyy, Eduard,
 Shutterstock.com, p.265cl
Ladtkow, Tanner, Read, Tim,
 Fabri, Andrea, University of
 Colorado at Boulder,
 p.242r
Lewis, Vickie, Getty Images,
 p.278br
Libbrecht, Kenneth, SPL,
 pp.210, 211l/c/r
Lippert Photography,
 Shutterstock.com, p.86br
Looker_Studio, Shutterstock.
 com, 70bl
Los Alamos National
 Laboratory, SPL, p.276
Lye, Jordan, Shutterstock.
 com, p.129tr
M88, Shutterstock.com,
 p.187bl
Marent, Thomas, Getty
 Images, p.94bl
Mario7, Shutterstock.com,
 p.265cr
Markkstyrn, Dornveek, Getty
 Images, p.92br
Maxim, Kostenko,
 Shutterstock.com, p.167
Mayatt, Anthony, Getty
 Images, p.35tl
Michler, Astrid & Hanns-
 Frieder, SPL, p.205l
Microscape, SPL, p.209
MikhailSh, Shutterstock.com,
 p.97tl
Mille, Christian (ABB,
Västerås), Tyrode, Eric
 Claude (KTH, Royal Institute
 of Technology, Stockhom),
 Corkery, Robert William
 (KTH Royal Institute of

Technology, Stockhom),
 p.178t/b
Miller, Josh, Getty Images,
 p.251l
Milse, Thorsten, Wildlife
 Photography, Getty Images,
 p.60tr
Mimi Ditchie Photography,
 Getty Images, p.153br
Minakuchi, Hiroya, Getty
 Images, p.26tr
Munns, Roger, Scubazoo,
 Getty Images, p.274br
My Good Images,
 Shutterstock.com, p.47
Nagel Photography,
 Shutterstock.com, p.16tr
Napat, Shutterstock.com,
 p.5br, 272
NASA, ESA, ESO, D. Lennon
 and E. Sabbi (ESA/STSCI),
 SPL, pp.76–77
NASA, Oxford Science
 Archive, Heritage Images,
 Getty Images, p.110
NASA, pp.160–161
NASA, SPL, Getty Images,
 p.103bl
Naturepl.com, pp.8, 26br, 27,
 32tr/br, 33, 35bl, 37, 40tl,
 60br, 62, 115, 117, 122,
 129bl, 136, 144, 174–175,
 250, 251r, 252, 253, 256,
 259t/tc/tr, 259bc, 262c/cr/
 br, 265tl/tc/bc, 265b, 266tl
 tr/bl/b, 268tl/tr/bl/br, 269bl,
 271tr, 273tl/cl/bl/br, 274tr
 cl/c/cr, 275
Nishinaga, Susumu, SPL,
 pp.9, 25
NOAA/University of
 Maryland Baltimore County,
 Atmospheric Lidar Group,
 p.125b
Noorduin, Wim, Harvard
 University, p.197
Noppharat, Shutterstock.com,
 p.50br